THE NUDE MALE

THE
NUDE MALE

A NEW PERSPECTIVE

MARGARET WALTERS

**PADDINGTON
PRESS LTD**

NEW YORK & LONDON

Library of Congress Cataloging in Publication Data
Walters, Margaret, 1938–
 The nude male.

 Bibliography.
 Includes index.
 1. Men in art. 2. Nude in art. I. Title.
N7572.W34 704.94'23 77-20967
ISBN 0-448-23168-9

Printed in England
Bound in England by R. J. Acford Limited, Chichester, Sussex
Designed by Patricia Pillay

IN THE UNITED STATES
PADDINGTON PRESS
Distributed by
GROSSET & DUNLAP

IN THE UNITED KINGDOM
PADDINGTON PRESS

IN CANADA
Distributed by
RANDOM HOUSE OF CANADA LTD.

IN SOUTHERN AFRICA
Distributed by
ERNEST STANTON (PUBLISHERS) (PTY.) LTD.

Contents

Acknowledgments 6

Introduction 7
The Classic Nude 34
The Naked Christian 66
Naked into Nude 94
Michelangelo 128
The Well-mannered Nude 152
Nude Directions 176
Revolutionary Eros 204
The Disappearing Male 228
The Nude Disembodied 256
Newsstand Nudes 288
Through the Looking Glass 314

Notes 332
Selected Reading 339
List of Illustrations 340
Index 344

Acknowledgments

I WOULD LIKE TO thank the many people who have helped me while I was working on this book. From the start, Edward Lucie-Smith has given me invaluable suggestions and criticisms. Enid and Bernard Moore shouldered much of the burden of gathering illustrations. I would also like to thank the following people who took time and trouble in finding pictures or information: John Christian, John Dowling, William Gerdts, Helene Muensterberger, Cindy Nemser, Janet Schneider and Peter Webb. I am especially grateful to Kathryn Boland of Paddington Press for all kinds of suggestions and help; and to those artists who so generously lent me slides and gave information about their work—Jillian Denby, Martha Edelheit, Eunice Golden, Rosalind Hodgkins, Alice Neel, Anita Steckel and Marjorie Strider.

My editor at Paddington Press, Emma Dally, has been unfailingly encouraging and helpful in so many ways. And I owe a lot to discussions with Barbara Abrash, Jane Kenrick, Rozsika Parker and Virginia Spate; and also with Professor Donald J. Gordon who died just before this book went to press.

I owe a special debt to Juliet Mitchell, who encouraged me to start this book; to Philip Martin, who gave unstintingly of time and ideas when I was first drafting it; and most of all, to Clancy Sigal, for his rigorous criticisms and unfailing support throughout.

Introduction

THE MALE NUDE is a forgotten subject. For most people the word nude conjures up the image of a naked woman—a pinup in a girlie magazine or a Venus de Milo. Over the last two hundred years or so, most artists interested in the human body have been obsessed by the female nude.

Yet for nearly two thousand years the male nude overshadowed the female: the naked gods and athletes of the ancient world, Christ stripped and suffering on the cross, Michelangelo's sensuous but spiritual nudes. In the two formative periods of Western art, early classical Greece and the early Italian Renaissance, the male body was all-important. Both periods saw the evolution of a new naturalism, based on new ways of seeing and feeling. Impelled by scientific curiosity about the structure of the human body, and by a belief in man's divinity, his central place in the universe, artists created images of the human body at once lifelike and idealized. But it was the male body they studied so lovingly, the male that was taken as the norm and ideal.

The male nude remained the basis of art training—in a sense, of art itself—from the fifteenth century almost to the present day. Renaissance artists often used male models for their female figures; even those later artists whose sole interest was in women or animals or landscape had to begin their studies with the male nude. By the nineteenth century, more progressive artists began to question this whole tradition of academic drawing as boring and irrelevant. But it would hardly have survived so long if it had not answered some real psychological need in the—male—artists. When an artist is learning to draw, to see, perhaps he learns best from a body like his own; his basic

7

image of the human body, of the whole external world, derives from his own body. The male self-image is persistently present in Western art, implied even in its absence.

Over the centuries of Western civilization, the male nude has carried a much wider range of meanings, political, religious and moral, than the female. The male nude is typically public: he strides through city squares, guards public buildings, is worshipped in Church. He personifies communal pride or aspiration. The female nude, on the other hand, comes into her own only when art is geared to the tastes and erotic fantasies of private consumers.

Most characteristically the posture and movements of the male nude suggest potency, those of the female, passivity. A victorious Greek athlete raises his arms to crown himself; a Venus, with an almost identical gesture, adorns her naked body with a necklace. Yet the effect is altogether different. The nude athlete, his body molded by exercise, incarnates virtues that were regarded as distinctively Greek; in his body, society celebrates its disciplined virility, its conquests, its civilization. The Venus exists simply to be looked at—as an object of desire. The distinction is even sharper if we compare two great Renaissance nudes. Michelangelo's enormous marble *David* stands watchfully erect in the Piazza della Signoria in Florence, tensed to test himself against his own and his city's enemies. The spectator is encouraged to identify with his youthful courage and determination. Giorgione's Venus, probably painted around the same time for a private customer, reclines in a calmly beautiful landscape whose curves echo the fertile curves of her nude body. Eyes closed, she is at once receptive and mysterious, endlessly desirable because any desire can be projected on to her.

The male nude derives much of its power and meaning from the reverence accorded in patriarchy to the phallus. I am using phallus to mean not the penis as such, the anatomical organ, but its rich and complex symbolic significance. The phallus represents abstract paternal power; it is almost by definition political. In however sophisticated and disguised form, phallic imagery remains the basis of present-day religious and political attitudes. It is worth noting that we have no female equivalent to "phallic," no word which sums up the symbolic power of the mother and of female sexuality.[1]

Yet the very earliest images of the human body were not male but female: the paleolithic figurines with exaggerated breasts and bellies,

presumably fertility icons and profoundly venerated. In cave art the vulval triangle seems to have been a more common and sacred symbol than the phallus. It has even been argued that the earliest phallic images are found in shrines to the mother goddess, as offerings to her glory.[2] But there is little direct link between, say, the prehistoric "Venus" of Willendorf and a Greek Venus, who is no more than a shadow of the earlier mother goddesses, once rich and mysterious figures whose worship vanished or was driven underground before recorded history. Equivalent phallic figures evolved later, and lasted much longer. It was the phallus, and not any image derived from the female body, which came to represent human fertility, and the creative and renewing powers of nature. At the same time, the phallus was associated with tools and weapons, the means by which man asserts his control over nature and other men. For the Romans Fascinus, the god of luck, was a personified phallus. (The modern word "fascinate" derives from the Latin word meaning enchant or charm; that magic power of warding off evil and attracting good fortune from the gods was the phallus.) In ancient Egypt, in classical Greece, all through the Roman world, phallic objects and figures abound. The phallus is carved in monumental stone, painted on domestic objects, worn as a charm (called *fascinum*) round the neck; herms, stone pillars with human heads and genitals, stood guarding crossroads and doorways.

And the nude gods of the Greeks, for all their naturalistic anatomy and neat unobtrusive penises, continue to derive much of their authority from being identified with this archaic but still vital phallic symbolism. The whole body may come to represent the phallus; Hercules is the archetypal phallic nude. He is the epitome of muscular masculinity, a strongman whose bodily exploits win him fame and finally the status of a god. One of the most popular of all ancient heroes, he survived to be Christianized into an emblem of fortitude. The Renaissance employed him as an all-purpose symbol of manhood (*virtu*) and political power; in debased form he lives on—for example in the musclemen who figure so large in the visual propaganda of twentieth-century totalitarian regimes.

Even after the advent of Christianity, a creed hostile to sex and whose art nervously concealed the genitals behind fig leaf or loincloth, the male nude retained much of its phallic significance. Artists often compensate for the hidden penis by putting the whole body into an

exaggeratedly aggressive posture, or by enlarging other parts of the body—the muscles in shoulders or thighs, or the arms. Or—to make up for the inadequacies of mere flesh and blood—the nude is provided with a club, a lance, a sword, a bow and arrow. (Modern technology has opened up new lines in phallic substitutes: homosexual pinups, for example, accessorize the nude with everything from electric drills to motorbikes to machine guns.)

Christianity retreated from the phallic pride and assertiveness of the ancient world. In Christian iconography the male nude is in a sense feminized—it is shown as passive and submissive. But Church art glorifies not true passivity but masochism, submission to violence, a perverse enjoyment of punishment and pain. In a sense, adoration is transferred from aggressor to victim. Christ is nailed to a phallic tree— crowned with thorns and his side pierced by a lance—to propitiate a vengeful patriarchal God. His martyrs, helpless victims of brute male force, win glory by enduring the most bloody and sadistic tortures. "It is no accident," claims Kenneth Clark in his book *The Nude*, "that the formalized body of the 'perfect man' became the supreme symbol of European belief. Before [a] Crucifixion of Michelangelo, we remember that the nude is after all the most serious of all subjects in art."[3] But it is as if the Christianized imagination, fearful of the flesh, can treat the naked body seriously only when it is brutalized; it becomes "supremely symbolic" only when it is mortified, dying or dead.

The naked body can sum up everything we desire and everything we most fear. The body is the source of our deepest pleasures and traumas; our whole experience of the world is set by the way we experience our bodies, by forgotten but all-pervading infantile fantasies. To be naked can mean humiliating exposure, discomfort and shame. Or it can satisfy some of our profoundest narcissistic needs, the desire to be seen which is as basic as the desire to see. To see another person naked can reassure or alarm, satisfy curiosity or provoke guilt, arouse desire or disgust and often both together. The body preserves a memory of lost wholeness, and carries the seeds of our death. Most of us shrink from contemplating the aging naked body. Lines and wrinkles in the face may be taken as signs of character and maturity. But how—without denying the flesh altogether—do we deal with that tattered coat upon a stick, the aging body?

In our ambivalent attitudes to the body we are heirs of the Judeo-

Christian denial of the flesh, heirs as well of nineteenth-century reticence and repression. For all the talk over the last decade or so about the "permissive" society, few of us are really easy with the naked body. For some people nakedness signifies liberation, a joyful and un-neurotic sexuality; for others, it stands for a licentiousness which threatens traditional moral standards. Both of these seemingly contradictory attitudes rest on a common assumption: that the exposed body is emotionally charged and potentially subversive. If the naked body remains an effective sales gimmick—in pornography, in advertising, on record sleeves, on screen, in a whole series of stage shows since *Hair*—it can only be because we are still self-conscious about nudity, feel that it breaks some still potent taboo.

Other cultures treat nudity far more casually, so that the exposed body is not such a focus of over-heated erotic fantasy. The psychiatrist Robert Stoller argues that we overly sexualize both nudity and clothing, that we "mystify the anatomy, functions and pleasures of sexuality," tantalizing children with hints of forbidden delights.

> In societies where there is unlimited nudity, no one is keenly interested in looking at the freely available anatomy. On the other hand, in a society such as ours in which certain body parts are proscribed, sexual curiosity is aroused about just those parts. The subtleties and shifts in degree and parts proscribed create fashions in dress, carriage, fantasy, and pornography.[4]

But some ambivalence about the body—hence some kind of taboo about nakedness—may be built into human psyches. Thus Freud argues that sexual repression, some shame and inhibition about both the genital and anal functions of the body, is a consequence of man's first step toward civilization, his adopting the upright position.[5] Fifth-century Greece is often cited wistfully as a society with a healthy acceptance of nudity; in fact, it is simply that their taboos differ from ours and are therefore harder for us to recognize. The Greeks too accepted only certain kinds of nudity in certain contexts. The young athletic male is allowed all the narcissistic pleasures of self-display, but women's bodies were usually well draped, and the Greeks were acutely anxious about the aging bodies of either sex.

The nude in art is of course different from the mere naked body. Kenneth Clark argues that "the nude is not the subject of art, but a form of art," a way of seeing the body first articulated in fifth-century Greece.[6] But the formal conventions which govern nudity in art are

not just a matter of aesthetics. What, in any given culture, is seen as beautiful or ugly, exciting or indecent, is always a complex and often contradictory matter, determined by social and sexual assumptions and by fears and fantasies operating below the level of conscious belief.

The "classic" nude in Western art is a paradoxical mix of sensuality and fear. Kenneth Clark talks as if the impulse to idealize the naked body were simple and self-explanatory. For him, "to be naked is to be deprived of our clothes, and the word implies some of the embarrassment which most of us feel in that condition." Actual naked bodies, he claims, fill us with "disillusion and dismay. We do not wish to imitate; we wish to perfect." The nude, on the other hand, is "a balanced, prosperous and confident body: the body re-formed."[7] As his own definition unwittingly indicates, this idealizing can be deeply ambiguous. It may be a celebration of human beauty which helps us experience our own bodies more intensely, or it may be a way of keeping the intolerable naked truth at bay. Dürer's *Apollo*, his body patterned after the newly discovered Belvedere god, is a moving expression of a dawning sense that human beauty should be enjoyed, not denied. But in the same artist's even more memorable drawing of his own naked body, we are reminded of everything the classic nude tends to exclude—the animal energies of the body, the fact that it is doomed to decay and dissolution. By the late eighteenth century, the nude in art was acceptable only at the furthest possible remove from the imperfect individual body. The traditional nude had ossified into an empty formula which provided an excuse for not really looking at actual flesh and blood. More original artists were impelled to break through the comfortable aesthetic expectations of their audience; they might distort and even degrade the body in the effort to get back to the naked truth. John Berger, writing about his later period, offers a definition of the naked and the nude almost directly opposed to Clark's: "Nakedness reveals itself. Nudity is placed on display. To be naked is to be without disguise. . . . Nudity is a form of dress."[8]

A theme that will recur throughout this book is that the word nude as applied to male and female has quite different meanings. According to Kenneth Clark our notions of ideal beauty are "the diffused memory of that peculiar physical type which was developed in Greece between the years 480 and 440 B.C. and which, in varying degrees of

intensity and consciousness, furnished the mind of Western man with a pattern of perfection from the Renaissance to the present century."[9] But that "peculiar physical type" was *male*. It would be possible, if paradoxical, to argue that on Clark's initial definition, the nude is always male. It is the male and not the female body that becomes a symbol of order and harmony between human and divine, the male that embodies man's supreme cultural values. However hard Clark tries to distinguish a celestial Venus from her purely erotic and earthly sister, the fact remains that there is no female equivalent to Apollo or Christ.

The precise significance of the male nude varies from period to period and artist to artist. Nevertheless, the ideal of male beauty has been far less subject to the vagaries of fashion than the female. The different male archetypes first formulated by the Greeks—the massive and muscular Hercules, the graceful but virile Apollo, the fragile adolescent Narcissus—all tend to refer back to some constant norm. They could almost be seen as the same body at different stages of its development. Women's bodies, however, have suffered drastic and varying deformations. The elongated nymphs of sixteenth-century court art hardly seem to belong to the same species as Rubens's fleshy hausfraus, and the skinny Gothic women with their swelling bellies are worlds apart from the petite and pretty girls of rococo. It is as if male fantasy constantly reshapes the woman's body to better fit his shifting desire, at the same time being careful to preserve the integrity of his own male self.

The relatively recent predominance of the female nude springs from a tendency to see nothing *but* sexual meanings in nakedness, to treat the nude purely as an object of desire. The metaphors for artistic creation itself become sexual rather than theological. The Renaissance artist, for whom the male nude is the supreme test of his genius, identifies with God making man; the nineteenth-century artist is more likely to see himself as a Pygmalion who makes—in every sense of the word—his ideal woman. And where the earlier artist could take a narcissistic pleasure in his own idealized self-image, celebrate his own masculinity in superhuman form, his later counterpart found an enhanced image of his manhood reflected in submissive woman. The female nude of the last couple of centuries exists *only* as an incarnation of male desire. As John Berger has argued, "Her nakedness is not a function of her sexuality but of the sexuality of those who have access

13

to the picture. In the majority of European nudes there is a close parallel with the passivity which is endemic to prostitution."[10] The nineteenth-century picture buyer is excited and flattered by the female nude's apparent yielding and availability, and is often threatened by the very idea of a male in a comparable state of passive undress.

It is possible that the woman's body will always arouse more intense sexual responses in men and women, though the anxieties it kindles may in certain cultures mean that, almost literally, it is too hot to handle. At some level the woman's body is always the mother's, which is, after all, our primary source of happiness and grief. In her arms we had our first glimmerings of bliss, of being at one with the universe, and in her arms we discover our terrifying separateness; at her breast, we first experience fulfillment and frustration, and our capacity for destructive anger. In psychoanalytic terms, it is in relation to the mother's body that the boy confronts his fears of castration and the girl her permanent lack of a penis. For all these reasons the female becomes the symbol, as the male can never be, of a desire that is so intense simply because it can never be satisfied.

Nevertheless, there are a great many classical and Renaissance nude males which are openly erotic, existing simply because they are sensually beautiful. More recent art historians, like artists, have tended to retreat nervously from the erotic attractions of the male body. A Greek Apollo or a Renaissance David express men's enjoyment of the male body, though it is too simple merely to label this homosexual. Homosexuality is after all as variable as masculinity and femininity. It means one thing in fifth-century Greece, where it was accepted as a way of transmitting cherished cultural values, another in Renaissance Italy, where it was culturally important but had to be disguised because of centuries of Christian disapproval. (Ironically, many Christian characters, from the martyr Sebastian to the young David to John the Baptist, became favorite homoerotic types. The openly homosexual myth of Ganymede caught up by Jupiter disguised as a great phallic eagle was a predictably popular theme, though it was often respectably dressed up as an allegory of the Christian soul being overwhelmed by God.) In the nineteenth century, homosexuality— now seen as a perversion unthinkable for the normal male—often takes the form of a protesting parody of rigid sexual stereotypes, and the male nude is often put into exaggerated and camp feminine poses.

14

Though the male and female bodies are usually sharply differentiated in art, some hint of androgyny, conscious or unconscious, is very common. (In the late Greek world, actual hermaphrodites— figures with both penis and breasts—were popular. Originally celebrations of the power of bisexual deities, most surviving examples are simply sophisticated jokes about a man's latent homosexual, or latent heterosexual, inclinations.) The androgynous figure, whether masculine woman or feminine man, can be both attractive and terrifying. Obviously its roots are in the child's earliest attempts to distinguish between the sexes. It may express an impossible but potent dream of wholeness; or it may spring from the man's deep, unacknowledged envy of the female body.[11] In the man's eyes the mature woman with masculine strength—the phallic mother—is usually very disturbing; so Greek Amazon or nineteenth-century vampire are at once nightmares and jokes. On the other hand, the virginal and boyish girl is often very reassuring. The feminized male is an equally ambiguous figure. He may simply seem a safer sex object than a woman, as soft and smoothly graceful as she is but without her disturbing difference. The young boy may focus a man's tenderness for his own younger self, or serve as a symbol of the man's dream of himself *incorporating* femininity, rediscovering in himself those qualities prohibited to him as a grown man. If there are many androgynous nudes that express a man's longing to recover his repressed femininity, there are others that hint at his fear of being polluted by a feminine softness which threatens to submerge his male identity. (So Rubens shows Adonis starting stiffly away from a soft and clinging Venus; and in another drawing shows him limp in her arms, more sensuous and feminine than she—and dead.)

Most of the nudes discussed in this book are, like the whole of our official culture, created from a male point of view. (This does not mean they did not, or do not, appeal to women as well; up to the nineteenth century, men took it for granted that women have a sensuous response to male beauty.) But though we know a great deal about how men see both male and female bodies, we know far less about how women see men.

Until the present century, few women arists ever did male nudes. For one thing, women were simply not allowed into life classes until late in the nineteenth century; that is, they were excluded from

essential training. How absurd! The male nude, this central symbol of Western art, the image of God himself, is too scandalous for women to study. If anything, the idea was even more shocking in the early modern period, with its increasingly rigid notions of propriety, than it had been in the Renaissance. The highly successful eighteenth-century painter Angelica Kauffman was criticized for her inadequate knowledge of anatomy and her effete male figures—and at the same time hounded by rumors that she had secretly worked from a fully exposed male model. When Zoffany painted the members of the British Royal Academy gathered around nude models in the life class, the only two women academicians, Kauffman and Mary Moser, were naturally absent—though their portraits were shown hanging on the wall. Even at the end of the last century, when women had finally won their point and gained entry at least to separate life classes, one respectable art critic lamented the injury the students were doing themselves. Drawing from the male nude, they sacrifice, "not the flower of maidenhead but its delicate perfume."[12]

For the same reason, we have little record of what women thought of the male-created art. What did a Greek woman think of all those nude athletes and warriors? Or an Italian woman of Michelangelo's Sistine ceiling? We can only speculate. In the past women have certainly been important as patrons and purchasers of art; but as one might expect, their tastes are rarely distinguishable from that of their male contemporaries. So Isabella D'Este, like other Renaissance humanists and connoisseurs, enjoyed nudes of both sexes acting out erudite allegories, and Marie de Medici looked to Rubens for the same kind of eulogistic political propaganda that most seventeenth-century rulers wanted in their art. And the great mistresses, from Diane de Poitiers to Madame de Pompadour, always bore in mind the tastes and sexual fantasies of their royal lovers, and surrounded themselves with female nudes that served as flattering images of their own charms.

Women, with their modesty and delicate sensibilities and higher moral standards, are not interested in looking at the male body—so the nineteenth-century myth ran. Underlying it was another view of woman. Given the chance, she might turn the tables, treat the man in his turn as an object to be judged and assessed. The very act of looking is often associated with aggressive and even sadistic fantasies: it is a way of transfixing, possessing, taking control. Many men still seem afraid of being looked at by woman, as if her gaze might have a

Medusa-like effect, paralyzing and petrifying its object—or perhaps more accurately, softening and weakening it. Thus one of D. H. Lawrence's super-virile gamekeepers protests, with desperate and excessive rage, against his ex-wife who had taken aesthetic pleasure in his body, by looking at him as if he were a Greek statue.[13] Contemporary women artists who have dared to portray the naked male body have been violently attacked for obscenity by men who are unruffled by the most pornographic female nudes. When, in England, there was a temporary and joking fashion for male strippers entertaining women in pubs, one judge, trying a proprietor for keeping a disorderly house, treated the case as if it marked the beginning of the end of civilization as we know it. And I found that men sometimes reacted defensively and sarcastically when told I was writing about the male nude; comments ranged from the crude joke—"What a lot of old cock!"—to sophisticated analyses of my penis envy.

Women are not encouraged to express their sexuality by looking at all. They are expected from the day they are born to suppress any curiosity about the male body. Prudishness was one of the defining traits of bourgeois femininity; we have still not shaken it off. A well-brought-up woman of the nineteenth century probably *was* shocked and disgusted at her first sight of the male body. (At an English design school, a genteel married woman student even complained about the exposed penises on the plaster casts; at her request, they were chipped off and replaced by fig leaves. And when Thomas Eakins removed a loincloth from a male model in his Philadelphia drawing class, it was said to be a few of his women students whose protests led to his resignation.)[14] But even today, a woman is expected to take a narcissistic pleasure in fulfilling male fantasies rather than in exploring and acting out her own. There is still a rigid division between the sex that looks and the sex that is looked at. The dichotomy is bound to breed perversion in both sexes: in the man voyeurism, hostility and envy, in the woman masochism, exhibitionism and hypocrisy. Both men and women are deprived and impoverished.

Lately, women have begun to ask whether this division is natural or artificial, man-made; to consider whether it is universal, or the product of very specific social conditions. Feminists have questioned the invisible sexual bias of our culture, and are beginning to explore

and create alternative possibilities. At the moment there is no language, verbal or visual, through which a woman can readily articulate her feelings about the male body. A whole time-honored range of metaphors crystallize male feelings about women. The female nude may be seen in a landscape, her body itself a landscape which can be explored, penetrated and possessed by the man. Or the woman is surrounded by jewels, silks and precious objects so that she is turned into a still life that arouses the man's acquisitive instincts along with his sexual desire. Linda Nochlin has discussed another of these metaphors, the comparison of a woman's breasts to fruit.[16] Nochlin juxtaposes a picture of a nearly naked girl holding a tray of ripe apples for sale with a parody photo of a nude male holding an equivalent tray—of bananas. Her point, though humorous, is important: the impossibility, and the absurdity, of simply trying to reverse roles.

Yes, women *are* capable of treating a man as men have traditionally treated women. They *can* learn to see him merely as a sex object, look at his equipment in a detached and comparing way, talk about him being well hung just as men talk about a woman being stacked. Turning the tables on men may be necessary, even satisfying, but only in the short term. For women to adopt a "masculine" role toward men or each other simply begs the question. Struggling against their traditional passivity does not mean becoming imitation men: which is the assumption made by magazines like *Playgirl* trying to sell nude pinups to women. Such magazines are trying to reduce a woman's feelings to a formula even before she knows what they really are or might be.

Obviously it is impossible to will into existence a whole new visual language, a mythology that would truly express women's deepest and most suppressed sexual feelings. Radical change never happens overnight. But there are at least some writers and artists working at the moment who seem to be feeling their way toward new ways of seeing. And looking again at the nude of tradition—far more various and interesting than conventional histories allow—may help women discover and recreate their feelings about their own bodies and men's as well.

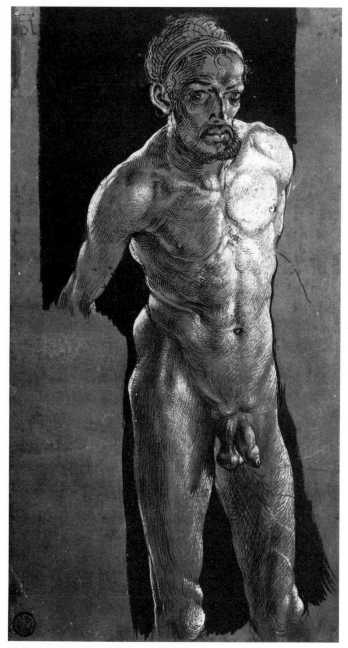

Naked Self-Portrait, c. 1503, Dürer

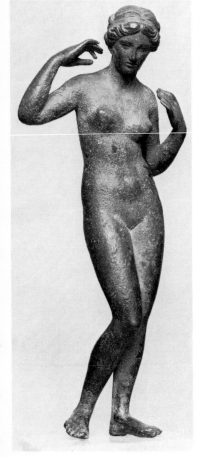

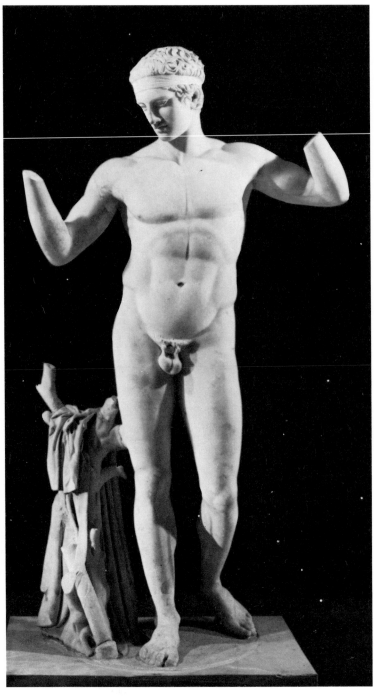

LEFT: *Aphrodite*, third century
B.C., Greek
RIGHT: *Athlete*, copy after
Polykleitos, *c.* 430 B.C.

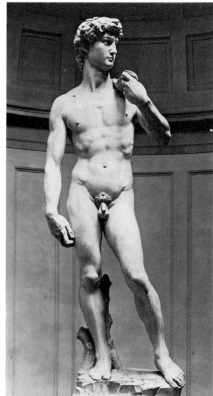

LEFT: *David*, 1501–4, Michelangelo
BOTTOM: *Venus, c.* 1510, Giorgione

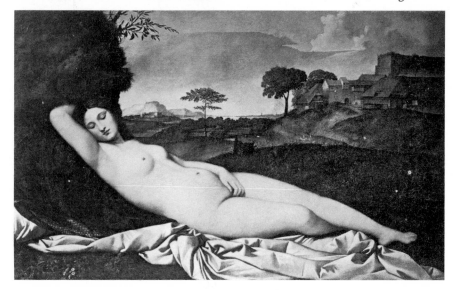

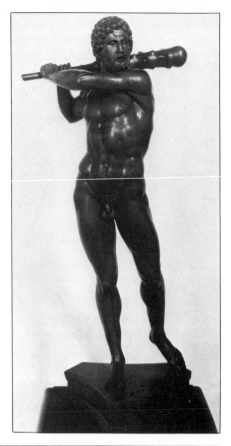

RIGHT: *Hercules*, 1520,
Francesco da Sant'Agato
BOTTOM: *Hercules, c.* 1910,
Bourdelle

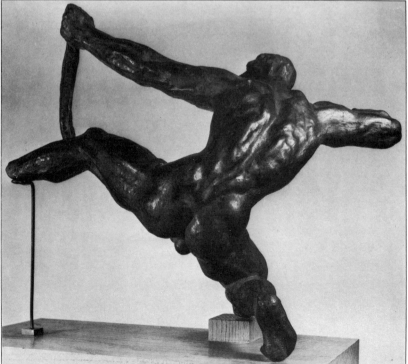

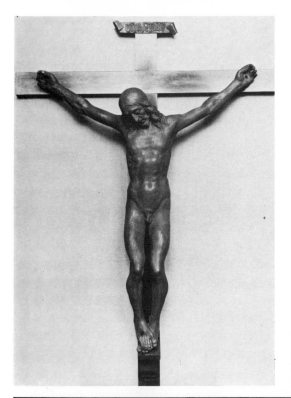

LEFT: *Christ Crucified*, fifteenth century, Florentine
BOTTOM: *Dead Christ, c.* 1500, Mantegna

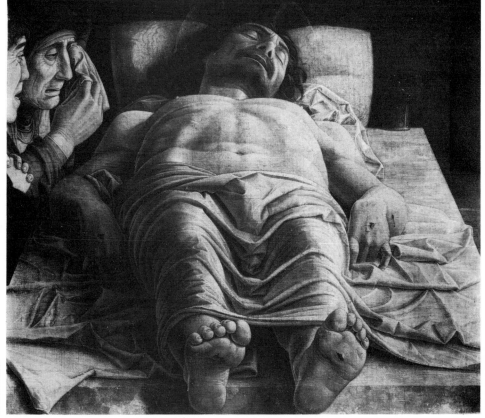

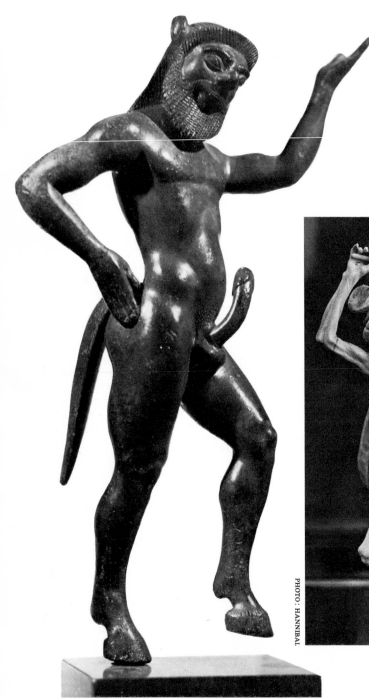

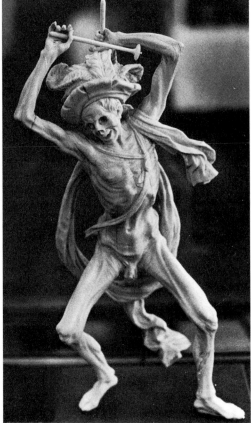

LEFT: *Satyr*, sixth century
B.C., Greek
BOTTOM: *Death*, sixteenth
century, German

PHOTO: HANNIBAL

24

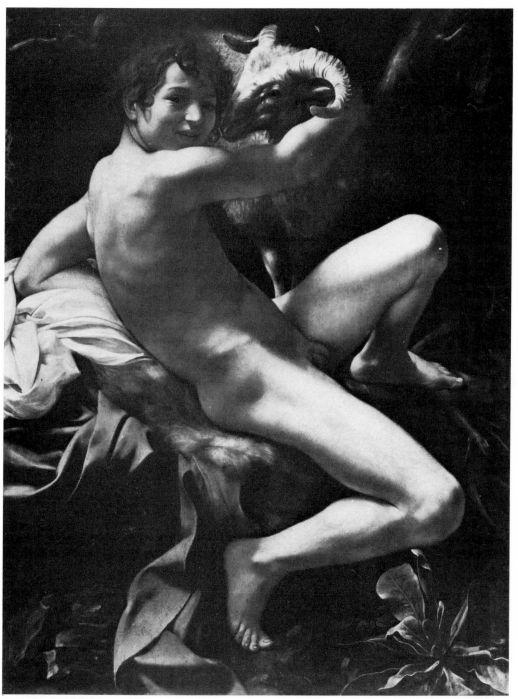

St. John the Baptist, c. 1595, Caravaggio

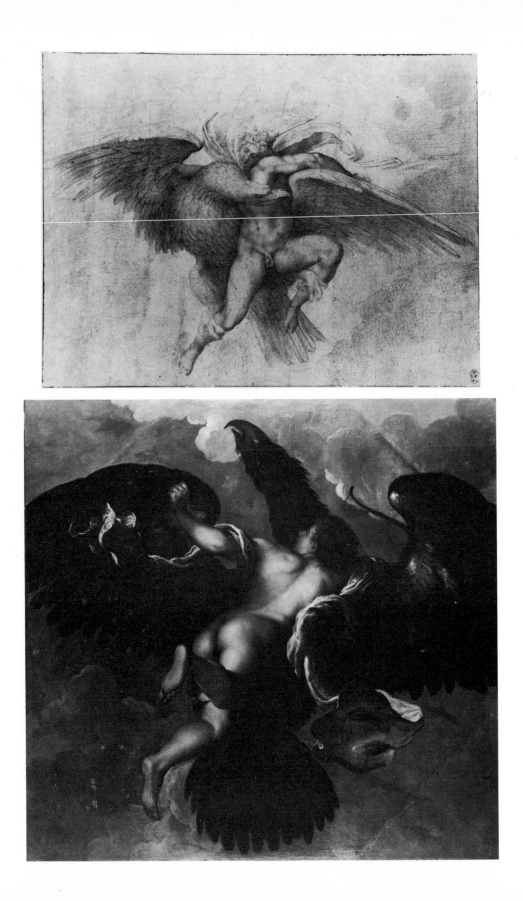

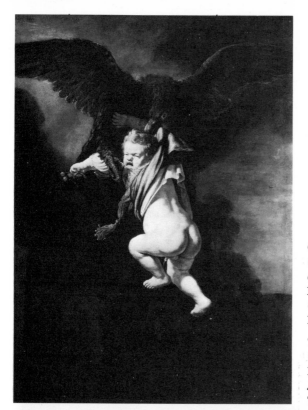

OPPOSITE, TOP: *The Rape of Ganymede*, sixteenth-century drawing after Michelangelo
BOTTOM: *The Rape of Ganymede*, sixteenth century, Damiano Mazza

THIS PAGE, LEFT: *The Rape of Ganymede*, 1635, Rembrandt
BOTTOM: *Ganymede with Jupiter as the Eagle*, 1817, Thorwaldsen

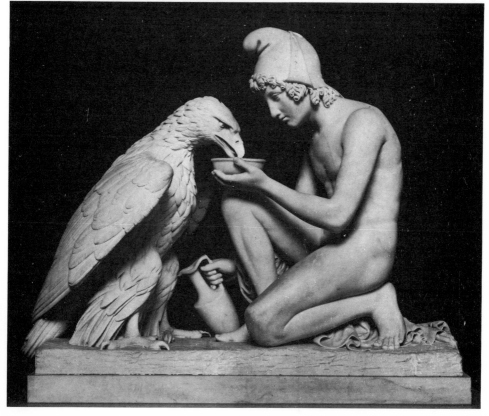

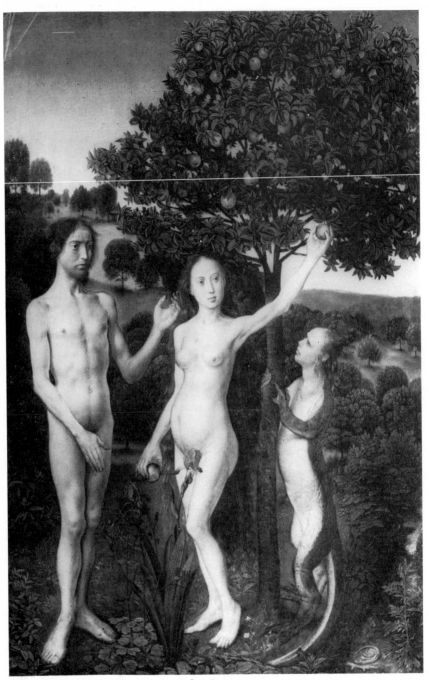

Adam and Eve, c. 1470, Hugo van der Goes

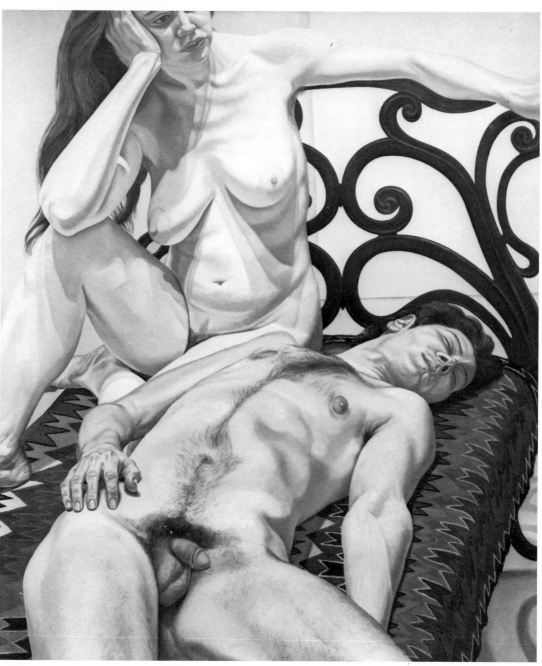

Male and Female Models on a Cast Iron Bed, 1974, Philip Pearlstein

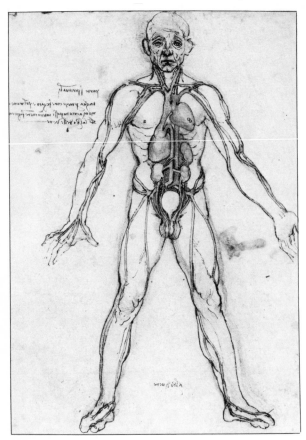

TOP: *Anatomical Study of a Man*, showing the
blood vessels, *c.* 1504–6, Leonardo da Vinci
RIGHT: *Anatomical Study* of a flayed man, 1804–6,
George Stubbs

RIGHT: Study of a Male Nude, 1810–12,
Géricault
BOTTOM: Drawing of a Male Nude,
1857, Degas

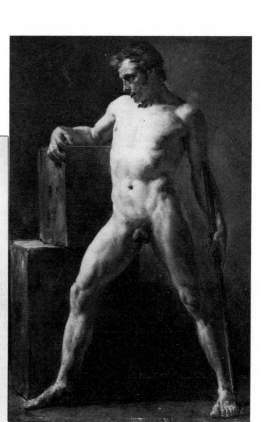

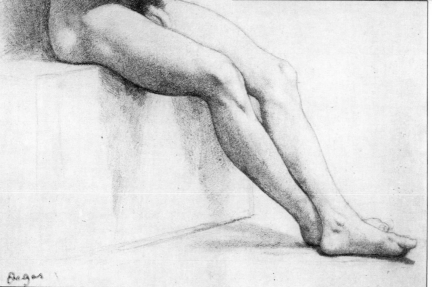

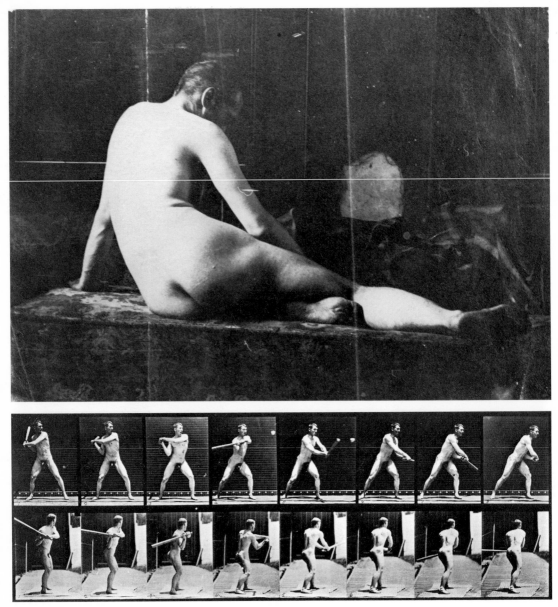

TOP: Thomas Eakins posing in the nude, *c.* 1884–9
BOTTOM: *Man Batting Baseball*, 1887, Edweard Muybridge

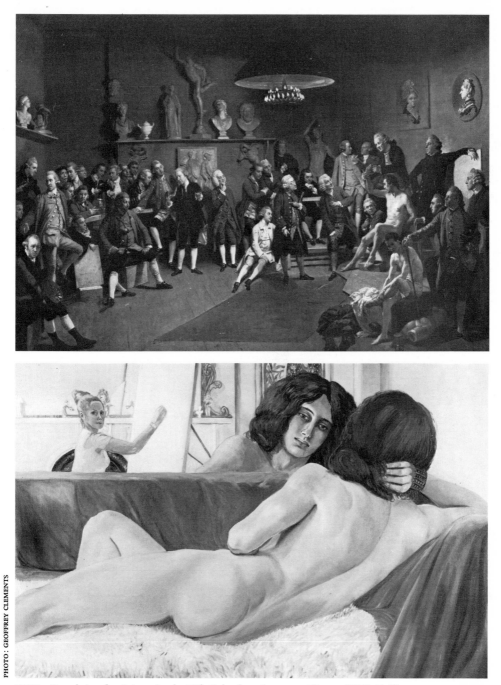

TOP: *Royal Academicians in the Life School at Somerset House*, 1772, Zoffany
BOTTOM: *Philip Golub Reclining*, 1971, Sylvia Sleigh

33

The Classic Nude

THE GREEK NUDE, the classic nude, is male. The young male body is the central image in Greek art, from its archaic beginnings until its decline. Naked Apollo embodies the most cherished cultural ideals of the Greeks. At once god and man, he is a dominating figure in the classic art of the fifth century and survives, though in sometimes degenerate forms, until the last days of the Hellenistic world. Naked Aphrodite is a latecomer, and comparatively unimportant. She hardly existed before the fourth century, and she bore little of the complex meanings that made Apollo so important.

The classic nude, at once sensual and ideal, has indeed provided a "pattern of perfection for the Western imagination since the Renaissance."[1] But comparatively little art from the fifth century has survived intact, and succeeding generations have had to reconstruct it from fragments or later copies, and from literature. They have fashioned it out of their own desires and frustrations. To the Christian, taught to despise and discipline the body in the interest of the soul, the classic nude seems like a messenger from an unfallen, guilt-free world where flesh and spirit were one. For the aesthete, the Greek nude is symbol of a high civilization in which the beautiful is also the good, and "nothing is sacred but beauty"[2]; and it hints, to the homosexual, of a golden age when his desires were freely admitted and even celebrated. Kenneth Clark argues that the nude is the expression of the Greek "sense of wholeness." It "implies the conquest of an inhibition which oppresses all but the most backward of peoples; it is like a denial of original sin."[3] For other contemporary writers influenced by psychoanalysis, the classic nude is an examplar of psychic health, a

projection of the integrated ego moderns can only glimpse if at all, after years on the couch.[4]

The dream is powerful, persistent—and far too simple. If Athenian civilization was founded on bitter inequalities of race, class and sex, the Greek vision of the ennobled and godlike body rests on the same kind of exclusion. Greek art, philosophy and literature all celebrate man, and locate him confidently at the center of the universe. But it is always, in the words of Hanns Sachs, "a man of their own language, their own people, their own kindred in whom every individual could recognize himself."[5] Every *male* individual, that is. What Greek art celebrates, with remarkable singleness, is masculinity. We can only speculate about the reaction of Greek women to the persistent, insistent idealizing of the male body.

GODS AND GODDESSES

The history of Greek art is often told in terms of its evolving naturalism. For the first time in human history, the body escapes the bonds of archaic abstraction and comes to life. Sculpture and vase painting show an ever-increasing understanding of the structure of the body, and ease and subtlety in suggesting movement. And, as Gisela Richter has pointed out, "the laboratory in which they worked out their naturalistic art" was the standing male nude.[6] It is the *male* body that is observed in such close and loving detail. There is remarkably little interest in the distinctive characteristics of the female body.

As early as the seventh century B.C., vase painters sometimes show the Greeks and their gods going into battle heroically, if implausibly, naked. (Even when they are clothed, their short tunics often seem to fly up and expose their thighs and genitals.) Given the archaic convention which presents the torso frontally but legs and heads in profile, the robust warriors run and wrestle and kill with splendid verve and vitality. By the late sixth century B.C., the freer-flowing techniques of red-figure pottery allowed artists to experiment further. The male nude still occurs mainly in traditional scenes from myth or epic, but now it is often isolated against a plain background and enjoyed for its own sake, as an aesthetic object. And there was a new market for vases, presumably for private use, which showed scenes from contemporary life: banquets, athletics, domestic interiors.

The nudes are younger and more refined than the first massive

35

fighting-men; they are fresh, lively, and even comic. Athletes are a favorite subject: running and jumping and standing still, throwing or wrestling, or just admiring their own beautiful bodies. Sometimes they are copulating, with women or other men, and they adopt the most complicated postures with nonchalant acrobatic ease. Participants and artists alike seem to enjoy showing off the number of poses at their command, and painters take a pure virtuoso pleasure in studying bodies foreshortened and variously intertwined.

These late archaic vases show naked women as well, but their roles are much more limited. No respectable woman, no wife or daughter of a citizen, would appear without her clothes. The vase girls are entertainers, courtesans and flute girls, and the better looking the better. But the word *kalos* (beautiful), so often and so enthusiastically applied to boys, is rarely used of girls. Greek art (and literature) romanticizes masculine and not feminine beauty. One painter even seems to get his genders mixed and labels a girl, carrying her clothes and a bucket as she goes to wash, as *kalos* instead of the feminine *kale*.

The girls *are* less beautiful than the men. Artists always seem to have the male body in mind as a scheme and an ideal. Young girls have hard muscular bodies, broad shoulders and narrow hips, with firm, full buttocks. Their breasts often seem an afterthought, and are certainly of secondary interest. They may move or stand awkwardly: the poses developed to show off the athletic male body are not altogether appropriate for a girl playing the flute or dancing or unfastening her sandals.

There is an even sharper distinction between the sexes in the public and monumental art of sculpture. Classical sculpture derived from the life-size stone statues of youths and maidens placed in sanctuaries and cemeteries as early as 700 B.C., as votive offerings to the gods or memorials to the dead. Both sexes have a remote, impassive beauty reminiscent of the Egyptian figures from which they probably derive. But the Greeks emphasized the nakedness of the youths, the *kouroi*, and covered up the girls with elaborate drapery. "Drapery makes the bodies of sixth-century maidens as beautiful as those of young men," comments Kenneth Clark, missing the point of his observation.[7] The drapery occasionally hints at the body beneath, particularly the buttocks and legs. More often, the intricate formal patterning of the cloth, made even busier by colored paint, distracts our attention from the body beneath, as if to make up for its inadequacies.

In some earlier *kouroi*, the broad shoulders and swelling athletic thighs and buttocks are exaggerated almost to the point of caricature. The body is an ideogram, asserting masculine strength. For more than a century, the stiffly erect pose—hands usually clenched at the sides and one foot slightly advanced—hardly varies at all. And the strange archaic smile also persists—optimistic, impervious to all the ravages of real life. But there is an increasing tension between the abstract, almost geometric shape, and the sense of living flesh. The stance becomes subtler and more flexible, and the body seems animated by an eager but controlled energy. The Strangford Apollo, dating from around 490 B.C., retains the archaic stillness and self-containment, but he is altogether more human, his body smoothly integrated, graceful and sensual. The stiff square *kouros* shape, so impassively confident, is still discernible in the standing athletes, however relaxed and naturalistic they may be, of classical Greek art. It is one of the sources of their ideal, godlike detachment.

The *kouros* might be a man or a god. The perfect young body could commemorate a hero or a victorious athlete; it is sometimes the idealized image of a donor, and sometimes the great god Apollo himself. (The function of the maiden seems less complex. There is no evidence that she ever represented a goddess, and she was often presented by a male donor. She seems to have been a formal offering to a goddess, a beautiful girl dedicated to her service.) Two *kouroi* which have survived at Delphi were erected, so Herodotus tells us, to commemorate the virtue of the brothers Kleobis and Biton—their strength, their devotion to their mother, and their piety. Their proud mother prayed to the goddess Hera that they be granted "the best thing that can befall a man."[8] They fell asleep in the sanctuary and never rose again. But they have another, more perfect life in larger-than-life stone: untouched by time or misfortune, they are remembered in the full bloom of vigorous youth. And if man in his first strength is godlike, so the god Apollo appears in that shape. One hymn, dating from around 600 B.C., describes him as "like unto a man, lusty and powerful in his first bloom, his hair spread over his broad shoulders."[9] It is the perfect description of a *kouros*.

That the Greeks imagined their gods in human form is a commonplace. The sculptor Polykleitos was praised by con-temporaries because his athletes represent perfectly proportioned man. The athlete referred to as the *Doryphoros* was a canon of perfect

measurements, a demonstration of the Greek belief that ideal beauty can be expressed mathematically. Phidias was said to have done even more than Polykleitos: he created the likeness of the gods. But in practice, gods can often hardly be distinguished from heroes or athletes. A later fable tells how a sculptor was approached by two customers, one wanting a particular statue to dedicate to the god Hermes, the other wanting the same figure to commemorate his dead son.

The great nude Apollo on the east pediment of the Temple of Zeus at Olympia may seem superhuman as he stands in stern majesty, remote from the confused struggle of Lapiths and drunken, lustful centaurs. A convincing personification of order and civilized values, his extended arm ensures the victory of the Greek tribe, the Lapiths, and the reign of law. He is invisible to the participants in the struggle, and a world apart from the fierce, snarling centaurs, who are human only to the waist, and animal below. But the Lapiths, even in painful and violent struggle, reflect some of Apollo's heroic dignity, and aspire to the self-control and order that he incarnates. Heroically naked like their god, their nakedness a paradoxical symbol of high civilization, the Lapiths vanquish the enemies of Greece: the anarchic, the barbaric, the hardly human.

By the fifth century, Greek sculptors had developed an impressive range of types and poses for the male nude. The simple standing figure remains a favorite, but others are tensed for action. Myron's discus thrower is a good example: caught, as if by a high-speed camera, in that moment of perfect balance when the moving body seems completely relaxed. And so is the great bronze god—an older man, perhaps Zeus or Poseidon—who strides in all the confidence of his virile maturity, arms outstretched to unleash a thunderbolt. Even the reclining god from the Parthenon suggests an easy power that might be exerted at any moment.

The classic nude is rarely marked in any way by effort or suffering. Even in the thick of battle the tense bodies of the warriors are clear and undistorted, and those rare works which show the death of a hero insist on his untouched beauty. One of the sons of Niobe, stretched at full length, seems to relax into death as into sleep, and a fallen warrior from the temple at Aegina, an older, bearded man, still retains his dignity even in his death agony. An aristocratic self-control means that the body is never abandoned—to rage or joy or even pain. Even

the nudes carved on tombstones, express a gentle melancholy and regret for all that is lost, rather than overwhelming grief.

The Greek ideal is the young but fully grown body, molded by gymnastics to the peak of its power. The delicately effeminate boys so popular from the fourth century onward win little admiration in classical art. The child is interesting only for his promise of virile strength, and the older body acceptable if it retains its hard muscular energy. Herakles on the Olympian Temple of Zeus actually ages as he goes through his labors, though his force remains undiminished. But even this degree of realism is rare. Most older men—the very old never appear naked—are stunningly well preserved, walking advertisements for the efficacy of athletic workouts. The athletic Apollo, the Apollonian athlete, is the favorite fifth-century type: the idealized self-image of every Athenian citizen and the proud symbol of Greek culture.

There is no female equivalent to Apollo, no Olympic goddess who is, like him, "a whole being with unlimited potential for growth."[10] Even when he treated them half-jokingly, as charming anachronisms, the fifth-century Athenian male still felt his personal identity confirmed and enhanced by the Homeric myths. But there is an impassable gulf between the power of the goddesses, and the narrow, limited lives of real Greek women. The Olympic goddesses themselves represent a scaling down of the powers of the original mother goddesses. The qualities once combined in a single figure are separated and parceled out, in ways that correspond to the real-life divisions between wife and courtesan. Hera, great Queen and wife to Zeus, is often portrayed as a tricky, jealous shrew, Artemis becomes a fanatical and inimical virgin, and Aphrodite is simply the personification of sexual love.

Aphrodite is the only goddess ever portrayed naked, and rarely before the fourth century. Some fifth-century sculptors are obviously attracted by the female body, and use drapery to reveal the contours beneath. But the promised unveiling is always witheld. With a surprising number of statues, even in the fourth century, the vitality is in the creased and crumpled cloth, rather than the body beneath. Praxiteles's nude Aphrodite of Knidos was famous partly because of her novelty. The naked goddess was assimilated so slowly because she was associated with Oriental, that is, un-Greek, cults. And she was only undraped when her earlier, more disturbing associations with fertility and childbirth had been suppressed or transferred to other

figures; when she had been reduced to an object of sexual desire.

It is usually argued that in the naked Aphrodite, "the beauty that arouses physical passion was celebrated and given a religious status."[11] According to Sarah Pomeroy, "as the male nude embraced a medley of elements, both homosexual and heroic, so the Aphrodite figure was sexually attractive while she simultaneously embodied religious ideals."[12] As far as we can tell from later copies, she was indeed beautiful, gentle and graceful, and Praxiteles had a real love and sensual appreciation for the female body. The goddess's hand reveals and conceals her sex in a gesture dimly recalling her sacred origins—a gesture that only too easily, in later copies, became a self-consciously provocative modesty. It is easy—and was apparently easy for the Greeks—to treat Aphrodite simply as an attractive woman. Lucian's account of a visit to her shrine (you paid extra to see her from behind) is not exactly memorable for its religious fervor. Both he and Pliny mention the man who was so overcome by love for the statue that he hid himself in the sanctuary at night, leaving a stain on the statue "as indication of his lust."[13]

The Knidos Aphrodite was said to be modeled on Phryne, the sculptor's mistress and a courtesan famous for her miraculous beauty. But the point is that she represents an idealization of *one* aspect of woman, and one only. She is courtesan and not wife or mother. Apollo, on the other hand, represents man in his often contradictory completeness. The religious awe associated with the great goddess is always on the point of dwindling into a connoisseur's pleasure in a beautiful object, into voyeurism, or into simple lust.

The Greeks may have been totally unembarrassed by the naked male body, but they could be very prudish and evasive about the female. The rest of Greece was shocked by the story that Spartan girls were allowed to exercise naked with the boys. And though the young and boyish female nude was acceptable in certain contexts, the body of the sexually mature woman was absolutely taboo. Zeus was sculpted naked, Hera never. Several myths tell of a mortal who is punished by death (or symbolic castration) for looking at the body of a goddess. One legend tells how Tiresias was blinded when he saw Athene naked, and the hunter Actaeon was killed by his own hounds when he intruded on Artemis bathing. Conversely, married women were never allowed to watch the great athletic contests where men competed naked, though some sources suggest that it was permitted to

young girls. The mature woman, presumably in fantasy the mother, is the focus of fear and hostility; as if it were dangerous for a man either to see or be seen by her naked.

But there are hints that the Greeks envied the female body. In some curious stories, the male usurps the powers more commonly associated with the female, and actually gives birth. One legend describes the birth of Aphrodite from the severed genitals of Uranus; and the child Dionysus, snatched from the lightning-seared body of his mother Semele, was brought to full term in the thigh of Zeus. In the *Oresteia*, the god Apollo, defending Orestes for the murder of his mother Clytemnestra, insists that the female body plays a secondary role even in normal reproduction, for she is no more than a passive vessel for the male seed. "The mother is not the true parent of the child which is called hers. She is a nurse who tends the growth of the young seed planted." And the god proves his point by summoning Athene, who was "never nursed in the dark cradle of the womb," but sprang fully armed from the head of Olympian Zeus. And a thoroughly male-identified goddess she is, asserting "the father's claim and male supremacy in all things"[14]; powerful in battle, and even taking male form in her efforts to protect the Greeks.

Athene represents the benevolent aspect of a fearful fantasy that haunted the Greeks—of the manlike, phallic woman. Clytemnestra, murderer of her husband, wears her more sinister face, as do the women of Lemnos who killed their husbands and took over the island. Atalanta runs and wrestles better than any man—but is finally tricked into marriage and submission. The most common of all these manlike women are the Amazons, and scenes showing Greeks fighting them are extremely popular on vases and in monumental stone.[15] They are part joke, part nightmare. They confirm the male anxiety that underneath, women may be just like men after all. Amazons hint at a terrifying possibility—a world where all rules and roles are reversed. The oppressed turn and oppress their former masters: women govern and fight, and it is boy and not girl babies who are rejected and even exposed.

One of the tests of heroic manhood for the great heroes was a contest with an Amazon. Theseus abducted Antiope, Achilles killed Penthesilea, and Herakles, as one of his labors, had to steal the girdle of the Amazon Queen. And temple sculpture often pairs a struggle between Lapiths and centaurs with a battle of Greeks and Amazons. In

each case, the heroically naked Greeks triumph over unnatural, un-Greek barbarians. In each case, perhaps, the Greeks must vanquish enemies who are internal as well as external. Animal man or phallic woman: each is a nightmare, a repressed possibility that returns to threaten the controlled and controlling masculinity of the Greeks.

The Amazons have little to do with the lives or feelings of real women. We can never know what those women felt about the exclusively masculine bias of Greek culture and its glorification of the male body. (Playwrights in the late fifth century indicate that men were beginning to worry about a growing hostility between the sexes, and at least admitted the possibility that women might rebel against their inferior treatment, being regarded as "mere nothings.")[16] For women, trapped in their second-class bodies, the male cult of physical perfection and the Apollonian ideal of self-discipline and self-development must surely have seemed irrelevant and perhaps oppressive. Women certainly flocked to the mystery cults, to the Dionysiac rites glorifying madness and offering a temporary escape from the body in frenzy and intoxication. Women must have accepted heroic masculinity on which Greek culture rested; what choice did they have? At the same time, at some level, they must have resented it.

Philip Slater has erected a whole psychoanalytic interpretation of Greek myth and art on this assumption. According to him, the woman in this kind of situation is likely to be ambivalent toward men, and especially toward the one male over whom she has some power, her small son. She "alternately accepts him as an idealized hero, and rejects his masculine pretensions." So a vicious circle is set up. The boy, responding to his mother's unease, is likely to become abnormally preoccupied with proving his own masculinity, and at the same time doubtful about it; he will feel that "if he is not a great hero he is nothing," and need to assert his virility over and over again, in competition with other men. And since "it is after all his physical maleness on which his mother's pride is focused and it is his childish pride in it that she is unable to tolerate," so "his physical maleness becomes of enormous importance to him. The male body dominates his art and his sexual life."[17]

PHYSICAL CULTURE

The Greek male took a deep and narcissistic interest in his own body—in displaying, perfecting and testing it. It is hard for us to grasp

the central importance of athletics in the personal and communal life of the Athenian citizen. The gymnasium was the center of his social life: boys were taught there, young men did military training, and older men met to keep fit, to admire or criticize, or to pick up boyfriends. Vase paintings give vivid and charming glimpses of gymnasia routines and the socializing that went with them. And the great athletic contests—at Olympia, at Delphi or at Corinth—were important religious and political events, crucial to the national self-image.

Athletics served an important practical purpose. All through the fifth century, most Greek cities were on a permanent war footing, and all Athenian citizens, for example, did two years military service. Any warrior society—and for all its urban sophistication Athens remained just that—will be concerned with the physical fitness of its potential soldiers. The values and customs of a more primitive heroic society were kept up consciously and nostalgically. The great games, local and pan-Hellenic, were a proud assertion of the continuity of Greek history—their Homeric origins were never forgotten—and a way of consolidating a shaky national identity against the ever-present threat of Persia. "Greeks traveled to Olympia to experience themselves as Greeks," Peter Brown has suggested. "They did this by rallying round what they considered to be the most satisfying imagery that they knew of male excellence."[18]

In life as in art, nudity is the sign of Greek civilization. If the Greeks were proud of the games as a uniquely Hellenic institution, they were equally proud of the fact that they exercised and competed naked. (The word *gymnos* means naked.) The custom was comparatively recent. Thucydides dates it from the Olympiad of 720 B.C. when a runner dropped his loincloth, ran naked, and won.[19] He saw it as a stage by which the Greeks asserted their superiority over the barbarians; they took a certain self-conscious pride in the fact that foreigners regarded the whole thing as eccentric and probably indecent. Heroically nude statues were dedicated to athletic victors, and hymns composed in their honor. Athletes brought honor—and wealth—to themselves, and glory to their families, their cities, to the whole Greek world.

If Greek art is almost exclusively preoccupied with the perfected body, the whole of Greek culture suggests an unusually intense concern with bodily values and the embodied self. For the Greeks, the body *is* the self, the essential being, and the soul a mere shadow. After

43

death, men are mere phantoms, squeaking shades pathetically concerned with the fate of their corpses and their memory on earth. Greek tombstones look back and not forward, and show the dead, poignantly, in their full earthly beauty. Homer, Hanns Sachs points out, "tells that the wrath of Achilles cast into Hades the souls of so many brave ones, but *'they themselves'* were left for the birds to devour. The body was the real being, and remained so throughout antiquity."[20]

The qualities most prized in gods and men, and celebrated in art and literature, are physical as well as spiritual. The beautiful—*kalos*—is equated with the good—*agathos*; and bodily beauty aroused an almost religious awe. One of the characters at Xenophon's *Banquet* was so beautiful that "not one among the guests who looked upon him but had his soul moved; some fell silent, others made some gesture."[21] Another youth, recognizing the way beauty can move and subdue spectators, says that he would rather be beautiful than have a king's power. Even Plato's most refined and abstruse speculations about divine love are rooted in intense appreciation of a beautiful boy.

The patient development of the body by athletic exercise, and its testing in competition, is seen as the basis of all virtue and as metaphor for other kinds of self-development. Xenophon's Socrates gives a long lecture to a youth who has neglected and abused his body.[22] Not only may he be putting his life at risk in battle, but he also forfeits health, a keen intelligence and, perhaps most important of all, his reputation. *Arete*—which means virtue, or nobility or manliness—has to be won from other men, by the feet or the fist, by strength in battle as well as by force of mind and character. And, according to Thorkil Vanggard, "the phallus is the specific symbol of *arete* with all its complexities of meaning. Apollo's power of manliness is concentrated in his phallus."[23] Even as late as the fourth century B.C., when philosophers redefined *arete* in more subtle ways, the word retained its primary association with the male body and with virility.

But the body is not, in fact, enjoyed or admired for its own sake. It has to be constantly tested, its strength proved in competition with other men. (Competition was one of the bases of Greek culture: there were contests in drama and music as well as athletics, and even beauty contests. They perhaps served as a way of formalizing and containing the male aggression which might otherwise have disrupted the *polis* and issued in civil war.)[24] The joy of athletics was not in the doing, and

there was little or no team spirit. Each man fought for himself, and fought to win. The winner took all—reputation, honor—while the loser was humiliated and unmanned. Defeat and loss of face are a constant threat and presumably, in the end, inevitable.

The Greeks may not have felt guilt about their bodies or embarrassment about bodily functions. They certainly experienced shame and contempt—shame at any physical failing in themselves and contempt for the weakness of others. The Greek love of the nude is often interpreted as an expression of their sense of the wholeness of human life; "nothing which related to the whole man could be isolated or evaded."[25] It could as easily, if as one-sidedly, be seen as insecurity, a nervous dislike of any body that is not visibly, demonstrably male. The Greeks had reservations about the female nude; and they anxiously avoid all marks of weakness—of illness or suffering or old age—in the male. Life must have been miserable for those, even among the ruling élite, who were in any way physically inadequate. One vase sets up a comic but cruel contrast: a tall, thin, stooping youth squabbles with a short fat one, while two standard models go complacently through their routines.

Weakness is suppressed, or caricatured, because it is feared. The ideally youthful body that dominates classical art must have offered men profound narcissistic satisfaction; at times it must have been the source of deep disquiet. Youth, strength and beauty are permanent only in stone or bronze. Investing everything in bodily values, the Greeks are haunted by a sense of instability and impermanence. Beneath their proud assertion of order runs an intense perception of its opposite—of chaos and change. At the peak of good fortune, the Greek looks anxiously over his shoulder, forseeing defeat, enslavement, and ignominious death.

For even the most triumphant hero will finally meet a younger, more powerful man. Death lies in wait for everyone; but even an untimely death may seem preferable to the slow decay of strength and the humiliations of senility. Bodily decrepitude is emphatically not wisdom for the Greeks. Homer's Priam, foreseeing the fall of Troy exclaims that the most pitiful sight of all is the body of an old man who is "dead and down, and the dogs mutilate the grey head and the grey beard and the parts that are secret." The fall of a young warrior is less sad, for "though dead, still all that shows about him is beautiful,"[26] and he will be remembered so. The great gift granted to Kleobis and

Biton was an early death. They are immortalized in their perfect young manhood: ideal figures whose optimistic strength can never be eroded, as it must have been had they lived, by illness or the misfortunes of war, or by old age.

These contradictory attitudes to the male body are linked, of course, with the complicated question of Greek homosexuality. Explicitly homosexual scenes are common, even in the private art of vase painting, only for a comparatively short period, from around 530 to 470 B.C. Many of these are very open indeed, good-humored and casually obscene. Some vases show older men courting boys, or making more direct advances by tickling their genitals. Others show homosexual, as well as heterosexual orgies. Others again, the so-called "love vases" which ecstatically praise a particular youth for his beauty may have been presents from lover to beloved. Mythological loves are portrayed as well. Ganymede, beloved by Zeus, is a popular figure, and so is the love god Eros, a healthy and handsome adolescent hardly to be distinguished from any other athlete except by the wings that sprout, improbably, from his shoulders. But the same intense and narcissistic interest in the male body is expressed in the great stone and bronze nudes of public and monumental art. Homosexual feeling, however sublimated and transformed, is the key to their sensual grace *and* to their idealism.

The cult of homosexual love was probably confined to the aristocratic élite whose sports and entertainments are so vividly portrayed on the early classical vases. Even for that élite, homosexuality was not necessarily an exclusive choice, and the lover of boys might also be a family man. Many cities had laws against certain forms of homosexuality. A citizen who prostituted himself lost his political rights, for example, and intercourse between boys and slaves was forbidden. Effeminate homosexuals were mocked, and so were men who hung around gymnasia trying to bribe or seduce boys. In the fourth century, accusations of effeminate homosexuality were often used as slurs in court cases. But all the activities criticized were ones in which, in one way or other, a man risked losing his dominance and therefore his male pride.

For many, homosexuality—like the practice of naked athletics— was associated with everything that was distinctively Greek. Fifth-century Athenians traced it back to military-aristocratic societies like Sparta, where sodomy was an initiation rite. Half admiring, half

46

nervous of Spartan prowess, they saw homosexuality as the source of that competitive aggression that makes good warriors. For Xenophon or for Plato, a handful of lovers fighting together could defeat the whole world. Each man must prove his masculinity to his beloved, and a lover "would die a thousand deaths rather than be shamed in front of his beloved by showing cowardice or weakness."[27]

Homosexual love is often idealized in fifth-century literature into a teaching relationship between an older man and a boy. Many vase paintings suggest that the teaching had a firm physical basis. In some orgy scenes the participants are all quite young as, given the acrobatic ingenuity demanded of all concerned, they would need to be. But the point is that it is homosexual and not, as in other societies heterosexual love that is romanticized. Tombstones suggest that relations between husband and wife were often close and tender, and Greek men certainly enjoyed sexual relations with courtesans. But only feelings between man and man become a focus for wider cultural interests and a metaphor for the values most Greeks aspire to attain.

For homosexuality is associated, not just with physical and military prowess, but with the highest achievements of Greek civilization—with "divine philosophy," with good laws and the love of liberty, with democracy itself. The gods and heroes—from the great Zeus himself to Apollo to notable fighters like Herakles—were all lovers of boys. (One lively and charming terracotta group shows an enormous half-draped Zeus marching complacently off with a naked and complaisant Ganymede tucked under his arm.) As one of the speakers in Plato's *Symposium* argues, those inspired by heavenly rather than earthly love are always attracted to the male sex and value it "as being naturally the stronger and more intelligent." In the same debate, Aristophanes argues that lovers of men, who may have a deep natural disinclination toward marriage and reproduction, are "the best of their generation because they are the most manly."[28]

Art and literature alike make it clear that homosexual love offered a deep narcissistic satisfaction to each partner. Both men fall in love with "what is akin to themselves," a reassuring mirror image. Philip Slater quotes a poet who exclaims "seeing a kindred shape I swooned away."[29] Men are attracted, not by the pre-pubescent or effete boy, but the one who gives promise of virile maturity—the youthful athlete favored by artists. The man finds and cherishes the image of his own boyhood, the boy aspires to rival his lover's masculine strength, his

arete. Theocritus describes Herakles's love of the youth Hylas, teaching him "as a father would teach his favorite son, all that he himself had learned in order to be brave and worthy of a poet's song. He was ever at his side . . . longing to fashion the youth in his own image, that he might end by becoming truly a man."[30]

So homosexual love is like an initiation rite, a way of producing men, producing heroes. Its functions are far too complex to consider here. It was perhaps a way for a boy brought up by slaves and women to find a male role model and so move into a world where he is expected to prove himself as a man, to men. An idealized and institutionalized love between men may be a way of containing and canalizing the viciously competitive and envious spirit that is at the center of the Greek sense of manhood. And it is possible the boy is exorcizing one of the deepest fears of the Greek male—the fear of being forced into a submissive, or feminine, role by another man. As part of his education into aggressive manhood, he plays—without loss of face—the passive role. It may serve as a magical defense against that disgrace occurring in real, in adult life.

Certainly the Greek male confirms and redoubles his masculinity in homosexual relations, as in competitive athletics. He finds in another male body the reasurring reflection of his own maleness, his phallic strength. The most important things in Greek society, and in Greek art in the classical age, all take place within the charmed, closed circle of man-to-man relations. The Greek male seems arrogantly confident, but only as long as he stays within that circle. Outside lie chaos, weakness, femininity. There are moments when the Greek need to prove himself over and over again in competition with other men suggests anxiety rather than confidence; when the proud celebration of homosexual values seems like a nervous retreat from the women who might threaten his control; when the obsession with the naked body looks like insecure exhibitionism. And in those moments, the classic nude, for all its calm splendor, can seem rather limited and sterile.

THE LATE ANTIQUE NUDE

All through the long centuries of Hellenistic expansion and decline, the male nude remains the favored type. The godlike nude of the fifth century rapidly achieved "classic" authority, and was endlessly revived and reinterpreted. Radically changed—humanized and even humorized—it became more dramatic and at times melodramatic. But

it survived even into the Roman world, though the Romans were faintly suspicious of the nude except in erotic contexts and did little more than collect and copy Greek masterpieces.

But the heroic nude had been the product of a particular kind of society which disintegrated with the renewed and self-destructive wars among the city states, the final collapse of Athenian hegemony in 404 B.C., and the assimilation in 338 B.C. of the Greek states into the Macedonian empire. Cities like Athens survived, but only as tiny units in a far-flung, increasingly cosmopolitan empire. Athenian traditions were admired and copied all over the Hellenistic world; but in a real sense, the city was living on its great past. From the fourth century on, art, literature and philosophy all hint at deep changes in the way Greeks regarded their cities, their public and private relationships, and their own bodies.

As early as 400 B.C. some Athenians had begun to question the cult of male strength and even the sacred institution of athletics. Euripides, for example, mocks the professional strongmen, mere "slaves of their belly and jaw," and asks scornfully:

Whoever helped his fatherland by winning a crown for wrestling or for speed of foot, or hurling the diskos or striking a good blow on the jaw . . . ? Crowns should be given to the good and wise, to him who guides his city best, a temperate man and just, or who by his words drives away evil deeds, putting away war and faction.[31]

That amounts to a redefinition of the whole basis of *arete*. And indeed, not much later, another writer does make the radical assertion that "*arete* is the same for men and for women."[32]

Something of this change is reflected in Plato, whose work is both a culmination of fifth-century values, and a break with them. The *Symposium* glorifies physical—homosexual—love, as a basis for a higher love which aspires beyond the body to contemplate divinity. In his later work the dualism is much sharper. The body is relegated to a lower sphere and only the spirit counts. His Republic gives no room to the artist, for even the idealizing art of the fifth century is dismissed as irrelevant imitation of the material world. There is real imaginative appropriateness in the fact that at the Symposium, a woman expounds the doctrine that taken to its logical conclusion will divide body from soul. Diotima, teacher of Socrates, is not of course present at the banquet; she is summoned from the past to explain how love must lead

us away from the flesh to ghostly forms and ideas lying behind nature. Her language is the language of the Orphic cults, for whom the Apollonian worship of the embodied self seemed irrelevant and unsatisfying. The mystery religions, ever more popular in the late antique world, see man as tragically divided between flesh and spirit. The body is a prison and earthly life an apprenticeship for immortality. That sense of division was to find its most lasting expression in the greatest of all the mystery cults, Christianity. And from the fourth century onward, art, though it clung to the classic forms, was insensibly but increasingly affected by the dualism.[33]

The heroic nude, at once man and god, is as common as ever, but much of its significance evaporates. Once a focus for community pride, it was turned by Alexander of Macedon into something very different—a self-aggrandizing assertion of his personal power, a propagandist puff for his dominion over Greece and the East. His court sculptor Lysippos placed a revealing hubristic epigram on the base of one of his many statues of the emperor. "The bronze seems to look up to the god and say, 'I have set the earth under my sway: Zeus, you may keep Olympus.'"[34] A portrait head tacked on to a conventionally "divine" body: the formula is used automatically by generations of Hellenistic and Roman rulers. Only once does it come to late, unexpected life—in the statues commissioned by the Roman emperor Hadrian to immortalize his favorite Antinous who had drowned under mysterious circumstances in the Nile. And the life springs from the incongruity: the contrast between an anonymously perfect body, and that sulky, sultry, willfully sexy face.

A great gulf stretches between, say, the majestic young Apollo from Olympia, and almost any of his later incarnations. Even in the fifth century, Aeschylus is said to have complained that though the gods of his own day seemed alive, "the old gods were more godlike."[35] The humanizing of the gods is even more pronounced in the following century. Thus Praxiteles presents Apollo as a fragile, effete adolescent, whose body sways sinuously as he leans on a tree trunk, one hand lazily raised to swipe at a lizard. The sculptor is probably making a humorous reference to the old myth about Apollo slaying the great Pythian serpent, and there are almost certainly homosexual overtones to the joke. (An admittedly much later epigram by Martial makes sexual puns about a boy catching a lizard in his fingers.)

Some cult statues of the gods exaggerate their size; others adopt a

consciously archaizing severity; others again romanticize them in the effort to convey their divinity. In the famous Belvedere statue, perhaps a copy of a late fourth-century original, Apollo is very much a god again. But the sculptor no longer takes his godhead for granted. He gives Apollo a refined and ethereal grace, and in the attempt to convey his spiritual beauty and meaning, ends up with a faintly theatrical elegance. And this is certainly one of Apollo's last convincing visitations. A vast nude now in the British Museum is typical of his later appearances. Broad-hipped and flabby, weighed down by a fancy lyre, he is no more than a parody of his former splendor.

As the gods changed, so did the image of man. For Polykleitos, the athlete was a potent symbol, a type of spiritual as well as physical perfection. A century later, Lysippos's young man, scraping down his body after exercise, is simply what he seems to be—a handsome athlete. In some ways he is even more beautiful than his predecessors. His slender body is caught in a transient gesture, and beside his subtle and self-absorbed grace, earlier athletes may seem rather stolid. According to Lysippos, whereas older sculptors had depicted men "as they really were, by him they were represented as they appeared."[36] The sculptor is fascinated by the illusions created by art, an art elaborated and enjoyed for its own sake. He tries to catch, in the permanence of bronze or stone, the shifting grace of the human body, celebrating its changing appearance rather than its symbolic meaning.

Even the type of body preferred by artists changes over the centuries; the different fashions can be clearly traced in vase painting. The first archaic athletes were heavily built fighting men, bred for endurance in battle. By the early fifth century, a more refined type is common: strong, but light and graceful, an urbane aristocrat who is clearly a gentleman not a player. But by the following century, the male nude tends to one of two extremes. There are many immature boys, slim and undeveloped, and there are as many muscle-bound brutes with heavy limbs and pin heads. It is only a small step to the circus strongmen often portrayed in Roman art—boxers, gladiators and professional killers.[37]

These tough guys appear in sculpture as well. Even the fourth-century Lysippos, still deeply imbued with the classic ideal of masculinity, was ambivalently attracted toward the superman whose sheer size or brutally exaggerated strength would stun the spectator.

He sculpted Herakles many times, as a tiny table ornament or as a colossal cult image so large that "a cord which fit around its thumb could be used as a man's belt, and the shin of its leg equalled the height of a man."[38] The massive Farnese Herakles is probably based on an original by Lysippos, and the point about the statue is that, for all his bulging muscles, the great hero seems lax and impotent. Leaning on his great club, as no fifth-century hero would do, he is exhausted not just by his labors but by his own weight and strength. J. J. Pollitt has argued that Lysippos's different versions of Herakles amount to a reconsideration of the great hero and everything he traditionally stands for.[39] (The sculptor may also have intended a skeptical glance at his master Alexander who, like so many rulers after him, proudly identified with Herakles.) Certainly, in the course of the fourth century, quite contradictory meanings cluster around Herakles. He is no longer a straightforward incarnation of masculine power; or rather, attitudes to masculinity itself seem more confused. On the one hand, Herakles acquires new ethical and religious associations, becoming a symbol of moral courage in adversity and even of man's power to win the status of a god by his own efforts. On the other hand, Herakles is often seen in literature and art as a crashing boor, all brawn and no brains: a mere figure of farce.

The male nude is either overbearingly virile, or it is feminized. The emergence of the naked Aphrodite and her growing popularity from the fourth century onward, is a symptom of profound social and psychological changes. The tradition of citizen participation in city life, all the heroic values handed down from tribal days, became less satisfying and less relevant to the average Greek male. A stoical withdrawal from the world, an epicurean enjoyment of its pleasures, a sophisticated cosmopolitanism, or a yearning to abandon the self in the flourishing mystery cults—all these things hint at radical change throughout the Greek world. Women were given more freedom, and conversely, men seem to have turned inward to family life, to an exploration of feeling for its own sake, to that whole area of private experience which was associated with the feminine. Art—increasingly catering to private tastes—reflects a new preoccupation with subtle and transient emotions, with sensuality and sensation. Artists are not just interested in how the body looks and performs; they try to convey something of the way we *experience* our bodies, our sensual pleasures and pains. The new female nudes are sometimes coolly

elegant and sometimes—as in the statues of Aphrodite crouching— warm and voluptuous. And if hitherto the female body had been patterned after the male, so now this new "feminine" feeling for the flesh affects the male nude.

Praxiteles's superb statue of Hermes holding his baby brother Dionysus is far more gentle and human than the great Phidian gods. Though he shares their close-knit muscular strength, the sculptor has made his body smooth and subtle, and given his flesh the illusion of softness and delicacy. And the god displays a playful tenderness alien to the heroic severity of the previous century. The same sculptor's *Apollo with Lizard* is much younger—slim, fragile and effeminate. So apparently was his nude *Eros* which, according to Pliny, was the equal of the Aphrodite for its fame, "and for the injury which it suffered; for Allketas the Rhodian fell in love with it and also left upon it the same sort of trace of his lust."[40] Skopas cast Pothos, the personification of desire, as a languid and languishing adolescent who gazes yearningly at the sky. The changes in the love god Eros are revealing. At first a graceful but thoroughly virile youth, he gets steadily younger and more effete. Lysippos's famous statue shows him as a young child, delicately built though with a hint of chubbiness, and playfully provocative. In later Hellenistic art, he is a mere baby, cute and cuddly, his earlier malice dwindled to mere mischief.

Homosexuality clearly loses much of its cultural significance in the Hellenistic world; it is common enough, but simply a matter of personal preference. For the first time, fourth-century poetry and romantic fiction begin to praise feminine beauty and heterosexual love. One popular literary device is a debate about the merits of the two kinds of love. The language and rituals of homosexual love have clearly changed; they borrow from the new heterosexual romanticism an interest in minutiae of feeling, in etiquette, in "feminine" elegance.

An actual hermaphrodite is a fairly common figure in late antique art—a boy with girl's breasts and a girl's delicacy, or a woman with a penis. (It was almost unknown in the classical period. Sarah Pomeroy has suggested that in the fifth century, "the male was clearly the superior being, and to taint him with the characteristics of 'the inferior' would have been a lessening of perfection.")[41] The idea had once had profound religious significance in myth and legend, though only a little of that survives in visual representations. A great many

Hellenistic hermaphrodites are clearly intended as titillating jokes, no more. Satyrs are often shown surprising and being surprised by hermaphrodites. Other figures are more sophisticated, designed for an erudite audience who may have the mythic significance of the hermaphrodite somewhere in mind, even as they get their sexual thrills and enjoy getting two for the price of one. The famous reclining hermaphrodite in the Louvre is designed partly in a spirit of playful perversity, to appeal to a sexually sophisticated spectator. He/she has a stunning androgynous elegance: the back is slender-waisted, its curves almost impossibly refined. The other side, which reveals both penis and breasts, is oddly disconcerting. The figure is at once a grotesque sport and a poignantly beautiful image of an impossible dream—of combining male and female in one body.

The new inwardness and sensitivity is reflected in overtly erotic art as well. Late archaic vases had displayed a cheerfully matter-of-fact attitude toward sex, treating it as a purely physical activity, like eating, drinking, or athletics. More often than not, it is a group activity: the participants may be at a banquet, or they are painted in a frieze, forming a human chain as they run through most possible positions. They fuck or are fucked, suck or are sucked, with apparently tireless enthusiasm. The women, the prostitutes, enter into all this with great good humor, though they are more concerned to give than to get pleasure. It is often pointed out, for example, that though women (and men) are often shown going down on men, the reverse almost never happens.[42]

A good deal of later erotic art displays the same kind of bouncing and energetic sexuality. But many vases reveal a changed attitude to bodily experience. More artists concentrate on isolated couples, and the settings—a bedroom or boudoir—often suggests domestic privacy. The psychology of sex becomes as important as its physiology: the body is animated, not just by healthy appetite, but by emotion. Lovers kiss and caress each other, expressing tenderness and affection, emotional as well as physical intimacy.

If sex is domesticated, other kinds of family feeling become a popular theme in art. Some of the most beautiful of all Greek tombstones date from the fourth and third centuries, and they convey, with poignant clarity, the depth of the bonds between husband and wife, or between parents and children. The young nude athletes are not just symbols of Greek pride; they are mourned as sons, as brothers

or as friends. Even monumental sculpture portrays the affection between parents and children, and interestingly, men express tenderness as commonly as women. The nude Hermes playing so gently with his baby brother is the example that springs at once to mind. But equally attractive is a figure of Silenus, a much older man, who grasps the baby Dionysus with comic but endearing awkwardness. Children themselves—almost unknown in high classic art—are popular subjects. Some are sweetly sentimental, others twist and play with vigorous enjoyment, and sculptors present their plump naked bodies with humor and affection.

Old men and women are often depicted, and so are laborers and foreigners; sometimes with a condescending interest in picturesque oddity, but sometimes with real compassion. Hellenistic art, ranging as it does over several centuries and a vast, and racially varied, geographical area, resists generalization.[43] From one point of view it marks a decline from the confident perfection of fifth-century art; it is also less excluding and exclusive.

FASCINATING PHALLI

Nevertheless, through all this variety, the youthful male nude of classic art with his unruffled aristocratic assurance survives as some kind of norm. He remains the ideal against which all other human types are invisibly measured and judged. His physical integrity and his phallic potency are superstitiously protected. Though Hellenistic art often shows the body in extreme states, racked by pain or excitement, this is still comparatively rare with the male nude. Women, far more often than men, are shown in states of mindless ecstasy. Friezes occasionally show men dancing with frenzied joy in Dionysiac processions, but there is no male equivalent to Skopas's *Maenad*, whose twisting body is completely possessed by the spirit.

Even in the fifth century, some battle scenes had shown the strains on both victor and vanquished; and in following centuries, the sufferings of the defeated were rendered more dramatically and realistically. Pain and pathos reach a climax in the art of third-century Pergamon, the state that for fifty years took the full brunt of barbarian attacks on the Hellenistic world. Proud of their role as defenders of the great Greek tradition, they returned to fifth-century themes—battles with Amazons and giants, for example—but handled them with a new dramatic energy and new sensitivity to the anguish of the fallen. A

Gaul sprawls backward, straining, even in his death throes, to stay on his feet; a wounded man painfully props himself on one arm as he loses consciousness; a Gaul kills his wife and then himself to avoid capture; the bodies of Persians and Amazons lie carelessly, pathetically, where they have fallen. The Pergamese deeply respected these savage but noble enemies, and identified with their agonies. But it seems significant that even the Pergamese tended to project suffering on to the others, the non-Greeks. Even when they are preoccupied with pain and death, the Greeks prefer to contemplate it, at least in art, at a certain distance.

The strength and beauty of the gods is never marked by suffering; indeed, their invulnerability is proof of their divinity, and the Christian idea of a humiliated and suffering God would baffle generations of educated pagans. Those who suffer in Greek mythology are those who have in some way offended the gods. Laocoön, whose struggles are the subject of the most famous and melodramatically forceful of all Hellenistic groups, was a priest who had violated the sanctuary of Apollo. And one of the most poignant of all Pergamese nudes is Marsyas, who hangs from his tied wrists waiting to be flayed to death. (More than a thousand years later, his body would be adapted for the crucified Christ.) But Marsyas was a satyr who had presumed to challenge that most archetypically Greek god, Apollo.

Satyrs—men with animal tails, hooves and ears—often perform a useful function by acting out the absurd and undignified aspects of male virility. They probably originated in fertility rites where dancers wore animal masks—rites that echo all through antiquity though their origins are lost in pre-history. But on archaic vases, satyrs are already comic figures. Crude and rude, they prance around masturbating, showing off their huge and perpetual erections, peering voyeuristically at women and clutching at any stray nymph or maenad. They are often fat, hairy and misshapen—grotesque parodies of the refined, restrained nudes of high art. In later centuries, they appear, not just in vase painting but in monumental sculpture as well. Hellenistic satyrs dance, or stagger drunkenly, or try to catch their own tails; they struggle with nymphs and hermaphrodites, or sprawl, legs wide apart, in sodden sleep. They are comic incarnations of man's animal nature. And by projecting his more ludicrous lusts onto the satyr, the Greek male manages to retain his dignified self-image, and preserve it from any kind of extreme.

The satyr's parody of virility, like so many parodies, attests to the seriousness with which phallic power was regarded—and continued to be regarded, all through Greek and Roman history. Erotic art— heterosexual just as much as homosexual—celebrates the male body, the erect penis, the act of penetration. Hellenistic artists could be sensitive to feminine beauty and to "feminine" qualities in the male; but the female nude was never the sole and exclusive object of sexual feeling that it has become since the Renaissance. As a result ancient erotic art can seem, to modern eyes, both disconcerting and refreshing.

The continuing centrality of the male nude is a product of the religious and cultural reverence accorded the phallus, the symbol of *arete* and manly strength. The abstract symbols turn up everywhere in ancient folklore, cult and art. They range from comic personifications of virility like Silenus and his satyrs, to great abstract shapes like the phallus and testicles placed on a high pillar in the theater at Delos. Enormous phalli were carried in Dionysiac processions and actors often wore big artificial members strapped to their bodies. One vase shows a naked woman marching determinedly off with a monstrous phallus tucked under her arm; it is not clear whether her intentions are religious or lustful. Herms—pillars with human heads and genitals—were placed at doorways and crossroads to bring luck, and vases often show ceremonies, many involving women, around them. They are sometimes treated as jokes—and sometimes very seriously indeed. When someone went round Athens during the Peloponnesian wars and mutilated all the herms, there was a city-wide panic. His enemies blamed Alcibiades, who was accordingly exiled.

The phallus, rather than the vulva, was the most sacred fertility symbol, summing up all the procreative powers of nature. This aspect was hinted in the satyrs, but personified most clearly in the god Priapus, whose cult originated in Lampascus but spread all over the ancient world. He was the god of gardens and vineyards and orchards; early bronzes showing him pouring oil on to his large erect penis probably refer to ancient rituals to ensure the growth of the crops. In the later Hellenistic world, he is a gross and jolly figure, all belly and penis, and is used as a garden ornament by sophisticated town dwellers. In rough wooden form, with a moveable sexual organ, he serves as a scarecrow to frighten birds away from the harvest. But he never quite loses his magical powers. He, or his phallus, attracts good fortune and wards off the powers of evil.[44]

Phallic symbols were almost as important to the Romans. The genius worshipped on the hearth of every home "represented the virile potency of the master of the house"; the god Fascinus, who ensured fertility and warded off the evil eye, was a personification of the phallus. Phalli were often worn as good luck charms around the neck. The image occurs with remarkable frequency in the remains of Pompeii—and was something of an embarrassment to those eighteenth-century neoclassicists who excavated the buried city and who were so anxious to assert the moral purity of the ancient world. The most ordinary domestic objects in Pompeii—lamps, vases, handles and lids—are decorated with phallic figures, sometimes elegant, sometimes grotesque.[45] Dancing dwarfs and pigmies with enormous members are common; and animated phalli, some ridden by dwarfs and hung with bells, were placed outside buildings for luck. The local casino advertised itself with a bas-relief showing a vase set between two phalli.

Phallic symbols were sometimes placed in the grave to symbolize man's hopes for an after life. "*Hic habitat felicitas*" runs the roughly printed legend above another Pompeiian relief showing phallus and testicles: happiness dwells here. Phallic symbols are carved everywhere, on shops, on public buildings, on private houses. They were the most powerful of charms, designed to propitiate the gods and ensure good fortune. Unearthed so many centuries later, they survive as poignant and pathetic reminders of that final inauspicious day when the city died.

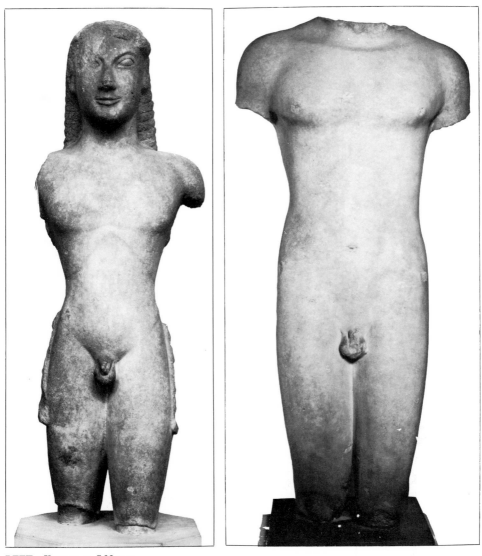

LEFT: *Kouros, c.* 560 B.C.
RIGHT: *Kouros, c.* 520 B.C.

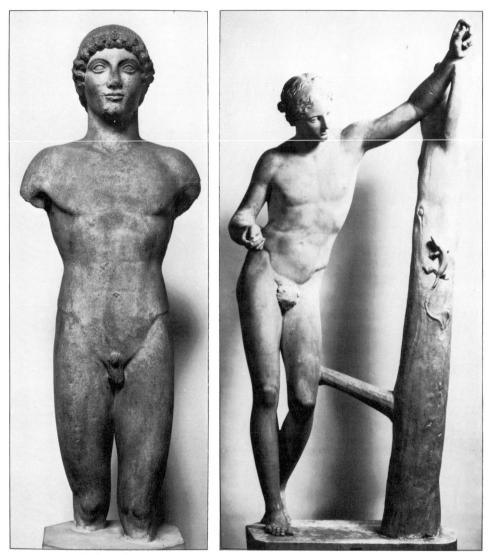

LEFT: *Strangford Apollo, c.* 490 B.C.
RIGHT: *Apollo with a Lizard,* Roman copy after Praxiteles, *c.* 350 B.C.

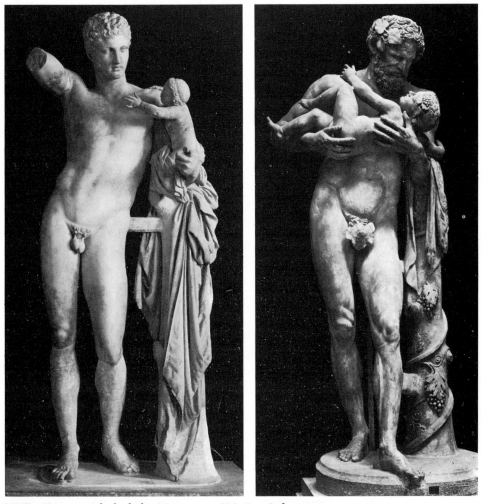

LEFT: *Hermes with the baby Dionysus, c.* 350, Praxiteles
RIGHT: *Silenus with the baby Dionysus,* fourth century B.C.

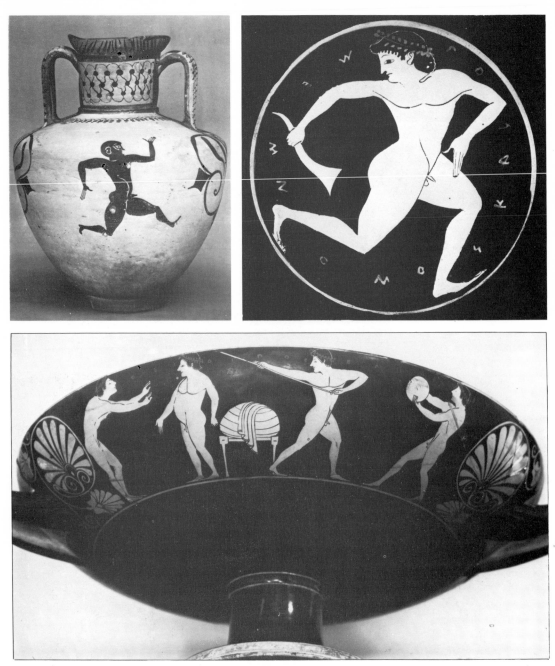

TOP LEFT: *Running Man*, black-figure vase *c.* 550 B.C.
TOP RIGHT: *Running Boy*, red-figure cup, fifth century B.C.
BOTTOM: *Athletes*, early fifth century B.C.

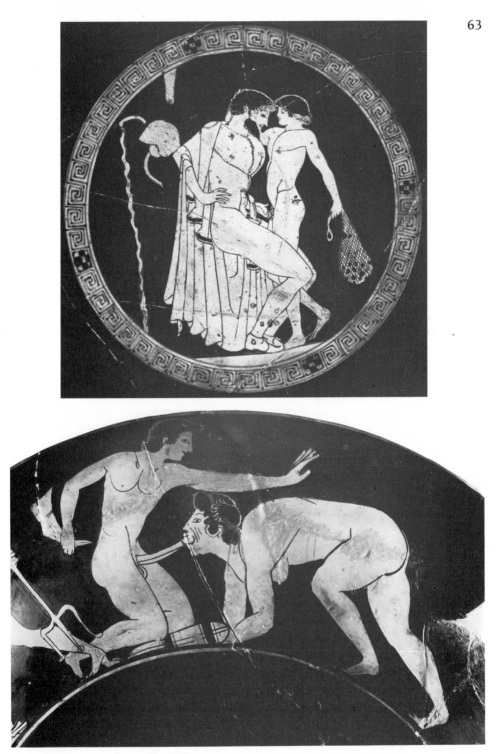

TOP: *Man courting boy*, early fifth century B.C.
BOTTOM: *Orgy*, early fifth century B.C.

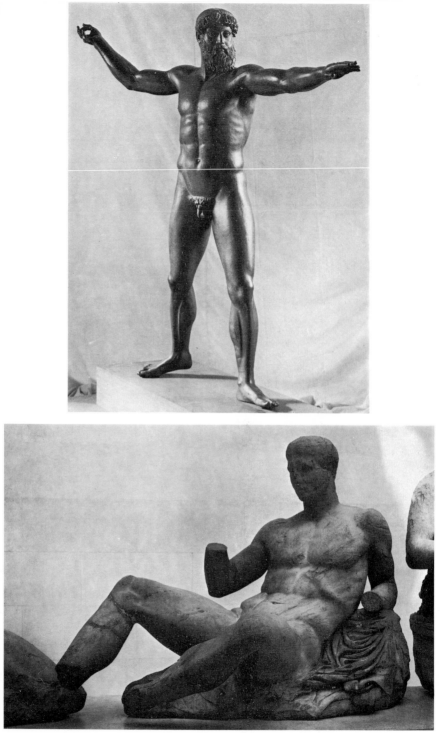

TOP: *Bearded God* (Zeus or Poseidon) *c.* 470 B.C.
BOTTOM: *Reclining God* (Herakles or Dionysus) *c.* 440 B.C.

TOP LEFT: Herm, c. 500–475
TOP RIGHT: *Phallic lamp*, Roman
BOTTOM: *Phallic Altar of Dionysus* at Delos, Hellenistic

The Naked Christian

IN CHRISTIAN ART, THE NAKED BODY is a symbol, not of pride but of pathos. To be naked is to be vulnerable, sexually self-conscious and guilty. Images of suffering, humiliation and death, rare in Greek art, are central in Christianity. Naked Adam is a reminder of our lost innocence; Christ naked on the cross redeems sin and conquers death, but only by himself enduring a brutal and bloody death.

The story of the Fall—an attempt to explain why life is so hard and short and man so plagued by guilt—is a story about nakedness. Adam and Eve lived innocent and, according to many theologians, sexless, until Eve yielded to the promptings of the serpent and persuaded Adam to eat the forbidden fruit. Then "the eyes of them both were opened and they saw that they were naked; and they sewed fig leaves together and made themselves aprons." Embarrassment about the naked body is the first fruit of sin, and the symptom of all future woe. God throws the guilty pair out of paradise; they are condemned to hard labor—Adam to sweat in the fields and Eve to agonize in childbirth—and to lives shadowed by the knowledge that they must die.

Masaccio's great fifteenth-century painting of the *Expulsion from Paradise* crystallizes the tragic meaning of the story. Adam and Eve move slowly and despairingly; Adam buries his face in his hands as if to blot out his despairing vision of the future, Eve cries out with animal intensity for all she has lost. Their still beautiful bodies have become burdens; they embody that alienation *from* the body that runs so deep in the western psyche.

And men and woman are locked in separate shames, their shared

66

misery and loss only dividing them further. The Christian distinction between the male and female nude is far sharper than it ever was in antique art. Adam is a tragic figure, but Eve's naked body becomes— as Aphrodite's never was—the focus of shame and disgust. Woman may have her role in the divine scheme for our salvation, but in practice, her body represents the flesh, with all its charms and all its deadly perils.

The most distinctive and disturbing thing about Christian art, especially during the last thousand years, has been its tendency to glorify suffering. The fallen flesh is redeemed only in pain and suffering; it has to be tortured into spirituality. Our most sacred image is Christ on the cross, a man in the last stages of agony. The Crucifixion can be a protest against human suffering—an attempt to confront the intolerable fact of death—and as such, can make Greek art seem shallow and complacent. But because the Crucifixion is so common, it has become commonplace, and lost its power to shock. The theatrical beauty of a painting like Ruben's *Three Crosses* tends to play down the human content of the scene in favor of its devotional meaning— Christ's paradoxical proof of divinity in death itself. But it is also a picture of three men being vindictively punished, and dying a particularly painful death. The high gloss of Rubens's art should not distract us from asking a simple question: why an image of such cruelty and violence should hold such sway still in our art and our imaginations?

VILE BODIES

Christian art—unlike the art of antiquity—is based on a dualistic view of the world. A sense of being divided between body and soul goes back to Plato; but in the late Roman empire, increasing numbers of pagans, as well as Christians, felt like aliens in the world and strangers in their own bodies. All the things traditionally valued by the Greeks and Romans—bodily pleasure and prowess, worldly achievement and honor—simply hamper a man's spiritual growth. The body must be mastered and subdued because its very existence degrades us, holds us unwilling exiles from eternity.[1]

Christianity, more powerfully than any of the other cults and mystery religions that spread like wildfire in the late antique world, offered the masses a real possibility of entering a new élite of the spirit. In Christ, all worldly and physical distinctions can be erased; we are

neither Jew nor Greek, male nor female, bond nor free. The Christian dies to his former self and is spiritually reborn. A whole new pantheon of heroes emerges, based on the paradox that we must die to live. Men admire, not the classical hero who attains glory through his physical strength but the martyr who gladly yields up his body to violent death. The ascetic who mortifies—symbolically kills—his flesh, because its life means death to the spirit, replaces the athlete as a cultural ideal.

"I am killing it because it is killing me," one fourth-century ascetic exclaimed, schizophrenically, about his own body. According to E. R. Dodds, hatred of the body was "a disease endemic in the entire culture of the period."[2] But it was in the Gnostic and Christian sects that it took the most extreme and sometimes pathological forms. Particularly in the fourth century, some ascetics went to grotesque lengths— starving themselves, refusing to wash till their bodies were a mass of putrefying sores, loading themselves down with chains—in the attempt to prove, incontrovertibly, their sanctity. (Ironically, both martyrs and ascetics continued to use the language of classical athletics; in fantasy, they were competing, strenuously, for the victor's crown and a glorious death.) A hysterical contempt for the body was to remain a permanent strand in Christianity, stronger at some periods but never entirely forgotten. Heretical sects in the early Christian world and the later middle ages might take self-torture to lunatic extremes; but the church colluded with their fantasies by persecuting them, destroying their bodies for the sake of their immortal souls. Even orthodox Christians tend to turn their fears, their rage at all the evil and injustice in the world, against their own bodies. Evil is identified with the flesh; men expiate their unconscious guilts and find release from overwhelming anxiety by abusing, punishing and even mutilating it.

All the natural bodily processes—eating, excretion, sex, menstruation, childbirth—seem disgusting and polluting. Sex, especially, becomes a symbol of corruption. Men are terrified of losing control, and in fantasy, sexual abandonment in orgasm is associated with the dissolution of the body in death. In serious theological works and not just in fairy stories, virginity is given magical powers. Daniel, we are told, survived the lion's den because his virgin body was too tough for the animals; while the bodies of saints, untainted by sexual intercourse, may be miraculously pre-

served from putrefaction after death. A few ascetics actually castrated themselves, and the practice had to be formally condemned by fourth-century church councils. But this was only an extreme form of the pathological fear of sex and obsession with celibacy which gripped the early Church fathers and influences Roman Catholic thinking to this day.[3]

If the body is loathsome, the woman's body is particularly deadly. She is, after all, the cause of the Fall; she embodies sin and sex and death, everything that distracts man from God. And when, say, St. John Chrysostom attacks women, he writes out of his frantic disgust at himself:

> The whole of her bodily beauty is nothing less than phlegm, blood, bile, rheum, and the fluid of digested food. . . . When you see a rag with any of these things on it, such as phlegm and spittle you cannot endure looking at it. . . . Are you then in a flutter of excitement about the storehouses of these things?[4]

For centuries, woman stands for everything that the would-be saint most fears in himself.

It is hardly surprising, given this background, that the early church found the antique celebration of the body at best irrelevant, at worst obscene and spiritually dangerous. Beauty is a matter of soul, not of body, said St. Basil; "it is not in any comely proportion of the limbs, but in thought alone, purified to the highest point, that the beauty of our Lord is apprehended." St. Clement thought that Christians would be wasting their time as artists, for even though man is made in God's image, mere statues—the images of the image—count for nothing.[5] In fact, visual images soon become very important in Christian worship. But early church art is other-worldly, paying little attention to the body except as vehicle for the soul. And even High Renaissance art, that celebrates the body as God's temple, is shadowed by other visions, other images: the body as a temporary dwelling, a garment to be discarded; the body as our enemy and murderer; the body as a dark prison, a tomb.

When, after centuries of depicting the body in abstract terms, late medieval artists began to look at the body again and present it in naturalistic detail, they were obsessed by its wretchedness. The austere self-denying hermits of the early church—St. Antony and St. Jerome—enjoy a new popularity in art. The loss of Eden and all the woe that followed, the suffering of Christ and his martyrs, the horrors

of death and the pains of hell are all depicted with the greatest realism. Paradoxically, it is not until the fourteenth and fifteenth centuries— when there was a new worldliness in the air—that hatred of the body finds its most graphic expression. A greatly increased fear of mortality means that artists see the helpless naked body, the dead and decaying body, with intolerable clarity.

The overt message of late medieval art is that all earthly pursuits and physical pleasures are vain and transitory, that death is the only reality. Dead bodies are everywhere, proclaiming their terrible message to the living: "Wretch, what reason hast thou to be proud? Ashes thou art, and soon thou wilt be like me a fetid corpse, breeding ground for worms."[6] But the effect of these death figures is not other-worldly at all. The obsession with death springs in part from a suppressed but intense desire for worldly pleasure; from a feeling of being cheated by the brevity and hardship of this life; and from outraged fear that death and decay may be all that awaits us.

There is an unprecedented concentration on the physical facts of death. Tomb sculpture often shows, not just an effigy of the dead man as he was in life, but his corpse, observed with gruesome, and often necrophiliac, realism. Bones poke through the rags of rotting flesh, and worms or toads crawl from eye sockets or mouth. One very popular subject shows three living men unexpectedly confronted by three dead bodies, their own future shapes; artists often differentiate very precisely between the corpse that is newly dead, the putrefying body and the skeleton.[7]

And these decaying bodies are no mere shells, gladly discarded by the triumphant spirit. The decomposing flesh, the very bones, seem to be alive, and acutely conscious of what is happening. In Villon's famous "Ballade des Pendus," for example, the corpses hanging from the gibbet describe how they are swayed by every wind, blackened by the sun and scoured by the rain, while their eyes are picked away by birds. In fantasy, the century-old dualism is reversed; now the body *is* the self.

The terrible epidemics of the thirteenth and fourteenth centuries must have intensified the preoccupation with the physical facts of death. A Europe already in a state of extreme unrest—with chronic food shortages, increasing numbers of people reduced to beggary or scraping a living on the margins of society, constant peasant uprisings and millenarian movements—was further ravaged by a series of

plagues that reached a peak with the Black Death of 1348. Up to one-third of the population of Europe may have died; and died messily, in extreme agony, and inexplicably.[8] It is hardly surprising, then, that death seemed omnipresent and omnipotent in the late middle ages, the dead more real than the living. Death is personified, and his skeletal body has a terrible phallic energy. He lunges at us with spear or scythe, or rides a great horse that tramples all in his path; or, like a hunter, he stalks down his living prey.

Sometimes—and there is a vengeful pleasure as well as terror in this—his terrible democracy is stressed: "Sceptre and crown/Must tumble down/And in the dust be equal made/With the poor crooked scythe and spade." In the famous *Dances of Death*—Holbein's series of woodcuts, for example—death is a leveller, a socially subversive figure who delights in catching out corrupt lawyers or cheating merchants, ignorant doctors or immoral priests.[9] He is a clown who dances feverishly, elegantly, in a cruel parody of our living energy. Sometimes death appears in the guise of a lover, or rapist; he bites the cheeks of a young girl, or clutches her breasts in his bony hands. Death is everywhere—a figure glimpsed in the crowd, over the shoulder, in the mirror; an intruder, alien but horribly familiar, on our most private moments. As J. Huizinga once suggested, in confronting death, man confronts his own double.[10] The death we all carry in our own bodies, who lies in wait for us all our lives, is suddenly objectified. And—as in so many fairy stories—when we see our double we die.

When the later middle ages imagines life after death, it is usually a terrible one; the body is resurrected to an eternity of pain. The facade at Bourges cathedral, for example, shows the blessed climbing cheerfully out of their tombs, their nude bodies graceful and beautiful. But they are dressed in long robes to prepare them for their ascent to God, while the damned are trapped in humiliating nakedness. Almost every parish Church had its Last Judgment or Doom; in England, they were even more common than the Crucifixion itself.[11] The bliss of the saints pales into insignificance beside the reality of Hell, and the realism and ingenuity with which artists suggest the endless physical torment of the damned.

Thus the most powerful scenes on Lorenzo Maitani's bronze doors, made in Orvieto in the early fourteenth century, contrast the desperation of the sinners, who are being eaten and mauled and clawed, with the gleeful cruelty of the all-too-human devils. Many

71

artists take sadistic pleasure in fitting punishment to sin. Giotto shows the lustful suspended by genitals or tongue, while Bosch depicts the naked bodies of the envious savaged by dogs, and gluttons being force-fed or themselves devoured by monsters. The Doom certainly served to frighten men into repentance and into church; but it also offered them a vindictive pleasure at the thought of their enemies or oppressors cast into hell. Dante consigned his political opponents to the Inferno, and one of the delights promised the blessed was the sight of the miserable and hopeless struggles of the damned. There is a strict hierarchy in the next world, but it may well reverse the hierarchies we know; popes, prelates and priests, along with other sinners, are hurled into the bottomless pit and the inextinguishable flame.

A very few artists bring compassion and a deeper psychological insight to their studies of hell. Roger van der Weyden, for example, suggests the way panic and despair dehumanize us; his naked sinners crouch like terrified animals as they scramble toward the abyss. In other paintings he shows the damned falling endlessly, nightmarishly, through space, all sense of self lost in their dizziness and panic. And in the fifteenth century, Signorelli powerfully communicates the rage of the damned, faced with a situation they can never escape or change. In their impotent protest, they have more humanity and more dignity than the complacent saints.

CHRIST CRUCIFIED

It was only in the later middle ages that the Crucifixion emerged as the central image of Christian art.[12] The first images of Christ—dating back to the time when Christians were a small persecuted sect—celebrate his divinity rather than his sufferings as a man. He is the Good Shepherd, or the King of Kings reigning in majesty. A fourth-century sarcophagus shows scenes from the Passion—Christ on trial before Pilate, being crowned by thorns, and carrying his own cross. But the central panel shows, not the Crucifixion itself but the cross surrounded by a laurel wreath. The instrument of torture is transformed into an abstract symbol asserting the sovereignty of Christ and his conquest of death.

The earliest surviving scenes of the actual Crucifixion avoid presenting Christ's agonies realistically. On a fifth-century Italian ivory in the British Museum, Christ is triumphantly alive; standing before the cross, his eyes wide open, he spreads his arms wide in a

gesture of benediction. His body, nude except for a narrow loincloth, faintly recalls the Greek gods; he is contrasted with the clothed, all-too-human Judas, dangling ignominiously from a tree.

This living Christ, unmarked by torture, is common at least until the twelfth century. As late as 1054, the Roman Church officially opposed Byzantine images of the suffering Christ on the grounds that these diminished his divinity. "How can you nail a dying man to the Cross of Christ, in such a way that any anti-Christ may take Jesus's place on the cross and seek to be worshipped as though he were a god?"[13] He is often shown dressed in a long formal tunic which conceals his pain and accentuates his remote dignity. Even when his body is uncovered to reveal his pains, we are not asked to identify with the man, but to concentrate on the redemptive meaning of his sacrifice. Cimabue's great thirteenth-century crosses, designed to be carried in procession or to loom over worshippers in church, turn Christ into a monumental and awesome figure. The man who died so shamefully on the cross is also creator and judge of the whole universe.

But gradually another Christ emerges—as early as the tenth century in Germany, though he is most common in the fourteenth and fifteenth centuries—who is creature rather than creator. The Christ who dominates men's minds in the late middle ages is a man like themselves, suffering with and for them. There was a widespread yearning for a more direct contact with God, for a vividly subjective experience unmediated by the Church bureaucracy, for a personal faith that would help men make sense of their own fears and pains. Artists and mystics all over Europe re-create Christ's life and death in ways that make him immediately relevant, their contemporary. But it is above all his passion and death that obsess them, and each stage of his progress to Calvary is elaborated in the most concrete and circumstantial detail.

Christ's nakedness becomes a symbol of his humanity, and of the humiliation and shame he underwent for our sake. The flagellation—Christ is stripped then brutally scourged by the soldiers—is a favorite subject; and so is the incident when his body, torn and bruised from the beating, is exposed to the mockery of the people. At Calvary itself, he is sometimes shown being stripped of his garments, stripped of the last remnants of his dignity. (Occasionally, when an artist wants to stress his willing acceptance of shame, he is allowed to undress himself.) One new and popular scene shows Christ sitting, his

73

naked body already wounded and exhausted, as he waits to be nailed to the cross; in Emile Mâles's words, this Christ "has explored all the depths of violence, ignominy and bestiality in man."[14] Fifteenth-century Flemish painters often dwell on the bitter grief of Christ's mother and friends when he is taken down from the cross. His lifeless body, pale and bony, contrasts poignantly with their rich draperies.

The Crucifixion itself changes. Christ no longer stands proudly upright against the cross; he hangs heavily, with sagging head, his knees and shoulders wrenched by the dead weight of his body. The crown of thorns replaces the imperial crown and blood, real and not just symbolic, pours from wounds shown with almost surgical realism. Most terrible and moving of all are the plague crosses. Roughly carved in wood, Christ's body is hideously distorted; his stomach is sunk, his arms and legs nothing but skin and bone. Yet these are genuinely popular images, set up in parish churches and at wayside shrines during epidemics; they play on men's guilts and fears, but they also offer real comfort in times of trouble.

The plague cross finds climactic expression in Grünewald's great *Crucifixion* painted for the high altar at Isenheim in the early sixteenth century. Christ towers over the mourners in the painting, over the worshippers in church; a gigantic figure racked by the most appalling pain. His skin has a greenish pallor, and is covered all over with cuts and bruises. He is twisted into a grotesque, almost inhuman shape; the feet are swollen from the nails and the fingers locked into a rigid cramp. Grünewald somehow suggests both the horrible rigors of death, and the even more horrible softness of putrefaction.

Because Grünewald dwells on every detail with such morbid precision, it is hard to look at it for very long. But the final effect is not morbid: the painting is a protest against the ravages of illness, against death itself. It was commissioned by the Athonites, a hospital order specializing in the care of those ill with plague, with leprosy and with the terrible new disease syphilis. When the sick arrived at Isenheim, they were taken to pray before an image of God in their own diseased shape, which perhaps helped them to objectify and accept their tragic condition.[15]

The contemplation of Christ's sufferings was not always enough; in their increasingly anxious identification with Christ, men sought to experience his agonies in their own bodies. St. Francis—who stripped naked in front of his fellow townsmen to signal his renunciation of

worldly roles, and who devoted his whole life to the imitation of Christ's poverty and love—actually received the stigmata in his hands feet and side. For many, Christ's flagellation was almost as important as the Crucifixion itself. It is not only painted and described in morbid detail; from the eleventh century on, self-flagellation was widely accepted, even by the most orthodox, as a penitential technique. Monks and laymen went to dreadful lengths in the effort to reenact Christ's suffering. Norman Cohn quotes a fourteenth-century friar who would strip naked in his cell then beat himself with a sharply spiked scourge until his flesh tore away from his body. There is a note of satisfaction and emotional relief as the friar tells how, in excited fantasy, he momentarily becomes Christ.

> He beat himself so hard that the scourge broke into three bits and the points flew against the wall. He stood there bleeding and gazed at himself. It was such a wretched sight that he was reminded in many ways of the appearance of the beloved Christ when he was fearfully beaten. Out of pity for himself he began to weep bitterly. And he knelt down, naked and covered in blood, in the frosty air and prayed to God to wipe out his sins from before his gentle eyes.[16]

The physical imitation of Christ could itself become a mass movement. In times of crisis, when rumors of plague were terrifying Europe, great processions of flagellants would wander from town to town, whipping themselves into frenzies of repentance. By cruelly torturing themselves, they were taking out an insurance policy against worse calamities in this world and the next. Moreover, these landless peasants, beggars, slum dwellers from the newly crowded towns, could see themselves as a chosen people, singled out by Christ to share his suffering. Like him, they were taking on their own shoulders all the sins and injustices of the world. Caught up in masochistic ecstasy, the flagellants believe that they are reenacting Christ's redemptive sacrifice, shedding their blood to save mankind.

Identification with the scourged Christ lies behind one of Dürer's most moving drawings. It is at once a self-portrait and a devotional image of Christ holding birch and scourge. This Christ has Dürer's own tired face and thinning disheveled hair, Dürer's own body with its slumped shoulders and soft rolls of flesh on the belly. The painter's melancholy and anxiety give a new immediacy to the traditional figure; at the same time, by playing the part of Christ, Dürer is freed to

express and explore his own masochism, his self-love and his uneasiness about his aging body.

For the first time, we have some clue as to what women thought and felt about Christ's suffering naked body. All over Europe, as part of a growing lay participation in religious life, women wrote or dictated records of their inner spiritual lives. The Church, or sometimes heretical sects, offered one of the few non-domestic outlets for women's energies in the late medieval world. Women speak with a growing confidence that spiritual truth is not the exclusive property of the clergy or the educated or the well-born. Julian of Norwich apologizes for her presumption; at the same time, she speaks with absolute subjective certainty out of her personal relationship with Christ. "God forbid that ye should say . . . that I am a teacher, for I do not mean that. . . . For I am a woman, unlettered, feeble and frail. But I know well this that I say, I have it on the shewing of him who is sovereign truth."[17]

Like other mystics, Julian is consumed by her eagerness to *see* Christ's suffering body, and to communicate her "shewing" as vividly and dramatically as she can. Her language is homely; she takes her metaphors from ordinary domestic life, the life women know so well. Christ hangs on the cross "like some cloth hung up to dry"; the drops of blood on his face and body are round as herring scales, and they fall "like the drops of water that fall from the eaves after a heavy shower."[18] Church art was proverbially regarded as the book of the poor, the unlettered and women; and in fact, many women incorporate the art from their local church in their visions. Catherine of Siena, for example, was visited by Christ "in that form in which she had seen him painted in church."[19] Bridget of Sweden might be describing a plague cross when she speaks of the crucified body of Christ. "His mouth was open, his tongue bleeding, his cheeks hollow. His body was so greatly sunk that it seemed he no longer had any entrails," and his tortured feet "twisted out like a door pivoting on its hinges."[20]

The suffering Christ becomes the focus for the most complex feelings; women address him as lover or husband, as father or child. Sometimes their language is overtly sexual, sometimes they extract a morbid pleasure from his agony, as if they were taking unconscious revenge for the long-standing view of woman as sinful and disgusting. And sometimes, women clearly identify their own sufferings, the self-

abnegation expected of them as women, with Christ's. Julian of Norwich—in her daring and moving pages on God the mother—actually identifies Christ's pains on the cross with a woman's pains in childbirth, and his love with the "intimate, willing and dependable" services our mothers do for us. "He is in labour until the time has come for him to suffer the sharpest pangs and most appalling pain possible,"[21] the moment when, to give birth to us, he dies.

This many-sided response to Christ may be seen most clearly perhaps in the memoirs of Margery of Kempe, who writes naively, but with a moving energy and conviction. She was a burgher's wife living in late fourteenth-century Norfolk, who began to have mystical visions after her first child was born, though she had thirteen more children before she yielded to the voices which were forbidding her to lie with her husband again. She then proceeded to pour all her anger and frustration, and her immense talent and energy, into Christ. An irritant to fellow pilgrims, a trial to her confessors and something of an embarrassment to Rome, she took herself off on an astonishing series of journeys to shrines all over Europe, and eventually got as far as Jerusalem. Stimulated by actually being in the holy land, she relives Christ's life in her own emotional terms. Sometimes she is his mother; sometimes a friend of the family; sometimes the repentant Mary Magdalen. She bustles round arranging things more comfortably when he is born, or she keeps record of the number of the blows he received when he was scourged. ("She saw sixteen men with sixteen scourges, and each scourge had eight pellets of lead . . . and those men with the scourges made covenant that each of them would give our Lord forty strokes.")[22] And she describes the Crucifixion with a love close to hatred, a compassion trembling on the verge of sadism. She sees Christ,

> before her bodily eye in his manhood . . . all rent and torn with scourges, fuller of wounds than ever was a dove house of holes, hanging on the cross with the crown of thorns on his head, his beautiful hands, his tender feet nailed to the hard tree, the river of blood flowing out plenteously from every member . . . then she fell down and cried out in a loud voice, wonderfully turning and wresting her body on every side, spreading her arms abroad as if she would have died, and could not keep herself from crying, and from these bodily movements for the fire of love that burnt so fervently in her soul with pure pity and compassion.[23]

But pity and compassion are only part of it. A good many ambivalent emotions—anger at men, a mix of self-disgust and self-importance, sexual frustration issuing in sadomasochism,—are involved as well.

But of course, like most other women, Margery identifies most often with the mother of God. At a fair, she sees women weeping as they hold on their laps a small wooden effigy of the baby Christ; she herself is moved to tears by a *pietà*, Mary with the dead Christ on her lap. The great popularity of the *pietà* in the late middle ages certainly springs from the new involvement of women in the life of the church. The first known reference to the *pietà* is by a woman; in the early thirteenth century, St. Mechtilde of Hackeborn meditates on Christ's naked wounded body lying in his mother's arms, and so do many visionaries after her.[24]

The *pietà* tended to be placed on secondary altars, close to worshippers, and it appeals very directly to our human feelings. Some groups are crudely carved, and Christ lies like a stiff doll on his mother's knees; some—most notably Michelangelo's *Pietà* in St. Peter's, Rome—are polished, elegant, supremely sophisticated. But the relationship between the two figures is always disturbing. (We can understand why, for example, someone recently tried to smash Michelangelo's beautiful—and profoundly incestuous—group.)

The *pietà* reaches deep into the ambiguous feelings that link mother and son. Mary holds Christ tenderly, as if the grown man were still a baby, as if her body, that once gave him life, could now restore it. Occasionally the dead Christ is no bigger than a child; occasionally the baby Christ adopts the pose of the dead man. The *pietà* touches on every mother's fear for her child, her intuition of his eventual death even in the joy of his birth; just as it appeals to the son's desire to return to his mother's body even if that is only possible in death. Artists occasionally try to make a theological point by showing Mary smiling at his dead body: she understands even in her grief that he will rise again. But that smile seems to hint at the emotional ambiguity in any mother's love. The *pietà* celebrates the mother's power and persistence; the way she feels both love and resentment for the son born of her body who is her only justification as a woman.

CHRIST AND APOLLO

"Hearts pledged to Christ are closed to Apollo," a fourth-century

Christian poet had written, with perhaps a touch of regret.[25] And according to Byzantine legend, a sculptor who gave Christ the body of Jupiter found his hands withered and useless. For centuries a lingering hostility to pagan beauty prevented more than sporadic attempts to adapt it to Christian themes. But during the fifteenth century, particularly in Italy, a few artists tried to reclaim the nude heroes of the ancient world for God's service. The Platonic idea that physical love may lead us up to love of the divine was revived by Renaissance humanists; a Christianized neo-platonism lies, for example, behind Michelangelo's fervent belief that in celebrating the strength and beauty of the human body, we worship God. Even the northerner Dürer, creator of such powerful images of the suffering Christ, exclaimed longingly that:

> even as the ancients used the fairest figure of a man to represent
> their false god Apollo, we will in all chastity employ the same for
> Christ the Lord, who is the fairest of all the earth; and as they
> figure Venus for the loveliest of women, so will we in like manner
> set down the same beauteous form for the most pure virgin Mary,
> the mother of God, and of Hercules we will make Samson.[26]

Hercules could become Samson easily enough. He was one of the first pagan nudes to be brought back into the Christian fold and stands, a muscular personification of moral strength, on a thirteenth-century pulpit by Niccolo Pisano. But the more sensual beauty of Apollo—let alone Venus—was harder to assimilate. The boldest neo-platonists never quite lost the old Christian suspicion that fleshly beauty is a distraction and a snare.

Many Renaissance artists were attracted to the theme of Adam and Eve because it allowed them to imagine man undivided and un-ashamed. Our first parents are given the perfect beauty of classical statues. But very few artists achieve anything like the untroubled Greek confidence in the body. Even in prelapsarian bliss, their genitals are often discreetly shielded by fig leaves or flowers. An Adam by Della Quercia or Michelangelo may have the body of an Apollo, but as he stirs to life, he seems troubled by some foreknowledge of his future fall and death. Many Renaissance artists (Dürer for example) seem particularly interested in that tense moment when Eve offers the apple and everything, our whole destiny, is still in the balance. It is as if, by considering that symbolic moment when Paradise was lost and innocent nudity became naked shame, the artist

79

is trying to understand and perhaps free himself from the burden of the Fall.

Christ, who came to restore all that Adam lost, is now seen as perfectly beautiful man. But the Renaissance is torn between two contradictory ideas—a suffering Christ, and a serene antique god who stands above all life's vicissitudes. In flagellation scenes—Sebastiano del Piombo's is a good example—Christ and his tormentors now perform with the controlled grace of athletes and Christ's fair skin remains unblemished. Even when he is nailed to the cross, many painters stress his bodily beauty and minimize his wounds. The Christ on the cross which Michelangelo drew for his friend Vittoria Colonna is suffering, but pain shows more in his face than his powerful athlete's body. As an old man, possessed by the thought of his own approaching death, Michelangelo turned again and again to the consoling image of the Christ who suffers with us. The model for one of his greatest drawings of the Crucifixion is not Apollo but his satyr victim Marsyas, who was hanged from a tree and flayed. Michelangelo gives his late Christs neither the idealized Apollonian beauty of his earlier nudes, nor the desperately real pain of a Grünewald. Instead, he returns to the abstract forms of medieval art; the tragic body speaks to us because it is so blurred, its forms so simplified and archaic.

The Renaissance gives a meaning to physical beauty that the Greeks had never dreamed of. Christ's bodily beauty, surviving death, becomes a symbol of his spiritual victory over death. Many of the greatest Renaissance paintings show, not the Crucifixion itself, but Christ at peace afterward, when death has smoothed away some of the marks of stress. Bellini's great painting of the dead Christ with Mary and John may depict his tragic suffering—the terrible holes in his hands—as well as the grief of the mourners; but the calm, classical beauty of his torso assures us that he will rise again. Another Venetian, Alvise Vivarini, straightforwardly transfers a Greek Apollo on to canvas to suggest the spiritual comeliness of the risen Christ. And Michelangelo even tries to adapt the classic nude to show the moment of Resurrection itself. In one drawing a sleek athletic nude springs out of the grave, its energy seeming to defy gravity, defy the bonds of death. Michelangelo is using the classic nude in the service of a dream that would have been incomprehensible to the Greeks: the paradoxical Christian hope that the corrupt body itself may rise in perfected nakedness and live eternally.

In its preoccupation with Christ's perfect beauty, the Renaissance sometimes turned him into a remote and inaccessible figure, above the realm of human feeling. A certain loss of accessibility may result. There are hints of this aloofness early in the fifteenth century when Brunelleschi, we are told, criticized a very moving Crucifixion by his friend Donatello because "it seemed to him that Donatello had put on the cross the body of a peasant, not the body of Jesus Christ which was the most delicate and in every part the most perfect human form ever created."[27] Christ's classic beauty, meant to suggest his spiritual grace, sometimes looks more like aristocratic refinement and good breeding. Some sixteenth-century Christs are not just noble, they are clearly noblemen. And when in the seventeenth century a few painters reacted against this idealizing tradition to show Christ once more as an ordinary suffering man, their work seemed shocking, even blasphemous.

Other Renaissance Christs seem distractingly sensuous, with a beauty that undermines the intended devotional meaning— Michelangelo's fleshy statue of the *Risen Christ* is a good example, and so is Rosso's willfully erotic *Dead Christ with Angels*. The inability to resolve the dualism between flesh and spirit is seen most clearly in scores of paintings of that favorite Renaissance martyr, Sebastian. Only too often, a loving appreciation of his golden Apollonian beauty outweighs his religious meaning.

Sebastian had been popular for centuries, both as patron saint of archers and as a plague saint. Pestilence is traditionally associated with deadly arrows sent by God, or in classical myth by Apollo. In one of those odd inversions so typical of Christian hagiography, Sebastian becomes an Apollo, though an Apollo victim of his own arrows. According to legend, he had been a captain in the Pretorian guard under the third-century Emperor Diocletian. Condemned for his Christian faith, his fellow archers, as the Golden Legend quaintly puts it, "shot at him till he was as full of arrows as an urchin full of pricks."[28] Miraculously surviving this treatment, he was bludgeoned to death and thrown into the great sewer of Rome. Medieval painters usually show the full cycle of his sufferings, while Renaissance painters concentrate on the single episode of the target practice when his body is bound and pierced by the arrows. (In some earlier pictures, he looks like a pincushion, or a devil-doll constructed by a particularly malicious witch.)

81

At first he was seen as an older, bearded man, as he still is in Grünewald's Isenheim altarpiece; but he gradually gets younger, prettier, nuder. He is politely uncomplaining about the arrows that penetrate his side or his groin or even his head. Cima or Perugino paint him as a pensive and passive adolescent, whose air of dreamy pleasure suggests that he has been struck by Cupid's darts; Botticelli or Antonio da Messina show him narcissistically absorbed in his own exquisitely beautiful body. Some artists—Mantegna in one of his last paintings, or Sodoma—dwell sadistically on the pain caused by the arrows; but the effect, as the fleshy body seems to writhe in masochistic delight, is even more explicitly erotic.

Contemporaries were probably aware of the ambiguities of many Sebastians. Vasari reports that a nude Sebastian by Fra Bartolommeo had to be moved because women coming to confession complained that it aroused lascivious thoughts.[29] The martyr is often no more than an excuse to paint a luscious classic nude; he also provides an outlet for usually suppressed homosexual fantasies. The arrows signify pleasure *and* punishment, the nude saint is a focus for a growing delight in the flesh, *and* for guilt at being seduced by the grace of the body.

Grace, for the Renaissance, is a quality of soul and of body. Christian art, from the fifteenth through the seventeenth centuries, can be seen as a series of attempts to demonstrate that unity, to reconcile flesh and spirit. The fusion is achieved, but only occasionally and precariously.

LEWD NUDES

The early Christians had smashed or mutilated the nude deities of the ancient world, because they attributed a demonic power to their nakedness. The unclothed body was primarily associated with sex, and therefore with sin and death, and a prudish horror of it was attributed to Christ himself. Gregory of Tours, writing at the end of the sixth century, tells how when an image of Christ naked except for a loincloth was placed in a church at Narbonne, Christ appeared in person, complaining bitterly about his scandalously uncovered state, and threatening a priest with death unless the painting was decently veiled.[30]

The *idea* of nakedness did retain some positive meanings, in theological writing if not in art. It is used as a metaphor for innocence and purity; or it may signify the willing self-deprivation of those who

82

"naked follow the naked Christ." Two nude horse-tamers in Rome, statues which had somehow managed to survive the destructive puritanism of the early church, were explained away in moral terms: they were philosophers who wore no clothes because they represented the naked truth. But it was not until the Renaissance that these verbal metaphors were translated into realistic visual images.

And the old mix of superstitious fear and prudery survived well beyond the Renaissance. The sculptor Ghiberti, for example, writes regretfully of a beautiful antique nude discovered in fourteenth-century Siena. It was greatly admired and set up, to public acclaim, in the marketplace. But when the wars with Florence took a turn for the worse, the statue became the focus of fear and anger, and was eventually broken up and buried in enemy territory. In 1525, the northerner Pope Adrian VI, on seeing the great Vatican collection of antiquities so lovingly assembled by his humanist predecessors, commented coldly that "those are the idols of the ancients." And later still, the counter-reforming Jesuit Possevino railed against the whole Renaissance revival of "Jupiters, Venuses and other unclean beings, recalled from the infernal regions" to the great distress of the saints who had shed blood to destroy them.[31]

A few Renaissance artists, confronted by religious critics whose denunciations triggered off their own inner doubts about the nude, repented dramatically. Fra Bartolommeo, for example, deeply affected by Savonarola's diatribes against art that arouses indecent thoughts, was "persuaded that it was not good to keep paintings of male and female nudes in the house, where there were children." And when Savonarola held great public bonfires in Florence, Bartolommeo and Lorenzo di Credi brought along all their nude drawings to be burned.[32] Nearly a century later, the sculptor Ammanati went through a comparable conversion, publicly wringing his hands over all his undraped statues, and urging fellow artists "never to make anywhere any work of your indecent or lewd—I am referring to entirely nude figures—nor anything else that may move any man or woman, of any age, to wicked thoughts." He even applied to the grand duke of Tuscany for permission to clothe his nudes "artistically and decently, entitling them with the names of virtues."[33]

Even in his own lifetime, Michelangelo's nudes came under increasing attack. More and more voices were raised in protest at his "obscene" nudes and his cultivation of "art" at the expense of

devotion. Even that cheerful pornographer Pietro Aretino expressed virtuous horror that the Sistine Chapel—the Pope's private place of worship—should contain so many figures better suited to a bordello, "shamelessly uncovered both before and behind."[34] Michelangelo's greatest admirer, the painter and biographer Vasari, commented shrewdly on the growing prudery in Counter Reformation Italy. In the second edition of his *Lives* he piously conceded that total nudity may not always be appropriate in church. But, he added pointedly, those who find all nudes indecent merely expose "the unsoundness and corruption of their own minds, by drawing evil and impure desires out of works from which, if they were lovers of purity, as they seek by their misguided zeal to prove themselves to be, they would gain a desire to attain to heaven."[35] But Vasari was already swimming against the tide. Hostility to the nude increased after 1563 when the Council of Trent published its decrees insisting on the need to maintain decency in sacred art. Michelangelo's *Last Judgment* was actually threatened with destruction, and was only saved by protests from other artists. The painter Daniel da Volterra, hired to clean it up by painting over the exposed genitals, earned the nickname "the breech-maker."[36]

The Christian fear of the naked body is above all a fear of the genitals, which seem to sum up all the irrepressible and amoral life of the flesh. "Naked" bodies in Christian art, particularly after the great movement for Catholic reform in the sixteenth century, almost always wear a fig leaf or loincloth. There are some superb Renaissance exceptions—Della Quercia's early fifteenth-century panels showing the Creation and Fall, for example. A few artists even dared to portray Christ in full nakedness. Michelangelo's *Risen Christ* was commissioned—by a cleric—completely nude, and the vulgar swirl of gilded drapery was only added later. Cellini carved a Christ nude on the cross which so scandalized Philip II of Spain that he covered the offending member with his own handkerchief. One counter-reforming theologian argued that even when Bible stories explicitly described characters as naked, they should be provided with loincloths, and another insisted that the baby Christ should always be decently draped.[37]

The anxiety to keep the genitals hidden is a symbolic castration of the male body. But ironically, the self-conscious avoidance of full frontal nudity is more titillating than nudity itself. Michelangelo's nudes are less narrowly erotic than all those baroque saints with their

sexily slipping loincloths. In fact, seventeenth-century church art is often very prurient indeed. Painters treat the bodies of Christ and his martyrs with an overt and often sadomasochistic sensuality; nobody is shocked, as long as there is a scrap of cloth in the right place.

The determination to conceal and deny the genitals usually implies preoccupation, even obsession with them. The spectator is asked to imagine the missing parts, to endow them in fantasy with impossible power, impossible pleasure. The sixteenth-century Jesuit Possevino exclaimed, with almost Victorian coyness, that "if a man has any decency in his head, he will scarcely dare to look at himself."[38] By "himself," Possevino means, of course, his genitals. When he looks at the human body, they are the only things he sees. And to this day, it is hard for us to see the body steadily and see it whole. The genitals are still the exclusive focus of our shame and curiosity, the center of the body. In his own fantasy, in the fantasy of others, a man *is* his genitals.

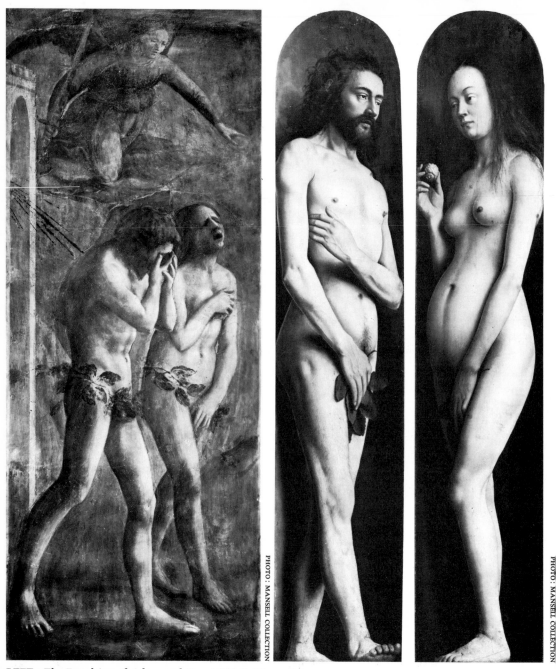

LEFT: *The Expulsion of Adam and Eve*, 1427–8, Masaccio
RIGHT: *Adam and Eve, c.* 1432, Jan van Eyck

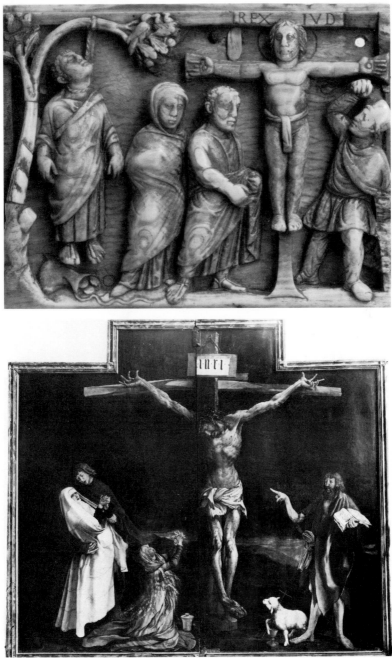

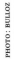

TOP: *The Crucifixion and the Death of Judas, c.* 420–30, Italian
BOTTOM: *The Crucifixion,* 1513–15, Grünewald

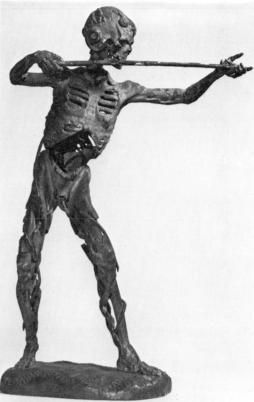

RIGHT: *Death*, sixteenth century, German
BOTTOM: *Hell* (detail), Orvieto Cathedral, *c.* 1310–30, Lorenzo Maitani

88

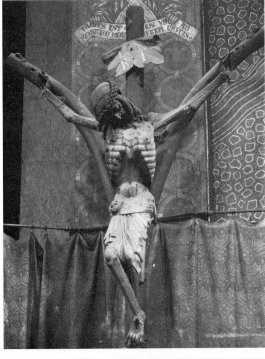

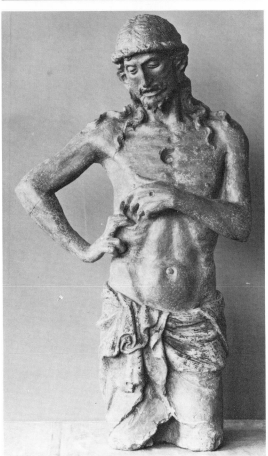

TOP: *Plague Christ, c.* 1304, German

BOTTOM: *Christ Showing His Wounds,* early fifteenth century, Italian

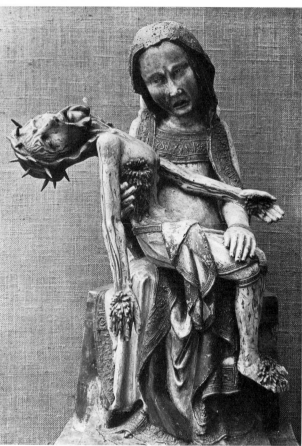

TOP: *Pietà*, *c.* 1300, German

BOTTOM: *Pietà*, late fifteenth century, Italian

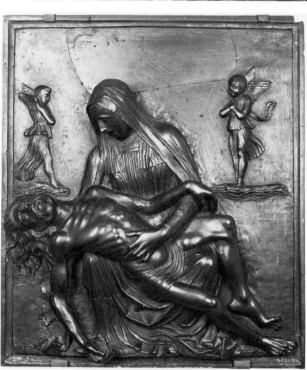

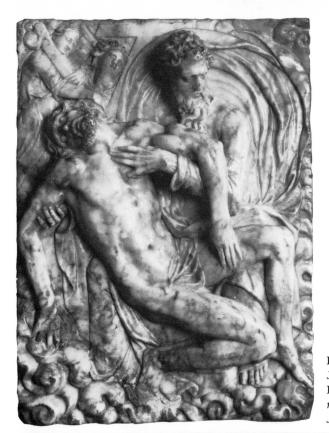

LEFT: *Dead Christ*, 1535,
Jacques Dubroeucq
BOTTOM: *Dead Christ
mourned by the Virgin and St.
John,* c. 1465, Bellini

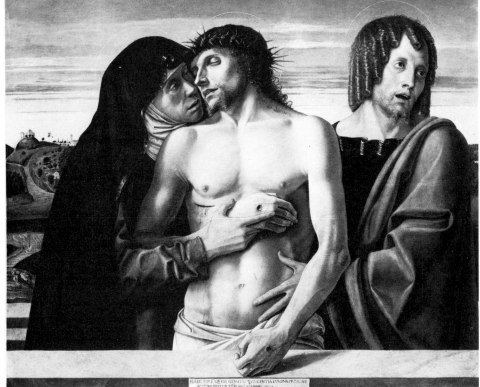

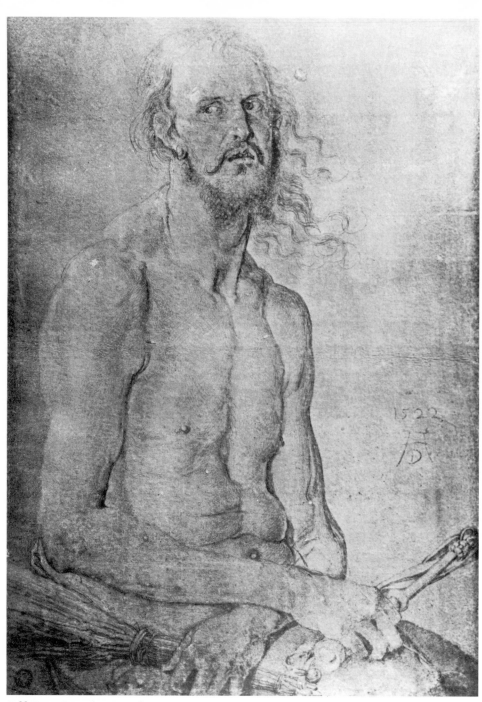

Self-Portrait as the Man of Sorrows, 1522, Dürer

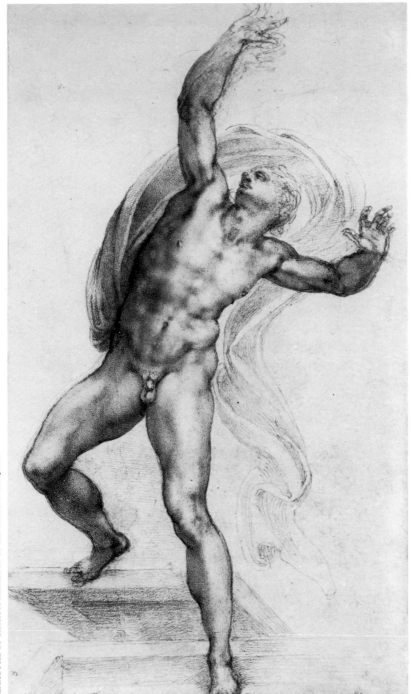

Risen Christ, c. 1532–3, Michelangelo

Naked into Nude

FOR THE RENAISSANCE ARTIST, hoping to revive and rival the long-lost art of antiquity, the male nude is *the* subject for art. In making a lifelike nude, the artist even felt that he was imitating God himself.

A traditional theme—the creation of Adam—is adapted to express man's growing confidence in his body and in his creative power. Medieval versions show an enormous draped God standing over a tiny doll-like Adam; in Jacopo della Quercia's panel made in Bologna in 1425, Adam rises to meet his maker almost on equal terms. The proportions of his nude body are not quite right, the head being a shade too large for the body. But he is a nude in the strict sense, beautiful, classically beautiful. Light ripples over his muscles as he stirs to life, seeming to enjoy his own flesh and his newfound potency. And the artist identifies as well with the creating God; like that God, he takes a wondering pleasure in his own handiwork, in the living being he has shaped from inert matter.

Christian and classical culture combine to give first place to the male. (The creation of Eve is very different from Adam's; her emergence from his rib posed knotty technical problems, and artists had to call on all their naturalistic sleight-of-hand to avoid making it look like a minor but unpleasant bit of surgery. The female nude became a central theme of Renaissance art much later—around 1500— and her importance is linked to the growing market for purely decorative art, for easel paintings on secular subjects.) As in early classical Greece, it was through study of the male body that artists developed their understanding of anatomy and proportion. If there is a renewed sense that the body reveals spiritual beauty, that

tends to mean the male body; and many of the greatest Florentines found the female nude far less erotically arousing than the male. The most memorable nudes of the early Renaissance—from Donatello's *David* to Mantegna's *Sebastian* to Pollaiuolo's *Hercules*—were male. The "divine" Michelangelo, whose long life's work is a celebration of the male body, carries that preference to its logical conclusion.

After being denied for so long, the Renaissance body begins to reassert its own reality. Clothes, for example, draw attention to the body beneath; men enjoy their bodies, and enjoy displaying them. For the first time, fashionable clothes are cut to fit closely, to reveal and improve the body and enhance sexual appeal. Until well into the fourteenth century, both men and women had worn long loose garments, minimizing sexual difference. Now women's breasts are bared and pushed up, while tight corsets and full skirts hamper easy movement. The man's clothes which, according to Geoffrey Squire, may have been the first to change, are even more sensual.[1]

The new style enhances a virile masculinity, leaving the man free to stride quickly and easily. The tunic is cut shorter and pads out the shoulders; tight-clinging hose emphasize the shape of the legs right up to the genitals and buttocks. (For many artists—including Leonardo and Signorelli—the legs are the main erogenous zone.) The new dress is worn to perfection by Carpaccio's fashionable young Venetians, who pose and parade, casually displaying their long slim legs, and taking a gentle sensual pleasure in their own grace.

Renaissance art does not simply offer the body as a beautiful object to be contemplated; we are reminded of the pains and pleasures we experience in our own bodies. Masaccio's fresco of St. Peter baptizing converts includes a naked man who shivers in the cold air, his arms huddled round his chest; the painter plays directly on our physical memories of being cold or uncomfortable. Piero della Francesca's *Death of Adam* contrasts the withered, almost transparent body of the dying man, with the solid beautiful boy who leans so easily on his staff. The fresco makes a theological point but in strikingly sensuous terms: we feel, as well as grasp intellectually, the passage from youth to age, the cycle of time in which we are all caught. For the Renaissance believes that emotions, "the movements of the soul," are expressed in and can only be known through, the body. Erwin Panofsky has suggested that when Renaissance artists began to draw man nude or semi-nude, they "unveiled not just the nature of the human body, but

95

the nature of human emotions. They stripped man of his clothes and of the protective cover of conventionality."[2] And artists often stripped themselves as well; both Dürer and Leonardo, for example, speak a little uneasily of the painter's tendency to make figures that resemble his own.[3] Early Renaissance nudes often seem to express the artist's difficult attitudes toward the body; curiosity, aggression and anxious fear accompany his newly liberated delight in the flesh.

THE ANTIQUE NUDE RENEWED

Looking back in 1550, the painter and biographer Vasari attributed the great art of the last half century to the artists having seen "some of the finest works of art mentioned by Pliny dug out of the earth; namely, the Laocoön, the Hercules, the great torso of Belvedere as well as the Venus, the Cleopatra, the Apollo and countless others, all possessing the appeal and vigor of living flesh."[4] Surprisingly few life-size antique nudes were known to the fifteenth century; the Apollo Belvedere only turned up around 1490 and the Laocoön not till 1506. The few that existed symbolized everything that the Quattrocento aspired toward, everything that had been forgotten or willfully suppressed in the dark ages. Because respect for the antique hardened so soon into an academic dogma that fettered rather than liberated the imagination, we can only dimly recapture Renaissance excitement as statues were actually dug up from the earth. The Florentine sculptor Ghiberti marvels at the subtle workmanship of a hermaphrodite discovered in a Roman drain; when another nude was uncovered in the course of building works in Florence, he imagined some gentle and congenial spirit in late antiquity making a sepulcher to preserve the statue from primitive Christian anger.[5]

It was as if, now, tombs were being opened and dead bodies resurrected. Artists and scholars alike marveled at the eloquence of mere bronze and marble, which seemed to speak across the dark intervening centuries of another and more congenial world. Mere stone seemed almost alive and breathing—but "what fine chisel could ever yet cut breath?" An intense archaeological excitement lies behind Renaissance claims that art can rival nature and make good its defects, that it can preserve human actions and virtues from oblivion. The antique nude, miraculously surviving the puritanism of the early church, bears witness to the power of art over the fourth dimension, over time. In the words of the humanist Leon Battista Alberti, art

makes the gods visible, the absent present and the dead seem alive.[6]

This archaeologist's vision informs the work of that ardent, even obsessive, classicizer, Andrea Mantegna. Like many other Renaissance artists, he had an impressive collection of his own; fragments and smaller pieces which were not just working models but cult objects endowed with magical significance. (Mere artists were soon priced out of the market by wealthy connoisseurs; Mantegna was desolated when financial troubles forced him to sell some of his finer pieces to the patron Isabella D'Este.) Fragments of statuary turn up in his paintings regardless of subject. Mantegna combines a scholarly eye for detail with deep romantic feeling—nostalgia for the vanished might of Rome and a melancholy enjoyment of its ruins for their own sake.

According to Vasari, Mantegna believed that study from the antique was more valuable than from a living body.[7] The structure of the nude and its muscles and veins can be discerned more clearly in sculpted stone than in flesh; at the same time, the antique nude is more perfectly beautiful than any single living man. It was a dangerous doctrine. Within a few decades of Mantegna's death, respect for the antique was getting in the way of a first-hand response to the body; and for centuries, artists could hardly see the nude *except* as a classical statue. Some of Mantegna's contemporaries felt that he had already gone too far; his paintings, they claimed, were peopled not by living beings but by stone men. But for Mantegna, the dead stones are the source of life, and his excitement about the recovered past makes his vision of man as statue profoundly dramatic. His constant, underlying theme is the relationship between past and present, classical and Christian, nature and art.

Thus his *Dead Christ* in Milan is brilliantly realistic. The stunning foreshortening stresses the anatomical accuracy with which he has described the wounded body. But the body lies like a great fallen pillar. Cold and still as stone, its flesh has been transformed by art and acquired the impersonal symbolic power of an antique statue.

The *St. Sebastian* now in the Louvre is comparable. Its theme is a favorite with Mantegna—the clash between the brutal military power of Imperial Rome, and the very different values of Christianity. The painter is as attracted to one as to the other. Sebastian is older and more heavily built—more masculine—than usual; for once, he looks like the Roman soldier of the legend. He is shown painfully learning a new kind of heroism—the patience and better fortitude of martyrdom. His

still acceptance contrasts with the cruel faces of his executioners. More nobly Roman than they, he convinces us that his faith will prevail against their force. And time is telescoped in the painting, the ruin of Empire foreshadowed. The great imperial arch, so beautifully and intricately carved, is already a crumbling ruin. Behind it, the fantastic beetling cliffs and towers are as remote as a dream. Mantegna feels intensely for the suffering saint and no less intensely for the world that destroyed him but was in its turn ruined by his faith. And which in the end is stronger? For now the Christian artist searches the ancient ruins to re-learn the lost arts, and gives the saint the body of an antique hero. Sebastian lives again, and so do the broken stones.

If Mantegna admired an austere and occasionally stolid manliness, other artists were attracted by rather different nudes. Ghiberti—who singled out an antique hermaphrodite for special praise—preferred the subtle curves of the adolescent body. Signorelli liked strongly muscled athletes, while Antonio Pollaiuolo returned again and again to rather scrawny nudes stretched in violent action.

At first, artists were attracted simply by the ideal beauty or expressive power of isolated figures, and more or less classical nudes often pop up in unexpected settings. As Panofsky has argued,[8] it was only slowly that Renaissance artists came to understand the significance of the classical nude and the world that had given it birth. Like each following generation, they recreated the ancient world according to their own needs and fantasies.

Rome, rather than Greece, attracted the first generations of humanists; Italy, after all, was rich in Roman remains, and the growing interest in Greece was literary rather than visual. Florentines especially dreamed of Republican Rome, a powerful city with two populations, one of flesh and blood, the other of bronze and marble. The stone beings, heroically nude, reflected and perfected the virtue of the living, and preserved their memory. (An eery story describes Rome after it was sacked by barbarians, a ghost town inhabited only by statues.) Hercules, somewhat moralized, was adopted as a Florentine hero, and his nude figure carved on one of the doors of the cathedral at the very beginning of the fifteenth century. The great saints and prophets carved by Donatello and Nano di Banco were probably part of a humanist-inspired dream of making Florence a second Rome. They are *statuae viriles*, images of manly virtue which sum up the pride and aspirations of the whole community.[9]

But they are draped, not naked. The classical convention of heroic nudity was known and understood, but it was rarely copied in the fifteenth century, at least in large-scale public stone. Michelangelo's enormous *David*, a belated symbol of Florence's Republican independence, fulfilled earlier humanist dreams. But when it was placed in the Piazza della Signoria in 1504, it was stoned during the night, perhaps by political enemies, but more probably by people shocked by its insistent nudity.

For the nude was appreciated only by a small élite, a self-consciously classicizing avant-garde whose ideas filtered down slowly and against some opposition. Public feelings about the nude —and indeed, about the whole cult of the antique—remained conservative, and ranged from incomprehension to outright hostility. In the 1490s, Savonarola's furious attack on the new paganism and the nude as its symbol woke a wide response in Florence itself, home of the new humanism.

There were a few who probably enjoyed shocking conservative public tastes, and many more who recognized the subversive possibilities of the classic nude, and the challenge it offered to Christian puritanism. But most were careful not to offend too far. Alberti, who took it for granted that study of the nude is the basis of all art, reminds painters that it should be included in the finished work only where shame and modesty permit. Those parts which are ugly or unpleasing should be covered by a hand or a bit of drapery or a stray frond. It is hardly a classical attitude to the body.[10] Artists seize on those Christian subjects which permit nudity, though their real interests and feelings sometimes work against the ostensible theme. Sebastian was so popular partly because he was conventionally martyred in a state of graceful undress; he could be given a seductive beauty that artists hesitated to attribute to Christ himself. Signorelli, almost as exclusively interested in the male nude as Michelangelo was to be, sometimes seems to be smuggling it into his work on the slightest of pretexts. I can never believe, for example, that the handsome boys standing behind one of his Madonnas express anything more profound than the artist's pleasure in handsome boys.

The full acceptance of the nude only came with the growing demand for secular art designed for private enjoyment. The late Quattrocento saw an increased market for small-scale works—engravings, easel paintings and statuettes. It was in small bronzes, and not, as earlier

humanists had dreamed, in monumental stone, that the classical nude was fully assimilated into Renaissance art, its whole repertory of poses and gestures imitated and varied. The bronzes are very attractive; some take pleasure in the subtlety and grace of the human body, others display it in strenuous action, others again are piquantly erotic. But their small scale tends to mean that the impact of nudity is to some extent distanced. Exquisitely worked, playfully erudite, they are designed to flatter the taste of the wealthy connoisseur. They are playthings to be contemplated and handled by a man with an eye for art—and for a beautiful body. In the sixteenth century, for the first time since antiquity, the nude is treated purely as an aesthetic object, and is enjoyed and valued accordingly.

The nude is accepted partly because it is insulated in a world that increasingly asserts its own terms and values—the world of art. Toward the end of the fifteenth century, the nude often turns up in a natural setting, which paradoxically stresses its artificiality. In art and literature, pastoral becomes fashionable; as always, it is the creation of sophisticated town dwellers who enjoy playing with the idea, if not the reality, of the simple life. Aristocrats turn their country estates into places of rest and relaxation, decorating their luxurious holiday villas with paintings that sum up the pastoral ideal—idyllic landscapes where men throw off civilized restraints with their clothes, and live at ease among the trees and streams. The Christian Eden merges with the pagan Arcadia: pastoral conjures up a golden age of carefree happiness, a world where it is always summer, and men have nothing to do but make love and music.

Even Mantegna executed some of these idylls, after the erudite specifications of Isabella D'Este, though he was clearly working against his temperament and his own urban vision of antiquity. Perugino seems more at home in Arcadia; his painting of Apollo and Marsyas has a delicate and wistful grace denying the ugly outcome of the satyr's challenge to the god. His Apollo is smoothly radiant, but even the seated satyr has a gentle awkward charm. Perhaps the most beautiful of all these idylls is Signorelli's *School of Pan* destroyed during the Second World War. (The naked gods—the reclining boy, or the youth standing with his back to us—are far more sensuous and mysterious than the rather stiff, fully frontal nymph.) But the charm of the painting lies in its recognition that the idyll is fragile; that at a breath from the real world, the gods will vanish. Panofsky and

100

Saxl have described how the "classical past became a visionary harbor of refuge from every distress; a paradise lamented without having been possessed and longed for without being attainable, it promised an ideal fulfilment to all unappeased desires."[11] Even as early as 1500, when men were still in the first flush of excitement at recovering the past, there are hints that the dream is an impossible one. Signorelli's painting is at once fresh, and tinged with melancholy. Antiquity is a dream that can never fully be recreated, and this blissful pastoral world where men are innocently naked exists only in the imagination, in art.

NAKED AND NUDE

A naked man, realistically drawn, stands with arms and legs outstretched inside a square and a circle, the geometric symbols of perfection. Leonardo's stern athlete is only the best known of dozens: the figure, taken from the antique writer Vitruvius, was a favorite with Renaissance artists, and is a key to their often contradictory attitudes to the body, to their mix of pragmatic mathematics with mysticism, of scientific interest in anatomy with belief in the metaphysical significance of the proportions of the body.[12]

Vitruvian man was a symbol of the harmony between man and God, microcosm and macrocosm. In the ideal male body, the proportions of the whole universe are reflected; as Luca Pacioli explains it, "from the human body derive all measures and their denominations, and in it are to be found each and every ratio and proportion by which God reveals the innermost secrets of nature." That meant the male body. According to Cennino Cennini, women, like animals, have no proportions because they have no spiritual significance.[13] Empirical researchers like Alberti or Dürer or Leonardo certainly studied the female body; but the Vitruvian figure is always male.

But Leonardo's magnificent nude is something of a tour de force. Few artists manage to make the awkwardly shaped human body fit as well as he does. A foot may project from the magic circle, or the figure slumps, or its arms are extended to ape-like lengths to touch the square. In retrospect, Vitruvian man is not wholly convincing as an image of harmony. It hints, rather, at the difficulties artists experienced when they tried to turn flesh into formula, a recalcitrant naked reality into ideal nudity.

Art and science were inextricably mingled in the early Renaissance.

The detached and systematic study of the body dates back at least to the early fifteenth century. Writing in 1435 Alberti takes it for granted that even draped figures are based on preliminary study of the nude and perhaps of the skeleton as well. Working drawings show artists exploring pose and gesture, or experimenting with perspective, foreshortening and movement. The Pollaiuolo studio attracted students from all over Italy because of its work on the nude in action, and Antonio Pollaiuolo clearly derived both scientific and erotic pleasure from the accurate delineation of the muscles as they bunch and tense beneath the skin. Michelangelo's cartoon for the *Battle of Cascina*, little more than a catalogue of the poses possible to the male nude, was hailed as a great artistic advance and copied until it fell to bits.

The body is like an unknown territory, gradually mapped and measured. Alberti was one of the first to take compass and ruler to make a careful, pragmatic study of human proportions. He compared antique statues with living bodies, contrasted different human types and codified his findings into a guide for working artists. Leonardo and Dürer, both driven by a scientific curiosity that took them far beyond their needs as artists, elaborated and refined his researches. Dürer spent years trying to work out, as precisely as possible, a series of mathematical formulae that would express the changes that take place in the moving body, as well as the differences in the bodies of, say, a child and an old man.

One of Dürer's prints suggests some of the complex feelings that were sublimated in this long and scientific study of the body. It shows an artist working out the proportions of a naked reclining woman; the grid he has drawn up has materialized and serves as a grille, a barrier protecting the active analytic (male) intelligence from the relaxed and debilitating flesh. Dürer, like so many of his contemporaries, found it particularly hard to come to terms with the female body, even advising apprentices that they should avoid touching or seeing a woman naked, "for nothing weakens the understanding like impurity."[14] But he needed to keep the male nude as well at a certain distance, and his curiosity and scientific detachment express—are made possible by—his underlying hostility and fear. He neutralizes the body by reducing it to a numerical scheme, by dividing it into parts, by symbolically dismembering it.

There were others who went further and literally dismembered the body. Curious about its hidden workings, as well as its appearance,

artists turned to dissection. Because it is taken for granted now, it is easy to forget what a radical step this was. At the time, even doctors had little practical experience of dissection; contemporary engravings show anatomy classes where the professor reads from a book, while a sort of butcher's assistant wields the actual knife. Corpses were hard to come by and often had to be begged, bought or stolen, and handled in secrecy under the most unhygienic conditions.[15]

Renaissance pioneers were proud of their daring and new skills. Leonardo justifiably boasts of the number of bodies both male and female that he had dissected, "destroying all the various members and removing even the very smallest particles of the flesh which surrounded these veins, without causing any effusion of blood other than the imperceptible bleeding of the capillary veins." And he warns anyone doing the same that "you may perhaps be deterred by natural repugnance, or, if this does not restrain you, then perhaps by the fear of passing the night hours in the company of these corpses, quartered and flayed and horrible to behold."[16] According to the Wittkowers, sixteenth-century artists made it a point of professional honor to demonstrate their coolness in dissection; some cracked under the strain. Michelangelo discontinued the practice because it made him sick to his stomach, and a later painter, Cigoli, broke down completely, with loss of memory and epileptic fits. And Bartolommeo Torri must have been unbalanced, to put it mildly, when he was thrown out of his master's house because "he kept so many limbs and piles of corpses under his bed and all over his rooms that they poisoned the whole house."[17]

Even today, dissection can be a disturbing activity. It may release our archaic anxieties about death, or touch on our hidden springs of sadism. In general, understanding of the female body lagged behind the male, partly because woman was still regarded as secondary, a mere variation on man, but perhaps also because dissecting the female body is more likely to set off infantile fantasies of penetrating the mother's body and tearing open her womb. The knife may release our most frightening fantasies about the inside of our own bodies, our anxiety about the integrity of our bodies even after death. At the same time, dissection is only possible given a certain detachment from these fantasies; it depends on an ability to view the body simply as a collection of parts, to concentrate on problems of function, and to test traditional assumptions against the evidence of the eye and the knife.

103

Leonardo's extraordinary series of anatomical drawings—a scientific as well as an artistic achievement—spring from his ambivalent feelings toward the body. Icily detached from what attracts him most, Leonardo's curiosity itself becomes a passion, a compulsion. Some of his drawings—particularly ones of male legs and genitals—have a disconcerting, frozen sensuality. In the famous drawing of a couple copulating, the young man's profile and parts of his body have a fragile beauty, in contrast to the cross-section of their insides and sexual parts. It is as if Leonardo can only cope with the sexual act by treating it with clinical detachment; he deals with his mingled attraction and disgust by focusing, with cold x-ray vision, on a single part of the body. Though even his analytical detachment has its limits. According to R. H. Eissler, his drawings of the penis indicate that Leonardo may have simply accepted Galen's claim that it has two canals, one carrying the animal soul to the future embryo, the other for sperm and urine. He overcomes his castration fears enough to draw the penis cut across, but may not have been able to bring himself to the point of actually cutting one up.[18]

At some level, dissection is clearly a symbolic act of aggression for Leonardo. But the aggression is transformed, and the drawings are a tribute to the complex beauty of the body—though a curiously non-human beauty. Some of his studies of muscle and bone turn the body into a marvelous machine, a delicately balanced system of cords and pulleys. In other drawings, the body seems to blossom with an almost vegetable life. The elaborate tangle of veins and arteries is like a repellent but beautiful plant growing beneath the familiar skin.

Yet this scientific study is inseparable from an effort to define ideal beauty. Alberti, almost in the same breath, commends art as the imitation of nature, and warns that the ancient painter Demetrius "failed to gain the highest praise because he strove to make things similar to nature rather than lovely."[19] Beauty is not just a matter of individual taste; it is objective, and can be expressed mathematically. The Renaissance believed that the ancients must have possessed the canon or mathematical formula for ideal beauty; Dürer was inclined to suspect the Italians had the secret and were holding out on him. Later in his life, he was disturbed by doubts about his long chase after the ideal. He is often overwhelmed, he tells us, by the sheer variety of the physical world, which resists human attempts to observe and codify; and by man's subjectivity, the way painters tend to "paint figures

resembling themselves." Ideal beauty is not to be found in nature, yet its beauty surpasses all human creations. But Dürer never quite abandoned his original dream; for him, as for the early Renaissance generally, there seemed no impossible gap between an empirical study of nature, and the attempt to improve and idealize it.

For Dürer—like his contemporaries—analyzes in order to synthesize. He takes the body to bits, in the hope of putting it together again in a more perfect shape. He was familiar with the story of the ancient painter Zeuxis who, seeking a model for Helen, had to select from the five most beautiful girls he could find. But Dürer turns the act of selection into something aggressively physical. "If you desire to compose a fine figure, you must take the hand from one and the chest, arm, leg and foot from others."[20] As in his scientific studies, he rapes the individual, dismembers him; but the violence paradoxically hints at how desperately he dreams of wholeness. He reaches deep into his frustrations, into his anger at the body, so as to remake it, to restore something lost—an image of the body wholly satisfied and satisfying.

These unresolved paradoxes give Dürer's art its vitality. Brought up in a society traditionally more puritanical than Italy about the nude, he was inclined to equate the exposed body with humiliation, guilt and suffering. His most moving work springs from his fascination with the individual, the eccentric and the ugly, from his patient recording of the ravages of age and disease. At the same time, some of his nudes are more convincingly classic in their beauty than those produced by his Italian contemporaries. The two sides of his work—of his personality, of his times—are summed up in two studies, a naked self-portrait and a nude Apollo.

In the self-portrait, Dürer confronts, with great courage, all his fears about the flesh. The torso is blocked in in a way that reminds us Dürer had studied the antique, but it is lined and stooped, and looks tired. And Dürer focuses on two things which the classic nude always minimizes—the face and the genitals. Apollo's penis is so tiny and pretty as to be invisible; the god is clearly impervious to sex, as he is to the passing of time. But in the self-portrait, the genitals are drawn with painstaking accuracy; hard and knotted, all the troubling and rebellious life of the body seems concentrated there. Dürer breaks one of the deepest of all taboos: he brings his scientific curiosity to bear even on his own sex; and his uneasiness before his own double, that beautiful dying body, only sharpens his perceptions.

The Apollo, based on Italian drawings of the newly recovered Belvedere statue, may hold less appeal to modern tastes. The idealizing has clearly been achieved with a certain effort; as we can see if we compare an earlier, almost embarrassingly fleshy, and not very classical version of the same figure. (And the beauty here does not extend to the unfinished torso of the woman, probably Diana. She is just a heavy, rather unattractive back, as she cowers away like an animal from the god's bright clarity. She serves as a reminder of all the dislike of the body Dürer has had to suppress to create the Apollo.) The god is refined, graceful, and clearly articulated, though there is a hint of instability in his stance, as if he were faintly surprised at being brought out into the light again after so many centuries. The sunburst in his hand sheds a romantic aura on his body; he is like a messenger from a lost world glimpsed fleetingly in the dark. But he is not an academic figure; he springs from as deep a level of the mind as the self-portrait, and in a sense complements it. Apollo represents the artist's effort to repair the ravages of anxiety and sexual guilt, to resurrect everything that has been lost in living.

The Renaissance vision of the body re-formed and idealized is always shadowed by an equally powerful counter-vision, of man as a poor forked animal doomed to die. Donatello celebrates the perfect beauty of the young David—and carves as well as the old man Jeremiah, worn out by the burden of prophecy. Leonardo can paint the androgynous charm of the young St. John—and the emaciated and penitent Jerome, beating his breast in the desert. The later Renaissance developed a "classical" formula that enabled the artist to bypass or to short-circuit his taboos about the body. There are hints of it even in Raphael who sometimes plumps for an easy idealizing, ignoring individual complexity and drawing on a ready-made repertory of poses and expressions.

The ambivalence that makes the earlier Renaissance nude so moving is summed up in a story that Vasari tells about Signorelli. When his dearly loved son was killed, he

> caused the boy to be stripped naked and with extraordinary consistency of soul, uttering no complaint and shedding no tears . . . painted the portrait of his dead son, to the end that he might still be able, through the work of his own hand, to contemplate that which nature had given him but which an adverse fortune had taken away.[21]

106

The painter denies neither the depth of his own grief nor the finality of death. Accepting them, he is able to paint a naked *memento mori* that is also a nude memorial to living beauty.

MASCULINE–FEMININE

Renaissance men and women seem to live increasingly in different worlds. The cultural ideal of the saint, the ascetic whose gender is finally irrelevant, gives way to the hero. The man of action is the favored type, forging his way in the world, rewarded by worldly success, the praise and envy of competitors—and by the wife who takes care of things at home or the mistress who represents the pleasures of the flesh. Among the prosperous urban classes whose money derived from banking or trade, women were increasingly confined to private life. In Alberti's treatise on family life—a close adaptation of Xenophon's piece on the fourth-century Greek family— an older husband advises a much younger wife on her domestic duties. Marriage is a business partnership, a way of making economic and political alliances with other families. But where the husband goes out into the world to accumulate wealth, the wife is a kind of sleeping partner who takes care of the family property. Women at the princely courts were expected to take a more equal role in conversation and intellectual life, and had opportunities denied to most women. But where the male courtier had, in theory at least, an active part to play advising the prince and even fighting, the lady was simply expected to be accomplished and decorative, and to add to the graces of life. It is significant that the word *cortigiane* is used both for an aristocratic woman at court, and for a courtesan.[22]

We occasionally get glimpses of an almost Victorian double standard. In 1444, St. Bernardino of Siena poured scorn on the husband who expects his wife to be honest, temperate and obedient, while he cheats his way through life, spending his time in taverns and storming at straws.[23] According to Ruth Kelso, the Renaissance gentleman lives out a pagan ideal, of self-expansion, self-realization and self-assertion, while the lady is expected to conform to older, Christian values like patience, modesty and chastity.[24] Renaissance misogyny is often very complicated. If it is in part simply the familiar puritan distrust of the sexual charm of women, at other times men seem to be berating women because they fear the "feminine" or passive element in themselves. This often goes with bitter attacks on

women who are shrewish, or dominating, or unfaithful—that is, women who take advantage of the new individualistic climate and behave like men.

The familiar story of Adam and Eve reveals man's fears and fantasies about contemporary relations between the sexes. Many artists set out to contrast the male and female body in their ideal and unfallen state. But though Adam easily takes on the shape of a classical nude, Eve often looks like a real woman who has just removed her clothes. Thus the Venetian sculptor Antonio Rizzo sees Adam as a rather conventionally noble antique god, while Eve, with her slightly ungainly pose, seems acutely conscious that people are looking at her. Dürer's 1504 engraving is comparable. As he often does, he idealizes the male nude by projecting his doubts about the flesh on to the woman. His Adam is as refined and romantic as an Apollo, while Eve looks like an ordinary hausfrau, with narrow sloping shoulders, flabby hips and the hint of a double chin. Her confident fleshiness is irritating, and provokingly erotic. Kenneth Clark has argued rightly that "the very degradation the body has suffered as a result of Christian morality served to sharpen its erotic content" in the Renaissance. But that applies only to the woman, whose pathetic exposure easily becomes arousing. Adam's nakedness, on the other hand, is sometimes heroic and always tragic.[25]

His helplessness in the face of a disaster he sees only too clearly is often contrasted with Eve's complacency. The man who deals heroically with the rest of the world is vulnerable to the woman, to her very passivity. Dürer puts a big fat cat at Eve's feet, ready to pounce on Adam's tiny mouse. In Hugo van der Goes's painting, Adam makes an impotent gesture of protest, while Cranach's boyishly baffled husband scratches his curly head as his wife—a pert little piece— hands him the forbidden fruit with total assurance. The joke is occasionally turned against the man—Della Quercia's Adam slips one hand uneasily down to his penis while Eve chats up the serpent.

Artists try to work out characteristic poses for the naked bodies that will express their sense of the moral and intellectual difference between man and woman. Raphael's Eve leans casually against the tree, one hip curving out sexily as she extends the apple to her tentative stooping partner, and Tintoretto later paints a seductively golden woman who leans forward while Adam, in nervous retreat, almost falls backward out of the picture frame.

The division between the sexes is most subtly expressed by two of the most beautiful of all Quattrocento nudes, the *Adam and Eve* painted for the Ghent altarpiece by van Eyck. In this case, it is Adam who is more freshly seen than Eve. He has obviously been painted from the life, and his neck and hands are sunburnt against the paler torso, and fine, dark hairs are visible on his belly. He stands uncertainly, one hand covering his genitals, the other curved protectively round his body. The bearded, lined face is as individualized as the body, and expresses a thoughtful regret for all he has lost. Eve too is faintly melancholy, but her beauty is unmarked by thought or by the consciousness of sin that makes Adam tragic. Her full belly suggests she is pregnant, but that only enhances her sensual beauty. She is at home in her flesh, at one with the processes of nature as Adam can never be. She is disliked, envied, and endlessly desired.

The antithesis between the male and female nude is even sharper in the later Renaissance. As Michelangelo takes the male nude to its furthest limits as a symbol of spiritual and cultural aspiration, Titian celebrates the female nude as the flesh, the natural world. Celestial Venus may drift, a bodiless abstraction, through the labyrinthine speculations of neo-platonic philosophy, but she rarely finds convincing visual form. Botticelli's exquisite Venus is the obvious exception, but her spirituality depends on the fact that Botticelli has not seen her body very clearly—he paints her right breast and shoulder with an inaccuracy that never mars his naked youths—and on the fact that she is so slender and transparent as to be hardly in the body at all. When Titian contrasts a clothed woman with a beautiful nude, it is the latter who represents sacred and not profane love. But the emotional and sensual impact of the painting is surely at odds with the iconography. Nude personifications of wisdom or truth are rarely completely convincing; the identical woman with different props—a mirror or perhaps a skull—can as easily represent vanity, and allegory is often no more than the thinnest of disguises for eroticism.

The female nude inhabits a purely physical world. Sometimes she is simply a courtesan—the wealthy Renaissance collector often wanted an image of his mistress in the guise of Venus or Diana—and sometimes she is the symbol of nature. The male nude is of course part of nature, but a harmonious and hierarchical nature that can be analyzed mathematically. The female nude is often associated with another vision of nature, one that the Renaissance found fascinating and

terrifying. She is mysterious, alien to man, at once beautiful and threatening in her anarchic energy and rich, wasteful fertility. Leonardo—with his coldly detached attitude to woman—was one of the first to crystallize out these associations. As Clark points out, his *Leda* was intended as an "allegory of generation,"[26] and early sketches of the nude show her body surrounded by leaves and grass, lush vegetation that twists and twines together with a frightening energy. (She is sister, surely, to that enigmatic Madonna seated in a rocky landscape in front of a sinister, gaping cavern.) There is perhaps a similar feeling, expressed with far more direct sensuality, in Giorgione's *Tempest*, where a clothed man stands watching, at a distance, a naked woman suckling her child. She is at home, as he is not, in the rich stormy landscape. It was certainly Giorgione who first gave expression to the most distinctive of all the Renaissance's female nudes—the Venus reclining naked in a landscape. As Panofsky has pointed out, Florentine taste ran to the beauty of an erect David, while Venetians preferred a recumbent Venus, at once receptive and elusive. A full understanding of the difference would probably involve considering the growing Venetian love of landscape for its own sake, and not just as background, as well as the greater importance of courtesans in the social and economic life of Venice.[27] Woman in a landscape, woman *as* a landscape—the theme, so popular even today, first emerges around 1500. Renaissance painters still show both sexes naked in Arcadia, and a few couple a naked man with a clothed woman. (Botticelli's *Mars and Venus* and Titian's *Three Ages of Man* are two of the most beautiful.) But Giorgione and Titian in their *Concert Champêtre* set the pattern for the future. Two men, elaborately dressed, are accompanied by two beautiful and graceful nudes. Edgar Wind has argued that their nudity means that the girls are spiritual presences, muses inspiring the male musicians.[28] Rather, the men need the women to get back in touch with the senses, with nature itself. Woman offers rest, a release from the strains of everyday life; she is the flesh, and everything that man is expected to deny and repress in himself. In the division, man, as well as woman, loses something.

Masculinity, as we define it, dates from the Renaissance. (Patriarchy may be constant throughout history; masculinity is no more a God-given constant than femininity, and changes as it changes.) In the course of the fourteenth and fifteenth century, the masculine is

reasserted as the norm, the absolute human type. The word *homo*—a human being—is often replaced by *vir*—a male. *Virtu*, which sums up so much Renaissance striving, means what is proper to a man. The adjective *virile*, a common term of praise in art as in life, means masculine, and a *virago* was an exceptional woman who by some accident of birth or talent transcends the limits of her sex and becomes manlike.

Art itself becomes an explicitly masculine activity. Michelangelo sees sculpture as work fit for heroes, while Cellini presents his whole career as a triumph of assertive confidence—a series of macho coups, social, sexual and artistic. He is an individualist unhampered by convention or morality, and not at all worried by modesty. Biographies of artists often present them as self-taught, driven by the demands of their individual genius, and by their competitive drives. Free from the guilds that both hampered and protected them, artists negotiate their own contracts, and many become freelances, moving from city to city and sometimes country to country, for the highest bidder. The rewards were enormous, and so were the possibilities of failure.

These qualities are hardly new. But a city like Florence, with its long-established trading and financial empire, its cycles of boom and bust, its constant struggles to survive against other city states, put a new premium on aggressive individualism, mobility and competitiveness. The classics are invoked to validate the qualities needed for success in early mercantile capitalism; those qualities are seen as defining a man, as being equivalent to masculinity, even to humanity.

But the new man is out there on his own. And though woman in her otherness may reflect a flattering image of his strength, he may also find it hard, as it were, to keep it up. One interesting phenomenon was the cult—in life as in literature—of male friendship. The historian Gene Brucker has commented on the surviving letters exchanged by Florentines giving advice, expressing affection and asking for help.[29] They suggest that the bonds of friendship were taken very seriously indeed, as a lifelong obligation and source of support. In the vicious rat race of the all-male world of business and politics, these friendships must have been an important lifeline. And so perhaps was more explicit homosexual feeling.

The Renaissance was also a renaissance of homosexuality. Centuries of Christian disapproval and the cruel legal penalties still on the

books ensured that it stayed more or less underground, and historians since have joined the conspiracy of silence. In the absence of a thorough study, it is only possible to speculate about its incidence and importance. But even a casual reading in the period suggests that it was, not necessarily more common than before, but certainly more visible, more widely discussed and more significant culturally and psychologically.

References, obviously varying widely in their reliability, range from jokes to gossips to sermons to philosophical discussions of Plato on the love of boys.[30] Florence especially was the target of endless jokes about the modern Sodom. When Savonarola died, after thundering from the pulpit against that unspeakable and abominable vice, the love of "beardless boys," a member of the governing body of the city is said to have announced with sardonic satisfaction to his colleagues, "and now we can practice sodomy again."[31]

A surprising number of artists were rumored to be homosexual; they included not just Michelangelo and Leonardo, but Donatello, Verrocchio, Della Quercia and of course the notorious Giovanni Antonio Bazzi, nicknamed Il Sodoma. A few actually suffered the humiliation of being charged and imprisoned; theoretically, sodomy was still punishable by death and undoubtedly shocked the more conservative. Many denied or disguised their homosexuality, or determinedly sublimated it, but there were others who openly flaunted their preferences. In the 1490s, Florentine neo-platonists seized eagerly on Plato's praise of homosexual love and celebrated it— in rather abstruse forms—in their lives and writings. Ficino dedicated his commentary on Plato's *Symposium* to his beautiful friend Giovanni Cavalcanti, and the tombstone to Pico della Mirandola and his friend Benevieni proclaimed that "the bones of those whose souls love joined in life, are not separated after death." Pico, discussing two poems about love, explains that earthly love is designated by a lady, while celestial love is rightly labeled *amore*, which is a masculine noun. As earthly is inferior to heavenly love, so the female is secondary to the male.[32]

So homosexuality is, in part, a reflection of the belief that the male is all-important, the female hardly worth loving. It may also enable the man to admit his own gentleness, his passivity, all those qualities that are increasingly defined as "feminine" and therefore unworthy of a man. Renaissance literary texts, endlessly debating the nature of

112

beauty, attribute it exclusively to women; the male is defined by function and activity. The humanist Lorenzo Valla argues that the power of Hercules is preferable to the self-absorbed grace of Narcissus, and Castiglione insists that the courtier's bearing and appearance, however graceful, should reflect his athletic and military prowess. But—particularly in Quattrocento Florence—art tells a very different story. The adolescent youth is the most highly favored type, and women tend to be slender, virginally undeveloped and boyish.

Thus Ghiberti carves a smooth and supple Isaac, kneeling naked as he submits to his father's knife. (The panel won Ghiberti the commission of the Baptistery doors; the subtle grace of his nude was obviously more to Florentine taste than the scrawny rebellious boy carved by Brunelleschi.) The same graceful adolescent often turns up as the young St. John, painted in the days before he took up his prophetic mission and long before his death at the instigation of Salome. Veneziano paints him as sadly undressing in the desert, the surreal mountains reflecting golden light on the body so soon to be covered by the hair shirt. Part of his appeal—the appeal of all these adolescents—is the transience of his charm; it offers a man an image of his own youth, before he was forced to grow up into assertive masculinity.

Again and again, feminine grace is created in the male body, femininity given male shape. Botticelli's reclining Mars is a good example. The god of war sleeps langorously as baby satyrs playfully remove his armor. He is sensuously relaxed, far more erotic than the goddess of love, the clothed Venus who eyes him with a faintly baleful expression. The painting may have been commissioned to commemorate a Medici wedding; and it is often interpreted as a joking comment on the future dominance of the bride. But perhaps she is simply irritated at the way the man has appropriated her femininity.

One reaction to the sharper division between the sexes is a dream of bisexuality—a single personality, a single body that combines both elements. There is some interest in the *virago*, the woman who aspires to masculine strength; but the more popular fantasy is the male who combines and reconciles masculine with feminine, active with passive. An actual physical hermaphroditism repels the Renaissance, but men act out both sides of the sexual dualism and play both male and female roles. A gracefully effeminate boy is contrasted with a man who is actively, even brutally, virile. *The Martyrdom of St. Sebastian* by the

113

Pollaiuolo brothers is a good example. The youthful saint is bound to the high stake, and submits dreamily to the gaze of the spectators, and to the arrows. The tough athletic archers are absorbed in activity, some bending to stretch their bows, others poised to take aim. The saint plays the submissive, Christian and feminine role as against the archers' aggressive maleness; the confrontation will be pleasurable, and violent.

The effect is paradoxical. The dream of escaping the harsh and exclusive dichotomy between the sexes ends up foundering in even harsher distinctions between man and man; the effort to repress or transform the power struggle between men breaks down in more intense violence. None of those gentle, androgynous youths—Isaac or David, Sebastian or St. John—is free from the shadow of violence, and that is part of their appeal. And one subject—rare in antiquity but very popular in the late Quattrocento—openly admits the sexual excitement that cannot be disentangled from brutal struggle. Hercules and Antaeus turn up again and again, in engravings, drawings bronzes and easel paintings. Antaeus could never be defeated as long as he stayed in touch with his mother Earth, the source of his strength; Hercules defeats him by lifting him off the ground and crushing him to death against his own chest. Later Renaissance artists use it simply as an excuse for exhibiting two nudes in a tricky pose. A bronze in the Wallace Collection looks like a couple of ballet dancers who have mistimed a leap, and there is a fountain in Italy where the water comes out of Antaeus's mouth as Hercules squeezes. But the late Quattrocento versions by Pollaiuolo or Mantegna have a genuine and equivocal power. The two men are locked in an embrace that is a deadly parody of love, a brutally sexual struggle to the death. They say something about the terrifying intimacy that grows up between enemies, and something as well about the love between men that can so rarely be expressed except through struggle.

THREE AGES OF MAN

Throughout the Quattrocento, three male nudes recur, figures which seem to express some of the century's deepest preoccupations. They could be labeled as Cupid, Narcissus and Hercules, though they perform all kinds of secular and sacred roles. Celebrating man at different stages of his life—in childhood, adolescence and maturity— all three are dream images of a perfection unattainable except in art.

114

Most appealing of all are the *putti*, the naked boy babies who swarm everywhere, in churches and palaces, on tombstones and fountains. No adult nude ever moves with anything like their pure physical joy and untrammeled freedom. They are wild, impertinent and amoral. Cheerfully phallic, they kick and twist, play musical instruments or wrestle with dolphins or geese. Some dance on tiptoe as if they might fly at any moment; others have erections, or are caught urinating, even in church. The greatest of all is Donatello's bronze *Attis-Amor*. He stands with uplifted arms, his breeches cut to reveal his genitals. The fleshy body is almost buoyant, and his face and stance suggest wild excitement. The figure almost certainly had some esoteric classical significance now lost to us; but he is also a real child and sharply observed. Donatello has caught something else about childhood—its anarchic energy, so attractive and disturbing to adults, its uninhibited vitality and polymorphous sexuality. Looking at Donatello's boy, we begin to understand why Eros, the god of love, and sometimes of death as well, came to be represented as a small child.

At the same time, Renaissance artists enjoy the comic charm of the *putto*. The baby Cupid may be dangerous but he is also a little prankster, comic and cunning, whose mischief sometimes rebounds on him. He peers slyly, and knowingly, at the spectator beneath his blindfold—but then has to run to his mother Venus when he is stung by bees. Sometimes the Christ child takes on Cupid's sensual energy. (Sixteenth-century Catholic reformers who objected to the baby Christ going naked did have a point.)

Artists clearly had fun with *putti* and used them to play tricks on the spectator. In a *trompe l'oeil* ceiling in Mantua, Mantegna paints them clinging to a balustrade, their roly-poly bottoms and thighs apparently just over our heads. Yet, in a tradition going back to late antiquity, *putti* are often found on gravestones. They play even in the presence of death, asserting through their undiminished vitality the possibility of life renewing itself even in the grave.[33]

The *putto* easily loses his peculiar fascination. Some of Donatello's dancing angels, for example, are disturbing because of their too-explicit sexuality. They have the rounded chubbiness of small children, but their size, their proportions, their knowing faces and exhibitionist poses suggest a much older and consciously provocative sexuality. There are hints of what was to become so common in the eighteenth century: children become the playthings of adults, who

115

take a perverse pleasure in watching them act out adult sex fantasies. On the other hand, sculptors like Desiderio or Verrocchio sometimes come close to being simply cute. As Michael Levey says, their children are playful and innocent, "as adults like to think of children."[34]

Both self-conscious sexiness and pretty sentiment disguise the profound attraction of the *putto*. He incarnates a dream which is not quite a memory: of a time when the body knew neither guilt nor embarrassment. He embodies the uninhibited playful energy that we lose when we become sexually conscious. *Putti* are almost always male. (Indeed, the word comes from the Latin, meaning boy.) They are visual confirmation of Freud's claim that we all go through a phallic phase, that the pre-Oedipal girl is also a "little man." Our culture can only imagine that primal pre-moral energy as phallic, though it predates consciousness of gender. But the *putti* are exhilarating because they embody a potency we feel we must know, but can never quite recall: a freedom that we always dream of recovering, but can never, in our adult bodies, experience fully.

Like the *putto*, the Narcissus, the effeminate adolescent, can easily become sentimental, or merely fashionable. He was intellectualized by the neo-platonists into a symbol of reconciliation; his fragile youth holds together flesh and spirit, masculinity and femininity. The type gave rise to the two most remarkable of all early Renaissance nudes.

Donatello's bronze *David* is perhaps the first free-standing life-size nude since antiquity. Nothing prepares for it, nothing follows it; though the type is fashionable, there is nothing else quite like it. Unfortunately, we know nothing about how it was commissioned, and little about its inconographical meanings. In 1469, it stood in a courtyard in the Medici palace, though it was probably made in the 1430s. It has little in common with Donatello's earlier draped *David*, that stern and thoughtful savior of his people; and Verrochio's *David*, perhaps made in imitation and criticism of Donatello, is far more coolly restrained—and is anyway more or less clothed.

Donatello's nude seems to be a deeply personal work, expressing all the artist's ambivalent feelings toward beautiful adolescence. David almost willfully eludes all efforts to allegorize and moralize; he is totally unconvincing as a type of virtue. His high boots, the fancy hat shadowing his sensual face, the sword almost too big for him to lift, only emphasize his provocative nakedness. His body is very individual. He is barely adolescent, and the light playing on the

116

bronze focuses our attention on odd details—the swaying stance, the droopy buttocks and the soft stomach muscles. The boy's toes are tangled in the beard of the great severed head at his feet and its helmet plume trails up the inside of his leg to tickle his thigh suggestively.

Donatello celebrates the boy's beauty, and at the same time recognizes its disturbing power. Lost in some private dream, David is unmoved, cold, perhaps incapable of passion. He is detached from the brutal murder he has just committed, and impervious to the sexual fantasies artist and spectator may weave around his body. Donatello catches that elusive self-absorbed grace in the polished perfect bronze, but it is David who finally catches the artist, like Goliath, in his strong toils. The statue sticks in the memory with obsessive clarity, the product of a vision as dark as the one that gave rise to Donatello's supposedly more typical works, the tragic old witch of a Magdalen or the grim and emaciated doomster Jeremiah.

The narcissistic boy reaches some kind of extreme in another deeply personal and baffling figure, Leonardo's *St. John*. He is older than David, but more completely an androgyne. Freud commented on John and a similar Bacchus that they are:

beautiful youths of feminine delicacy and with effeminate form; they do not cast down their eyes but gaze in mysterious triumph, as if they knew of a great achievement of happiness about which silence must be kept. . . . It is possible that in these figures Leonardo has denied the unhappiness of his erotic life and has triumphed over it in his art, by representing the wishes of the boy infatuated with his mother, as fulfilled in this blissful union of the male and female natures.[35]

But the point is that it is a *dream* fulfillment, and the whole painting—the boy's sinister smile, the full fleshy arm and shoulder curving out of the dark—has the unreality of a dream. Leonardo rarely painted the male nude, though he sometimes drew and often dissected it: it is as if he hardly trusted himself with it. This painting implies rather than reveals the young saint's body. The "blissful union" has been displaced upward into the face. The painting is about the retreat from biology into fantasy.

Like other figures of this type, *St. John* combines the characteristics of both sexes; he is both masculine and feminine—and so is neither. The androgyne is equivocal, uncommitted—and that is where its appeal lies. It is a retreat from the threatening aspects of mature

117

sexuality. A transient adolescent beauty is used, paradoxically, to deny time; it allows us to equivocate endlessly about gender, to remain in a timeless world in which everything is still possible.

I can never lose a faint suspicion that Leonardo may be playing some kind of joke on the spectator. That finger pointing upward comes perilously close, combined with the insinuating smile and the general suggesting of corruption, to obscenity. *St. John* may be pointing the way to God — or giving us the finger. It is worth recalling a sardonic comment Leonardo once made about an unspecified painting:

> It happened to me that I made a religious painting which was bought by one who so loved it that he wanted to remove the sacred representation so as to be able to kiss it without suspicion. Finally his conscience prevailed over his sighs and lust, but he had to remove the picture from his house.[36]

The third figure, Hercules, is masculinity incarnate. He is the archetypal hero, who ventures out alone to do battle with his enemies. In the most literal sense of the word, he is the type of *virtu*, embodying the courage proper to a man; and like so many proper men, he was finally done for by the gullibility and jealousy of his wife.

He was one of the earliest of the classical nudes to be adapted to Christian art, and he stands in for Samson, or personifies Fortune, or even foreshadows Christ himself. At the beginning of the fifteenth century, the Florentine chancellor Salutati wrote a treatise on his ethical and political significance; he was to be exploited for centuries as a symbol of courage by republican, monarch and emperor. The Renaissance admired, above all, his sheer physical strength. Earlier versions usually show him at rest, his nude body a type of patient resistance and endurance; but in the course of the fifteenth century, he moves into vigorous action, and is celebrated as a conqueror.

Antonio Pollaiuolo, who takes him as a constant theme, is fascinated by his sheer virility rather than by any allegorical significance. He treats Hercules romantically; he would like to believe in his own myth of the individual hero, his dream that the strong man takes all. But doubts creep into his work. In one small panel, probably painted for a Medici Villa, Hercules strides out against the hydra, his animal ferocity stressed by the lion's jaw on his head. His angular body is dramatically outlined against a low, bare plain with a river winding toward the horizon. Hercules dominates it, and is at the same time oddly diminished by its featureless distance. And as Frederick Hartt

remarks,[37] his dark adversary, its tentacles echoing the black lines of the river, seems too evasively formless, too feminine perhaps, to be defeated by that desperate concentration. And the battle with Antaeus shows Hercules pushed beyond his limits. In killing his enemy, his brother, he seems to destroy himself as well.

If Pollaiuolo is fascinated by physical power, he is haunted by images of impotence. The famous engraving of *Ten Fighting Nudes* is a good example. The combatants are posed like dancers against a decorative background; but at second glance, it is the pointlessness of the brutality that strikes us. Each man defeats his opponent, but someone is ready to hack him down in his turn. The nudes are locked in a closed circle of destruction, a dance of death that may well leave no survivors. (And when Pollaiuolo paints dancers, they seem as somber and strained as his warriors. His fresco of nude dancers for one of the Medici villas is badly damaged now—it was whitewashed in some surge of puritan hostility to the nude. But the figures move as jerkily, with as much effort, as if they were fighting; there is no easy or ecstatic flow of energy, but a painful willing of the body to life.)

As Kenneth Clark points out,[38] a nude battle became an almost obsessive subject in Florence toward the end of the century. Clark argues that the theme has no iconographic or social significance. It was often, certainly, an excuse for the artist to demonstrate his virtuosity. But fashions usually have some meaning, and these battle scenes surely express, at the least, a preoccupation with masculinity, a desire to exalt pure physical strength, as well as doubt about its contemporary relevance. With the increased use of artillery and mercenaries, the old dream of hand-to-hand combat must have seemed attractive, but increasingly anachronistic; the classical hero doing battle, nude, with all the world must be taken metaphorically or he is absurd. ("Think you there was, or might be such a man / As this I dreamed of?" The answer, of course is No—except in imagination.)[39] Some nude battles are simply conscious pieces of nostalgic artifice; others are interesting because they make no distinction between winners or losers. Each man seems to be fighting for himself, for his own identity. What the battles suggest is the continuing importance of the notion of combat to the masculine personality, the man's sense—at once exciting and tragic—that he can assert his individuality *only* in conflict, that it is only through aggression and destruction that male creative power can be released.

119

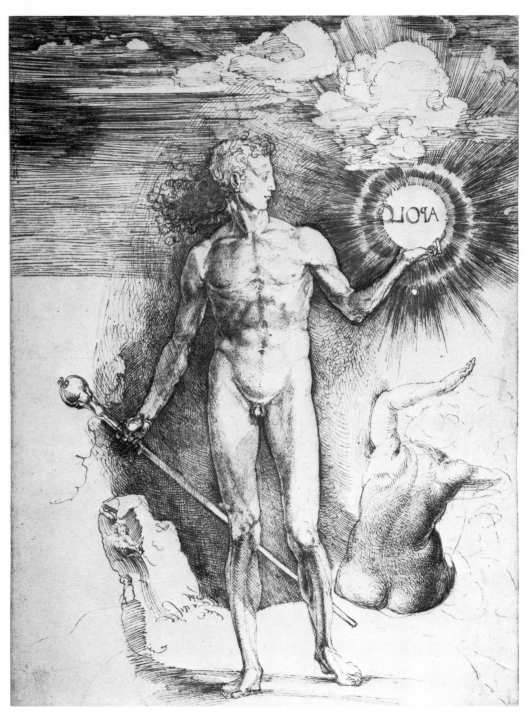

Apollo and Diana, c. 1501–3, Dürer

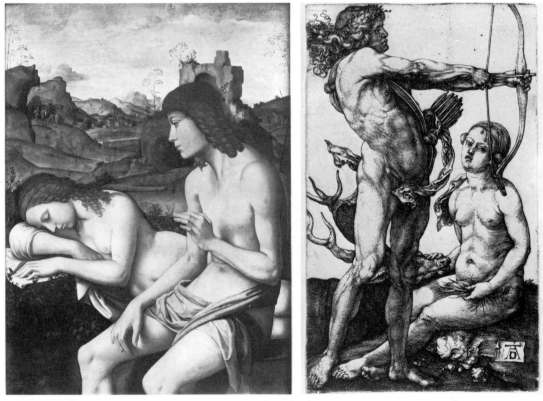

LEFT: *Daphnis and Chloë*, late fifteenth century, Bianchi dei Ferrari
RIGHT: *Apollo and Diana, c.* 1505, Dürer

THIS PAGE, TOP: *Boy with Bagpipes,*
late fifteenth century, Andrea della Robbia
RIGHT: *Attis-Amor, c.* 1440, Donatello

OPPOSITE: *David, c.* 1440, Donatello

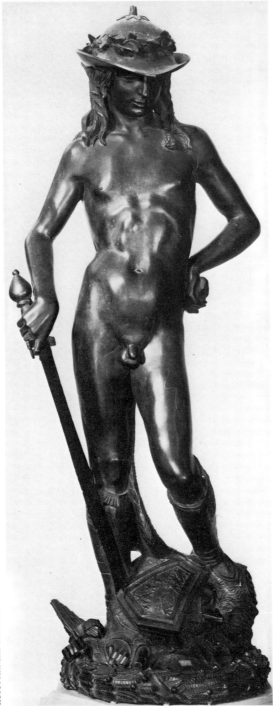

124

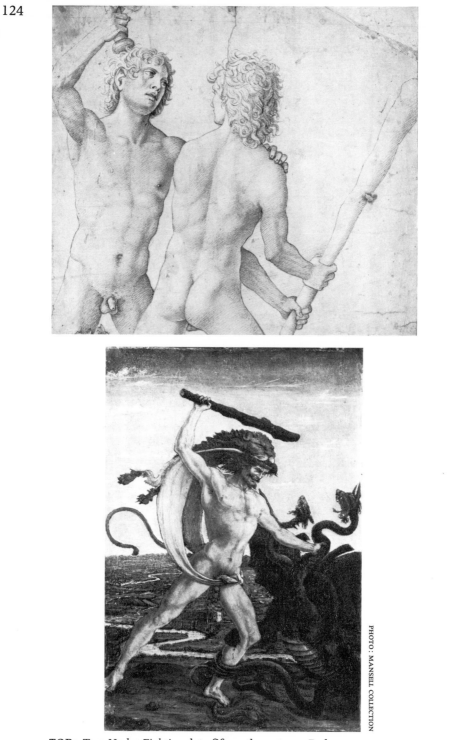

TOP: *Two Nudes Fighting*, late fifteenth century, Paduan
BOTTOM: *Hercules and the Hydra*, c. 1460, Pollaiuolo

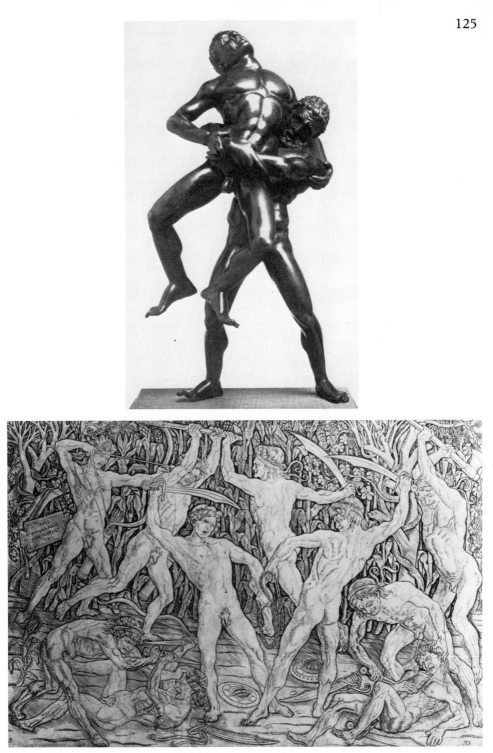

TOP: *Hercules and Antaeus*, late fifteenth century, Florentine
BOTTOM: *Ten Fighting Nudes*, 1460–80, Pollaiuolo

Anatomical Study, *c.* 1492–4, Leonardo da Vinci

TOP: *Apollo and Marsyas*, c. 1495, Perugino
BOTTOM: *Three Ages of Man*, c. 1515, Titian

Michelangelo

MICHELANGELO'S ADAM LIES on the Sistine ceiling like a beautiful Greek god. His muscles are still relaxed and his penis falls limp on his thigh. Propped on one elbow, he gazes dreamily at his great father, one arm lifting toward him almost of its own accord. The divine energy flowing through God's massive outstretched arm fills and impregnates him, and will bring him erect. But the spirit that awakens man to consciousness of himself and his God will also disturb his classic serenity. There are hints already of future pain. Adam is brother to those other nudes on the Sistine ceiling who strain desperately, and can find no continuing satisfaction in their bodies.

All through his long working life (he died in 1564 aged eighty-nine) Michelangelo was exclusively, almost obsessively, interested in the male nude. He neither liked nor understood the female body, which seemed inferior and a little frightening. (Many contemporary artists used male models for women, but the presence of the male within and behind the female is unusually conspicuous in Michelangelo.) The world he conjured up is populated, overwhelmingly, by males. The male nude expresses almost everything he has to say and becomes a world in itself.

In his celebration of the male nude, as in so much else, Michelangelo sums up the ideas and ideals of two generations before him. His impact on his fellow artists derived not just from his stunning technical skill, but from the consistency with which he developed and fulfilled Quattrocento aspirations. His was indeed a godlike art that rivaled the antique, rivaled nature itself.

Michelangelo always works with traditional themes, but gives them

profoundly, often disturbingly subjective meanings. What is often described as his "grand universality" springs directly from his inner dramas. His personal preoccupation with masculinity makes explicit the masculine bias of both classical and Christian culture. The commonplaces of Christian myth are taken with absolute, intense literalness. God creates man in his own image, is incarnated in the male body and takes on masculine flesh again when he comes to judge the world. Divine power—passing from God to Adam and reflected in the artist's own genius—is paternal, is phallic. All Michelangelo's work is a celebration of that masculine creating power—and an exploration, in the end, of its limits.

FATHER AND SON

Because Michelangelo's art is so personal, it is worth digressing to say something about his life.[1] He was born in 1475, in the tiny mountain village of Caprese, where for a short time his father was *podesta* or governor. The family had once been well-to-do, but their fortunes had declined and they were all acutely aware of it. The family moved almost at once back to Florence, where Michelangelo, a second son, was put out to nurse with the wife of a local stonecutter. He may have stayed with this laboring family for some time; to the end of his life, he would refer to his mountain origins, and say, half-jokingly, that he had sucked in the love of the stonecutter's tools with his nurse's milk. He never lost the habit of spending a lot of time actually in stone quarries, with laborers and apprentices.

Michelangelo was only six when his mother died, after giving birth to three more sons. (Her absence is centrally important in his life and his art; if at the conscious level Michelangelo is always concerned with the male, unconsciously he is always seeking the mother.) His father, Ludovico, was a difficult man, weak and bullying; he boasted that he had never worked but always lived off a small inheritance. When Michelangelo showed a precocious talent for art, his father and uncle tried to beat the notion out of him. An artist, a mere artisan, would compromise family dignity. But Michelangelo's untutored skill, he later told Condivi, not only aroused envy in his master Ghirlandaio; it attracted the attention of the great Lorenzo de Medici who took the boy into his own household. After which his father, "seeing him always in the company of great men, gave him more and better garments."[2] In fact, Michelangelo's art was to support not just his

father but his brothers as well, all through their lives, and he never stopped telling them so. But the myth of the family's former nobility was almost as persistent as his pride in his own art. "I was never a painter or sculptor like those who kept shops," he wrote in 1548, "I always kept the honor of my father and brothers, and although I have served three Popes, it was through force."[3]

Michelangelo's letters show how inextricably enmeshed he was in this all-male family. Ludovico remarried, but Michelangelo rarely refers to his stepmother. Very early on, he assumed responsibility for the family, and never stopped insisting that all his labors were for them, all his reward to keep them alive and restore them to their former fortunes. (In the lunettes of the Sistine Chapel Michelangelo painted a series of family groups representing the ancestors of Christ. They are nomads, exhausted and depressed by their meaningless travels; isolated from each other and foreseeing no hope of salvation, they seem to hint at the nightmares underlying Michelangelo's life-long struggle to save and "resuscitate" his own family.) As early as 1497, we find him writing to his father, "What you ask of me I'll send you, even if I should have to sell myself as a slave."[4] In a sense, he remained enslaved to the family all his life, never breaking free of the tight circle in which he plays resentful child and mother and father all at once.

Worrying like a mother about their health, he nags at his brothers to work harder and to show proper respect for their father; he sends them money, buys property for them, accuses them of exploiting him. He lives, he says, only to please and help them, and they are always letting him down: "I have given my life for you, and gain only punishment." Letter after letter insists on his own fatigues and frustrations. "I have finished the chapel I have been painting," he writes, "The Pope is very well satisfied. But other things have not turned out for me as I'd hoped." The insistent depression—and it was the Sistine chapel he was talking about—is at once an accusation and an appeal for love. Alternating between rage and submissive pleading, he can never give enough or get enough: "You have all lived off me now for forty years, and I haven't even had a good word from any of you in return."[5] After his father and brothers died he transferred the whole complex bundle of emotion—love, anxiety and irritation—on to his nephew.

These ambiguous feelings for father and brothers seem to have set

the pattern for his professional relations, with apprentices and patrons alike. It is particularly noticeable in the case of Pope Julius II. Artist and Pope were well-matched, both violent and powerful men, described by contemporaries as *terribile*. They played out an extraordinary and perhaps mutually enjoyable drama of threat and counter-threat, with Michelangelo oscillating between angry defiance—walking out on a project—and theatrical submission—pleading forgiveness with a halter round his neck. Michelangelo was originally inspired by the scale and scope of the commission for Julius's tomb, but it became an albatross round his neck; he was partly unable to finish it because of the paralyzing mixture of guilt and persecution feelings the authoritarian old Pope had aroused in him. "I have wasted my whole youth chained to this tomb," he complained some thirty years after it was first initiated; "I am stoned every day as though I had crucified Christ."

Michelangelo's father died in 1531 but, according to Michelangelo, survived like "a sculptured image in my heart," and he looks forward to a restored and transformed love between father and son in heaven.[6] The Sistine ceiling is essentially a deification of paternal power, as the creating and controlling force that animates the whole universe. The fierce and bearded old warrior Julius who had commissioned it was the prototype for the Sistine God. The Son remains hidden. His sufferings and his power to restore and save man are foreshadowed but never shown. But one panel seems to hint at the son's terror in discovering that the father is not, after all, omnipotent. The old drunken Noah is discovered naked by his sons. Naked themselves, they avert their eyes, as if unable to contemplate that aging flesh exposed in all its humiliating weakness. In his impotence, they seem to foresee their own future failure.

In his old age, it is no longer the patriarchal God who compels Michelangelo's imagination, but the Son. *The Conversion of St. Paul* is like a reworking of the *Creation of Adam*. The elderly bearded saint—often taken as an idealized self-portrait—is flung to the ground as if struck by lightning. He is blinded and devastated by the power that emanates from the immense plunging arm of God the Son. In the *Last Judgment* painted on the altar wall of the Sistine Chapel, a youthful and terrible nude Christ dominates, while an aged Bartholomew, holding his flayed skin which is said to bear Michelangelo's own caricatured features, shrinks away in awe.

131

In 1503, Michelangelo had painted a Holy Family which hints at some of his unresolved contradictions toward both mother and father. It was commissioned by a Florentine merchant, Angelo Doni, and probably based on a similar tondo by Signorelli. The massive figures of Mary, Joseph and the naked Christ child dominate the foreground; behind, in a bare mountain landscape are five beautiful nudes. Lounging against a low wall, their poses are langorously suggestive. One has his arm around his friend, who leans back between the knees; a third boy pulls a cloak away from the pair. They are softly drawn, bathed in nostalgic light very different from the harsh lines and metallic colors Michelangelo gives to the Holy Family. Another wall accentuates the sharp division into foreground and background, and the infant St. John, on the far side of the barrier, gazes wistfully toward the tight family group. Yet that group is somehow repellent, and all three figures are disconcertingly strained. The nineteenth-century critic Justi says that "an idyll of family happiness has been turned into an exercise in gymnastics."[7] The baby Christ balances awkwardly, as he steps onto Mary's shoulder; his gestures are ambiguous—he seems to be pushing mother and father away from each other, though at the same time his body reconciles them and knits them into a group. If it is an idyll, it is one sustained by an immense effort of will, against the flow of Michelangelo's deep feelings. What the background represents, in its lyrically flowing but faded beauty, is the possibility of escape from the strain of holding together mother and father, of dealing with the conflicting feelings they arouse in him.

Father and son, and son and mother are common themes in Michelangelo's work; he rarely shows all three together. When he does—in the Sistine ceiling lunettes,—the threesome is an image of depression and exhaustion. Toward the end of his life, Michelangelo returned, over and over again, to the theme of son and mother, the dead or dying Christ held in his mother's arms, recovering in death what death had taken away from him. But one group—and it was intended for his own tomb—attempts to reconcile son with both mother and father. Michelangelo is said to have given his own features to the old man who stands behind, supporting the group; he certainly identifies with the broken body of the dead son, so centrally important to him in his last years. The group was never finished; Michelangelo actually destroyed part of it, breaking off the left leg of the Christ. All

kinds of explanations have been given for this: according to Vasari, he was angry at a fault in the stone, or disappointed because the work fell too far short of his standards. Leo Steinberg has argued that though most of Michelangelo's images of Mary and Christ are deeply sexual, he was troubled in this case by a too overt incest. The leg, originally slung across Mary's lap in a way that signifies intercourse to the Renaissance, was unacceptable and had to be obliterated.[8] But the disturbing factor in this group is perhaps Michelangelo's sense, even at the end of his life, of being hopelessly torn between his empathy with the son and with the father. The shadowy mother divides, and can never unite the men; the father turns on his own son, the creator on his creation.

LOVER

Michelangelo was of course homosexual. That obvious fact still needs restating, simply because generations of art historians have been embarrassed by it. Attempts to deal with the subject have a certain comic interest. E. H. Ramsden, who translated Michelangelo's letters, refutes the slur of homosexuality with a resounding old-fashioned "Tush!" Anthony Burgess gives an equally Victorian shudder over the *David*, "so epicene that it invokes unpleasing visions of Michelangelo slavering over male beauty."[9] Many nineteenth-century critics denied him any sexuality at all, apparently preferring a eunuch to a deviant; and even today, it is a common ploy to argue that his genius inhabits some transcendently bisexual—and therefore non-sexual—realm.[10] The evidence for his homosexual loves is too strong to be denied, particularly in the letters to and about one of his models Febo di Poggio, and those about the fifteen-year-old Cecchino de' Bracci. And it is immediately obvious in his art.

To an unusual extent, even for a Renaissance artist, Michelangelo lived in an exclusively male world. He was nearly always served by men, all his professional contacts were with men, and so were his friendships. He urged his brother and later, his nephew to marry, but only so as to perpetuate the family that meant everything to him. And he reassured the nephew that "if, however, you do not feel physically capable of marriage, it is better to contrive to keep oneself alive than to commit suicide in order to beget others."[11] Michelangelo's only recorded intimacy with a woman was with Vittoria Colonna. He was in his sixties, she nearly fifty, an aristocratic and virtuous widow famous

for her religious fervor. Michelangelo, who once said that love of a woman was unworthy of a wise and virile heart, praised her for her miraculous masculinity—a man, or even a god, spoke through her mouth. Later still, he took some interest in the painter Sofonisba Anguissola, again a woman who was exceptional, therefore masculine, this time because of her talent.

He met the great love of his life, the young Roman aristocrat Tommaso Cavalieri, when he was nearly sixty. According to Vasari, he even did a life-size portrait of Tommaso, though "never before or afterward did he do any other portrait from life, because he hated portraying any subject unless it were of exceptional beauty."[12] Whenever he met someone with outstanding looks and talent, he once wrote, "I am constrained to fall in love with him and to give myself to him as prey, so that I am no longer mine but his."[13] The images run through the poems to Cavalieri. The artist is a helpless prisoner of his "armed cavalier," a mere target pierced by his beauty. The intensity of his feelings overwhelms and threatens to drown him: "instead of the trifling water I expected, the ocean with its towering waves appears before me."[14] His resolution dwindles and his will depends on that of the beloved; at the same time his love, he says, gives him new strength and power. He is reborn and renewed, his soul purified and led upward to the source of all earthly beauty.

Michelangelo always insisted on the spiritual purity of his enduring love for Cavalieri, and two drawings presented to the younger man as a love gift are allegories about platonic love and sublimation. In one, the bound and reclining figure of Tityus, overwhelmed by the vulture, serves as a warning about the pains of merely sensual love and the gnawing guilt it produces. In the other, Ganymede is borne upward in the clutches of Jove's eagle, representing the ecstasy of a sublimated love transporting man heavenward. But both drawings are profoundly erotic, and both explore the sadomasochistic fantasies that are the basis even of Michelangelo's most spiritualized verse and art. The soft and tender Ganymede yields gladly to the fierce phallic bird; as Tolnay points out,[15] boy and bird seem to merge into a single flying figure, a powerful image of sexual excitement and fusion. But there is as much erotic enjoyment in the second drawing, where the heavy sharp-beaked vulture is poised to tear and penetrate the helpless naked flesh.

Michelangelo certainly tried to deny his homosexuality partly

because he feared scandal, and partly because, as he grew more intensely religious in old age, he strove desperately to sublimate all love of worldly things into the love of God. Condivi, defending his teacher against malicious gossips like Pietro Aretino, insisted that Michelangelo loved human beauty simply because it mirrors God. And, he continues:

> that in him are no base thoughts may also be known from the fact that he loves not only human beauty, but universally every beautiful thing: a beautiful horse, a beautiful dog, a beautiful landscape. . . .[16]

Well, perhaps. But the fact remains that Michelangelo's art concentrates on one kind of beauty, and one only. There are no dogs, on my count five or six horses, and only occasionally hints of that high, bare, stony landscape from which he came. But beautiful young men are everywhere, depicted with warmth and loving pleasure. This feeling is most obvious in the drawings from life, where the artist lovingly compensates for the imperfections of the particular human body. (Compare, for example, a life drawing for the Sistine Adam with the final painted nude: chalk and brush work a metamorphosis on flesh until it takes on the perfected forms of art.) In Michelangelo's drawings from the antique, erotic feeling seems to warm the stone to life, as if he were restoring the statue to the freedom of flesh and blood. He is Pygmalion, in love with his own creation — but the creation is his double, his ideal masculine self.

The artist, Michelangelo sometimes claimed, always paints himself. He clearly took a deep narcissistic pleasure in his heroic nudes; they compensate, perhaps, for some imagined inadequacy. Even in his youth, Michelangelo brooded about his own ugliness, his squat body and the nose broken in his teens in a fight with a rival; he lived in squalor and even filth; and as he grew older, was acutely sensitive to the ravages wreaked on his body by hard work and by time itself. There are moments when he hated the art that had used up his youth and left him so grotesquely decrepit. But the beautiful nudes created by that art are a fantasy of his own body restored and made good again.

Michelangelo's female nudes are altogether different. At the request of Duke Alfonso D'Este, he once tackled an explicitly sexual subject—Leda copulating with the swan. But it is a coldly rhetorical piece of classical borrowing, lacking the sensual feeling that animates

the drawings of boys and birds. Michelangelo can barely contain his distaste and even fear; his uneasiness emerges even more strongly in the similarly posed *Night* in the Medici chapel, that strange and frightening nude whose body seems exhausted and irreparably damaged by sex and childbearing.

On the other hand, Michelangelo does not shrink from his sometimes ambivalent feelings about the male body. This is clear in the early *Bacchus*, the most straightforwardly sexual of all Michelangelo's nudes. The swaying god, caught at the moment when his high is ebbing away, seems dazed from sexual indulgence as well as drink. (The little satyr nibbling at a bunch of grapes held just at crotch level must have sexual meaning.) Vasari praised the figure because it miraculously combines the slenderness of a boy with the fullness of a woman's body.[17] But Michelangelo is both attracted and repelled by his ambiguity. From one angle Bacchus looks like a cheerful drunk; from another, his face is frozen in a grimace. His muscles are flabby and his stomach slightly distended. His seductive charm depends on the sense that he is shopsoiled, that he has been repeatedly used and abused.

The so-called *Dying Slave* intended for the tomb of Julius II is as sensual, though far more refined, as the pagan Bacchus. He is strongly built—Michelangelo was never attracted by the slim boyish body— but he droops languidly and voluptuously, as if yielding to a pleasurable bondage. One arm is thrown up behind his head, while the other hand touches the band tied around his chest; neither asleep nor dying, he drifts in the drowsy, faintly depressing aftermath of orgasm. His "feminine" passivity is contrasted with the masculine, even Herculean body of the second slave, who exerts all of his bull-like strength in the effort to break free. But rebellion and submission come to the same thing in the end; each represents an element within Michelangelo's own psyche.

A powerful erotic feeling runs through a great deal of Michelangelo's religious art; the spiritual can hardly be separated from the sensual. Thus nude youths play an important part in the elaborate scheme he worked out for the Sistine ceiling. Pairs of seated *ignudi* are placed around alternating scenes from sacred history; there are nineteen of them in all, muscular youths who hold swags of cloth supporting medallions or, in some cases, great bunches of oak leaves and acorns. The *ignudi* certainly have some iconographical function;

they have been described as angels, or more convincingly, as representatives of the pagan world dimly apprehending and apprehensive of the Christian mystery.[18] But the overwhelming impression they make is simply of abundant, overabundant flesh. Michelangelo repeats, varies and develops the same basic pose with staggering ingenuity. A few sit elegantly and easily—one is almost camp in his refined provocation; others are brooding, their bodies tense with repressed anger; others again seem to writhe in pain or ecstasy. Their tremendous muscular strength is exerted to no apparent purpose; if they struggle, it is against themselves, against their own passivity. We get a disconcerting sense that some great puppet-master is putting them through their paces. Michelangelo seems to enjoy the formal limits he has imposed on them, and takes an ambiguous pleasure in their confined power. He identifies with their helpless passivity, and insists aggressively, even sadistically, on his own artistic and sexual power. Though they are not actually tied up, they too seem to be in bondage. The bound nude bears profound philosophic meanings in Michelangelo's work; it serves as an image, for example, of the way the body imprisons the soul and the soul tortures the body. But the power with which he conveys that philosophic predicament derives directly from his mingled love and hate for other men, and from his ambiguous feelings about his own male body.

HERO

Art, for Michelangelo, was an aggressively masculine, even heroic activity. The artist shares in the paternal power of God himself; Michelangelo appropriated the Renaissance commonplace and gave it very personal meanings. Again and again, his poems refer to God as the great sculptor whose divine hammer guides his own; at the same time he longs to be possessed by that God, and compares his own spiritual growth to a statue being gradually freed from the stone.[19]

Vasari, for whom Michelangelo was the supreme artist, hailed him as a conqueror, the one hero who triumphs against all comers:

The man whose work transcends and eclipses that of every other artist, living or dead, is the inspired Michelangelo, who is supreme not in one art alone but in all three. He surpasses not only all those whose work can be said to be superior to nature but also the artists of the ancient world whose superiority is beyond

137

doubt. Michelangelo has triumphed over later artists, over the ancient world, over nature itself, which has produced nothing, however challenging or extraordinary . . . that his inspired genius . . . has not been able to surpass with ease.[20]

Michelangelo clearly saw his own career in similar terms. One of his first finished works was a Cupid which he successfully passed off as an antique; and his greatest contemporaries, Leonardo and Raphael, aroused his envy and anger. He dreamed of begetting a race of supermen who would defeat the ravages of time, and spoke of carving a colossus out of a whole mountain peak that would survive as his monument. All through his life he would accept commissions if they were vast enough, only to lapse into despair as the reality fell short of his grandiose visions. The tomb for Julius II was only one of many unfinished projects.

Living in a society which regarded manual labor as demeaning, and which was still reluctant to accept artists as more than artisans, Michelangelo resolved the contradictions, at least for himself. Sculpture, he declared, was work for great men, for heroes. Painting he tended to dismiss as a secondary art, more suitable for the lazy and for women, admirable only as it approached the clarity and relief of sculpture. He was reconciled to the Sistine ceiling, at a time when he longed to be working in marble again, by the sheer Herculean challenge it posed. His poems about the task insist, with a strong note of enjoyment, on the physical ordeal he underwent.[21] Contemporaries have described the tremendous vigor with which he attacked the stone. Even as a very old man, "he went at the marble with such an impetus and fury as to make believe that the entire work was going to pieces."[22] Sometimes, in fact, the aggression that was such an integral part of his creative power would be turned on the work itself and he would recklessly reject or destroy it.

The great marble *David*, carved when Michelangelo was not yet thirty, is not just a symbol of Florentine liberty, but the sculptor's idealized self-image. The obscure and youthful shepherd goes out alone to prove himself to his doubting family and countrymen and to carve his place in history: the personal implications for Michelangelo are obvious. David is at once classically ideal, and far more particularized than any ancient hero. The boy has been turned into a giant, but he is as gawky as a real adolescent. The enlarged hands, with their swollen veins and muscles, belong to a laborer, or a stoneworker.

138

On the study of the left arm of the statue, Michelangelo scribbled the words, "David with the sling and I with the bow," the sculptor's hand drill.[23]

The commission from the cathedral and the Wool Guild had been won in the face of keen competition. Even the block of marble was a challenge. It had been lying in the cathedral workshops for some forty years; twice before attempted, it had been so badly bungled that it was "completely botched and misshapen." According to Vasari, it was recognized that Michelangelo "worked a miracle in restoring to life something that had been left for dead."[24]

But despite David's size and his defiant nudity—he is stripped for action, and his nakedness is the sign that he is God's warrior—he is not altogether confident. From the front, he looks proudly relaxed; from any other angle, his pose seems more uncertain. The head turning over the shoulder disturbs David's poise, and his frowning face is both angry and anxious. The hero is shown, not in his moment of triumph, as is more common, but tensed *before* the fight. His energy remains petrified, forever unreleased and unrealized.

A moment of suspense is explored in another work for the Florentine government—the projected mural for the Council Chamber. Leonardo and Michelangelo were both commissioned to commemorate famous Florentine victories; in Michelangelo's case, the defeat of Pisa at Cascina in 1364. But he chose as centerpiece not the battle itself, but a moment before the fight when the Florentines, bathing in the Arno, were surprised by rumors of an enemy attack. Judging from surviving copies, it was a virtuoso exercise in the male nude, and has always been appreciated as such. The soldiers have the beautiful bodies of athletes, but they twist and turn to scramble into their clothes with undignified haste. The cartoon is hardly a celebration of heroic energy; it communicates, rather, the anxious confusion before an action whose outcome is still in the balance.

There was talk of Michelangelo carving a Hercules to match the great *David*, but it came to nothing—partly because the very notion of heroism must have seemed compromised by the vicious and chaotic wars preceding and following the Sack of Rome in 1527 and the final fall of the Florentine Republic three years later. One of the restored Medici suggested that Michelangelo sculpt a colossus to commemorate his family's rule. The artist—a republican who had actually worked on the city's military defenses—politely refused, and privately wrote

a poem about a giant trampling the city to death.[25] Michelangelo's later nudes are cast on a heroic scale, but they are increasingly troubled. He probably learned a great deal from a lucky accident. In 1506, the Laocoön, that great image of defeated heroism, was discovered in a Roman vineyard, and Michelangelo was present when it was resurrected. Its straining but doomed bodies helped him give convincing form to his own deepening pessimism.

The paradoxes always present in Michelangelo's nudes are spelled out more and more clearly in the work of his old age. At times, he seems to be doing battle with his own persistent attachment to the flesh. The once beautiful torsos grow thick and coarse, the powerful limbs become heavy and helpless. Michelangelo distorts the body, and uses it simply as a vehicle for his spiritual aspiration. The *Last Judgment* shows in extraordinary detail the resurrection of the body. The scattered bodies of the numberless dead are painfully reassembled; dry bones and dust, under the pressure of the spirit, become living flesh again. It is like a second creation, but men awake only to discover their helplessness. The saints and martyrs seem as impotent as the damned; their nude bodies are at the mercy of a power past human comprehension. Christ is the center of the painting, his body—faintly recalling a Greek Apollo—the source of the power that racks the universe. But in spite of his massive square torso and vigorously gesturing arms, even he seems to share the impotence of his creatures. He fails to dominate or bring order to that chaotic and disturbing assembly of nudes. Michelangelo seems to have come to the limits of an anthropomorphic vision of God.

Another work from the 1530s—the statue called *Victory*—could as easily be called *Defeat*. The main figure is the most beautiful of all Michelangelo's young men, and probably the last. His pose is anything but triumphant. Kneeling over the old man he has subdued, the youth turns away hesitantly, as if, in the moment of conquest, he has been disturbed by some intimation of mortality. The statue is often associated with Michelangelo's consuming love of the young Cavalieri—"alone and bare I go/The prisoner of an armed cavalier."[26] But its meaning is also more general and tragic. It takes as theme the way old age turns all heroism, all triumphs of the body, to mockery. From the front, we notice not the boy's refined elegance but his heavy, slightly sagging belly. It is almost as if he has given birth to some monstrous embryo, the old man who is his future shape.

The most pessimistic of all Michelangelo's images of the workings of time on the human body are the nudes sculpted in the late 1520s for the Medici Chapel: river gods who are copies of antique fragments eroded and dehumanized by the centuries, and four figures who symbolize the times of the day. All four are passive. *Day* is an immense figure, twisting to look back over his mountainous shoulders, but unable to force himself into action. The other male, *Twilight*, seems exhausted, with the heaviness of a body whose strength has been wasted and drained away. But even more interesting are the two female nudes—the only two Michelangelo ever carved. And he identifies even more deeply with them than with the men; they too are self-images summing up the fantasies that have always been hidden under Michelangelo's heroic masculinity. *Dawn* wakes painfully as if to recognition of her own impotence, and the passive fate to which she is doomed. She is obviously based on a male model, and that only underlines her personal meaning. It is as if a man—Michelangelo— wakes out of a castrating nightmare to find it a reality. The future that faces the virginal *Dawn* is spelled out in *Night*. Her body is painfully marked; her stone breasts look sore and swollen, and her heavy belly is deeply scored. Unlike *Dawn*, she is surrounded by phallic symbols—the owl standing beneath her raised knee, the headdress hanging down between her breasts, the hard breasts themselves. And those symbols only underline the damage that has been done to her; hurt past any hope of healing, she embodies all the child's suppressed guilts, and his deepest and darkest fears. She is the child's fantasy of the phallic mother turned to an accusing nightmare; everything lost is rediscovered in time, but in a form that makes tragic mockery out of the very notion of phallic pride.

SON AND MOTHER

All Michelangelo's art can be seen as reenacting one primary drama—the boy's struggle against passivity, his fear and his desire for the lost mother. His many versions of the traditional theme of Madonna and child speak of his personal struggle as man and artist. His first surviving work, a relief carved when he was still in his teens, shows the infant Christ asleep in his mother's arms. Most of his body is folded within her draperies, and we see only part of his back and one arm. But their rocky muscles are the focus of the relief, and suggest the effort it will take to free himself from the womb. The naked Christ

141

child is usually carved as a mini-Hercules, the most heroic of all Michelangelo's nudes. And he often chooses the moment when the child—painfully and reluctantly—has to seek his masculine identity apart from his mother. In the group now in Bruges, the child stands securely between his mother's knees; as he takes a tentative step away from her, he clutches her hand nervously. The child in the circular relief in London has been scared by the little St. John, and perhaps by his own independence, and dives back into his mother's lap. But his body is already distinct and masculine; it is too late to retreat into the idyll of babyhood. In the St. Peter's *Pietà* Christ has been restored to his mother's body and lies helplessly across her lap; he has recovered the lost union with the mother—but at the cost of his life.

The Madonna in the Medici Chapel is rather different. A little monster of a baby sits astride his mother's knees twisting energetically to get at her breast. She droops toward him, tender but sad, as if her life were draining away under his attack, as if, as he grows, she wastes away. The underlying fantasy in Michelangelo's sculpture is always of the stone as female, maternal. Throughout his life, he was fascinated by stone itself—by its mountain origins, its resistance and its primitive life. The notion that stone is fertile and contains the seeds of life goes back to antiquity; Cicero and Pliny both speak of rocks being broken open to reveal the forms of living beings.[27] In one of Michelangelo's poems the worked stone itself speaks—or is it the artist speaking through the stone? "Down from the high mountains and from a great quarry/Hidden and guarded within a great rock/I descended to be uncovered against my will in such a tombstone."[28] Michelangelo takes the commonplace idea that the statue is potentially present within the marble, as it were in embryo, with profound seriousness. The sculptor strips away the superfluous mass to free the figure into life; his tools create "in hard and alpine stone a living figure which grows the more the stone wastes away."[29] The block feeds the statue, but the sculptor has to attack the stone, rape it, in a sense destroy it, in the interest of his own creation.

Michelangelo again and again projects his own creative struggle onto his creatures. So the great unfinished slaves seem to wrestle with the formless weight of the stone, which is also their own weight. They exert all their strength to disengage and disencumber themselves from that oppressive, life-giving, death-dealing matrix. Even in his most carefully polished and finished works, Michelangelo still suggests the

142

shape of the stone from which the statue has been resurrected. The carved image long outlasts its maker; but in the end it too is eroded and its distinctive shape is blurred. Michelangelo's favorite classical nude was apparently the Belvedere torso, which has been so worn that it begins to revert to the condition of unworked stone. The primitive, pre-human "feminine" life of stone itself remains, a reminder of past and of future as well.

If Michelangelo's work is a celebration of masculinity, there is hardly a figure in which it is taken for granted. The fight to attain and retain masculinity seems increasingly to exhaust his creatures; the very intensity of their efforts renders them finally impotent. Masculine independence is never—how could it be?—securely achieved. Michelangelo exaggerates the size of his nudes, their virile strength, insists on everything that makes them distinctively male. But the more they aspire to that impossible phallic strength, the more it drains away. From the Sistine ceiling onward, his most characteristic nudes seem entangled in their own strength and weight. The *ignudi* struggle violently—but with whom? The enemy in Michelangelo's work is always invisible and internal. The Sistine nudes do battle with their own passivity, their own desire to lapse into a heavy "feminine" unconsciousness. Even the great creating God of the Sistine ceiling lies like a recumbent Venus; not even the most heroically phallic male can entirely throw off the shadow of the feminine.

The mother—lost or rejected in the distant past—always lies in wait, in time. The feminine, associated with the primitive and barely human, is also the shape lurking in the future to which all Michelangelo's bodies tend. He carves figures in hard and alpine stone that will outlast time, but time remains the greatest, the last enemy. In Michelangelo's last drawings of Christ crucified, the male nude that is everything in his art is reduced to a paradigm, all its beauty and strength forgotten. In the Rondanini *Pietà*, which he was still working on a few days before he died, the bodies of Christ and his mother are blurred into one another, and into the stone. The body of the mother is the body of death. The Madonna carved when Michelangelo was only a boy shows the baby Christ hardly taken shape; he is still embedded in the stone, in the mother's body. And all the work of the intervening years seems to lead inevitably to the last great *Pietà* where the bodies of mother and son finally merge, formless, and all masculine striving and all sexual distinction is finally submerged in death.

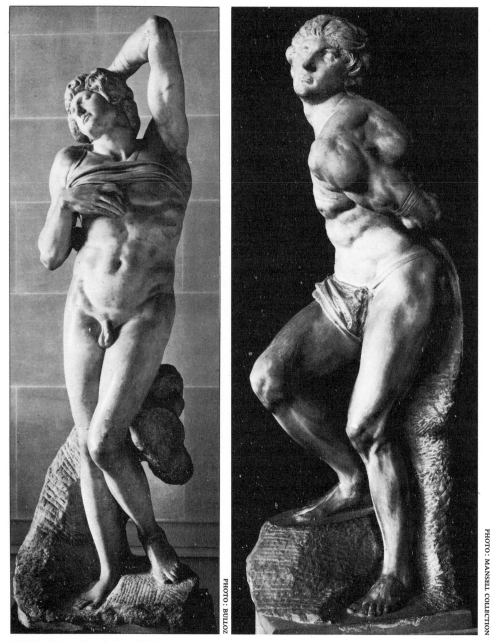

LEFT: *Dying Captive, c. 1514*
RIGHT: *Struggling Captive, c. 1514*

144

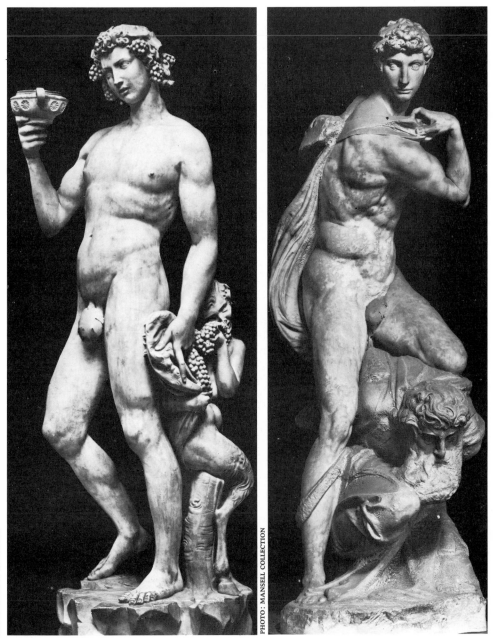

LEFT: *Bacchus*, 1496–8
RIGHT: *Victory*, 1527–30

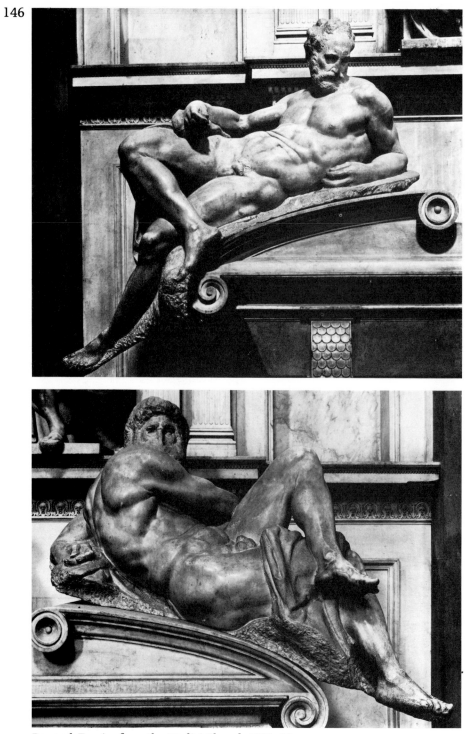

Day and *Evening* from the Medici Chapel, 1521–34

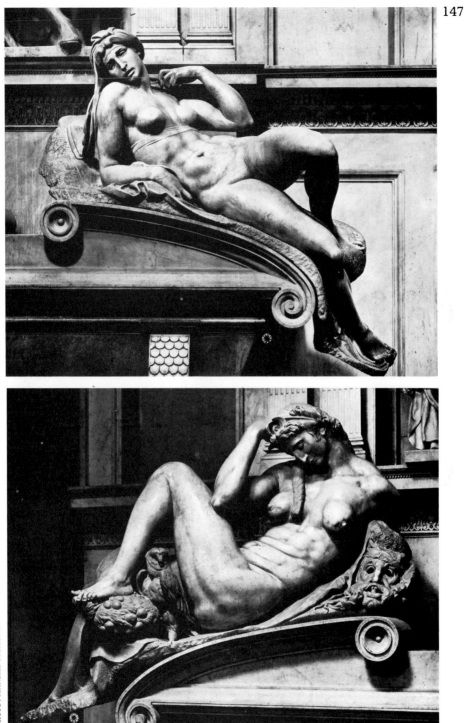

Dawn and *Night* from the Medici Chapel, 1521–34

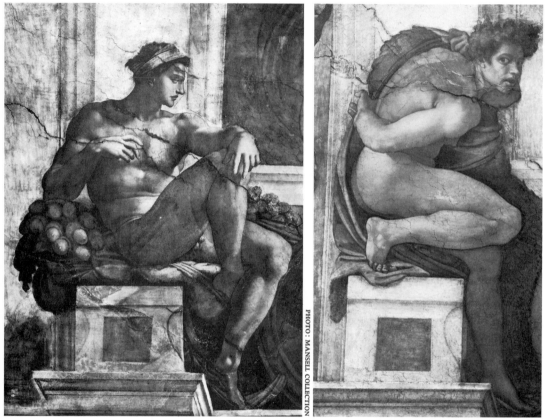

Two Nude Youths from the Sistine Chapel Ceiling, 1508–12

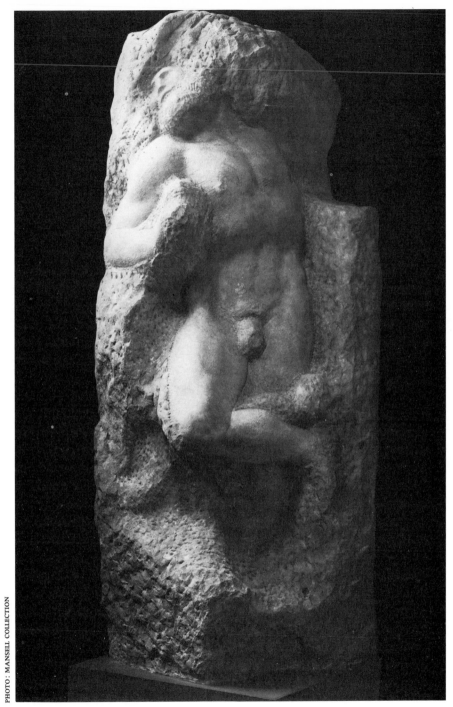

Awakening Slave, 1520–3

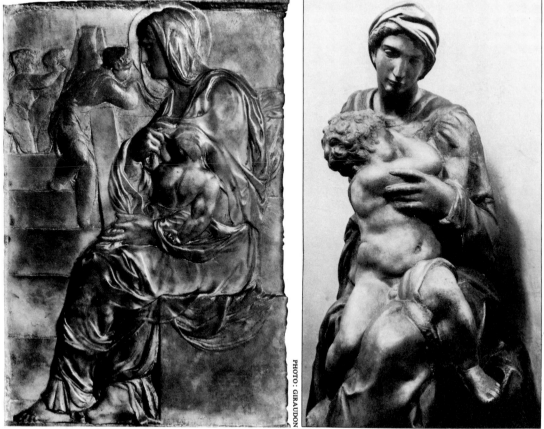

THIS PAGE, LEFT: *Madonna of the Stairs, c.* 1491
RIGHT: *Madonna and Child* (detail) from the Medici Chapel, 1521–34

OPPOSITE: *Rondanini Pietà,* 1555–64

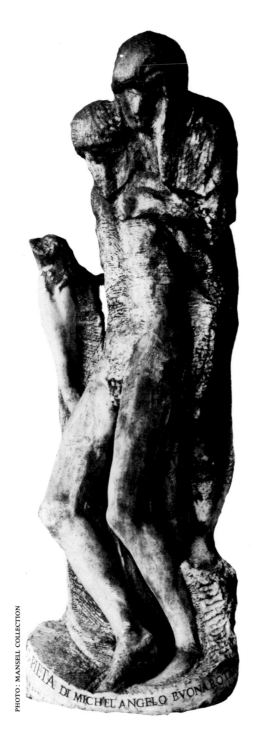

151

The Well-mannered Nude

IF THE FIFTEENTH CENTURY was slow in assimilating the nude, the sixteenth made up for lost time. Nudes are everywhere, in more and more elaborate poses. They swarm over painted ceilings throughout Europe, flexing their muscles in competition with Michelangelo's *ignudi*; they are coiled into intricate and fabulous shapes in book margins. Nude torsos serve as door knockers, cup handles or table legs, and decorate inkwells and saltcellars. Aristocrats have themselves painted as classical nudes, and gaze out at the spectator with unruffled self-possession. Giant marble nudes stalk through city squares making pompous propaganda for minor princes, or sprawl lazily in grottoes or gardens. And, as Gombrich once remarked, sacred scenes sometimes seem to have been invaded by teams of young athletes in training.[1]

To the educated sixteenth-century eye, the early Renaissance nude seemed stiff and earthbound; it lacked *maniera* or style, lacked all those qualities of refinement and aristocratic ease summed up in that favorite term, grace. The mannerist ideal is summed up in Giovanni da Bologna's bronze *Mercury*, to this day a popular symbol of speed and transcendence. The god is precariously but perfectly poised on one foot, reaching skyward so that his bronze body seems weightless, and we have the illusion that he is actually in flight. He defies gravity, defies the limits of the human body, with a balletic grace that looks like child's play.

In the pursuit of grace, many mannerist artists abstract the body further and further from its natural shapes. They endlessly redesign the body, as if impatient or jaded with the dull reality. Some push

Michelangelo's massive nudes to bulging and caricatured extremes; others, like Parmigianino, elongate the body and stretch neck and limbs into an inhuman elegance. Artists demonstrate their originality by twisting the body into asymmetrical serpentine poses, and Christ and the saints, as well as the ancient gods, move with all the calculated grace of dancers. Mannerist nudes are often self-consciously sexy, but they are rarely sensual. Both sexes aspire to a neutral chic, and the male body is as decorative, as affectedly elegant, as the female.

ART FOR ART'S SAKE

The mannerist nude inhabits a closed world, stranger and more beautiful than the real one—the world of art. There is no hint of animal nakedness in its studied and stylish curves; the imperfect flesh has been refined and polished to a cold mineral perfection. The male nude is accepted without question as the supreme subject for art and test of virtuosity, and is used whether or not the subject demands it. A symbol of intellectual and spiritual aspiration, in practice the nude is reduced to an aesthetic object.

The Renaissance value on art as a separate and self-justifying activity is carried to new and self-conscious lengths by the sixteenth century. Earlier claims about the godlike power of the artist are repeated as dogma, but what is actually admired is sheer technical ingenuity in manipulating and elaborating traditional material. John Shearman argues that from about 1520, there was a growing demand for works of art simply as examples of their creator's *virtu*, while the artists of the golden age of the High Renaissance, are treated respectfully as "old masters." Many collectors show little interest in theme; Shearman cites the case of engravings of Raphaels's *Transfiguration of Christ*—not of the finished work, but a preparatory sketch where all the figures are nude. "It could only bear witness to the role of the artist as creator, in which it must have been felt that a public was now interested."[2]

In a letter to his friend Aretino, Vasari talks of painting "a group of naked figures fighting, first to show my skill in art, and second to follow the story."[3] Giovanni da Bologna is said to have made one elaborate marble group without any subject in mind, simply to display his cleverness in contrasting different nudes, "exemplifying wasted old age, robust youth and feminine delicacy."[4] He found a title for the group only later: *The Rape of the Sabine*.

153

Maniera, style, becomes more important than action or feeling. The most serious religious subjects are hardly to be distinguished from decorative mythologies. Bronzino paints *Christ in Limbo*, striding like a gymnast in the middle of an elaborate tangle of sexy nudes. The painting was singled out by Vasari for its beautiful and varied nudes; but as early as the 1560s, growing numbers of Catholic reformers were complaining (with some reason) about all the inappropriately elegant nudes in church. In 1564, Gilio da Fabriano mounted a blanket attack on the kind of painting that "puts art before decency, that considers it a great thing to twist a head, the arms, the legs . . . that seems to prefer figures who do exotic dances and strike poses . . . rather than figures in contemplation."[5]

Parmigianino—in his Madonna with saints John and Jerome, for example—refines even the chubby flesh of the Christ child into a voguish silhouette. The St. John kneeling in the foreground is twisted like a yoga adept, with knees facing forward and shoulders almost completely reversed. Parmigianino has sensibly masked the implausibly turning hips; but the saint seems more disconcertingly nude than many fully exposed figures because of the way his arm, far too large, has been emphasized and sexualized. In fact, an undercurrent of sex runs through the whole painting, and is glimpsed in John's upward-pointing arm and pimp's face, in the sharp focus on the child's penis and his mother's nipples, and in the pose of the half-naked Jerome, lying back as if overcome by sexual ecstasy.

The Renaissance treated the body as a whole, as an integrated object firmly located in space; the mannerists see it as a collection of parts which can be enlarged and exaggerated at will, and combined into an arbitrarily decorative pattern. An impossible serpentine posture like St. John's becomes almost obligatory; the truly graceful figure, according to theorist Lomazzo, must be twisted like the letter "S," like a "live snake in motion" or a waving flame.[6] Michelangelo's *Victory* was cited as authority, but where its turning movement is a profound image of doubt even in the moment of triumph, Michelangelo's many imitators distort the body simply to show off their own inventiveness. Theorists sometimes claim that the flamelike movement is an image of spiritual aspiration, but it is rarely more than a decorative cliché.

Artists and their patrons clearly delight in piquant deviations from the norm. They willfully bend the rules of anatomy, proportion and perspective formulated with such difficulty by earlier generations.

One writer on art advises aspiring painters that "in all your works you should introduce at least one figure that is all distorted, ambiguous and difficult, so that you should thereby be noticed as outstanding by those who understand the finer points of art."[7] But these "difficult" figures must seem effortless and uncalculated. Vasari boasted of the speed at which he worked and—like other courtiers—aimed at *sprezzatura*, the mastery that conceals art and makes "whatever is said or done appear to be without effort and almost without any thought about it."[8] The late mannerist painter Fréminet "in the presence of his sovereign . . . rapidly sketched on the canvas first a foot, then a hand and a head as if at random. In the end, to the King's great astonishment, a whole figure appeared."[9]

Mannerist artists always felt themselves in competition with the great age just passed, the High Renaissance; it was at once inspiration and burden. Leonardo and Raphael were dead, but the "divine" Michelangelo survived till 1564. And what, in the shadow of his life-long study of the male nude, remained to be done? Vasari admitted that younger men might well be thrown into confusion by his genius, and stumble in his footsteps as if "bound by chains." Acknowledging the religious power of the *Last Judgment*, Vasari is far more comfortable discussing the fresco in purely technical terms, as the supreme school for all students of the nude, with exemplars of foreshortening and all other difficulties of art.[10] A few artists— Pontormo, for example—responded to the personal ambiguities in the great man's work, to his restless energy and the sexuality all the stronger for being repressed; but most simply used his work as a catalogue of poses. They retreat from Michelangelo's spiritual fervor and simply copy his mannerisms, refining or exaggerating them. The sculptor Bandinelli is a good example of someone who coarsened a minor but real talent by striving to do it bigger and better than the master. As Cellini commented with cruel accuracy, the *Hercules* designed to overshadow Michelangelo's *David* looks like a sack of melons. In a suppressed effort to assert their independence, some of his imitators come close to parody. The northerners Goltzius and Floris handle Michelangelo's massive nudes with cheerful cynicism; and Giulio Romano camps them up, producing some melodramatically horrifying effects any Hollywood director might envy. One of his painted rooms in Mantua shows Jove hurling the giants down from Heaven; enormous limbs and faces and boulders, the room itself,

seem to tumble around the spectator's ears in a *trompe l'oeil* effect guaranteed to thrill and chill.

It was only later in the century that artists felt free to admire, reject or remake Michelangelo's work as they chose. The young El Greco, with a confidence rooted in a different religious and artistic tradition (he grew up in Crete where Byzantine art was still alive) caused a scandal by offering to repaint the *Last Judgment*, dismissing Michelangelo as a good man but no painter. El Greco's *St. Sebastian*, for example, is posed after Titian and ultimately Michelangelo, but nude hardly seems the right word for it. The flesh is pale and nearly transparent, and its heroic bulk is almost ectoplasmic compared with the intensity of the tiny but precisely rendered face. El Greco uses the tapered, two-dimensional forms of the courtly mannerists, but with far greater intensity. Almost all his work is religious, but toward the end of his life—as if making a last comment on Michelangelo and the whole classical tradition—he painted a strange, anti-classical *Laocoön*. The bearded old priest sprawls on his back, gazing hypnotized at the head of one snake. He and his two sons seem lost in separate ecstasies. There is little suggestion of struggle or even of physical pain; one youth aspires upward, the other falls backward as if expiring while two mysterious androgynous nudes watch from one side. One of the most physical of all antique statues becomes spectral and insubstantial, the stuff of private vision.

But the early Italian mannerists can neither fully accept, nor dream of abandoning, the Renaissance tradition. They do not wholeheartedly share Michelangelo's troubled but persisting belief that the body is made in God's image; they lack as well Titian's feeling for the substantial beauty of the natural world; but they have none of El Greco's sense that the flesh counts for nothing in the light of the transcendent spirit. Though mannerists insist on using the nude at any and every opportunity, they are sometimes reluctant to let it speak for itself. They treat traditional themes, classical and Christian, obliquely, cleverly, but with caution. They seem to compensate for unacknowledged doubt or hostility by overelaborate allegory or technical complexity. When mannerists, like Rosso or Barrocci or Salviati paint the descent from the cross, Christ's naked, broken body may remain the painting's formal center, but the eye gets lost in an intricate pattern of crosses and balancing figures. They can look more like games of snakes and ladders than devotional dramas.

Some artists settle, comfortably, for a cool and superficial decorative style; others seem caught between their desire to conform, to accommodate their art to their courtly or clerical patrons, and their lurking dissatisfaction. Suppressed feeling sometimes seems to throw the most elegant figure or painting off balance. Sixteenth-century erotica is exceptionally cool and controlled, while a strain of perverse sexuality creeps into the most sacred scenes. Gruesome scenes are handled with stylized, masque-like grace, and a suppressed violence shadows the calmest idyll. Drawings are often more revealing than finished work; no longer just technical experiments and preparatory studies, they sometimes serve as outlets for an artist's eccentric or less acceptable tastes. The wayward Florentines Pontormo and Rosso are obvious examples and will be discussed in the next section. But even the deeply devout Tintoretto seems to express an unaccountable tension in his drawings; a restless and ambiguous energy animates his nude sketches, which tends to be subdued even in his more dramatic public work.

Giuliano Briganti has suggested that the early mannerists felt themselves at odds with a society "that lacked the moral strength to guide their difficult unconfessed longings into other directions, and lacked the awareness to free them fully."[11] The confident classicizing style with which High Renaissance princes and prelates advertised their secular glories echoed a little hollow in the wars and disorders that disturbed Italy for nearly forty years. The Church had lost much of its moral authority; in 1527, Rome itself—which artists and humanists had dreamed of recreating in all its former splendor and more—was actually sacked by German armies. The courts at which artists increasingly congregated after 1530 existed only by permission of the Hapsburg empire; the nude statues set up to assert the power and permanence of Medici rule in Florence were acting out a blatant fiction. In the absence of a new and assured vision, artists retreat—into artifice and learned wit, into technical innovation.

For the overvaluing of art in the sixteenth century is, in part at least, a compensation for a sense that traditional values are failing. The claim that aesthetic values are separate and superior, and the artist an individual set apart and uniquely privileged, disguises the extent to which art had become just another commodity, and the artist a professional up for offers, who would probably retreat into a safe niche as a courtly decorator.

157

DISTORTING MIRRORS

Two early sixteenth-century painters sum up the ambivalence of the period to classical and Christian values; both put the male nude through some strange permutations. Rosso Fiorentino and Pontormo were both born in the 1590s, and were trained under Andrea del Sarto in the great tradition of Renaissance design. Both stayed within the confines of that tradition, but in different ways subverted its balanced and already academic classicizing.

Vasari tells a story about one of Rosso's clerical patrons who was so horrified by the painter's work in progress that he fled in horror, saying that the saints looked like devils. It was Rosso's custom in his oil sketches to give "a sort of savage and desperate air to the faces, after which, in finishing them, he would sweeten the expression and bring them to a proper form."[12] It is hardly surprising that the emotional effect of some of the finished work is, to put it mildly, disconcerting. Rosso's fascination with the macabre, his love of figures that are skeletal, ghostly or witchlike, could never be fully articulated. But eccentric and warped forms shadow the sweet preciosity of his religious paintings, and hover behind even his cool and courtly nudes which were to set the pattern for decorative art all over Europe.

Rosso's work, like his life, is an odd mixture of conformity and rebellion, sweetness and grotesque fantasy. It is riddled with contradictions which are for the most part efficiently reconciled by his highly developed sense of theater. According to Vasari, he refused to follow a master because "he always took the contrary view to those in authority."[13] But his art gives the impression of individuality suppressed, taking covert and eccentric forms. And it was always successfully calculated to suit the taste of an audience who enjoyed a hint of ambiguity in its religious art, of perversity in its decorations.

Rosso's career is typical of the period. The usual insecurities of a wandering freelance artist were intensified by the events of the late 1520s; Rosso was actually imprisoned when the Germans sacked Rome, and for three years he trailed round Italy, finding reasons for not fulfilling commissions, suspicious, ill and taking every public disaster as a personal injury. In 1530 he fled to France, complaining that he had known only poverty and neglect in his native country, though major commissions and appreciative patrons had never been lacking. As painter to the king of France, Rosso more than held his own in a hierarchical and competitive court. The king himself appreciated

his courtly accomplishments, his "grave and gracious" conversation as well as his art, and for ten years he lived like a nobleman. But according to Vasari, Rosso poisoned himself after a quarrel in which he had accused his closest friend of robbing him. Even if Vasari's facts are not wholly accurate, the story says something about the strand of bitterness and paranoia darkening even Rosso's most brilliant successes.[14]

Rosso is an essentially theatrical painter, and his nudes, whether classical or Christian, always seem to be on stage. The 1523 painting of *Moses and the Daughters of Jethro* is a good example. Rosso takes an obscure incident from Exodus—Moses protects the daughters of the High Priest of Midian from molesting shepherds—and elaborates on it in an arbitrary and melodramatic way. The naked Moses hurls his opponents brutally to the ground; in the background another naked man rushes on to the scene while a bare-bosomed shepherdess raises her hands in rather affected surprise. The effect is stunningly dramatic—and it is very hard to say what it adds up to. On one level, the painting is about Rosso's efforts to come to terms with Michelangelo's Sistine nudes; it also expresses his own fascination with violence. But despite the size of the nudes, despite the vigorous gestures and dramatic foreshortening, the picture is static. The bodies, hurled toward the spectator, have been frozen into an abstract pattern. Brutality has been turned into a spectacle; it is exaggerated, and at the same time safely contained, flattened out as if behind glass.

Rosso's *Dead Christ with Angels*, now in Boston, is just as theatrical in an entirely different way. Christ's nude body is so openly sexual as to seem blasphemous. The line of the thigh, concealing but drawing attention to the pubic hair, the half smile on Christ's face, the slit in his side, the golden-haired angels with their refined but fleshy profiles— these things willfully contradict the religious theme. The Renaissance belief that physical beauty reflects the divine is being subtly parodied. Christ is based on a *Pietà* drawn by Michelangelo; but the older painter, even in works as ambiguous as the St. Peter's *Pietà*, uses his own sexual fantasies to discover the emotional meanings of the Christian myth, while Rosso seems to take a perverse pleasure in the contrast between the blatantly sexual body, and the religious symbols, the instruments of the passion and the torches signifying eternal life.[15] (A pleasure shared by many of his contemporaries; it is interesting to note that the painting was commissioned and

apparently approved by an eminent churchman, Bishop Tornabuoni of Arezzo.) It is a deeply cynical painting; and Rosso's sexual appreciation of the male nude seems to be intensified by the equivocally blasphemous context. Much later in his life, Rosso returned to the same theme; the *Dead Christ* in the Louvre is no longer smoothly sexual. Rosso has given Christ's body a weird, almost greenish pallor; the painting is tense and cramped, the gestures of the mourners emphatic and theatrically exaggerated. It seems to express an anxious, almost hysterical will to believe, rather than confident faith.

This extravagantly emotional Christ was done while Rosso was doing his cool and decorative work at Fontainebleau. Much of it is lost now; but a drawing done for Pietro Aretino before he left Italy catches the tone of his later work. Mars, the mighty god of war, is unsteady on his feet; his muscular torso is denied by his petulant expression, his delicate hands and feet, and his nearly invisible penis. Embarrassed, impotent, anything but heroic, the classical nude has become a joke. The philosophic enthusiasm of an earlier period, its delight in rediscovered beauty, are too simple for mannerist sophisticates like Rosso. He handles the nude obliquely, playfully, with a knowing wit. Self-consciously charming, poised and precious, the great Olympians—Mars, Pluto, Juno—are transformed to fashion plates.

Rosso's more introverted contemporary, Pontormo, took a rather different route. He too was a successful court artist, for the Medici, and he taught that arch-courtier Bronzino. He too was master of a cool and rather precious style; Vasari was in raptures about the refined but disconcerting grace of early decorative paintings like *Joseph in Egypt*.[16] But by the end of his life (he died in 1556) Pontormo's inventions were too much even for his most ingeniously mannered contemporaries. His later nudes—strange and insubstantial shapes—are seen through the distorting glass of his private obsessions. Yet his intensely private art remains as a comment on the fantasies suppressed in the work of his more accommodating contemporaries.

Like other mannerists, Pontormo tended to treat the nude as a collection of parts; he distorts its scale, emphasizes an arm or a leg as if it were independent of the rest. His diaries describe him working on the San Lorenzo frescoes as if on a vast intricate jigsaw puzzle. "Thursday I did an arm," he writes in May 1554, "Friday the other

arm, Saturday the thigh of the figure that goes like this. . . . Monday I began the arm of the above-mentioned figure. . . . Tuesday the other arm. Wednesday the 22nd the torso. . . . Friday the thigh and I finished the figure."[17] But his drawings, especially, suggest that Pontormo dismembers and distorts the body under the pressure of intense emotion. He hesitates and emphasizes, now blurring, now dwelling on a single part with fetishistic intensity. He seems at once detached and overinvolved with the bodies he draws; in the very movement of the chalk we feel his effort to bring his own fantasies into focus, to articulate not just what he sees, but his most obscure feelings.

Many of Pontormo's nude drawings are informed by an anxiety or anguish that has little to do with the model and even less with the work in preparation. His pastoral for the Medici villa at Poggio a Caiano has a sunlit charm, with picturesque and pretty peasants sitting on a wall. The tone of the preparatory drawings is altogether different, particularly the studies of naked children and *putti*. One, for all his babyish roundness, sits hunched and huddled; another stares out with hollow eyes, pointing urgently at spectator or painter. Pontormo seems deeply disturbed by his own voyeuristic pleasure in the immature body, and has transferred his floating anxiety on to the models. Their pose, legs spread wide apart to display their genitals, is a favorite with him, and is actually used five times in this single fresco. The delicate charm of the finished work prettifies and disguises Pontormo's painful infatuation with his small boys.

Many of Pontormo's drawings are highly subjective, and they form a fascinating record of everything that had to be repressed in his finished work. Until the 1530s, his nudes are all male; the only surviving exception is a sketch of a statue of Venus.[18] He sometimes gives his own features to preliminary studies of religious characters, and there are many fine self-portraits. One, a drawing of himself nude, makes an interesting contrast with Dürer's naked self-portrait. Pontormo is far more self-conscious than the German painter; he poses, theatrically, and like other mannerists—Parmigianino, for example—enjoys playing games with the mirror. The low angle of vision and the foreshortened arm flung out toward us give him a dramatic, slightly unstable elegance. The looking glass distorts the scale of his body, so that the head is tiny over the exaggerated length of the torso. Pontormo takes a narcissistic pleasure in his own image—he is still young and handsome but he is also uneasy with

himself. Unlike Dürer, he wears briefs, shielding his genitals from the gaze of the spectator who is also himself. His pose is both seductive and defensive, the casual elegance belied by the tension in the heavily drawn muscles of the belly and shoulder. The artist has caught himself half-turning, as if he is trying to capture and ward something off—the double that is feared, and too greatly desired.

In his later years Pontormo withdrew into a world of his own. According to Vasari, who had known him well, he was a melancholy eccentric, "solitary beyond all belief."[19] He avoided public places because he feared crowds, and was so terrified of death that he refused even to hear the word spoken. His late diaries show him neurotically preoccupied with his own body; he minutely records every ache and pain, everything he eats, his every bowel movement. His world is almost incredibly narrow: it is bounded by his own body and the bodies he traces with such meticulous care on the walls of San Lorenzo.

Increasingly, and despite his dreams of outshining all his contemporaries, Pontormo seems to have become his own and only audience. His reputation at the Medici court remained high, and he won the important commission to decorate the San Lorenzo choir. But he shut himself up for eleven years, sealing off his work from prying eyes with screens and curtains, and bursting out angrily at any and every intruder. We can only speculate about the frescoes, which were destroyed in the eighteenth century. But when they were unveiled, left incomplete by Pontormo's death, contemporaries were disappointed and puzzled. "If I tried to understand them," complained Vasari, "even I who am a painter, I believe I would drive myself mad, or become hopelessly confused."[20]

In his search for more intensely emotional forms, Pontormo had been influenced first by Dürer, then by the late Michelangelo. But he often seems uncertain about the intense but opaque emotions he seeks to articulate. And Pontormo is not, as both Dürer and Michelangelo were in different ways, a profoundly religious painter; he is introspective rather than visionary. Particularly in his drawings, his nudes are animated by some private grief or anguish that is neither explained nor contained by the ostensible theme. They are weightless, and drift purposelessly in a vacuum. Pontormo doubts the substantiality of the physical world; though his elongated bodies retain a weird elegance, they are neither beautiful nor heroic. But—unlike El Greco who used comparable forms—Pontormo distrusts the spirit as well. He searches

the body anxiously for signs of inner life, and finds in the end only emptiness.

THE GLASS OF FASHION

In sixteenth-century court art, nudity is another form of fancy dress. Aristocrats stripped down to dress up, and had themselves painted in idealized nudity as classical gods or heroes. Diane de Poitiers, mistress to Henri II, surrounded herself with flattering images of her Olympic namesake. Men enjoy exactly the same game; the Grand Duke Cosimo de Medici is painted by Bronzino as Orpheus, modestly seated in back profile, but still very bare; and he is as cool and complacent as if he were wearing full court dress. The Genoese admiral Andrea Doria strips off to play Neptune; an older man, he is not quite naked, but the drapery round his hips slips to expose the root of his penis, adding a touch of sex to what might otherwise seem an abstract classicizing compliment. Perhaps the oddest of all mannerist statues is a bronze of the Emperor Charles V by Leone Leoni. He wears an elaborate and old-fashioned suit of armor, but this can be stripped off to reveal his idealized nude body. The emperor is offered two images, two roles for the price of one: feudal knight or antique hero.

Mannerist art, increasingly, was court art. It flowered first in Italy—in Rome, under the restored Medici in Florence, in smaller principalities like Mantua and Urbino—and gradually spread across the rest of Europe. It reflects the insulated world of those Italian courts, and their preoccupation with pleasure, prestige and conspicuous display. The aristocrats peopling the puppet courts of Europe were a closed caste, acutely sensitive to status, but lacking any real social or political function. The leisurely cultivation of style became their life's work. Love, war, learning—the whole of life was turned into an elaborate game.

The courtier became his own work of art. He cultivates both mind and body, and plays with his own self-image; aiming in everything for that easy grace "without the which all his other properties and good conditions were little worth." Castiglione expects the courtier to be strong and athletic, to display himself well in "all the exercises of the body that belong to a man of warre."[21] But his instructions hardly sound like a recipe for success in the rough-and-tumble of real battle. The courtier must always appear to move easily, without any effort;

and he should never risk his dignity. He must never forget his effect on others; and he should always be cautious of entering into any physical competition with his social inferiors for, Castiglione exclaims, it would be a foul thing to see a gentleman out-wrestled by a carter.

For all their professed delight in invention and subjective fantasy, most mannerists are too courtly, too well-mannered, to risk real originality. However wild and willful their nudes may seem at first glance, their movements are, in fact, inhibited and precisely regulated. They are posed with exactly that negligent but decorous grace admired in real life. (The terms used to praise painting or sculpture— *maniera, grazia* and *sprezzatura*, or nonchalant ease—were all originally used to describe the deportment of the ideal courtier.)[22] So a nude *Pluto* engraved by Caraglio after a design by Rosso looks casually relaxed; but he is subtly off-balance, posturing against the natural movements of the body. His pose would delight any modern fashion model; many mannerist nudes display their bare bodies with that indifferent but calculated grace so familiar from the pages of *Vogue*.

Courtly nudes retain their controlled assurance even in the most violent situations. Cellini's beautiful *Perseus*, holding the severed head of Medusa aloft in triumph, preserves an unruffled poise, as if he could never have been out of breath. Vicenzo Danti's nude *Honor triumphing over Falsehood* is carved in imitation of Michelangelo's *Victory*, though the turning movement, as he leans back to tear out his opponent's tongue, is supposed to suggest violent energy; it conveys instead a languid and mutually enjoyable sadism. And Giovanni da Bologna's enormous marble *Samson* strangling his Philistine could be going through the rehearsed routines of a television wrestler.

Fashionable court clothes suggest the same detached and exhibitionist attitude to the body. They aim for theatrical effects; extreme styles must have demanded an almost gymnastic concentration in the wearer. Where earlier Renaissance styles had emphasized the natural beauty of the body, the sixteenth century enjoys artificial shapes that denature and desexualize both male and female. Brocades and stiff fabrics are popular, and are cut with little reference to the actual curves beneath. By the 1570s, some styles look like parodies of earlier ideals of physical perfection. As Geoffrey Squire suggests,[23] the body is treated simply as an accumulation of parts, with jarring and often absurd contrasts. Sometimes the arms, encased in vast swelling sleeves, have to be held stiffly away from the

torso; sometimes a costume's effect depends on the contrast between a stiff protruding belly with long slim legs, so that the wearer looks like an adolescent with a middle-aged paunch. And at times the man's doublet is cut with a wasp waist above round, padded hips; according to Squire, one of the few times in fashion history when male costume apes the female body.

At the same time, many courtiers are painted wearing large and conspicuous codpieces—blatant advertisements for their virility that mimic a penis in constant and spectacular erection. Parmigianino paints Pedro Maria Rossi with a big cloth codpiece poking through the folds of his clothes; his heavy-lidded, sultry gaze suggests that Robert Melville may be correct in claiming that the likeness was painted for his mistress's boudoir.[24] But that can hardly be the case with Bronzino's grave and formal portrait of the Duke of Urbino, or with Titian's full-length study of the Emperor Charles V, where the big metallic codpiece forms the center of the whole composition. Thorkil Vanggard argues that in these portraits the man's codpiece is a symbol, a "condensed expression of those eminent qualities as a man and prince which he wished to convey to the world."[25] The codpiece certainly looks rather like a weapon, a dagger always at the ready; and Urs Graf employs that association in some of his satirical studies of German knights flaunting a hilt-happy readiness to fight. Like many other mannerist styles, the codpiece is on the edge of being absurd; in the commedia dell'arte, it is Pantalone who wears one, as does the Fool in Shakespeare's *King Lear*. The symbol may be a substitute for reality; only in playacting, in fancy-dress, can men assert the virile energy normally negated by court life and court clothes.

In a court that turns everything into a stylized game, men are so detached from their own bodies that any part of the body may be sexualized—and by the same token the "sexual" parts may be viewed with cool detachment. The sixteenth century saw the growth of a considerable market for explicitly erotic art; some was geared to the private and expensive fantasies of princes, but it reached a wider audience all over Europe through the medium of engraving. Sets of prints illustrating the loves of the Olympians were common; gods, nymphs and satyrs are shown, in great detail, in the act of intercourse, sometimes straightforwardly, sometimes with variations. One of the most famous sets was Giulio Romano's illustrations to Pietro Aretino's series of poems on the different sexual positions. Many of these

sixteenth-century prints are lost, and the rest are hidden away in restricted collections; but they seem to have been surprisingly unarousing. The naked body is put into some eye-opening situations and poses, but the actors stay cool and controlled. The veneer of erudite classicizing helps distance the work. The actors go through the most intricate gymnastic routines, but there is rarely any release of sexual energy, let alone of feeling. Sex—like art—is freed from anxiety by being reduced to technique.

A number of themes normally taboo in Western art appear quite openly in the sixteenth century. A man raping a woman is commonplace but one engraving from Fontainebleau shows a rare reversal—a satyr with an enormous erection is carried toward a woman so that she can rape him. Another engraving shows a nymph castrating a satyr, in specific and unmetaphoric detail, the curved knife actually resting against his penis. There is a widespread interest in deformity—indeed, the fashionable type of male and female beauty is close to deformity. Bronzino is said to have painted the Medici court dwarf Morgante from the front and back, and his "bizarre and monstrous members" were greatly admired.[26] The same painter's famous allegory of *Venus, Cupid, Folly and Time* depends for its effect on the contrast between the icy manner and coloring, and the lascivious details—the provocative curve of the boy's buttocks, the way his fingers curl round the woman's nipple—that insist that this is no allegory, but incest between mother and son.

Games of role reversal add spice to a neutered court; gender sometimes seems to be treated as a matter of style. Provocatively effeminate boys are very common, and are simply enjoyed for their piquant and provocative charms. (There is little of the intellectual or psychological profundity associated with androgyny in the earlier Renaissance and in Michelangelo's work.) Giovanni da Bologna's bronze *Apollo* for the studiolo of Francesco de Medici is a good example of this detached and sophisticated play with gender. His pose—with hip thrust sexily to one side—exactly echoes that of a dozen female nudes. His genitals are tiny and flower-like, and the suave and expensive patina on the bronze heightens the ambiguity of his decorative curves. Various northern artists are particularly fond of a cool joking play with sexual stereotypes. They draw Herculean figures with enormous swollen muscles and miniscule penises, or Apollos so flabby that they look pregnant. Bartholomew Spranger,

court painter at Prague, constantly makes rather crude jokes about sex reversal. In his *Hercules and Omphale*, for example, the proud hero of the early Renaissance sits gloomily, his middle-aged spread only half-hidden by his female clothes, while a boyishly naked Omphale shoulders his enormous phallic club, grinning at the spectator over her shoulder.

The detached and modish manner, the erudition and sophisticated wit, effectively defuse these emotionally charged themes. Over and over again, artists willfully provoke sexual anxiety, only to dissipate it by reminding us that life is after all only a game. But the anxiety is never totally suppressed. A weird set of engravings—attributed to Juste de Juste in the Fontainebleau circle—is like a parody of the courtly nude in all its epicene artifice. Some plates show single nudes, with knobbly and grotesquely graceful bodies, caricaturing the elongated grace of mannerist nudes; in other plates, the nudes climb into precarious pyramids which again seem to parody the intricate and unstable structure of so many sixteenth-century paintings. Monstrously elegant, refined away until they are hardly more than skeletons—and with the terrifying loose mobility of skeletons—they hint at the more sinister fantasies underlying all that courtly cultivation and serpentine sweetness. They remind us how easily the desire to re-form and improve the flesh ends up by deforming it; they remind us that the cult of elegance always works against nature and tends toward death.

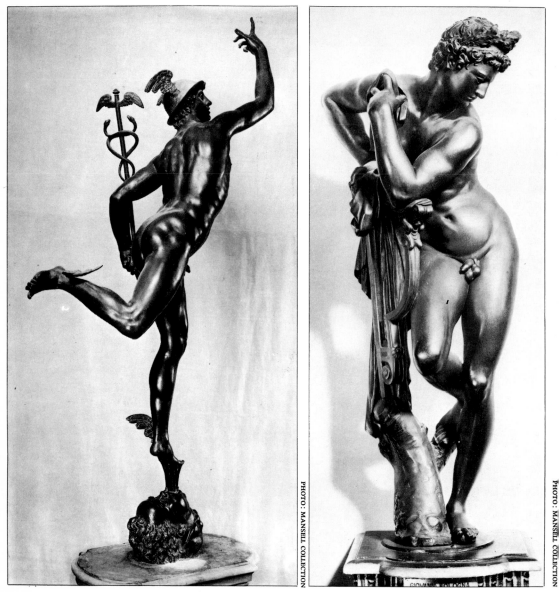

PHOTO: MANSELL COLLECTION

PHOTO: MANSELL COLLECTION

LEFT: *Mercury, c.* 1576, Giovanni Bologna
RIGHT: *Apollo, c.* 1573–5, Giovanni Bologna

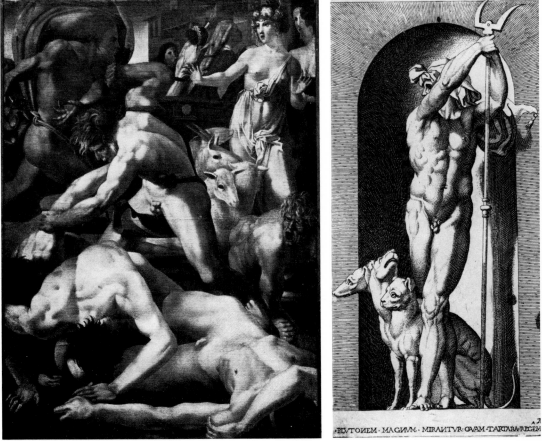

LEFT: *Moses Defending the Daughters of Jethro, c.* 1523, Rosso Fiorentino
RIGHT: *Pluto,* 1526, engraved by Caraglio after Rosso Fiorentino

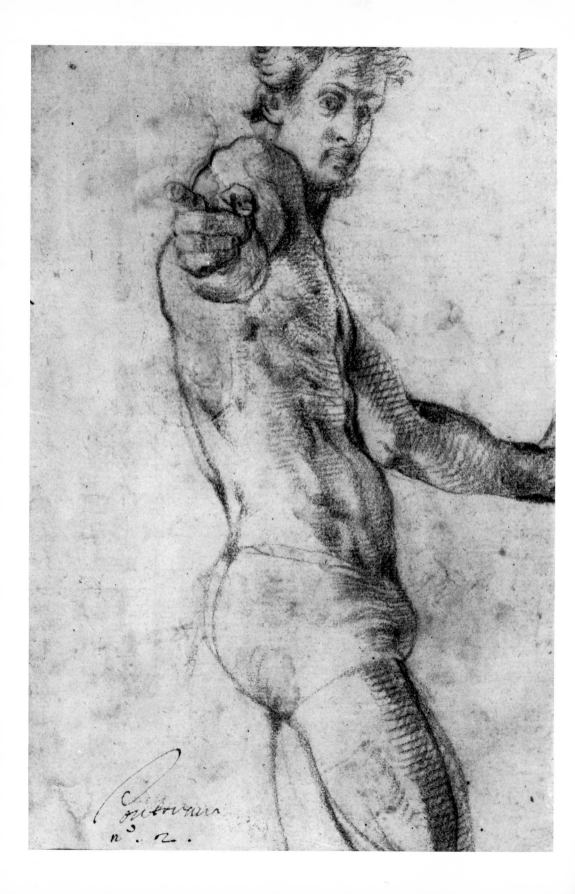

OPPOSITE: *Self Portrait, c.*
1525, Pontormo

THIS PAGE, TOP: *Nude boy, c.*
1520, Pontormo
BOTTOM: *Seated Man*, 1575–81,
Tintoretto

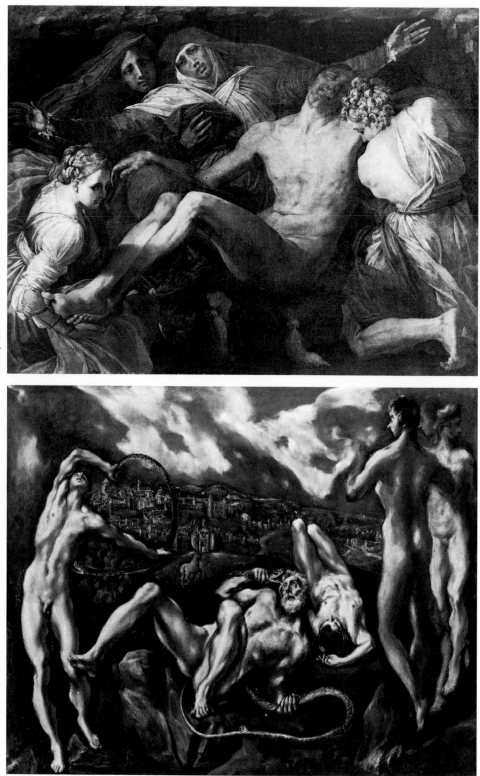

TOP: *Dead Christ*, 1530–40, Rosso Fiorentino
BOTTOM: *Laocoön, c.* 1610, El Greco

TOP: *Andrea Doria as Neptune, c.* 1550–55, Bronzino

BOTTOM: *Grand Duke Francesco I dei Medici as Orpheus,* Bronzino

TOP: *Nymph Mutilating a Satyr, c. 1543–4* engraved after Primaticcio
BOTTOM: *Venus, Cupid, Folly and Time*, 1545, Bronzino

LEFT: *The Dwarf Morgante*, late sixteenth century, Giovanni Bologna
RIGHT: *Acrobat*, sixteenth-century, engraving attributed to Juste de Juste

Nude Directions

SEVENTEENTH-CENTURY ART reflects a new materialism, a dramatically changing attitude to man and his place in the science of things. After the tight, ambiguous figures of the mannerists, seventeenth-century nudes seem to have been released from bondage. They are more lifelike and move energetically and naturally. Where mannerist nudes look as if they were on punishing starvation diets, their baroque counterparts clearly have healthy appetites. Pagan hero and Christian saint exist solidly, substantially, in the flesh.

Rejecting the mannerists who had created specters or empty shells, not living beings, most artists saw themselves as getting back to nature, back to the true classical tradition. Annibale Carracci's ceiling for Cardinal Farnese's Gallery in Rome is a good example. His hefty Olympians, broad-framed and colorful, act out their loves and hates with cheerfully emphatic gestures. Polyphemus heaves his great rock in spectacular rage, Anchises can hardly restrain his eagerness as he unties the sandal of an expectant Venus. And when Carracci copies Michelangelo's obscurely agonized Sistine *ignudi*, he transforms them into good-humored athletes comfortable with their bodies.

Drawings by Carracci and his circle are even more lively; sensual and witty, they reveal an interest in individual quirks that sometimes issues in out-and-out caricature. A study for the figure of Anchises on the Farnese ceiling has him pulling off Venus's stocking with comically undignified haste. And when Ludovico Carracci sketches a boy sleeping with his legs wide apart, he takes an earthy, unabashed pleasure in the exposed body; he is a world away from Pontormo's self-doubting voyeurism.

176

There is a new feeling for the body in action. Bernini, for example, liked his models to move about and talk as he drew them. "He said that a person who poses, fixed and immobile, is never as much himself as he is when he is in motion, and those qualities that are his alone and not of a general nature appear."[1] Bernini consciously measured himself against his great Renaissance predecessors when he carved his *David*. Like Michelangelo's hero, it is an idealized self-portrait, and Bernini's powerful patron Cardinal Barberini is said to have held the mirror for the sculptor as he worked. But Bernini aims at something more spectacular than Michelangelo's inward drama. His hero is committed to action; feet wide apart, body and face clenched with effort, he twists to unleash his missile. And—as many critics have pointed out— he seems about to lunge toward us; we, the spectators, stand in for the invisible Goliath.

Other artists enjoy putting the nude into extreme states, of agony or ecstasy, of humiliation or erotic excitement, and deliberately whip up the spectator's senses and sympathies. *"Ah, le pauvre homme,"* the queen of France exclaimed when she first saw Puget's statue of the athlete Milo of Croton, in desperate anguish as a lion savages his body. And a contemporary wrote approvingly of Ribera's *Ixion*, tortured on his great wheel, who so frightened a woman that she gave birth to a deformed child.[2] Christ and his martyrs are painted with the same physical immediacy, the same determination to arouse the most intense emotions—pity or horror or rapture—in the faithful. Rubens, for example, brings the same enthusiastic sensuality, the same feeling for the flesh, to a dead Christ, a drunken Bacchus and a naked Venus.

Even a painter as coolly classicizing as Poussin, who can claim that true beauty is incorporeal and "altogether independent of the body," still has a subtle and varied sense of what he calls "the language of the body," of the way pose and gesture express emotion.[3] And a few seventeenth-century painters ask us to look afresh at the human body and reconsider our conventional notions of beauty and ugliness. Caravaggio paints Christ and the saints as ordinary men off the streets, while Rembrandt's men and women, their bodies as worn and lived in as their faces, have almost nothing in common with the classic nude.

But—perhaps inevitably—there is a backlash against this new energy. Paradoxically, the seventeenth century with all its new and refreshing materialism and its keener feeling for the individual, also

sees the growth of much more rigid and defensive attitudes toward the nude. By the end of the century, the French had developed a strict program of art training, based on the study of the classic male nude, which was to remain in force for the next two centuries.[4] Conservative classicists reassert all the Renaissance commonplaces about the spiritual significance of the ideally proportioned body. In practice, their art and theory is less a confident celebration of man's divinity than a nervous retreat from anything excessive or undignified or common. Ideal beauty, supposed to be timeless and transcendent, comes to reflect an increasingly narrow sense of what is proper and polite. The powers of art have to compensate for a waning sense of the holiness of the human body.

Classical gods and heroes are part of the vocabulary of educated men all over seventeenth-century Europe, and any lingering doubts about using the nude in Christian contexts seem to have vanished. But the earlier Renaissance excitement about the classic nude—symbol of a whole new way of looking at the world—has vanished as well. The nude has become respectable, and is increasingly drawn according to formula. By the end of the century "high" art—dealing with antique and biblical scenes, and using the male nude as its central unit—is established at the top of a strictly maintained hierarchy of genres. And some of the most original and vital artists are forced to turn to "lesser" kinds—to landscape, still life, portraits, and to erotic scenes using the female nude. The female—associated with the senses and nature, and less important in classical and Christian culture—becomes increasingly popular. For the next two centuries, *nude* tends to mean a nude woman. The male nude, confined to the insulated world of high academic art, loses much of its vitality and only too often seems insipid or emptily rhetorical.

FLESH

The most striking feature of the seventeenth-century nude is its sensuality. This is seen most clearly, perhaps, in Bernini, who astonished contemporaries by creating the illusion of soft and supple flesh in cold stone. He handles marble as if it were clay, soft and pliable, and tries for effects of tones and texture usually confined to paint. His early work almost willfully denies the properties of stone, its hardness and permanence. In the *Apollo and Daphne*, for example, he plays a dazzling game—animal, vegetable or mineral—with the limits

of the sculptor's medium. Bernini stuns us with a double sleight-of-hand; stone is made flesh in the bodies of god and girl—the Belvedere Apollo is subtly transformed to suggest rapid movement—then Bernini petrifies the flying figures at the split second of further metamorphosis, as Daphne is rapt away from the god and her soft skin hardens into bark.

Bernini's youthful work, religious and secular, is a series of experiments in flesh contrasts, and with the body in active and passive states. The group showing Aeneas fleeing from Troy is a virtuoso study in physical—and psychological—contrasts between generations. The compact strength of Aeneas is set off by the plump curves of his small son clinging to his leg, and by the skinny torso of his father perched nervously on his shoulder. Another early group contrasts the massive middle-aged rapist Pluto with the delicate Persephone who twists, terrified, from the fingers digging into her soft flesh. Bernini's *David* is a superbly developed athlete, whose muscles seem to ripple beneath the skin. As a contemporary put it, "resoluteness, spirit and strength are found in every part of the body, which needs only movement to be alive."[5] On the other hand, the two nude saints Lawrence and Sebastian, carved when Bernini was still in his teens, are passive and blatantly sensuous. Lawrence was Bernini's name saint, and in the attempt to get his tortured expression just right, the young sculptor is said to have burned his own leg. All lines of the saint's luxuriant body and face express intense masochistic pleasure.

In his later work, perhaps nervous of its dubious appeal, Bernini seems to have avoided this kind of passive male nude. There are none of the ecstatically suffering male martyrs so popular with his contemporaries, and even Christ rarely figures in his work. Interestingly, the most personal of all Bernini's later works is a female nude, the *Truth Unveiled*. Symbolically speaking, she is as much a self-portrait as the heroic David or the ecstatic Lawrence. Bernini carved her for himself as an act of self-justification after the failure of one of his most important architectural projects, and on his death left her to his own family, as a token of his work and to remind them, he said, that truth is the greatest virtue.[6] Her exposed body is as shining and sensuous as any Rubens nude; she is sister to the desperately struggling Persephone, but the pose now suggests ecstatic joy, as she yields herself to the light and finds the reward for her patient passivity.

Rubens was probably the greatest of all seventeenth-century painters of the flesh. Though his nudes are based on classical prototypes, his feeling for the surface of the body and his love of soft, heavy flesh, completely transform the clear outlines of his originals. (Too much so for conservatives like Bellori who complained that Rubens's style altered antique statues of Apollo so much "that he left no form or vestige of these statues by which they might be recognized.")[7] Rubens warned younger painters not to reproduce the "stony luster" and harsh outlines of stone. Moreover, living bodies "have certain dimples, changing shape at every moment, and owing to the flexibility of the skin, now contracted and now expanded which sculptors ordinarily omit."[8] He was fascinated as no one before him by the skin: by its sheen and texture, its changing colors, by the way it creases or stretches, sags or pulls taut. His brush dwells on the surface of the body with a sensual, almost sexual pleasure, appealing to our fantasies of touch; as Sir Joshua Reynolds commented in the eighteenth century, he paints with a fluency that awakens in the spectator "correspondent sensations, and makes him feel a degree of the enthusiasm with which the painter was carried away."[9]

This tactile enjoyment of the exposed body can be seen in two nudes, both in Berlin. Andromeda stands with arms chained above her head waiting to be rescued by Perseus; Sebastian, with his hands bound behind his back, looks yearningly to God. Man and woman are built on very similar lines: Andromeda may be slightly more refined, but both have heavy legs, full hips and rather thick waists. (And there is not so much difference between Andromeda's bosom and Sebastian's muscular chest. Considering their size, Rubens's women often have small breasts; he is far more interested in flanks and thighs and bottoms.) Sebastian's skin is as soft and luminous as Andromeda's, its beauty unmarked by arrows. Both wear identical expressions of enjoyable expectation. There is absolutely nothing to suggest that one nude is pagan, the other Christian, or that one painting is erotic and the other devotional. The heroic nude becomes, in a new sense, a passive sex object; that is as true of the male as it is of the female.

The female is certainly more central in Rubens's work. And his changing attitude toward the female nude affects his vision of the male body as well, and affects it in unexpected ways. According to Kenneth Clark, "Rubens did for the female nude what Michelangelo had done for the male. He realized so fully its expressive possibilities that for the

next century all those who were not the slaves of academicism inherited his vision of the body as pearly and plump.''[10] But if anything, Rubens narrows the expressive possibilities of the female nude—and therefore indirectly of the male as well. He gives definitive expression to one potent male fantasy about woman. He is concerned with one type, and one type only: young, fair, comfortably padded. Her flesh, so sweet and abundant, is her sole justification; she is natural woman who simply is, who has no need to think or act or even feel. Male critics tend to rhapsodize about this Rubens nude as a fertility symbol; as Clark puts it again, ''the golden hair and swelling bosoms of his Graces are hymns of thanksgiving for abundance, and they are placed before us with the same unselfconscious piety as the sheaves of corn and piled-up pumpkins which decorate a village church at Harvest Festival.''[11]

Titian's great reclining goddesses had been confident of their sometimes sinister powers; Correggio's neat and pretty girls are swept away by transports of sexual delight; Cranach's ladies are skillful professionals who know just how to titillate the spectator. But Rubens's women—with some superb exceptions, like the great portrait of his second wife Hélène Fourment pulling her fur cloak round her vulnerable flesh and gazing back at the painter with wary amusement—exist simply and solely as objects of male desire. They have no sexual energy or personality; they stand still, to be contemplated and enjoyed, to be raped, rescued or painted at male whim. One of Rubens's favorite themes is the Judgment of Paris, and the spectator is asked to make an impossible choice between three identically beautiful bodies. Rubens is fond of painting three different views of the same body, as if the painter were striving to encompass it, to possess it from every angle.

Michelangelo had carved out his own self-image and asserted his creative power by a life-long study of the male nude. For Rubens, and for countless artists after him, the female nude is the reflection and central symbol of creativity. The relationship between male artist and female model is sexualized, artistic creativity is equated with sexuality, and more specifically with male virility. When Rubens was fifty-three years old he married the sixteen-year old Hélène Fourment. During the last ten years of his life, he not only did a very moving series of portraits of her, but painted her over and over again, in rich, glowing nudity, as goddess or grace. Contemporaries linked the

painter's continuing and stunningly abundant creativity with his possession of this youthful and renewing beauty. "Behold," exclaimed his old friend Gervartius, "he possesseth the living image of Helena of Antwerp who far surpasseth the Helena of Greece . . . in thine arms, young bride, he will grow young again, and he will win a new strength from thy charms."[12] The flowery and formal language should not distract us from the familiarity of the sentiments. This is the familiar modern equation between creativity and male sexuality, and Rubens, in many ways, is as close to Picasso as he is to Michelangelo.

Rubens's males often seem comically inadequate beside these larger-than-life women. As who would not be? Such an impossibly lavish and receptive femininity could only be complemented by an impossibly assertive masculinity. In painting after painting, the men clutch and push at those massive bodies, so complacently available, and so infuriatingly impervious to male desire. The two men in the famous *Rape of the Daughters of Leucippus* seem unlikely to succeed in heaving the nude women off the ground; and their manly lust is suggested not by their own bodies, which are almost completely hidden, but by their great rearing horses. Silenus or his half-animal satyrs are used to act out the grosser forms of male lust, but mere human males are usually draped. Indeed, in many paintings, Rubens contrasts a female nude with a man not just clothed but armed, his body encased and permanently erect in a rigid protective shell. A robot Perseus comes to the rescue of a complacently naked Andromeda, or a portly middle-aged hero with a tin-plate paunch is crowned by a lush golden Venus, his feet resting on the bare body of a defeated enemy.

Rubens almost never paints a man and a woman nude together; one exception, an early *Venus and Adonis* now in Russia, is revealing. The boy pulls nervously away from the goddess's embrace, as if he feared the infection of her softness. Nudity is associated with being exposed and susceptible; with passivity; and with femininity. As soon as the male removes his clothes and relaxes, he becomes "feminine," something which Rubens finds both attractive and disturbing.

Rubens cannot enjoy the sensual fleshiness of the male body, unless it is wounded or dying. In one of his oil sketches, two reclining nudes are as receptive and voluptuous as any of his females; transferred to a finished picture, they are used to express defeat or death. The exposed male body is nearly always the focus of ambiguous sadomasochistic

182

fantasies; pain is at once excuse and punishment for sensual excitement. Prometheus—one of the most beautiful of all Rubens's nudes, male or female—sprawls in helpless agony as the vulture claws at his eyes and digs cruelly into his tender flesh; Sebastian shivers ecstatically as the arrows pierce his helpless body. And in an *Elevation of the Cross* in Antwerp, gigantic muscular soldiers heave and strain to pull the cross upright, burdened by the equally massive, but soft and yielding body of Christ. The emotional impact of the painting is remarkably similar to some of Rubens's secular scenes of rape and abduction. The suffering Christ plays the "feminine" and submissive role, to the tense, but finally impotent masculinity of the soldiers.

SPIRIT

The seventeenth century was the great age of the martyr, and particularly the male martyr. Though suffering women saints like Catherine and Agatha are sometimes painted, it is the agony and ecstasy of men that inspire painters and patrons all over Catholic Europe. Counter reformers in the sixteenth century had argued that Church art should suggest the horror and the glory of martyrdom as powerfully as possible; the Jesuit Possevino even argued that the painter must experience the horror himself if he is to touch the heart of the spectator. Gilio da Fabriano criticized the rarefied grace of those mannerists who made, say, the flagellation of Christ look like a gymnastic routine. Instead, our hearts should be wrung by Christ's pain, by his body "afflicted, bleeding, spat upon, with his skin torn, wounded, deformed, pale and unsightly."[13] By the seventeenth century, painters follow his brutal prescription to the letter; the theme of flagellation—which dramatically reminds us that Christ was flesh and blood like us—is handled very emotionally. So Rubens paints Christ hurled to one side by the onslaught, his back torn and dripping with blood, his dazed face hardly human. Or the Spaniard Murillo shows him after his humiliating beating, as he crawls in exhausted stupor toward his clothes.

Many saints seem to be popular simply because of the extreme nature of their suffering. Bartholomew is skinned alive, Lawrence is grilled, John boiled in oil, Peter crucified upside down and Andrew on an X cross, and Erasmus disemboweled. The Church of San Stefano Rotondo in Rome was decorated by Pomarancia with scenes of almost unspeakable atrocity; and the Jesuits filled their novices' recreation

rooms at Sant'Andrea al Quirinale with images of contemporary martyrs and missionaries being stoned, strangled, gutted, crucified, burned or buried alive, "not only to honor their memories but to serve you as examples."[14]

That old favorite Sebastian takes on a new lease of life, a new and even more ecstatic sensuality than ever before. Given the limiting facts of his martyrdom—he was tied up for target practice—artists take intense pleasure in developing ingenious variations on his stance. The baroque Sebastian throws his head back langorously, or he slumps forward; he hangs from one arm, hangs from the other arm; he kneels or sits or collapses full length on the ground; he writhes with ambiguous pleasure as angels or holy women come to pull out his arrows.

The painter Ribera—a Spaniard working in Naples—produced a whole repertory of Sebastians that were widely copied. Then and since, Ribera had a reputation for sadistic cruelty; Byron joked that he "tainted /His brush with all the blood of all the sainted."[15] Pain and cruelty are certainly major themes in his secular and sacred work. In many paintings—like so many other baroque artists—Ribera glamorizes suffering; the Sebastian now in Berlin has a refined romantic beauty, and his anguish only adds to his sex appeal. In other paintings, Ribera goes for melodramatically horrifying effects; he shows, in repellent detail, the skinning of Bartholomew or Marsyas, or the agonies of the dying Cato clutching his own bloody intestines. But in at least a few works, Ribera shows an almost scientific interest in the physical and psychological effects of pain on victim and executioner. One of his most expressive paintings shows Bartholomew before the torture begins, as his naked body is pulled upright by ropes attached to a crossbar. Ribera notes, with painful understated honesty, the signs of strain on his face and body; and conveys something of the faith which sustains the saint against the casual brutality of his executioners. It is one of the very few seventeenth-century martyrdoms that forces us to think about what cruelty means. Ribera's unsensational realism allows us no escape into sentimentality or quasi-erotic fantasy.

"If this is divine love, I know it well," a French libertine exclaimed when he saw Bernini's famous statue of Saint Theresa in ecstasy. The comment could be made of scores of male martyrs, even of Christ himself. Sebastian yields submissively to God as the arrows pierce his

184

body, just as Theresa shudders in ecstasy as the angel from God stabs her with his javelin:

> and it seemed to me that, as he drew it out, he dragged me with it; but I felt entirely consumed by the love of God. The pain was so great that it drew moans from me, even though the ecstasy which went with it was so great that I could not have had the pain withdrawn—for the ecstasy was God himself. The suffering was not bodily, but spiritual, even though the body was involved in it.[16]

Mystics have always tended to use the language of bodily passion, or orgasm, to express the soul's ecstatic union with God. But Theresa, and many seventeenth-century Catholics after her, show a new self-consciousness about the paradoxical links between body and soul, between divine and human love. Painters and poets deliberately tread a tightrope between reverence and obscenity, as they play with the conceit that the martyr, the mystic, is like a woman who is penetrated and possessed by God, forcibly ravished into the joys of heaven.

Seventeenth-century Catholic art tries to make the unseen world palpable and immediately accessible; to whip the faithful into ecstatic identification with Christ and his saints. (Many artists were directly influenced by the meditative techniques deriving from Ignatius Loyola. Bernini, for example, regularly practiced his *Spiritual Exercises*, which encourage the believer to imagine in the fullest and most concrete detail, Christ's life and death, the joys of heaven or the pains of Hell. All the senses—including smell—are systematically deployed in the attempt to realize the spiritual.) Rubens, more than anyone else, succeeded in giving flesh and blood to the divine; Christ has never had a more convincingly and movingly human body than in his great series of Crucifixions and Lamentations. As Rogier de Piles commented later in the seventeenth century, the Christ in the Antwerp *Descent from the Cross* "has the appearance of a dead body if ever there were one," and the painter has "entered so fully into the expression of his subject that the sight of this work has the power to touch a hardened soul and to cause it to experience the suffering that Jesus Christ endured in order to redeem it."[17] But Rubens never doubts that Christ's dead body—sometimes pathetic, sometimes luminous and beautiful—is also the mystical body that is our hope of eternal life; that this flesh and blood is eaten and drunk every day in the Mass.

Few artists after Rubens manage this confident equation of flesh and spirit. Much seventeenth-century art seems to be straining, in John Knipping's words, to "restore a lost or diminished sense of holiness."[18] In the very splendor and insistence of baroque Church art, there are signs of a crisis of confidence. After a century of schism, the Roman Church was militantly reasserting its authority; and in so drastically excluding doubt and heresy, it cut itself off from some of the sources of its vitality. Even the most devout are imperceptibly touched by a growing rationalism and materialism. The body and the physical world are increasingly studied for their own sake, for their own irreducible reality. Loyola had expected that the devout Exerciser, having used his senses to support his faith, would in the end control and even deny them: if the Church so desires, he will declare that black is white. But it was often difficult to assign the senses just so much importance and no more. The body begins to assert its own claims.

Many seventeenth-century painters seem to have a sneaking sympathy with one of their favorite characters, the disciple Thomas, who doubted that Christ had risen, doubted everything but the evidence of his own senses: "except I shall see in his hands the print of the nails . . . and thrust my hand into his side, I will not believe." At the same time, artists strain to spiritualize the flesh. Bernini's *Daniel* is a good example. As solid and athletic as the sculptor's earlier *David*, he is a very different hero. Half-kneeling, his arms lift toward heaven as he prays for deliverance from the rather appealing lion who licks his foot. His pose is adapted from the central figure in the Laocoön group, and Bernini's drawings reveal the stages by which he turned that intensely physical death struggle with the serpent into an image of yearning spirituality.[19] Daniel concentrates not on any earthly opponent, but on the invisible God who will consume and so save him. He actively struggles to submit, summons up all his bodily strength in a desperate effort to go beyond the body.

Comparing the religious art of the Renaissance and the seventeenth century, Emile Mâle wrote that "there, all was peaceful love, serenity, harmonious union of body and soul; and here, all is transport, aspiration, painful effort to escape from human nature and to become absorbed in God."[20] Baroque art glimpses divinity, not in everyday life, but in extremes. It portrays the most heightened states of consciousness; in the search for an overwhelming, sensational

186

spirituality, it looks for those kinds of bodily experience—pain or orgasm—so intense that they seem to take us out of the body. The body is starved or tortured into ecstasy. Baroque saints and martyrs, existing only too solidly in the flesh, yearn to melt or dissolve, to levitate, to be overwhelmed and annihilated. Still very much in the body, they are intoxicated with an impossible dream of going beyond it.

REALISTS

At the very beginning of the seventeenth century, Caravaggio brought a new realism—psychological as well as physical—to the nude. The painter took up an aggressively anti-classical stance, cultivating an image of himself as an iconoclastic naturalist who cocked a snook at authority and went his own way. According to the disapproving Bellori, he

> not only ignored the most excellent marvels of the ancients but he despised them, and nature alone became the object of his truth. Thus when the most famous statues of Phidias or Glycon were pointed out to him as models for his painting, he had no other reply than to extend his hand toward a crowd of men, indicating that nature had provided him sufficiently with teachers.[21]

Caravaggio is interested not in the refined grace of the classic nude, but in the bodies of peasants or laborers or street boys. By casting these ordinary people as chief actors in his mythologies and religious dramas, he makes us see and experience the human body in a new way. In his early work he mocks the sexual hypocrisy of so many idealized nudes; his religious painting challenges the class basis of the classical tradition.

The boys in his early paintings—done in the 1590s when he was still struggling to establish himself in Rome—mock all our conventional expectations. No hint of idealizing softens their sex appeal; they openly proposition the spectator. The *Amore Vincitore* is a good example; the theme is conventional enough: a Cupid treads underfoot the symbols of human achievement in war, music and learning. But this victor is no abstract love but a kid off the Roman streets. He has little in common with the blandly pretty Cupids by Bronzino or Parmigianino, and the absurd stage-prop wings only stress his very individual come-on. Caravaggio dwells on details—on the creases at his waist, the contrast between the chunky thighs and the undeveloped child's penis. The boy grins cheekily, posing

187

provocatively with one thigh raised as if he were climbing into bed: the invitation could hardly be more direct.

The youthful *St. John* is just as blatantly sexy. A solidly built adolescent, his flesh, as a seventeenth-century writer remarked, "could not have been more real when he lived."[22] He poses like one of Michelangelo's *ignudi*, but simply to show off his body and genitals; he flashes an insolently inviting smile over his bare shoulder as he turns away from embracing his ram. (The lamb which traditionally accompanies the saint has grown up into a large and horny ram.) Caravaggio is surely making a sardonic comment on so many other versions of the saint where a repressed sensuality passes for spirituality. (Having seen this mocking nude, we can hardly look at, say, a St. John by Caravaggio's contemporary Guido Reni, with quite the same innocent eye.)

Bacchus is a favorite subject with Caravaggio, and again, he undermines the spectator's classicizing expectations by presenting the god as a seedy and sensual pickup. This, he seems to suggest, is the only reality Bacchus has nowadays. In one painting, Bacchus is plump and feline, made up to look as porcelain pretty as any geisha girl; in another he is raddled and dissipated, casting a side-long glance over a flabby yellowish shoulder. In still other paintings, Caravaggio abandons all classical or religious disguise, treating the boy as if he were a still life. These sexy youths—all pouting lips and disheveled hair, with shirts slipping off their creamy shoulders—are straightforward homosexual pinups. As ripe and smooth as the fruit they carry, they offer themselves—for a price—to be plucked and consumed.

Contemporaries report that Caravaggio painted some of these early figures with the help of a mirror. Even if they are not actual self-portraits, they certainly reflect Caravaggio's own temperament, tastes, and preferred companions. He was working also for patrons who shared those tastes. The Marchese Vincenzo Giustiano owned the *Amore Vincitore*, keeping it veiled behind a green curtain; showing visitors round his great collection, he would bring them finally, as climax and mocking comment on the rest, to this painting. Another of Caravaggio's most important patrons, Cardinal del Monte, used to give parties where transvestite singers and dancers provided the entertainment. Caravaggio was catering to an openly homosexual subculture in Rome; sophisticated, confident and wealthy enough to

indulge its fantasies and to develop its own codes and ironies. The tone of Caravaggio's work for this group is distinctive. It is, for the first time, recognizably camp, in its ironical and theatrical subversion of sexual stereotypes.[23]

Caravaggio's boys are based on the half-length portraits of nearly nude courtesans holding flowers and fruits that were popular in the sixteenth century; but they are more theatrically seductive than any woman. They pout and pose in a parody of femininity, imply that anything a girl can do, a boy can do better. A few other painters enjoyed the same kind of sexual role reversal; Lanfranco, for example, painted a naked boy posturing lazily on a bed in imitation of Venus. But occasionally at least, Caravaggio touches on something of deeper interest: through his provocative ironies runs a recognition that glamor is something created by the right props, by lighting or makeup or accessories, that femininity as we know it is a matter of role playing and artifice.

In his religious art, Caravaggio challenges social as well as sexual convention. He sees St. Matthew as a clumsy peasant with work-worn feet and awkwardly crossed legs; St. Jerome is a convincingly tired old man; and it was rumored that his dead Virgin was based on a drowned whore who had been fished out of the Tiber. Kenneth Clark has argued, rightly, that Caravaggio was more indebted to tradition than he or his critics were prepared to admit, and claims that the dead Christ in Caravaggio's *Entombment* is simply an antique nude with "the coarse hands and feet which were his usual declaration of independence."[24] In fact, the difference between the finer skin of the usually covered torso, and the coarse, veined limbs, is both moving and realistic. The painting is deeply moving simply because Caravaggio has put an ordinary, not very beautiful body, into the classic tragic pose.

The anger and excitement that Caravaggio aroused in his contemporaries suggest that he was doing something genuinely new. Genre pictures showing picturesque peasants and other "low" characters had been popular with wealthy connoisseurs for years; but Caravaggio, by putting those ordinary people into his sacred dramas, was making a radical break with tradition. His art challenges the assumption that the well-bred and well-fed are guaranteed Heaven as well as earth, challenges the equation of aristocratic refinement with spiritual worth.

Caravaggio's art, as Rudolf Wittkower has commented, is genuinely popular, of and for the people.[25] Ironically, it was mainly fellow artists and a small group of connoisseurs who recognized his originality and bought up the works often rejected by the original commissioners. The lower clergy and the mass of the people apparently found his art disconcerting and vulgar. The *St. Matthew*, for example, was criticized as indecorous and unsaintly, and the *Madonna dei Palafrenieri* as not just indecorous but indecent as well.

It is certainly an uncomfortable painting, though not indecent in any obvious way. The Christ child is insistently naked and the full-breasted Madonna young and sexy, but there is none of the slyness that Parmigianino, say, gave to the same figure. The painting has, however, an intensity that the iconography does not explain. The theme was common after the Counter Reformation: Christ and the Virgin tread down the serpent of heresy while Mary's mother, St. Anne is included as patron saint of the Vatican Grooms who commissioned, then refused, the painting. But—as with Leonardo's more famous *Virgin with St. Anne*—the relationship between the figures seems to reflect something personal to Caravaggio; it is disturbing because it has the quality of some half-forgotten trauma brought painfully to light. Mary holds her naked son in a grip at once loving and nervous, and he seems to have caught her anxiety. Beside them, the older woman stands watching, a malevolent shadow presiding over a symbolic castration. The same two women appear in other paintings in more openly destructive roles. The young and attractive Judith slices vigorously through the neck of Holofernes, a troubled Salome contemplates the severed head of St. John; in each case, the girl is accompanied by the same dark old witch. The two figures hint at Caravaggio's divided feelings toward the mother, toward women, and at the effect of those divided feelings on his own masculinity.

Caravaggio, it is often remarked, returns almost obsessively to the theme of beheading, and handles it with an intensity that is psychological rather than strictly spiritual.[26] The executioner is usually another man, not a woman. Violence between men excites and disturbs Caravaggio, and his fascination with the exchange of dominant and submissive roles is the source of some of his most powerful work. Contemporaries said that the painter gave his own features to the great bearded head of Goliath dangling from the hand of

a gravely beautiful David. But the sexy young boys he loved to paint in his early years have lost their sexual confidence. In several paintings, St. John sits sullen and somber, staring blankly as if foreseeing the violent defeat awaiting him in the still distant future. One of Caravaggio's most impressive paintings shows that boy's eventual death. Salome is a forgotten background figure, no more than a catalyst for the tragic but inevitable violence between the men. A brilliant light isolates and links the victim and the naked executioner leaning over him, and Caravaggio signs his name in the blood running from the victim's neck.

The same virile executioner appears as the murderer of St. Matthew. Caravaggio insists on his brutality, as he stands, sword in hand, over the helplessly protesting old man. But the golden light lingers on his stocky body and glamorizes him. The spectators, frozen in shock, react as ambiguously as the painter. A small boy starts up, terrified but unable to look away; his face is frozen in that silent scream so common in Caravaggio's work and which always suggests excitement as well as fear. It is as if the pattern of the boy's emotional and sexual life is being set in that traumatic instant; as it was set, long ago, for the bearded man—sometimes said to be Caravaggio himself—who looks back from the shadows at that brutal and familiar drama.

Caravaggio was only thirty-seven when he died in 1610. Though his techniques—his brilliant contrasts of light and shade and his love of dramatic moments—were widely copied, only a very few painters achieved anything like his radical realism. Velasquez rarely painted the nude, but several paintings—coinciding with his trip to Italy in the 1620s—treat classic figures with some of Caravaggio's sardonic humor. His plump, sly Bacchus sits in the middle of a crew of cheerfully squalid drunks who might have stepped out of any Spanish tavern. Their grinning faces and tattered brown clothes are observed sharply, realistically, with compassion. The smooth androgynous god and his reclining companion are like visitors from another planet. Nudes from high art are placed in the everyday world, and the clash of styles is the point of the painting. There is a similar satiric edge to the painting of Apollo visiting the forge of Vulcan. Velasquez makes pointed comedy out of the contrast between the blond god, prettily pompous and bathed in unconvincing radiance, and the workmen who pause in surprise—as well they might—at this unlikely intruder in the real world of work. In both paintings, Velasquez is asking

ironic, but ultimately serious, questions about the continuing relevance of classical myth to contemporary reality.

Perhaps the most interesting of his "classic" nudes is his seated *Mars*. The great war god is obviously a tired, not very fit studio model. His pose vaguely recalls one of Michelangelo's *ignudi*, but he is unheroically slumped, his head propped on one hand as if he were bored with sitting still. The bright pink and purple drapery across his groin, the stage armor at his feet and the magnificent helmet pulled low over his gloomy mustachioed face, all underline his very ordinary humanity. Seventeenth-century artists were always complaining about the inadequacy of their models, whose flawed flesh fell so far short of the idea of beauty. Velasquez, in a sense, answers those complaints: the model—flabby, hungover, rather depressed—is as interesting, as worthy of our closest study, as any imaginary god.

A drawing from Rembrandt's studio shows a similar sympathetic interest in the model for his own sake. Rembrandt's biographer Arnold Houbraken complained that though the artist took endless pains with his faces, his studies of the nude were hasty and imperfect. This sketch is certainly disconcerting to an eye accustomed to comparing the human body to an antique statue. The boy is plain and gawky; probably one of Rembrandt's students, he stands awkwardly, as if uncertain how to dispose his limbs.[27]

Classical themes are less important in Rembrandt's work than that of most of his contemporaries. He occasionally parodies Greek myth; his Ganymede, for example, is not the pretty boy who had enjoyed such popularity ever since the Renaissance, but a cross, squalling baby who is obviously giving the eagle a hard time and is literally pissing in his panic and excitement. And when he does paint biblical or antique dramas, the imperfect actors are usually more important than their roles. Diana or Susanna or Bathsheba are homely and heavy, Christ is skinny and unheroic: in their ordinary, unidealized flesh, they are far more interesting than the myths they embody.

IDEALISTS

Many contemporaries were genuinely outraged and horrified by realists like Rembrandt and Caravaggio. For the Spaniard Carducho, for example, Caravaggio loomed up like an anti-Christ, prefiguring the ruin of all art: a threat to morality, religion, the social hierarchy itself. Classicists like Bellori insist, more aggressively and pedantically than

ever before, that the artist's sole concern is with ideal beauty. Toward the end of the seventeenth century, the new French Academy laid down a rigid program for art students: the budding artist must start by copying drawings, move on to classical casts, and only then, when his taste is fixed and his imagination stocked with "ideal" forms, is he allowed to sketch the male nude posed after the antique.[28]

This anxious formality is in part a response to a new and disorientating sense of living in a diminished, secularized world. The Renaissance had tried, enthusiastically, to rival the ancients, and in Michelangelo believed it had succeeded; seventeenth-century artists often express fear that their greatest achievements amount to little compared with the past. Even Rubens, with all his material and spiritual confidence, complains that "human stature may be proved . . . to have gradually decreased," the body grown puny and pitiful. We need to study antique nudes because "we of this erroneous age are so far degenerate that we can produce nothing like them."[29]

Art is treated with a reverence verging on absurdity. (Bellori cannot believe that the Trojan war was fought over a flesh-and-blood woman; he insists that the beauty that launched a thousand ships and toppled the topless towers must have been a *statue*.) Only art elevates man above his brute nature; it provides his only intimations of order, perhaps his only revelations of divinity. Increasingly, men look to art to compensate for the frustrations of real life; they cling to it as a lifeline in a confusing, changing world.

Poussin, more than any other living artist, kept the great classical tradition alive. According to Sir Joshua Reynolds in the next century, "Poussin lived and conversed with the ancient Statues so long that he may be said to have been better acquainted with them than with the people about him."[30] Unlike most seventeenth-century painters, Poussin did little large-scale public work. His easel paintings were designed to be contemplated and "read" by a small circle of educated collectors in Rome and France, most of them from the solid middle class. Poussin learnedly and lovingly reconstructs a lost world, more beautiful and orderly than the real one; a world that only exists – only ever existed – in art. He treats Ovidian myth, classical history and sacred stories with the same gently poetic nostalgia.

The beauty of his nudes depends on their artificiality, on their distance from anything we know. His drawings from life are vigorous and spontaneous; his finished canvasses involve a process of

"classicizing" his first energetic shapes, a disciplining of the body into almost surreal serenity. In his later years, we are told, Poussin gave up direct drawing from the nude in case it interfered with his inner vision; he would experiment with tiny wax models on a stage, then paint from larger wax figures.[31] Even when his nudes dance or twist in Bacchanalian revels, they are treated like still lifes. Joy and lust exist in Poussin's work, and so does grief, but they never disturb his tranquil grace. Christ falls back in the arms of his mourning friends, Narcissus lies dead in an Arcadian landscape; neither body evokes more than a wistful regret. Within the consistent, self-contained landscape of Poussin's art, motion and emotion are refined and stilled, all passion is transformed into abstract pattern.

Most late seventeenth-century painters and sculptors, lacking Poussin's subtlety and self-consciousness, simply serve up the same old stereotypes with a palpable loss of conviction. Hercules labors on, making propaganda for princes and potentates all over Europe, but not even a painter with Lebrun's feeling for physical energy can give him much life. Louis XIV adopted the sun god as his own glamorous symbol, but though there are Apollos aplenty at Versailles, most are cut to a predictable pattern. Girardon's life-size group is typical enough: the Belvedere Apollo sits complacently in the middle of a bevy of plump nymphs doing the classical equivalent of bringing him his pipe and slippers. The only deity who goes from strength to strength is Venus, and she is confined to the boudoir, to a luxurious art whose sole and exclusive concern is sex.

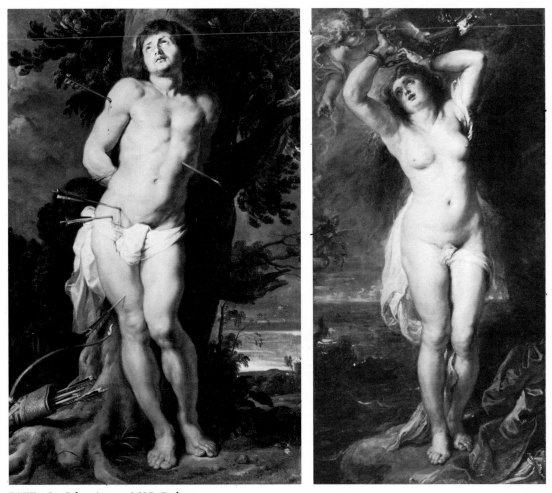

LEFT: *St. Sebastian, c.* 1615, Rubens
RIGHT: *Adromeda,* 1638, Rubens

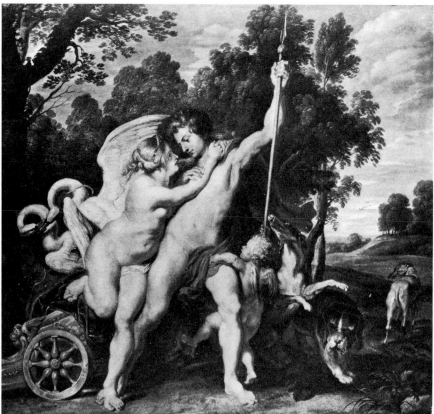

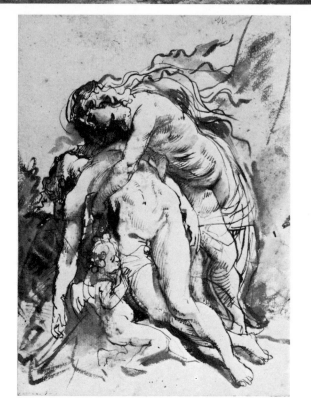

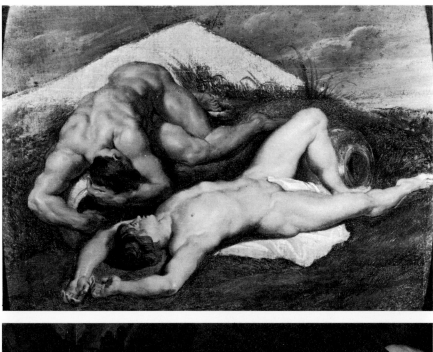

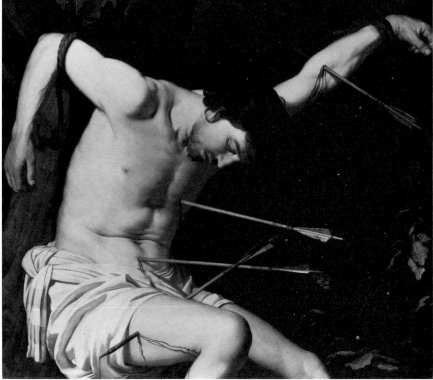

THIS PAGE: TOP: Study of Two Male Nudes, Rubens
BOTTOM: *St. Sebastian, c.* 1623, Gerrit van Honthorst

OPPOSITE, TOP: *Venus and Adonis, c.* 1615, Rubens
BOTTOM: *Venus Lamenting the Dead Adonis, c.* 1612, Rubens

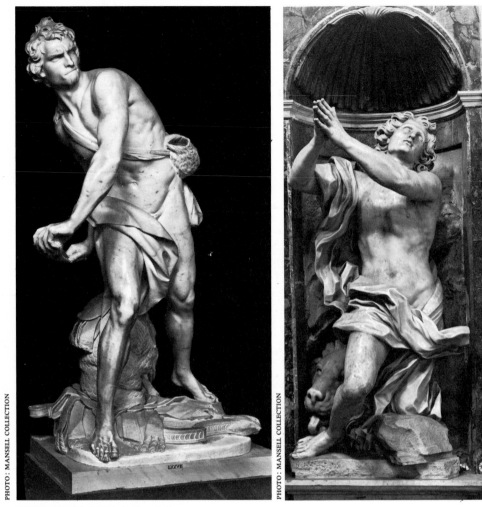

LEFT: *David*, 1623–4, Bernini
RIGHT: *Daniel*, 1655–61, Bernini

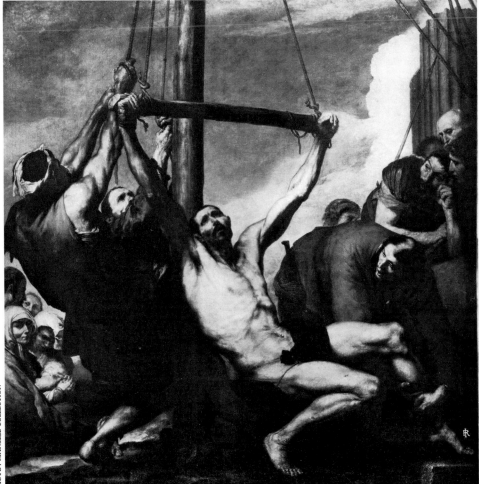

St. Bartholomew, c. 1638, Ribera

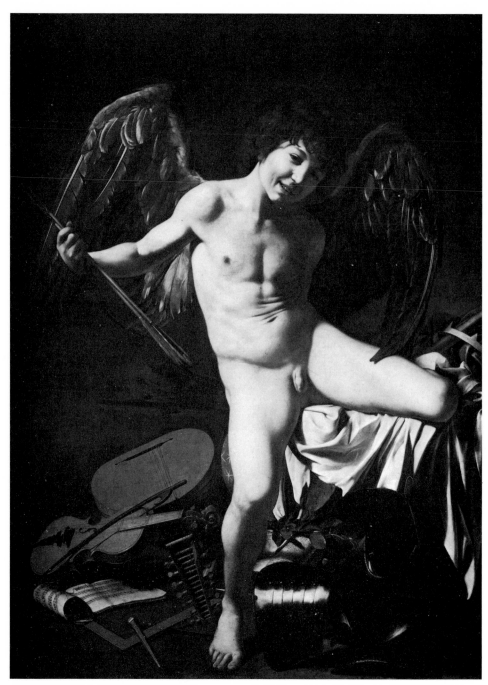

Amore Vincitore, 1598–9, Caravaggio

LEFT: *Silenus*, drawn from an antique statue, *c.* 1600–8, Rubens
BOTTOM: *Study of a Sleeping Boy*, *c.* 1585, Ludovico Carracci

RIGHT: Male Nude, *c.* 1646, studio of Rembrandt
BOTTOM: *Vulcan's Forge*, 1630, Velasquez

Mars, 1639–42, Velasquez

Revolutionary Eros

IN EIGHTEENTH-CENTURY ART, there are signs of a new and modern self-consciousness about nakedness. People are excitedly or uneasily aware that the nude is an *undressed* body. It is not nudity but clothes that excite and stimulate. Clothes are fetishized, and fabric—the sheen of silk, the deep pile of velvet, the delicate froth of lace—arouses artists more than mere skin. Rococo is the art of striptease. Where earlier nudes displayed their bare bodies directly, their rococo sisters excite by coyness, by the pretense of modesty. Far more often than ever before, the female nude is shown dressing or undressing. The spectator is tantalized by glimpses up skirts; shifts slide off pearly shoulders, and bodies are disposed on suggestively crumpled draperies.

The calculated unveiling of (young) female flesh is one thing. Male nakedness is more likely to mean embarrassing exposure. A Watteau drawing—a sketch for a conversation piece—provides a disturbing glimpse of the bodies beneath all those exquisite eighteenth-century clothes. The elegantly-coiffured seated man leans forward, half-turning in animated chat. Yet stripped of his elaborate silks and satins, he is hardly more than a shadow. He clearly lives at a great distance from his soft, bulky, unexercised body. Only clothes can supply social identity, gender, vitality.

Fashionable dress, with its subtle and constantly shifting messages about status and wealth, is *the* major theme of eighteenth-century art, at least in France. The obsession with fashion reflects, as J. C. Flugel has argued,[1] a fluid situation in which one class, the bourgeoisie, challenges an established but unstable aristocracy, increasingly

preoccupied with image rather than power. It is hardly surprising that in the latter part of the century, increasing numbers of moralists and reformers bitterly attack contemporary clothes as disfiguring, extravagant, as the symbol of everything phony and corrupt in their society. They want to denude man of his false sophistication and bring him back to a more natural state. For late eighteenth-century philosophers, the "classic" nude, which increasingly means the Greek nude, is important because it signifies a whole way of life, nobler because simpler than their own. They write nostalgically of the great days of Greece, when the body was beautiful because it was not deformed by disease or constricting clothes or civilized self-indulgence; when, free of false shame, men exercised naked. The antique nude is often associated with that other eighteenth-century dream of the noble savage. "My God," exclaimed the American painter Benjamin West on first seeing the Apollo Belvedere, "how like it is to a young Mowhawk warrior." And a member of Cook's expedition to the South Seas rhapsodized over the Tahitians as "models of masculine beauty" worthy of Phidias or Praxiteles.[2]

The idea of the nude, safely distant in time and space, was one thing. In practice, artists and audiences were increasingly uncomfortable with the unclothed body. Canova's Theseus was acceptable enough: sitting with self-conscious nobility on top of his dead Minotaur, he seemed respectably remote from everyday life. But those brave artists who tried to portray *contemporary* heroes in the nude ran headlong into growing public prudery and even prurience about nakedness. Diderot and his friends had the sculptor Pigalle carve a nude portrait of the aged Voltaire, a way of asserting that he rivaled any ancient philosopher; it highly amused its subject—and embarrassed the public. Canova managed to persuade a reluctant Napoleon that only heroic nudity could do justice to his imperial majesty, but the great man—with reason—took against the finished work. It stands now in the Wellington Museum, in its bland and chilly timelessness very dated indeed. And when the ladies of England commissioned an eighteen-foot-high Achilles "without a scrap of clothing" to be erected in Hyde Park as tribute to the Iron Duke, Wellington, London society was both amused and scandalized.[3]

Clearly, the nude could no longer be taken for granted as a public symbol, rooted in classical and Christian culture, of heroic virtue and man's aspiring spirit. More and more, nudity is the focus of private

erotic fantasies. Many late eighteenth-century neoclassicists, hostile to the sexual license and hedonism of Versailles, seem as preoccupied with sex as the most sensuous rococo decorators—and far more nervous about it. A growing bourgeois uneasiness about the body helps explain why, in a period on fire with new ideas and shaken with presentiments of radical change, most nudes turn out so boring. As Hugh Honour has argued, the neoclassic nude "was accepted only at its farthest remove from the naked human body."[4] All signs of organic life—veins and sinews—are anxiously smoothed away; petrified in white marble, respectably clothed in moral or allegorical significance, the nude is idealized almost to death.

BOSOMS AND BOTTOMS

Rococo decorative art scales down the Olympian gods, adapting them to the refined and intimate luxury of the boudoir. Early eighteenth-century artists conjure up shimmering fairytale worlds inhabited by youthful lovers: Bacchus and Ariadne, Venus and Adonis, Diana and Endymion, Cupid and Psyche. One couple is interchangeable with another. The ancient myths are no more than pretexts for painting doll-like girls, and sometimes boys as well, half dressed and carefully disheveled. The rococo world is cloyingly feminine, and the male nude is feminized along with everything else.

But this is a new kind of femininity, childish and devitalized. Boucher, whose girls epitomize the fashionable ideal, has obviously been influenced by Rubens. But he slims down, prettifies, those robust and fleshy Flemings. Boucher's nymphs and shepherdesses and goddesses are hardly more than children. With their rounded baby faces, their neat bottoms and bosoms, they recline in confidingly available poses. Coy, compliant, meltingly attractive, they are always modestly aware of the gaze of a presumed male spectator.

In a way, this was women's art. Women bought, commissioned and even painted it. Some of Rosalba Carriera's pastel girls, doe-eyed and scantily clad, are as sexy as anything by Boucher, and so, for example, is Elizabeth Vigée-Lebrun's modestly voluptuous semi-nude Bacchante. "Women reigned then," Vigée-Lebrun asserted of *ancien régime* France; "the revolution dethroned them."[5] Certainly the world of fashion—whether the bourgeois pursuit of aristocratic refinement or the aristocratic ritualizing of pleasure—was increasingly dominated by women. Art is seen as an integral part of fashion

and of interior decorating, and is therefore in a new way the preserve of woman. She is its central theme, and her tastes and sentiments are enshrined and flattered. As early as 1713, the English moralist Shaftesbury could complain that "whilst we look on Paintings with the same eye, as we view commonly the rich Stuffs and colour'd Silks worn by our Ladys, and admir'd in Dress, Equipage, or Furniture, we must of necessity be effeminate in our Taste."[6]

The eighteenth century allowed women considerable latitude—in the intellectual life of the salons, as writers and painters—as long as they maintained a certain image. As Diderot remarked of the neglected painter Lisiewska-Therbusch, it was not talent she lacked, "it was youth, it was beauty, it was modesty, it was coquetry; one must be ecstatic over the merits of our great male artists, take lessons from them, have good breasts and good buttocks. . . ."[7] Painters like Vigée-Lebrun and Angelica Kauffman enjoyed an unprecedented social success partly because—as their idealized self-portraits indicate— they managed to combine talent with feminine charm. For the first time, women artists are praised for bringing a distinctive "feminine sensibility" to their work.[8] (Some of, say, Vigée-Lebrun's flattering portraits of upper-class clients certainly suggest a sympathetic, insider's understanding of how hard women work to sustain, with clothes and cosmetics, their graceful femininity.)

A contemporary critic praised Kauffman after her 1769 exhibition because "her women are most womanly, modest and loving, and she conveys with much art the proper relation between the sexes, the dependency of the weaker on the stronger, which appeals very much to her masculine critics." But those same critics also dismissed her art as *merely* feminine, her anatomy as incorrect, and her male figures as insipid and effeminate. ("Were she married to such males/As figure in her painted tales/I fear she'd find a stupid wedding night.")[9] Like other women painters, Kauffman was caught in an absurd double-bind; for the one thing that would strengthen her drawing—study from the nude model—was of course unthinkable. Diderot was one of the few critics to recognize how women painters were confined and handicapped by false notions of delicacy. Posing for Lisiewska-Therbusch, he realized that she was having difficulties getting the anatomy right, so he went behind a screen and stripped. "I was nude, but completely nude. She painted me, and we chatted with a simplicity and innocence worthy of earlier times."[10] But Diderot goes

on to refer obliquely, even coyly, to the embarrassing possibility of an erection; and his tone—proud of his daring, a little self-conscious— suggests that he was going against the tide of increasingly narrow notions of propriety.

Much rococo art celebrates the triumph of woman—and reminds her that her true empire is to please. Boucher did some of his most interesting work for Madame de Pompadour, for nearly twenty years the mistress of Louis XV, and who wanted an art expressing and even advertising her gracious and accommodating femininity. Coming from a wealthy banking family, she created for the King, in his stiffly feudal court, a luxurious but cosy bourgeois domesticity. She was a highly intelligent woman who feared seeming too clever, an ambitious woman who pulled strings behind the scenes, a mistress who never much enjoyed sex and was half-relieved when *amour* shaded off into *amitié*. She connived in supplying the King with a series of pretty lower-class lays who could never threaten her own almost wifely position; she suppressed illness, miscarriage, grief at the death of her only child, depression—anything that might shake the romantic fiction on which her whole life depended.

I suspect that de Pompadour appreciated Boucher because his work caught, albeit in a heavily disguised and prettified way, some of these ambiguities. In many of his paintings, two contradictory impulses seem to be at work: the girls exist only for men's pleasure, but at the same time, they are narcissistically withdrawn into their own wholly feminine world of flowers and doves and pretty children. Michael Levey has described Boucher's art as a kind of "mythological or pastoral shop window" where the girls, "objects of *grand luxe*,"[11] are on display for the male. That is clearly true. But the paintings may also capture the secret fantasies of the woman who, confined by her femininity, falls in love with her own created illusions, and finds her greatest sexual excitement in contemplating, and allowing others to contemplate, her own beauty.

Boucher hardly *sees* the male body at all, and even his more muscular males seem to be patterned and posed after his girls. His art echoes the fantasies of the woman whose whole life is centered on a man, but who in revenge never really looks at him, allows him no independent life at all. In Boucher's large painting *The Rising of the Sun* (it belonged to Pompadour and was interpreted as a discreet and flattering allusion to her relations with the King) the nearly nude

Apollo draws himself proudly erect, as if to assert his virility as he sets off for a hard day's work shining. In the companion piece, *The Setting of the Sun*, the god returns eagerly to the soft and soothing world of the women. If the nymphs wait on his pleasure, the painting hints at their compensatory dream—which is that the man only exists when he is back home again, re-absorbed into their soft and loving femininity.

In several paintings, Boucher even makes covert fun of the male lover. So Vulcan is a bit of a ninny, gazing hopelessly up at his complacent and self-absorbed wife. In another work, the jealous Vulcan discovers Mars in bed with Venus; the two men, their bodies slightly out of focus, glare at each other in impotent rage, while Venus lies back, totally involved in her own pearly flesh, which clearly gives her far more pleasure than any man. Again, when Boucher paints *Pan and Syrinx*, we only see the head and shoulders of the god pushing hopefully through the reeds; the true lovers are the two identical girls, petite and curvy, who lie facing one another. They are not particularly startled by the lustful god, and clearly no male is necessary to their pleasure. The key to Boucher's work is his rendering of Jupiter's seduction of Callisto; the god takes on a woman's body to make love to the nymph who is indeed, like all Boucher's girls, far more likely to respond to a body which is a mirror-image of her own.

Many eighteenth-century women, encouraged to be narcissistic and childlike, clearly preferred the adolescent boy—pretty, unthreatening—to the mature male whose sexual demands might shatter the auto-erotic dream in which they lived. So Madame de Pompadour decorated her rooms with Falconet's sauve statuettes, or Clodion's lively porcelains of fauns and shepherds and satyrs who are charming and cheeky rather than lustful. Much rococo art has the fevered sweetness of adolescent sexuality: polymorphous pleasure indefinitely prolonged, sensuality expressed in romantic gazes and caresses and foreplay rather than intercourse.

The one male nude who is everywhere in rococo art is of course Cupid. He lurks in gardens, plays prettily in boudoirs, hovers in ceilings; he spies on lovers, tumbles around his mother Venus and even tries to make love to her. The sculptor Bouchardon carved an adolescent Cupid making his bow from the club of Hercules, and the figure is sometimes taken as a symbol of the century's delight in decorative grace at the expense of virile strength. To modern eyes, the swaying child with his artfully turned head and carefully hidden

genitals is likely to seem excessively sweet and sentimental. But the court at Versailles found it too realistic and banished it to a distant grotto. The boy, it was said, looked more like the street urchin Bouchardon had used as a model than any god of love.

More characteristically, Cupid is a baby. A typical and very famous example is the marble *Amour Menaçant* made by Falconet for Madame de Pompadour. His small body is beguilingly soft and sweet; but the knowing expression—he holds one finger warningly to his lips while slyly withdrawing an arrow from his quiver—hints that he may indeed be a menace. Michael Levey makes the interesting suggestion that this "is such an effective piece of sculpture because it is so serious. Other gods and goddesses might continue to be carved as a mere fashionable continuation of mythology, but this god is—as the century fully recognized—real."[12] But the fascination with this particular image, with love and sex embodied in a baby, remains a puzzling phenomenon.

The idea of the baby who is the most powerful of all the gods is of course an old one. But where the Renaissance *putto* had that exuberant amoral sensuality which belongs to childhood, eighteenth-century Cupids are projections of adult lusts and act out parts in highly sophisticated sexual dramas. The jaded hedonist who is only stimulated by the very young, even pre-pubescent, body may take his fantasies still further. Cayot's marble *Cupid and Psyche* shows, with conscious perversity, the rounded bodies of babies tense with sexual anticipation and excitement. Cupid's hand is on her stomach, and their lips are breathlessly parted as their naked bodies seem to move together. As Levey again points out, the scrap of cloth between Psyche's chubby thighs is an added titillation, a pretense of modesty about "the sex of one barely possessing sex."[13] The two figures are pornographic in their appeal, their embrace far more salacious than the most explicit sexual act between adults.

Again, it is Boucher who offers a clue to the complex roles played by Cupid in the eighteenth-century cult of love. Naked babies tumble everywhere in his paintings, at first glance part of that all-feminine world he conjures up with such charm and conviction. As silky soft as the girls they play with, the Cupids hint at the deep and comfortingly sensual pleasure a woman may find in a baby's body. But at second glance there is something wrong. For one thing, the winged babies are almost as large as the girls, and their playful gestures can suddenly

turn menacing. Their bodies are often un-babylike, even misshapen; their squashy faces and heavy limbs, and the blood red which Boucher uses to outline their joints and genitals, can make them seem almost monstrous.

Cupid is certainly the most masculine—most mobile and energetic—character in any of these paintings. In one work, he hovers above and along the body of Venus, as if he were about to make love to her; in another, he has been captured by three small nymphs and lies back in a lordly and unchildish pose, thoroughly enjoying the attention he is getting. Cupid is a symbol of male sexual energy— perhaps of the male penis—but the male infantilized, reduced to a playful and manageable shape. The baby god, disciplined by his mother Venus, supports the fiction that a woman triumphs in love, that she can trifle with a man's lusts as she would play with a baby. At the same time, Cupid is the male child whom she cannot permanently control or keep in her feminine world. And Cupid may even be the baby whom the woman wants, and does not want; he is a covert reminder that pregnancy, a real baby, is a possible and possibly disastrous consequence of the game of love.

GODS THAT FAILED

"I have seen enough of bosoms and bottoms," proclaimed the philosopher Diderot, enough of an art that corrupts taste and panders to the lower emotions.[14] All through the 1760s, crystallizing a radical change in taste, he singled out Boucher for special attack—inveighing against those endless Cupids flaunting their chubby pink posteriors, those commonplace and indecent nudes prostituting their powdered charms. Their seductive sensuality seemed to Diderot to symbolize the decadence of contemporary art and of the corrupt and exhausted society which fostered it.

This note of disgust with rococo—shallow, frivolous, aristocratic, *feminine*—sounds louder and louder in the course of the eighteenth century. Philosophers like Diderot, moralists like Rousseau, classical scholars like the German Winckelmann all urged the artist to come out of the boudoir, to stop wasting his talent on the whims of libertines and fashionable women, and assume public responsibilities. A "masculine" style, austere, objective, rational, depending on clear line, is opposed to the melting colors and silky textures of rococo. The great male nudes which had inspired artists ever since the

Renaissance, from the Apollo Belvedere to the Laocoön, were reinterpreted in narrowly moral terms: they show man as he might be, natural, noble, chaste. In painting, the amorous deities were (temporarily) retired in favor of the philosophers, law givers and soldiers of the ancient world—heroic models of civic virtue and courage.

All over Europe, writers and artists turn back to the classics with renewed fervor; hoping to remake the world, they return to first principles and seek a source of regneration in a nobler past. The French Crown itself, uneasily aware of public hostility to the Versailles of Louis XV and Pompadour, began to commission art on classical themes with an edifying patriotic message. Increasingly, the educated and ambitious bourgeoisie appropriated classical culture for their own ends. And in the late 1780s, as discontent spread and gathered in France, they used that culture as a battering ram against the old order. Reformers on the edge of becoming revolutionaries turned back to their school books: especially to stories about Republican Rome and ancient Sparta, seen as societies constructed on more rational and equitable principles, where men lived simply and frugally, putting public good before private pleasure. The Jacobins themselves would assert their revolutionary identity in terms and images derived from the ancient world. Brutus, who ordered the execution of his own sons for the sake of the state, was a favorite hero; and those who gave their lives for the Republic—Lepeletier, Marat—were identified both with Christian martyrs and with the self-sacrificing Stoics of Republican Rome.[15]

More than any of his contemporaries, David made the antique past speak for the revolutionary present. His *Oath of the Horatii*, ironically commissioned by the Crown and exhibited in 1785 to enormous public enthusiasm, was the great public work reformers had been waiting for. It exactly caught the mood of France, wrought up on the verge of a great revolutionary upheaval. In clear, concentrated and dramatic terms, David presents three young brothers, moving as if they were one man, pledging their lives to the violent service of Rome. The focus of the painting is their rigidly outstretched bare arms, rising in ardent salute toward the sinister gleam of the swords held up by their father. The men in the painting are tense, exalted by the prospect of combat; their women droop tearfully to one side, foreseeing bloodshed and powerless to prevent it. In the *Horatii*, David celebrates a disciplined

fanaticism that intoxicates men till they are ready to sacrifice anything, even their nearest and dearest, for an idea. (Legend had it that one of the brothers killed his own sister for her treacherous love of an enemy of Rome.) In the *Brutus*, painted four years later on the very eve of revolution, the hero's wife dominates the painting; she protests hysterically as her dead sons are carried into the house, but her love is powerless against Brutus's unflinching and single-minded patriotism.[16]

In David's early works, masculinity is a metaphor for everything public-minded, rational and revolutionary; energy and virtue are concentrated in the male. He divides the sexes rigidly. On one side is the male world with its stern and even brutal idealism, its energetic commitment to action; on the other side is femininity, associated with family affection, intimacy, all the graces of life, which David both distrusts and finds profoundly attractive.

Originally, David had adopted a masculine classicizing style with the fervor of a convert who can never quite still his doubts. A distant relative of Boucher, he was temperamentally attracted to his warm sensuality—and repelled by his frivolity. "The antique will not seduce me," David announced before his first trip to Rome, "it lacks life and movement."[17] He maintains his coolly disciplined style only by combating his own persistent hankering after the subtle and sensual graces of rococo, its delicate psychological insights. David represses the femininity, which he sees as weakness, in his own nature, in order to sustain his revolutionary sternness in life and art.

And that means avoiding the full male nude. When a pupil suggested David paint the *Horatii* undraped, he hedged, saying that he lacked the assurance to tackle *"une chose aussi difficile."*[18] David's art was based on a lifelong study of the nude model and the antique; but he associated the nude not with heroism, but with passivity and exposure. An oil study of the nude Hector, fallen backward in death, shows an almost Rubenesque sensitivity to soft, vulnerable flesh. In the public paintings which made his reputation in the seventies and eighties, classical subjects celebrating stoicism or heroic resolution, David never risks baring more than arms or legs, or at most, the torso of a dead or dying man. And he paints those exposed parts with a powerful sensuality. The bare muscular arms of the *Horatii* are far more dramatically expressive than any of his later attempts to depict full nudes. David has an almost obsessive interest in hands and arms.

213

Tensed for action, relaxed in death, extended in that open-palmed gesture so common in his work, they form the visual and emotional center of all his greatest paintings.

When David *did* attempt a full nude, it was in a very different context—an erotic scene commissioned in 1788 by the King's brother, the Comte d'Artois. Paris flirts with his langorously draped and drooping mistress, wearing nothing except a scarlet Phrygian cap. And David seems faintly embarrassed by his nudity. All the painter's sensuality has been diverted away from Paris, into the warm coloring and almost hallucinatory sharpness with which he paints the curtains and draperies. The nude Paris is posed self-consciously and painted flatly; except for one detail—his hand clenched on Helen's smooth arm—he is elegantly lifeless, even effete.

David's ambiguous response to the full nude is most clearly revealed in the beautiful unfinished study of the thirteen-year-old Joseph Barra, a republican standard bearer said to have been killed by royalists. His nakedness underlines the pathos of his untimely death. Barra has fallen to the ground clutching the tricolor to his breast as his body arches in a death spasm. There is no penis; the legs and hips are delicately girlish, and so are the face and full throat. Perhaps the idea of the child martyr disturbed David's rigid dichotomy between masculine heroism and feminine frailty. The child's naked defenselessness seems to arouse tenderly romantic feelings which David could never admit toward a grown man. If the painting had been completed, David might have added clothes, and the ambiguity—and the pathos—would have been disguised. As it is, the nude offers a touching glimpse into the sexual uncertainties underlying David's confident classicizing.

David's greatest painting—the one that comes closest to confronting his contradictory attitudes toward the nude, toward revolutionary heroism—is the *Marat Assassinated*. The radical journalist Marat was actually naked when he was murdered, on July 13, 1793, by Charlotte Corday. Suffering from a painful skin disease, he always worked in the bath, and David, who had visited him only a day before, records the humiliating circumstances of the murder. David concentrates on a few telling details—the bath filled with bloody water, the packing case beside it, the kitchen knife just fallen to the floor. Once again, David gets tremendous dramatic power by concentrating on Marat's arms and hands. The right arm has fallen over the rim of the bath as Marat

slumps toward us, his hand just slackening its grip on the quill pen; his other hand still holds Corday's treacherous letter. A single moment of time is frozen; the squalid accidentals are transformed, given a terrible beauty.

For David, Marat is in the company of the great ancient heroes and philosophers. "Plato, Aristotle, Socrates . . . I have never lived with you, but I know Marat and I have admired him as I do you." The painting was itself a political act; David was a delegate to the revolutionary Convention and in charge of propaganda for the Jacobin Republic. The painting is deliberately simplified so that it could be reproduced and circulated all through France, a reproach and an inspiration. David spoke passionately to his fellow delegates in the Convention:

> "David, take up your brushes . . . avenge Marat," I heard the voice of the people, I obeyed . . . It is to you, my colleagues, that I offer the homage of my brush; your glance, running over the livid and bloodstained features of Marat, will recall to you his virtues, which must never cease to be your own.[19]

Marat's pose, his noble face and wounded side recall traditional images of the dead Christ. (David had already exploited that association in his painting of another revolutionary victim, the deputy Lepeletier; it was later destroyed and only survives in a poor engraving.) But this lifeless body will not rise again. There is no suggestion that Marat's spirit survives—except in the minds of those like David who remember him. The wooden packing case bears a formal inscription: "A Marat—David. L'an deux." The painting is a tribute born out of David's sense of unity with the dead man, their shared belief that a new and juster society is possible. But David confronts as well the terrible consequences of the political violence to which he and Marat, as Jacobins, were committed; the violence which David had celebrated and to some extent glamorized in the *Horatii* and *Brutus*. *Marat Assassinated* is a magnificent propaganda image; more than that, it is a great tragic painting about politics. But it was a *tour de force* which even David would never repeat. The painting even seems to foreshadow David's own defeat. Within a year, the Jacobin Republic would fall, David's friends and colleagues would be executed, and he himself, threatened with death, would languish in prison.

It was only in the post-revolutionary world of the late nineties that

215

David was finally persuaded, by a scholarly disciple of Winckelmann, to use the full male nude in a large-scale political painting. *The Intervention of the Sabine Women*, planned while David was in prison, is a plea for conciliation, for a halt to the vicious factional fighting in which the ideals of the early revolution were being forgotten. Roman husbands and Sabine brothers are locked in pointless and self-perpetuating combat; the women, now, take the center of the stage, calling the nude heroes back to gentler emotions and family affection.

David intended the work as a tract for the times as the *Horatii* had once been. He also shows a new anxiety about archaeological accuracy, and the nudes are part of a self-conscious program to make his painting more "Greek"—which means more truly classic, more ideal.[20] But as he half recognized, the classical style had already lost its urgent relevance for the present. When David arranged a public exhibition of the painting, he had to write a pamphlet carefully elucidating his theme and in particular, finding scholarly justifications for those elegant and implausible nudes. David seems to be retreating into pedantry, into aestheticism, as a way of avoiding the heart-breaking confusions and opportunistic betrayals of post-revolutionary France.

Where the *Horatii* had been superbly theatrical, the *Sabines*, painted nearly fifteen years later, is merely stagey. David seems to be using the nude in quotes. Classical purists, including some of his own pupils, sneered at the painting as a rococo leftover. The naked babies tumbling in the foreground could indeed be lifted straight out of Boucher; the women are charmingly modish, and the two heroes seem as concerned to cover their genitals as to fight. The general public was quick to spot the affectation. The two attitudinizing nude warriors were unmercifully parodied in cartoons and vaudeville skits, and a punning popular song nicknamed David the "Raphael des Sans-Culottes."[21]

Leonidas at Thermopylae, begun in 1799 but not finished till 1814, is a sadder, more personal work. It harks back to those earlier, revolutionary paintings where David had celebrated men ready to sacrifice everything for the fatherland. The nude Leonidas sits still as stone, lost in reverie, while all around him his Spartan heroes prepare for the great battle with Persia which will save Greece at the cost of all their lives. By now, David had transferred his allegiance to Napoleon, seeing him as the only hope of preserving a few revolutionary reforms while restoring order. He persisted with the *Leonidas* in the face of

Napoleon's open disapproval of its theme, defeat. The painting expresses, perhaps, David's recognition, at a level far deeper than his enthusiasm for Napoleon or his adjustment to a France dominated by the most conservative sections of the bourgeoisie, that the great dream of a truly democratic republic *had* been defeated. *Leonidas* may hint as well at the painter's lingering hope that the death of his republican friends—Marat, Robespierre, Saint-Just—might at least remain in men's memories as inspiration for the future.

Ironically, David can only express that revolutionary nostalgia in a thoroughly conservative style, at once busily pedantic and fashionably elegant. For all its technical brilliance, the painting is a museum piece, speaking to us faintly, as if from an immense distance. The heroic nudes have the smooth, lifeless perfection of waxworks. Leonidas himself is nearly as insipid as that earlier Paris, or as the vacuous and vaguely amorous gods David was to paint when he went into exile in Brussels after Waterloo. David's personal tragedy is that his own work came to stand for everything devitalized and reactionary in the style he had once used with such subversive force.

Under the Empire, all remnants of revolutionary passion and vitality drained away from neoclassicism. The "Greek" style became merely fashionable. In any event, the distinction between rococo decoration and the high-minded severity of the neoclassicists had never been as sharp as some of the latter claimed. The cool, uncluttered classicizing style was easily adapted to the old amorous nudes. For a whole series of fashionable French artists—from David's first teacher Vien to his pupils Girodet or Gérard or Picot—neoclassicism was, in Denys Sutton's words, "a sauce to render the rococo more attractive to jaded palates." In Flaxman's illustrations to Homer, widely praised in the early 1790s for their archaic grandeur and purity, the sharp, refined line only accentuates the petulant fleshiness of his naked youths. And Girodet's 1792 *Endymion*, bathed in light and watched by a coyly sexy Cupid, is simply a translation of a rococo love scene into homosexual terms. By the turn of the century, returning aristocrats and the wealthy bourgeoisie were looking for an undemandingly decorative art, at once culturally respectable and soothingly erotic. Hugh Honour has remarked that Gérard's sweetly suggestive *Cupid and Psyche* "is nearly everything that Neo-classical artists had condemned in the Rococo . . . revived in superficially Neo-classical terms."[22] His words could apply to a dozen versions of the same

217

theme—even to the bland and tired nudes which David himself painted in the closing years of his life.

It was the Spaniard Goya, and not David, who made the final, most terrible comment on the eighteenth century. There are no heroic nudes in Goya's work, only naked victims. He uses the naked body rarely, and then only to reveal something that society would rather keep hidden. In the 1790s, after a brilliantly successful career as painter to the Spanish court, he fell ill and began, increasingly, to paint for himself. "The better to occupy my imagination, mortified by the thought of my illness . . . I set to work to paint a series of cabinet paintings; in these I have succeeded in making room for observation, which as a rule is absent from works made to order, where caprice and fantasy cannot be developed."[23] Goya is increasingly preoccupied with the bestiality and cruelty lurking just below the surface of fashionable life. He paints madmen posturing naked in a dingy, claustrophobic dungeon, in grotesque parody of heroic nudes, and of the "normal" citizens who have locked them up. He records the self-mutilating frenzy of religious flagellants, stripped to the waist and bleeding, and the agonies of Inquisition victims. Or he mocks contemporary dreams about the Noble Savage by painting naked cannibals in an obscene dance of death.

Like David, Goya left a record of the Napoleonic wars—but from the other side. A liberal who sympathized with the early revolution, he was appalled when France invaded the peninsula in 1808. A series of eighty etchings commemorates the atrocities committed by both sides, by resisters as well as invaders. The etchings, only published after Goya's death, are nightmarish because of their eyewitness accuracy. "I saw it," runs the legend beneath one scene of horror; "this is how it happened" under another. David's *Marat* makes us feel the awful finality of death; but Marat is a hero—perhaps the last hero—whose death may still inspire others. Goya shows the anonymous victims of pointless brutality; men fight like animals, and die like animals. Their lifeless bodies are stripped, looted, mutilated, dismembered, left to rot or hurled carelessly into mass graves.

Like David, Goya went into exile as an old man; fleeing from the reactionary Spain of Ferdinand VII to obscurity in Bordeaux. Deaf and lonely, he painted almost entirely for himself; his house was filled with somber murals, terrifying and grimly humorous, confronting all the darkness and cruelty that had been suppressed in the light,

bright decorations of the eighteenth-century courts. At times, Goya even turns to classical myth; but he exposes the sadistic and monstrous fantasies denied by the neoclassicists who had insisted on the "noble simplicity and calm grandeur" of the Olympians. In *The Colossus* a vast torso looms up, at once unreal and terribly palpable, while beneath him tiny toy armies scurry about in blind panic. And in the most shocking and prophetic of all Goya's works, a grotesque and bloody old Saturn stuffs the body of his own son into his mouth; man turns cannibalistically on man, greedily consuming what he has himself created, mutilating himself and destroying his hopes for the future.

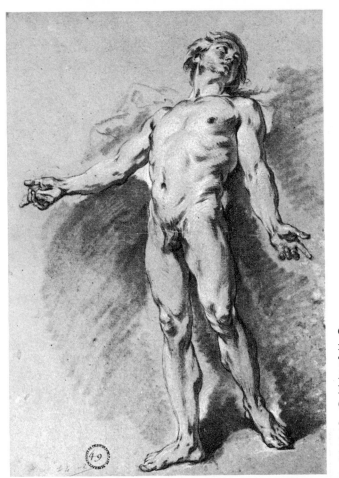

OPPOSITE, TOP LEFT: Sketch of a nude man, *c.* 1705–9, Watteau
TOP RIGHT: *Theseus and the Dead Minotaur*, 1781–2, Canova
BOTTOM: *David's Studio*, 1814, Cochereau

THIS PAGE, LEFT: *Apollo*, study for *The Rising of the Sun*, *c.* 1753, Boucher
BOTTOM: *Venus and Cupid with Doves*, 1754, Boucher

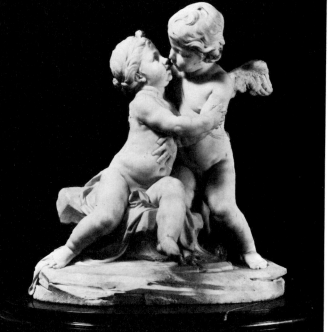

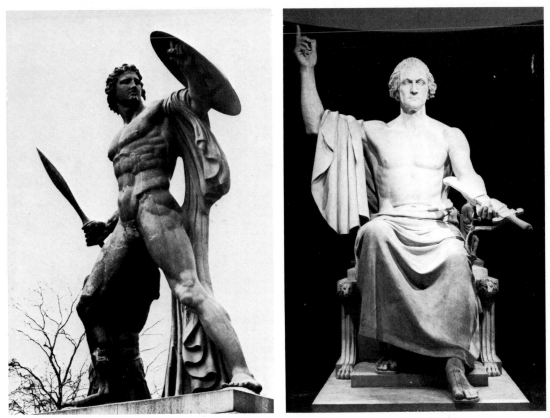

THIS PAGE, LEFT: *Achilles,* monument to the Duke of Wellington from the ladies of England, 1822, Westmacott
RIGHT: *George Washington,* 1840, Greenough

OPPOSITE, TOP LEFT: *Cupid Making his Bow from the Club of Hercules, c.* 1750, Bouchardon
TOP RIGHT: *Amour Menaçant,* 1757, Falconet
BOTTOM: *Cupid and Psyche,* 1706, Cayot

223

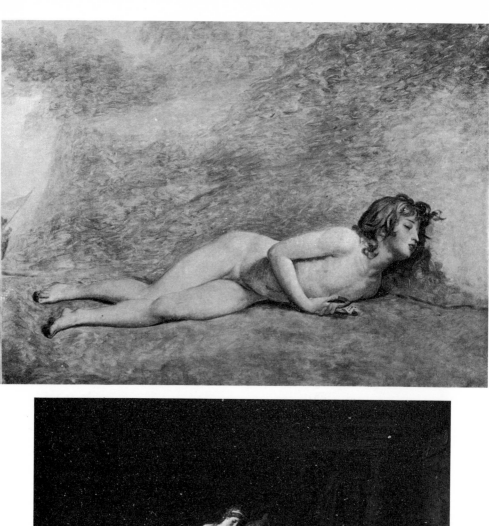

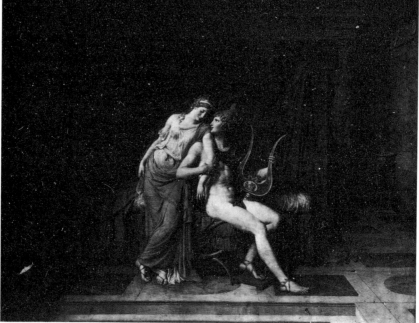

THIS PAGE, TOP: *The Death of Barra*, 1793, David
BOTTOM: *Paris and Helen*, 1788, David

OPPOSITE, TOP: *Intervention of the Sabine Women*, 1799, David
BOTTOM: *Leonidas at Thermoplylae*, 1814, David

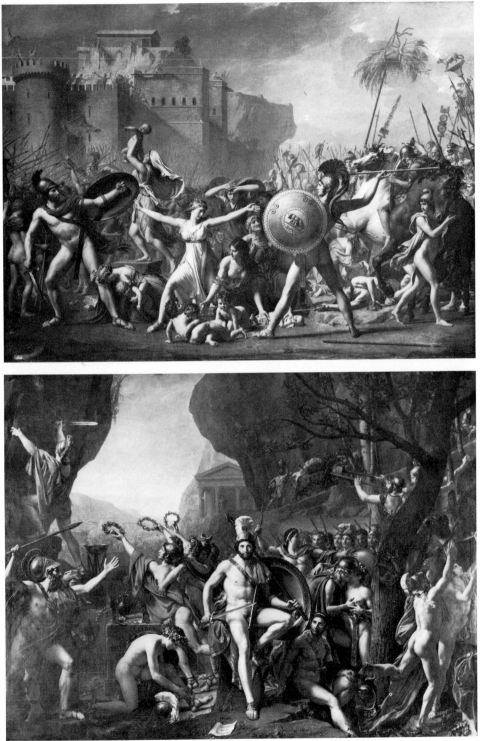

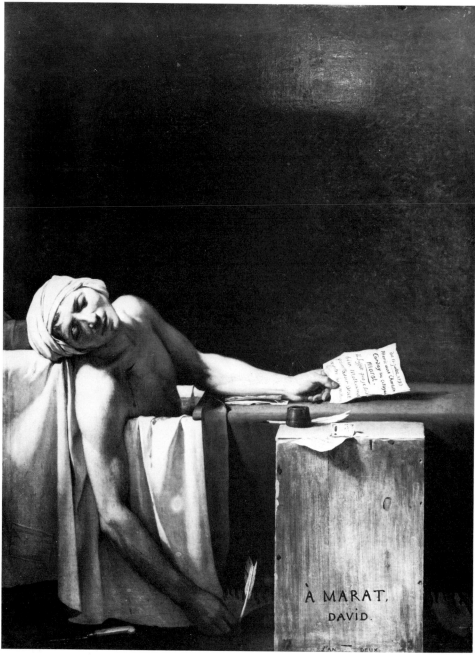

Marat Assassinated, 1793, David

LEFT: *Saturn, c.* 1820, Goya
BOTTOM: *Nebuchadnezzar,* 1795, Blake

The Disappearing Male

THE MALE NUDE fades out in the nineteenth century. The male body is determinedly and nervously covered up; and as the male goes out of focus, the female nude becomes the central symbol of art. For the first time, nude is automatically taken to mean a woman. "In antiquity, all was achieved through the male," remarked Stendhal, "our modern taste lets the female triumph."[1]

The male nude is a meaningless anachronism to Stendhal. He singled out David's *Sabines* for particular attack, mocking their attitudinizing with all the authority of a Napoleonic veteran. Modern artillery makes those nude warriors look ridiculous, makes traditional dreams of heroism absurd. The male nude is incapable of expressing any of those qualities that fascinate Stendhal's new man—elegance and wit, despairing loneliness and restless passion. "What do I care about antique bas-relief?" he demanded in 1824, sounding a battle cry that would be picked up by successive generations of painters. "Let us do good modern painting. The Greeks like the nude, we, we never see it, and I will go further and say that it disgusts us."[2]

The female nude, on the other hand, escaped this blanket condemnation. And she is the subject of some of the worst, and some of the best, nineteenth-century painting. In the 1890s, Cézanne's son advised his father to paint more women as they sold better than men.[3] His assessment of the market was certainly correct—there was an apparently insatiable demand at all levels of society for discreetly sexy Venuses. Forgetting his own body, nineteenth-century man uses woman as a screen for his fantasies. On her naked body the artist explores his longings and nightmares, and asserts his creativity.

228

Manet's *Déjeuner sur l'herbe* deeply shocked many contemporaries because it made this contradiction visible—it put clothed and very contemporary men into the picture along with a naked woman. She gazes, coolly self-possessed, out at the spectator, as if to challenge his comfortable voyeurism. But the men in the painting, for all their bohemian dress and casual poses, are not really relaxed. In that idyllic natural setting, they look faintly ridiculous, out of touch with their bodies. In his detached way, Manet hints at what the nineteenth-century male loses by his double standard about nudity, by his prudish reluctance to expose his own person.

NERVOUS NUDES

The unclothed body had become a potentially explosive image by the nineteenth century. Stendhal, certainly not coy in these matters, believed that the nude is indecent simply because in real life it is so carefully concealed. The painter heroine of Hawthorne's *Marble Faun* echoed his ideas; the nude inevitably arouses furtive and guilty fantasies because "nowadays people are as good as born in their clothes and there is practically not a nude human being in existence." And Ruskin, who was appalled by nudity in art and life, admitted that "from the very fear and doubt with which we approach the nude, it becomes expressive of evil."[4]

Even at the height of Victorian nervousness about the body, a certain kind of nude—anonymous, safely distanced by an antique or exotic setting—was permissible. And in general, sculptured nudes were more acceptable than painted ones: marble, so white, so cold, so expensive, seemed to certify the body as chaste. It was a sense of *actual* flesh that caused the recurring scandals that rocked the aesthetic calm of the salons. Manet's *Déjeuner* and his *Olympia* offended because the nude women were so vividly and individually sexual. His two paintings of the naked Christ were attacked almost as bitterly because they insisted on the immediate everyday reality of pain and death.

Nineteenth-century prudishness was never simple. As we know it, it is a specifically middle-class phenomenon; an assertion of moral and social respectability against a decadent aristocracy, and against the masses, who were seen as licentious and potentially subversive. Both tragic and comic, prudery is an attempt to plaster over fears and doubts, not only about sex, but about society itself. It springs from the new bourgeois stress on domestic privacy, and the sharper segregation

229

between the sexes, particularly when they are growing up. And it is a defensive screen constructed by people who no longer feel at home in their bodies or their world. The mass migration to the cities was cutting many people off from what they felt were their natural roots and rhythms in the countryside. Increasing numbers of people survived by not seeing or feeling too much; by ignoring the misery and poverty around them, by repressing their own instincts in the interests of property and propriety.

Running through much high-mindedness about the body is a pervasive fear, not just of the animal in man, but of man as no more than an animal. That frightening vision is foreshadowed at the beginning of the century in George Stubbs's comparative studies of man and animal, or even in Blake's *Nebuchadnezzar*, which shows man reduced to an animal, at once monstrous and pathetic. The old chain of being in which man took his place little lower than the angels is replaced by a disorientating Darwinian one, with man barely differentiated from the lower species. And the naked body serves as an ugly reminder that we *are* all animals, doomed to die. According to the philosopher Proudhon, "We have lost the religion of the dead. . . . We have no faith in prayers and make fun of the Life Beyond. The death of man today, in universal thought, is like that of an animal."[5] The sensationalism of much romantic art and the sentimentality of the academicians are both responses to a world suddenly drained of spiritual meaning.

At the same time the body is seen as a machine whose delicate mechanism is only too likely to break down; or, as Steven Marcus has argued, as "a productive system with only a limited amount of material at its disposal."[6] Sex is feared because it exhausts and depletes the body, making it less efficient and less amenable to rational control. As Marcus points out, the English slang for orgasm is "to spend." Industrial man, fearful of running out of energy, is preoccupied with accumulating and conserving it. Medical textbooks tend to treat sex as some kind of debilitating disease, solemnly repeating case histories of men either found dead in houses of ill fame, or who dropped dead on their wedding nights. Masturbation was the focus of extraordinary anxiety; "curing" it became an obsession with Victorian doctors and parents.[7]

Many nineteenth-century men were torn by contradictory terrors—fear of their uncontrollable animal urges, always threatening

their higher selves, *and* fear that they could never live up to their marital duties. In self-protection, men assumed that a "good" woman had no sexual urges; they talk as if a "decent" woman would be offended and even violated by the mere sight, not just of the living male body, but even of an exposed marble penis. Yet men were often as fearful, ignorant, and even more prudish than women. Ruskin was unable to consummate his marriage because he was shocked by his wife's pubic hair—so unlike the art nude. But he was deeply repelled by the mature male body; his lectures on Michelangelo are full of an almost hysterical revulsion against the painter's "dark carnality." The poet Robert Browning, though he insisted heartily that a naked woman is God's finest handiwork, was terrified of exposing his own body, and had a recurrent humiliating fantasy of being revealed to the mocking gaze of a crowded beach while undressing in a bathing machine. And even the painter Renoir, whose late female nudes are virtually synonyms for joyous and natural sensuality, was apparently too embarrassed to work from the naked male model.[8]

The whole complex of contradictory attitudes about nakedness and sex tended to be externalized by man, and put on to woman. She is at once an angel, far higher and purer than he; but she is also infinitely corruptible, and potentially far more bestial. She is the muse-mother who inspires man to his greatest achievements, and she is a vampire who sucks all his juices dry. The over-dressed Victorian wife, far above all carnality, is sister to the naked prostitute. The female nude is such a fascinating subject because, in tracing her body, the artist is tracing, at a safely symbolic distance, his own inner conflicts.

Real women were of course far less narrowly prudish than men claimed. Some women *did* throw vast amounts of frustrated energy— and resentment at the double standards set by men—into their role as guardian of public morality. Travel diaries and memoirs—especially those of American women traveling in Europe for the first time— certainly do express a sense of shocked affront at all those museum nudes. But it is fascinating to notice how often their discomfiture and disapproval springs from an embarrassed self-consciousness forced on them by the presence of men; alone, their reactions are often far more accepting. Queen Victoria herself, symbol of high-minded virtue, was not so easily shocked as men feared, or hoped. When she visited a London exhibition the male organizers frantically tried to keep her out of a room hung with nude drawings by William

Mulready. But she got in, admired them, and even accepted a sketch of a bewiskered Victorian gentleman without any clothes. It remains in the royal collection to this day.[9]

ROMANTICS

At the beginning of the nineteenth century, a few artists brought a new romantic energy to the classic male nude. The stereotype was enlivened by a growing emotional fervor, an almost hysterical energy. A fascination with violence, with extremes of all kinds, an interest in irrational states and nightmares: these were the hallmarks of a new sensibility. Even the neoclassical sculptor Canova hinted at changes to come in his colossal Hercules, heaving and straining not in a moment of triumph, but as he kills the innocent boy Lichas in a frenzy of rage and pain just before his own death.

Fuseli forms an interesting link between neoclassicism and the romantics. Though he was often too crude a draftsman to get beyond melodrama, though he sometimes verges on caricature, he also catches, with startling directness, changing sexual attitudes. He forces the classic nude into the pattern of his own dark obsessions, his dreams of omnipotence and his fears of impotence. His is an art of the extreme gesture. On the one hand, he does great striding supermen, all broad shoulders and swelling thighs; on the other hand, helpless captives being tortured and mutilated—or figures like his great blinded Polyphemus, paralyzed by despair. But Fuseli's typically low angle of perspective makes even his arrogant strongmen seem stagy and unstable, about to topple over into farcical indignity. A few drawings seem to hint, symbolically, at self-mutilation. A dramatically posing Achilles cuts off his long hair (always of intense fetishistic concern in Fuseli's work) and throws it on the pyre of his dead friend Patroclus. And Siegfried, wearing a high-braided, very feminine hairdo, sits with the great serpent he has just killed dangling limply between his legs.

Fuseli's wife burned most of his private erotic drawings, but the few surviving ones tend to show the passive male at once excited and humiliated by monstrous, phallic women. In one weird sketch a woman, her face and elaborate high hairdo described in meticulous detail, leans on a dressing table staring at a man. Naked, with an enormous erection, the outline has been left blank; it is as if he were actually fading away, being reduced to an impotent ghost under her malevolent gaze.[10]

The younger generation of romantic artists growing to maturity after Fuseli, in the depressing and reactionary aftermath of the Revolution and the Napoleonic wars, are equally attracted to sensational and sadistic themes. But few tackle their obsessions with Fuseli's crude but impressive directness. Delacroix, for example, hardly uses the male nude except to suggest pathos and death. He conjures up dreams of superhuman virility, and conceals his own underlying doubt by concentrating on brilliantly colored scenes of orgy and massacre, by painting great plunging stallions, or passive, beautiful women who testify to the strength of the men who master them.

Those few romantic artists who do deal directly with the male tend to glamorize, not the strongman master of his fate but the defeated rebel, the victim, the outcast. In the post-Revolutionary world, the artist, feeling increasingly at odds with society, becomes his own hero. Suffering and loneliness are the source, even the guarantee, of creative genius.[11] Seeking self-images, artists retrieve from past and present literature some curious and morally ambiguous characters. Milton's Satan was a favorite with English artists, who depicted him as a nude towering magnificently against the eternal flames, a Promethean hero damned for his rebellious energy but morally undefeated. Prometheus himself enjoyed a new lease of life, and so did Icarus. Philoctetes, who qualified by virtue of his ten years solitary agony on Lemnos, and Dante's Ugolino, driven by hunger to eat the bodies of his own sons, became stock figures in the romantic repertory.

Byron's Mazeppa, tied to the back of a wild horse running loose in the wilderness, was a favorite with a whole series of French artists including Delacroix, Géricault and Boulanger. All stress the delicacy of his naked body strapped to the untamed, brute strength of the horse, the hero's unseeing and swooning helplessness. For Géricault, merging rider and rearing horse into a single figure, Mazeppa becomes an impressive symbol of man as victim of his own passions.

The melodrama can easily lapse into absurdity. (Looking at some versions of Mazeppa's ride, it is all too easy to remember that it was a popular circus stunt in the nineteenth century.) Nevertheless, the excess, the sadistic violence, express frustration with the materialism and hypocrisy of the new bourgeois world; and also, sometimes, an oblique recognition of the real horrors—the exploitation and cruelty—lying just under the surface of its complacent respectability.

233

Géricault is one of the few early nineteenth-century artists to go beyond melodrama into a serious investigation of heroism. Unlike his contemporaries, he was consistently interested in the male nude, and he constantly experimented with the classical formula, trying to force it back in touch with real sensation. Some of his nudes are so blackly and heavily scored as to suggest that the very act of drawing was a physical struggle.

For Géricault, the body is simply itself, without any spiritual or symbolic significance. He is a materialist, preoccupied with the bulk and weight of the male body and its animal energies. Few of his nudes are at rest; they nearly all strain, geared up for conflict, or writhe in agony. It is as if Géricault only believes that the body is alive if it is somehow stretched to its limits. A few drawings show nudes being strangled or tortured, in explicit and sadistic detail. Others show naked or half-naked men struggling with horses, testing their strength against the hardly-tamed animals, as if by subduing them they might appropriate some of that fierce vitality.

Géricault's world is almost exclusively male—except for a few vigorous erotic studies, he almost never draws or paints women—and it is violent. He at once idealizes physical strength, and views it pessimistically. There are no traditional heroes in his work. Increasingly attracted by contemporary themes, he sought out incidents which summed up the brutality and betrayals that were at the foundation of middle-class peace and prosperity. His most famous work is *The Raft of the Medusa*, inspired by a current political scandal. In 1816, partly because of the incompetence of the captain, a political appointee, the government frigate *Medusa* sank off the coast of Africa. One hundred and fifty passengers, deserted by the senior ship's officers were set adrift on a small makeshift raft. A fortnight later, only fifteen were barely alive to be rescued.[12]

Géricault tackled this subject with almost journalistic enthusiasm, interviewing survivors and reading every account he could lay his hands on. His enormous canvas shows the crowded raft tilting precariously as half-naked men scramble desperately upward to hail a tiny sail vanishing over the horizon. Others, sunk in despairing lethargy, are hardly distinguishable from the corpses trailing in the water. The *Medusa* is an overwhelmingly physical painting, in which bodies speak more urgently than faces. Géricault insists that we identify with, almost participate in, the agony and struggle of these

men who are, as a contemporary put it, "jostled between life and death."[13]

Even more impressive, perhaps, are the scores of preliminary studies in which Géricault worked out his minutest feelings about every aspect of the affair—the quarrels on the raft, the ruthless killing of the desperately ill, the impulse to cannibalism, man's struggle to survive whatever the cost to others, his despair in the face of the vast impersonal force of sun and sea. What started out as a political protest became an anguished cry against the human condition itself.

Some of the *Medusa* studies have a scrupulous realism that remains shocking to this day. Trying to catch as precisely as possible the experience of the ill and dying, Géricault abandoned studio models and worked in a prison hospital. Little of this work was directly used in the final painting; Géricault seemed driven by a desperate personal need to understand and record the worst that could happen to the human body. "If there is any certainty on earth, it is our pain," he wrote to a friend; "only suffering is real."[14] It is as if he were trying in his art to come to terms with his own illness—the spinal disease that killed him, slowly and painfully, within a few years. Though his work occasionally approaches romantic sadism and ghoulishness, Géricault shows unflinching courage in confronting the physical facts of our bodily decay; even to the point of painting an extraordinary series of studies of severed heads and limbs. Somewhere behind all of Géricault's most energetically striving nudes lies this terrible vision, the body thrown aside as a meaningless lump of meat. Seeing *only* the body, Géricault forces us to feel with him the brutal fact of its death.

NEW MODELS

Toward the middle of the century, the nude again became a battleground, and all kinds of artistic and moral issues, lurking in men's minds for a hundred years and more, were fought out openly and angrily. Defenders of the classic nude still insisted—all the more vehemently because they were under such effective attack—that the nude "speaks a universal language . . . understood and valued in all times and countries."[15] Sculptors, in particular, clung to the traditional nude as the symbol of human nobility and aspiration. Why perpetuate in marble anything as ugly and ephemeral as breeches and frock-coat, top hat and crinoline? This conservatism was one of the reasons why Baudelaire could dismiss sculpture out of hand as

"boring"; and why very few sculptors before Rodin even begin to escape the slick secondhand competence of the academy.

Far from being a timeless language, it was becoming only too clear that classical myth was no longer a vital and readily accessible source of symbol and allusion. "What chance has Hermes against the Credit Mobilier?" asked Marx. "Can we conceive of Achilles in the age of powder and shot?"[16] Even the over-long explanatory titles in salon catalogues suggest that the wider middle-class audiences who now attended exhibitions and bought pictures had only a superficial and perfunctory acquaintance with antiquity. A classical theme was now little more than a cultural guarantee, to reassure people uncertain of their tastes. More and more, younger artists challenged the pretentiousness, the sentimental nostalgia and the sexual hypocrisies of much salon art. Their mood is crystallized in Daumier's brilliant and barbed series of cartoons on "Histoire Ancienne," which caricatures the bland and unreal beauty of the nude gods and heroes. Helen thumbs her nose at a pot-bellied Menelaus, and a skinny Narcissus kicks up his heels gleefully as he gazes down at his own ugly face.

The very notion that art is concerned with timeless abstractions, that it hovers above history, came under attack. "All centuries and peoples have their own form of beauty, so inevitably we have ours . . . absolute and eternal beauty does not exist," Baudelaire argued.[17] From about 1840 a whole generation of artists expressed a new passion to seize the texture and shape of the life about them, life as they were actually living it.

The urge to be contemporary meant different things to different artists. They were united only in a struggle against certain visual preconceptions—against the stale habits and out-of-date values drummed into them in the art schools. The invention and rapid development of the camera would have an important influence on many artists for the rest of the century, encouraging them to see freshly and immediately, to investigate the way the human body actually moves, to think about the whole problem of how our expectations determine what we see.[18]

Students attending official art schools began to grumble endlessly about the prescribed drawing from the male nude, lit and posed in ways that had nothing to do with how people actually stand and move. Manet, for example, asked an elderly, experienced and affronted model, "Is that how you hold yourself when you go to buy a bunch of

radishes?'' and on another occasion baffled and irritated his teacher Couture by persuading a model to pose with his clothes *on*.[19]

The nude, male or female, was not a central theme in Manet's work. But just as two of his paintings (the *Déjeuner* and the *Olympia*) challenge audiences by putting a naked and very contemporary woman into a traditional setting, two other works attempted the same thing with the nude male. His *Dead Christ* and his *Christ Mocked* undermine the sentimentality of conventional religious art by asking us—as Caravaggio had done more than two hundred years before—to see Christ as a man of real flesh and blood. Audiences were deeply offended. One critic jeeringly retitled the *Dead Christ* "The Poor Miner Pulled out of the Coal Mine," while others complained that "the most beautiful of men" should be depicted so starkly, should look so dirty and plebeian.[20]

Similarly, Degas's attempt at an antique theme—his *Young Spartan Girls Provoking the Boys*—shows up the stilted artifice of most nineteenth-century exercises in the classic. His naked adolescents strike us at once with their awkward reality. The boys stand uneasily, caught by surprise by the girls' aggression; one is even crouching, childishly undignified, on all fours. They seem uncertain whether to react playfully, or with masculine bravado. A haunting comment on the sexual tensions of adolescence, it is a deeply personal image of Degas's own sense of alienation between the sexes. It was Degas who, more than any of his contemporaries, finally freed the nude from the stranglehold of classical rhetoric. But—apart from this painting and some beautiful but more conventional studio drawings—Degas's more radical experiments were all done with women. "It is as if you looked through a key-hole," he said of his own studies of women washing or dressing.[21] Clearly, his own uneasiness with the female body, his odd blend of voyeurism, fascination and baffled dislike, pulled Degas constantly away from the male to an almost obsessive study of the female.

For a whole series of "realists" from Courbet to Degas, the naked woman, rather than man, emerges as central theme. By the fifties, female models were more or less a fixture in private studios and jokes about the sexual relations between models and artists had become commonplace. In his 1855 *Studio*, trying to sum up his relationship with the society he lived in, Courbet proudly painted a naked female model looking encouragingly over his shoulder as he sits at his

canvas. Certainly, in painting women, artists felt in closer touch with their own energies and instincts; their realism is determined and fuelled by sexual desire or disgust. By drawing the female nude realistically, by painting his own mistress or by depicting a prostitute instead of an ideal Venus, the artist could at once challenge bourgeois hypocrisy, yet not stray too far from the basic assumptions of the respectable moralists he scorned.

It is surprisingly hard to find the male nude in a convincing contemporary setting. Courbet seems to have painted it only once. *The Wrestlers*, exhibited in 1853 along with his "fat bourgeoise" of a bather whose solid fleshiness so shocked salon audiences, was neglected in all the fuss. In fact, Courbet reveals as sensuous a feeling for the muscular male body as for female softness; the two heavy wrestlers are locked awkwardly together, as totally involved with each other's bodies as a pair of lovers. A few critics attacked the painting as clumsy, and one contemporary cartoon suggested that it could serve as an advertisement for a fairground wrestling match.[22] That, presumably, was Courbet's point. These are not classical wrestlers but circus strongmen performing for the distant spectators. Daumier returned to the same subject in several paintings. His superb *Wrestlers* shows a tired, bulky, middle-aged man waiting nervously to go on stage; behind him, two men are actually performing, and beyond them again sit rows of spectators. The point is that it *is* a performance, a spectacle; that in contemporary society strength, like beauty, is for sale. The relation between the classical wrestler and the circus strongman is not unlike that between Venus and a modern Parisian courtesan.

Later in the century, a number of American painters seized eagerly on the subject of wrestlers and boxers. In fact, it sometimes became a way of proclaiming the red-blooded virility of New World painting, as against the decadent effeminacy of the Europeans. But Thomas Eakins did several superb paintings of fighters; most impressive perhaps is his *Salutat*, in which he deliberately recalls, and shares, classical admiration for the male body. His brush dwells tenderly, romantically on the delicate play of muscles in the boxer's back and raised arm. But Eakins suggests too the man's lonely vulnerability against those ranks of dark-clad spectators who applaud his victory but would be as pleased by his defeat.

NUDES AL FRESCO

Pastoral has always been a fantasy of townspeople: a green and vacation world where we can temporarily shed our work-day personalities, and perhaps our clothes. In the increasingly industrialized nineteenth century, the dream of an Arcadian world where men can shed their clothes, their shame, their civilized constraints, was more intense than ever before. Some nineteenth-century painters—from Ingres to von Marées—tried to revive the ancient myth of a Golden Age when men and women went innocently naked in the sunlight.[23] And the female nude bathing or relaxing outdoors became a very popular image of man's yearning to return to a free and natural sensuality.

But later in the century, a few artists began to paint men or boys as well, playing naked outside, swimming, relaxing. One of the most moving of all is by Daumier; his *Bathers* has a powerful and unsentimental beauty. A dark huddle of bodies takes up most of the foreground; in the shade of a tree, the boys clumsily haul off their clothes, as if they were struggling free of everything that normally confines and oppresses them. Behind them a naked boy steps cautiously into the water. Short and stocky, he is in no way idealized, but the golden light glowing on his body communicates his sense of sudden release. There is a comparable suggestion of hard-won freedom in Seurat's *Bathers, Asnières*. His obvious townspeople are unpracticed at removing their clothes in public. Some have only taken off a shirt, and most are still wearing their hats; one or two sprawl untidily, others sit stiffly and properly on the banks. Factory chimneys smoke in the distance, to remind us that when the sun goes down, the bathers will resume their somber clothes and their everyday identities. But for the time being they are quite still, dazed with pleasure in the hazy polluted sunlight.

Painters often seem to experience difficulties in showing men simply relaxed and passively enjoying their own bodies. The figures in Bazille's beautiful *Scene d'Eté* wearing their smart, striped drawers, look faintly self-conscious; if one man is simply lying back enjoying himself, some of the others are exercising energetically, wrestling or swimming. The nudes in Thomas Eakins's *Swimming Hole* again have a faintly artificial air, particularly if we compare them with the artist's many photographs of his students romping naked at the site of the painting. But the whole thing comes to vivid life because of Eakins's

sensual pleasure in the male body, and because of the precision with which he evokes his nostalgia for his own youth. The different nudes in *The Swimming Hole* are carefully distinguished by age; the diving boy is still immature; the youth who stands so confidently, his back to us, is in the full vigor of young manhood; while the reclining figure watching them is nearing middle age. And an older man, perhaps Eakins himself, swims out toward the stone jetty with his dog. The artist re-creates a vision of the happy, physical unself-consciousness of boyhood, seen through the long perspective of the aging process itself.

For a few painters, this nostalgia for lost youth merges into an explicit, though carefully disguised, homosexuality. In England, particularly in the 1890s, there were an extraordinary number of dreamy sentimental poems and paintings celebrating the beauty of boys bathing, sometimes contrasting their free young beauty with the approaching shadows of a depressing maturity, trapped in factory or office. The respectable academician Henry Tuke loved to paint naked bathers, and his soft, rather ennervated figures, determinedly idealized away from any overt sexuality, inspired several delighted poets. Alan Stanley's rhapsody on Tuke's *August Blue* suggests the quality of the paintings very well.

> Stripped for the sea your tender form
> Seems all of ivory white,
> Through which the blue veins wander warm
> O'er throat and bosom slight,
> And as you stand, so slim, upright,
> The glad waves grow and yearn,
> To clasp you circling in their might,
> To kiss with lips that burn.[24]

Even Cézanne's superb and monumental male bathers seem to have sprung originally from memories of the happy childhood described so lovingly by his friend Zola—a time when "they were possessed with the joys of plunging into the deeper pools where the waters flowed, or spending days stark naked in the sun, drying themselves on the burning sand, diving in once more to live in the river. . . ."[25] But that joyful abandonment has been almost wholly buried under the pressures of adult guilt and fear and sexual yearning. Cézanne's male bathers are not boys; their bodies are mature, tense, their poses enigmatic. (Cézanne based some of his figures on drawings of

traditional nudes in the Louvre; sometimes a memory of the original—violence or pain—seems to carry over into this idyllic setting.) In group scenes, each bather remains isolated, separated both from the landscape and his companions. There is no clear unifying rhythm linking the nudes; each is self-contained, and some give an odd impression of being paralyzed, unable to move freely or to relax.

One of Cezanne's commonest types—repeated almost obsessively— is a single bather with a tense body and stiffly outstretched arms. The critic Theodore Reff has interpreted it as an image of the painter's own loneliness, its tensions suggesting the painter's own unresolved doubts about his own body and particularly about masturbation.[26] Even the great solitary *Bather* in New York hints at Cézanne's continuing inability to fully accept the male body. The man stands isolated in a sketchy dreamlike landscape. Eyes cast down, he seems indecisive, at once static yet perpetually balanced in motion. There is an abrupt contrast between the flat torso and the fleshy legs; the heavily painted hands seem to hold on to the hips as if the man were in pain, as if he needed to keep a firm control of his own flesh. *The Bather* at once recalls and denies the age-old dream that by shedding our clothes, we free ourselves from shame and repression; the emotional ambiguities make the painting all the more haunting.

BEAUTIFUL DREAMERS

"What is uglier," asked the German novelist von Schlegel, "than the over-emphasized womanliness, what is more repulsive than the exaggerated manliness, which prevails in our mores, our opinions, yes, even in our art?"[27] All through the nineteenth century there were artists who attempted, sometimes covertly, sometimes openly, to break down the barrier or somehow subvert the strict division between masculine and feminine.

A few artists consciously embraced the ideal of androgyny. For Blake, heir to a long mystical tradition, the androgyne is symbol of equality, of harmony rather than hostility between the sexes. He takes the classical nude and makes both male and female approximate to his own vision of a perfected and bisexual humanity. Never denying sexual difference, he sees clearly how the exaggeration of that difference by society imprisons men and women in mutual and destructive misery. He conjures up, entirely inside his own head, a paradise that transcends civilized division; that seems not only to

241

echo the harmonies of a long-forgotten past, but to hint at the pattern of a Utopian future.[28]

Few others achieve so convincing an image of sexual equality. Some seventy years later, Gauguin would be haunted by a comparable dream. He left his wife and family and traveled the world, trying to find an alternative to the artificial femininity which makes men bitter and distrustful. He is attracted by Maori women, he says, because "the proportions of their bodies sometimes cause them to be mistaken for men. Maori woman is Diana the huntress, but with broad shoulders and slim hips."[29] Gauguin put a clearly androgynous figure at the center of his great allegory, *Where Do We Come From?*; he even advised a friend's young daughter that she should try to become a "hermaphrodite." But Gauguin's escape to more primitive worlds did not mean that he altogether discarded his European prejudices and ways of seeing. Like so many other nineteenth-century rebels, he is asking woman to symbolize a natural freedom he cannot fully achieve within himself.

In the nineteenth century, homosexuality often takes the form of protest against rigid and polarizing sexual definition. But precisely because a sensual boy was far more scandalous than the most provocative female, homosexual feelings had to be heavily disguised. Perhaps the most acceptable outlet was, ironically, in academic sculpture; its cool classical veneer was an efficient disguise for homosexual as well as heterosexual fantasy. For example, the eminently respectably Lord Leighton, who usually painted women, occasionally admitted, in safer sculptural form, his even deeper response to the young male. His bronze boy—his charms further disguised by the moral title, *The Sluggard*—stretches lazily, languidly, invitingly. Various classical themes provided a good excuse for dwelling on the grace and suppleness of the male nude. An archery lesson was popular, with an older man protectively embracing a boy as he teaches him to shoot; and so is the theme of Love and Death, personified as two young boys, often far prettier and more delicate than the prettiest girls, with arms round each other's waists. Picturesque genre figures—scantily clad Italian peasant boys—are common. And characters like the murdered Abel, the fallen Icarus or a drowned pearl fisher, all provide an excuse for the sculptor to dwell with loving attention on the smooth curves of the adolescent body.

The life and work of the painter Simeon Solomon shed a sad and

revealing light on the problems of the homosexual in the increasingly repressive climate of late nineteenth-century England. His art seems sick with a suppressed, displaced and inhibited sexuality. His men and women can hardly be distinguished from one another; with their heavy eyes, their drooping mouths and their languid and insubstantial bodies, they seem to inhabit a realm outside time or space. Solomon's mix of mysticism and high camp was very much to the taste of aesthetes like Swinburne and Pater and Wilde himself. But most of his friends disowned Solomon when he was arrested for soliciting in a lavatory; and in spite of his real talent, he ended his life as a pavement artist, in bitter poverty.[30]

In the last couple of decades of the nineteenth century there was more open homosexual art; that peculiar mix of sentimentality and humor that has been labeled "camp" comes into its own in those years—a knowing, insider's mockery of straight manners, a sly attempt to appropriate and to parody "feminine" modes and manners, and a retreat into the more perfect and precious world of art. The first issue of *Studio* for example, had an article on outdoor photography illustrated by nude shots of Sicilian boys, charmingly effeminate. The editor and the arty-crafty public who read the magazine may not have realized what the feature was all about, but it spoke quite clearly to initiates.[31]

Edward Burne-Jones spelled out some of the themes that were to attract artists increasingly toward the end of the century. He created pedantically precise dreamworlds, self-consciously archaic and aesthetic. Within these, he was freed to express his personal fantasies with almost embarrassing directness. When he tackles the theme of Pygmalion, for example, the sculptor, draped in see-through gauze, is far more fragile and feminine than the statue which stoops to embrace him; his Perseus and Andromeda are look-alikes, and if anything, she looks more suited to tackle the dragon. And Burne-Jones was one of the first to return obsessively to the contrast between the helpless, passive male, and the dangerous destructive woman. In his *Phyllis and Demophoön* (1870) he gives an odd personal twist to Ovid's story of the deserted girl transformed by the gods into a tree. She reaches out, not forgivingly but greedily, locking her arms around the body of her frail and frightened lover. (The London *Times* found the picture thoroughly distasteful, both because the woman is pursuing the man, and because Demophoön's penis is exposed.[32] And his genitals *are*

disturbing, simply because they are so diminutive, as if they had withered to nothing under the woman's onslaught.) The man is in even worse trouble in *The Depths of the Sea*, where the smug and sinister mermaid, her arms clamped round the loins of a beautiful nude youth, plunges him to his death. And this fantasy finds climactic expression for Burne-Jones in his many versions of *The Wheel of Fortune* where the nude bodies of men are bound to a wheel turned by a towering and sinister female. Despite their massive torsos and muscular legs—they were derived from Michelangelo—the men are effete, langorous, masochistic.

The contrast between the refined and feminized male, and the destructive monster woman—Salome, Medea, the Sphinx—was increasingly popular. Early in the century, Ingres had painted Oedipus as a radiant and poised nude athlete, who has confidently penetrated into the dark horrors of the cavern to confront the Sphinx—half beautiful woman, half ugly beast—and to defeat her. Nearly fifty years later when Gustave Moreau returned to the theme, the Sphinx has emerged from the shadows. Clinging by her claws to his chest, she dominates both hero and painting; beside her beautiful but horrible body, the naked Oedipus seems an undefined shadow. Another *fin-de-siècle* painter takes the theme even further. Franz von Stuck shows the Sphinx totally on top of things. Oedipus's naked body collapses helplessly backward under the onslaught of her vampirish kiss, while her long mane of hair entangles and almost strangles him.

Many of the artists and poets who called themselves symbolists and decadents revived the old notion of the androgyne as the perfect, and the truly creative human type. In 1885, the review *Le Decadent* claimed that "the Decadents are precursors of the society of the future, are close to the ideal type of perfection. The few fine, silky hairs on their faces are only remotely reminiscent of the animal. Man is growing more refined, more feminine, more divine."[33] But this ideal androgyny—only possible for men—is closer to misogyny. In fact—as Moreau's heroes suggest—their dreamy refinement exists *only* in contrast to the virile woman who is portrayed as lascivious, perverse, bestial and disgustingly animal. The "ultimate" magic rule of the Rose Croix Salons was that no woman be allowed to exhibit, and Moreau believed that "the serious intrusion of women into Art would be an irremediable disaster."[34] These languid males are not truly bisexual; they are not even fully homosexual. Their energy is expended largely

in loathing, terror and envy of woman. As a few artists admitted, the androgyne can only exist in a virgin state. Incestuous, narcissistic, adolescent, it implies a rejection of all mature sexuality; in the end, it is an image with only one meaning—sterility and death.

Even an artist like Rodin—capable of creating figures as vigorously graceful as his *John the Baptist*, as crudely vital as the great fat nude *Balzac*—was oddly preoccupied by the nightmare of the destroying, draining women. In a group like his *Three Shades*, the identical male figures seem to be merging in a ritualized mourning of their lost strength, exhausted by a fear that has stifled and blocked all their energies. George Minne's *Kneeling Boy* is one of the most effective and troubling expressions of this weary self-love. Slender to the point of emaciation, frail and old before he is fully grown, he tenderly and fearfully embraces his own body. Minne repeated the figure many times, and placed five copies of it around a pool so that each seems to be gazing at his own drowned face. The group sums up with almost nightmare vividness the obsessional power, and the sterility, of the narcissistic androgyne in the *fin-de-siècle* imagination.

All the decadent stereotypes—the monstrous women and the delicate hermaphroditic boys—turn up in Aubrey Beardsley's work; but he is perhaps the only artist to inform them with real erotic energy, with a sparkling, self-aware wit. Indeed, Beardsley's constant visual puns are a mocking commentary on a great deal of nineteenth-century art. The penis, which had been so anxiously minimized or blurred or fig-leafed away, is central to his fantasy. He was always trying to smuggle phallic images past his publisher John Lane's censoring and censorious eye. In the illustrations to *Lysistrata*, published only in an expensive limited edition, Beardsley endowed his men with the most enormous erect organs—at once proud proclamations of impossible virility and signs of hopeless frustration. Beardsley's open and provocative obsession with the penis is the other side of the century's prudery, a witty and despairing assault on its self-deluding respectability.

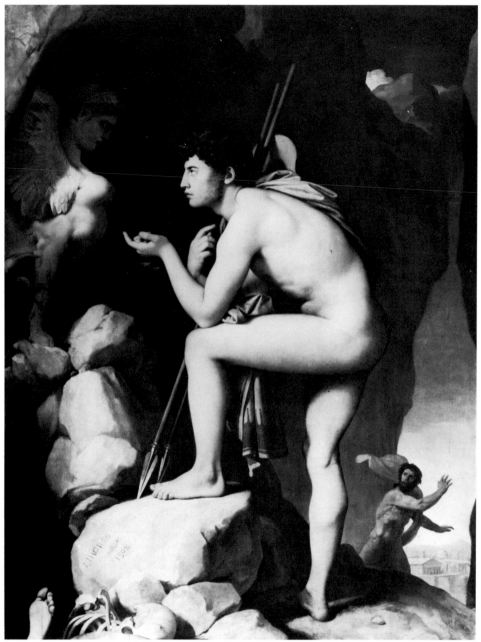

Oedipus and the Sphinx, 1808, Ingres

246

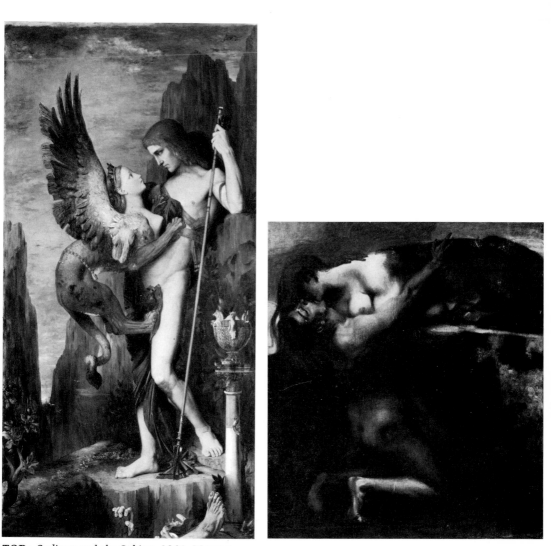

TOP: *Oedipus and the Sphinx*, 1864, Moreau
RIGHT: *The Kiss of the Sphinx,* c. 1895, von Stück

THIS PAGE, TOP LEFT: *The Wrestlers,*
c. 1867–8, Daumier
TOP RIGHT: *The Wrestlers,* 1853,
Courbet
LEFT: *Satan Calling His Legions*, late
eighteenth century, Lawrence

OPPOSITE, TOP: *Study of Two Severed*
Legs and an Arm, c. 1819, Géricault
BOTTOM: *The Raft of the Medusa,* 1819,
Géricault

THIS PAGE: *Dead Christ with Angels*, 1864, Manet

OPPOSITE TOP: *Young Spartan Girls Provoking the Boys*, 1860, Degas
BOTTOM: *The Swimming Hole*, 1883, Eakins

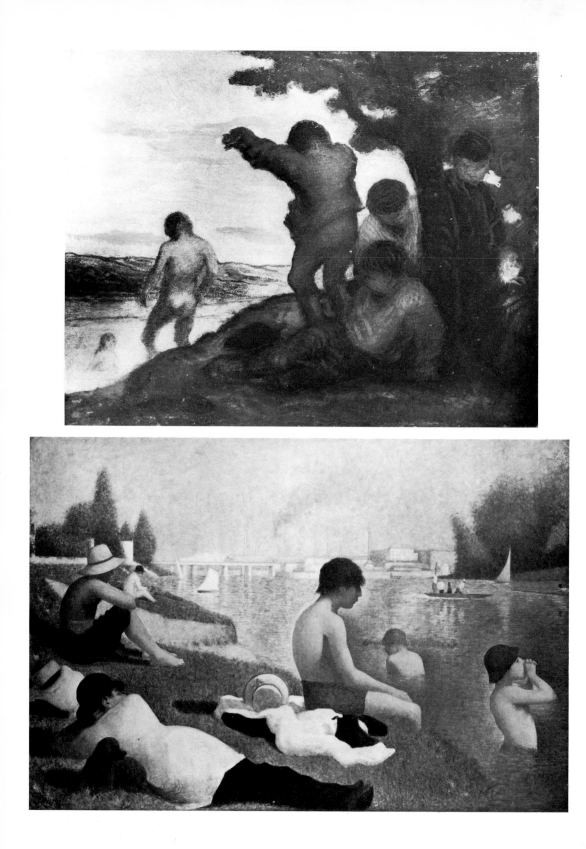

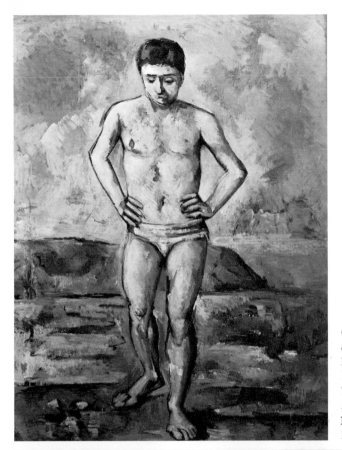

OPPOSITE, TOP: *The Bathers, c.* 1852, Daumier
BOTTOM: *Bathers, Asnières,* 1884, Seurat
THIS PAGE, LEFT: *The Bather*, 1885–7, Cézanne
BOTTOM: *Male Bathers, c.* 1875–80, Cézanne

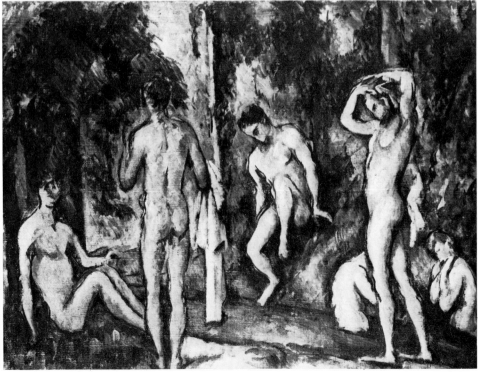

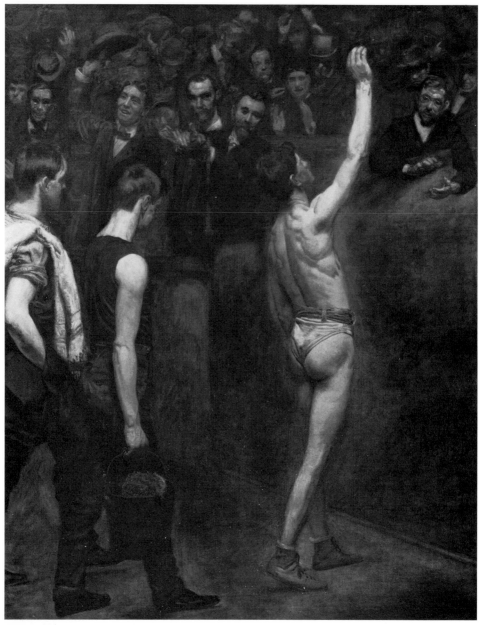

THIS PAGE: *Salutat*, 1898, Eakins

OPPOSITE TOP: Illustration to *Lysistrata*, 1896, Beardsley
BOTTOM: *The Artist and his Model*, 1911, Robertson

AUBREY BEARDSLEY

THE · ARTIST · AND · HIS · MODEL ·
· ERIC · ROBERTSON · NOVEMBER · 19ᵀᴴ · 1911

The Nude Disembodied

BY THE BEGINNING OF the twentieth century, the traditional nude was wholly discredited, its meanings debased and exhausted. Attacks on the sanctity of "ideal" beauty reached a violent climax. Artists spoke as if the classic nude stood for everything reactionary and repressed in their society; ironically, the nude—so potentially shocking to the Victorian bourgeoisie—had become a symbol of everything static, sentimental and hypocritically respectable in bourgeois life. So the sculptor Arp scoffs at all those "naked men, women and children in stone or bronze . . . who untiringly dance, chase butterflies, shoot arrows, hold out apples, blow the flute [and who] are the perfect expression of a mad world." And the Italian futurist Boccioni, rebelling against "the enthusiasm for everything moth-eaten, dirty, time-worn," proclaims that "we fight the nude in painting, as nauseous and tedious as adultery in literature."[1]

Deliberately, provocatively, artists insist that the human body is no more special or sacred than any other object, natural or man-made. Sculptors in particular may still start from the nude, but most insist that their figures are utterly devoid of all emotional, psychological and even sexual connotations. Absorbed only in abstract questions of weight and proportion, they feel free to ignore anatomy, to exaggerate or abbreviate the body as they choose. In the late nineteenth century, Mauric Denis had argued that a painting, before it is a battle scene or a nude, "is essentially a flat surface covered by colours assembled in a certain order."[2] The Cubists go even further. The nude must be dehumanized, to cleanse it of a sickly, dishonest and outdated humanism; it must be disembodied, so that its underlying structure

256

may be discerned more truthfully. For many Cubists in the years before the First World War, the subject as such becomes far less important; the act of perception, the way the mind works on the external world, is their primary theme. As Fernand Léger declared, "for me, human figures, bodies, have no more importance than keys or bicycles . . . for me they're basically plastically valid objects and they're for handling as I choose."[3]

Many twentieth-century artists have continued to avoid the nude like the plague; for decades, art based on the human figure was out of fashion. But the nude still haunts artists. It remains the starting-point and basis of some of the century's most daring experiments in abstraction. An artist like Picasso dismembers the nude, puts it through surrealist transformations, teases the spectator with his distortions and discoveries—then summons up all his magic in an effort to put the nude, like Humpty Dumpty, together again. Baudelaire once remarked that the "great tradition" of figural art had been lost and the new one not yet established. Even today, no clear tradition based on the nude has emerged. But still—shamefacedly, nostalgically, under the pressure of sexual feeling, or in despair and disgust at what man has done to man in our time—artists return and try to re-imagine the living nude.

PROPAGANDIST NUDES

The idealized, classic nude—once a living symbol of man's faith in his own powers—reaches its lowest point in our times: in the obscene, plastic perfection of publicity and propaganda.

In *Ways of Seeing*, John Berger has demonstrated how advertising not only quotes the art of the past, but has adopted wholesale the visual language—the carefully posed female nudes, their symbolic accessories and exotic settings—of post-Renaissance oil painting. This is not just a cunning commercial exploitation of High Art for the sake of its prestige. Berger argues that "oil painting, before it was anything else, was a celebration of private property. As an art form, it derived from the principle that *you are what you have*."[4] Publicity is "the last moribund form" of that art, playing on and promising to satisfy the spectator's sexual frustrations and material discontents. Looking at the publicity nude may help us see more clearly the underlying assumptions of some of the museum pieces we approach so reverently.

Propagandist art draws on the time-honored symbols of High Art

for similar ends—to inspire men with the dream of a perfect future that will compensate for all their present privations. As one National Socialist Minister explained in Germany in 1937, art should unfold a "world of wonder" so that people may "dream themselves into an enchanted ideal world which life permits us all to sense but seldom to comprehend and never to attain."[5] The male, rather than the female nude was the major symbol of totalitarian art, particularly in Nazi Germany. (Though the kind of nude I am talking about turns up in Italy, Russia and even in the States: for example, that over-muscled Atlas who strains so histrionically outside the Rockefeller Center in New York.)

In Germany, particularly, there was an almost unbroken line between the banal but high-minded salon sculpture of the last century, and the overtly fascist nudes of the 1930s and 1940s. Herbert Read has commented on the continuing influence of the classicizing sculptor Adolf Hildebrand, who claimed that he was reviving the great Renaissance tradition of spiritualized beauty.[6] Literally scores of sculptors followed in his wake; most of them— Blumenthal, Lehmann, the Italian de Fiore who found his most congenial audience in Germany—are almost forgotten now. Kattentridt's slim young athlete modestly holding his victor's wreath is treated conventionally, romantically; Franz Metzner's *Victor* is more abstract—super-masculine and at the same time coyly self-conscious. The sexual element in both works is distasteful, simply because it masquerades as something else—as a pure humanist appreciation of Beauty.

In the 1920s and 1930s, many artists who celebrated the male body slipped into a weak sentimentality. That is true even of artists as talented as Gerhard Marcks, or the painter Oskar Schlemmer, both later banned by the Nazis. The vacuous quality of their nudes springs, perhaps, from an almost desperate refusal to acknowledge the relationship between their own romanticism, and the emerging National Socialist ideology of the healthy, racially pure body. Georg Kolbe is an even more disturbing case. Capable of work as sensuous and sensitive as the poised, turning dancer illustrated here, he gradually adapted his work to official Nazi policy. During the war he undertook official commissions, and his studio, with its assertive and aggressive nudes, was one of the show-places of the regime.[7]

Interestingly, it was a woman, Renée Sintenis, who produced some of

the most memorable images of male virility. She seemed to identify closely and intensely with the male body strained almost to breaking-point by physical effort; her sculpture includes a boxer, an action portrait of the great long-distance runner Paavo Nurmi, and a footballer whose whole body is tensed and contorted as he kicks. Another woman—movie-maker Leni Riefenstahl—was perhaps the most effective of all Nazi propagandists. Her film on the 1936 Olympic games is an extraordinary celebration of masculine strength; in Susan Sontag's words, "one straining, scantily clad figure after another seeks the ecstasy of victory, cheered on by ranks of compatriots in the stands, all under the still gaze of the benign Super-Spectator Hitler whose presence in the stadium consecrates this effort."[8] And like those other artists whose work foreshadowed Nazism or served as overt propaganda, Riefenstahl has always defended her work in familiar humanist terms: "I am fascinated by what is beautiful, strong, healthy, what is living. I seek harmony."[9]

All through the post-war 1920s, the cult of the strong healthy body was being linked to something more sinister: the claim that classic, Hellenic beauty is most purely realized in the Nordic race. The *Napolas*, the state schools founded in the 1930s to train a future fighting élite, institutionalized the preoccupation with the body. Physical education was everything, and the chosen few spent the greater part of their time on gymnastics, athletics, all kinds of vigorous exercises, shading into military training, which were designed to build up a disciplined and corporate spirit. And the boys were encouraged to dream of themselves as heroes in a great, legendary tradition, ready to give all for the father land. In 1937, at the opening of the House of German Art in Munich, Hitler spoke ecstatically.

Never was humanity in its appearance and its feeling closer to classical antiquity than today. Competitive sports and combat games are hardening millions of youthful bodies, and they show them rising up in a form and condition that have not been seen, perhaps not been thought of, in possibly a thousand years.[10]

By the early 1930s, most of the radical and original German artists—Barlach, Kandinsky, Kollwitz, Grosz, to name only a few— had been attacked as sick degenerates whose distortions of the body were corrupting the German people. The SS weekly *Das Schwarz Korps* proposed the alternative; art is to reveal "an elemental godlike humanity. Only then does it become an effective means of educating

our nation in moral strength, folkish greatness and . . . resurrected racial beauty."[11]

The "elemental godlike" nude is perhaps the central symbol in official Nazi art; far more than guns or tanks or planes, it served as an image of the national will to power. The fantasy that equates the strong healthy body with the community is often spelled out directly. Thus in 1933 Goebbels remarked:

we who shape modern German policy feel ourselves to be artists . . . the task of art and the artist [being] to form, to give shape, to remove the diseased and create freedom for the healthy.[12]

But the naked Nazi warriors—overbearing, brutally muscled—are completely dreamlike. As Susan Sontag comments, they resemble "pictures in male health magazines: pinups which are both sanctimoniously a-sexual and (in a technical sense) pornographic, for they have the perfection of fantasy."[13] In Arno Breker's enormous relief *Kameraden* one nude supports his dying friend while straining angrily onward and upward. The reality of death in modern war is a thousand miles away. Josef Thorak specialized in great stone nudes gazing fervently into the distance, symbols of an ecstatic willingness to undergo any ordeal for the public good. The statue illustrated here is a storm trooper; but he carries a sword, not a gun, and his noble and timeless nudity summons up vaguely inspiring images of Greek heroes and Nordic gods. (Female nudes are as unreal as the male; Hitler commented once that his soldiers "coming home from the front . . . had a physical need to forget all the filth by admiring beauty of form."[14] The Judgment of Paris is a favorite Nazi theme—the usual muscular male looks with an appraising breeder's eye over three coy and antiseptic blondes.) One of the few works that gets beyond this sentimental and distracting unreality is Thorak's monument to the building of the autobahn; for once, the rhetorically stereotyped nudes do hint at the reality of labor in the modern world.

The point is that the fascist nude is not just a freak. It is rooted not just in certain elements in German life and art, but in the European classical tradition. Thorak's nudes, however crude and debased, have something, still, in common with a Greek warrior or a Renaissance Hercules. The recent exhibition of Third Reich art undoubtedly fed into the currently fashionable interest in fascism and its regalia. But it was valuable because it asked us to reappraise much that we take for granted in our own hallowed "classic" heritage.

GAMES ARTISTS PLAY

"For us the Greeks invented the human form; we must reinvent it for others," Jean Metzinger remarked in 1910, praising the Cubists and particularly Picasso who "rejecting every ornamental, anecdotal or symbolic intention ... achieves a painterly purity hitherto unknown."[15] In the years before the First World War, there was a new and exciting awareness that the classic nude is simply one convention among others, involving a way of seeing that is learned and not absolute. The early Cubists, restlessly experimenting, were often attracted by the drastic simplifications, distortions and exaggerations of Negro and Polynesian sculpture. Some artists insist on the scientific basis of their work; certainly more sophisticated cameras and microscopes, a new technology and revolutionary new theories about reality and relativity, were all complicating man's attitudes to the world around him. André Salmon could go so far as to claim that the seminal Cubist work, Picasso's *Demoiselles d'Avignon*, is like a scientific equation, with the figures "naked problems, white numbers on the blackboard."[16]

Pre-war Cubism is charged with all the excitement of revolutionary discovery, insisting on the complexity of the appearances that we have taken for granted for so long. Artists break open and rearrange the body, reduce it to schematic and geometric shapes. They deny the metaphysical significance of the nude, in an attempt to make us experience the full complexity of its material organization. Their nudes are both unreal, and intensely palpable. Aware that reality is multiple, they assault all our old notions about perspective, mass and space; and force us to think about the act of seeing itself, the *process* by which the mind constructs and experiences the body.

In much twentieth-century art, the dislocation and re-ordering of the body becomes a game—sometimes light-hearted, sometimes very serious. An artist like Picasso clearly enjoys teasing his audience, seeing how far he can go toward abstraction without losing touch with the human body. The same is true of the sculptor Brancusi. Sometimes he plays with "found" shapes; his oddly haunting *King of Kings* is put together from fragments of an old winepress. In his witty piece *The Kiss* the two embracing figures are barely sketched into the containing block of stone, but in spite of the minimizing of anatomical detail, the effect is disconcertingly sensuous. And so is his *Torso of a Young Man*, which simultaneously works as an intellectual symbol for

the male genitals, and echoes the structure of a real body.

A later and very different work—Noguchi's *Kouros in Nine Parts*—both mocks and fulfills the expectations aroused by its classicizing title. We enjoy its abstract pattern, *and* its subtle reference back to the living shape that is, after all, the basis of all our experience of form. Marisol's *Spaceman* recalls a classical herm, a column reduced to head and genitals, but she turns a relic from the past into a figment from a science-fiction future. And so called "super-realists" like sculptor John de Andreas are playing yet another version of the old game with illusion and reality. Modern technology has advanced to the point where he can make a polyester man whose body is so convincingly "lifelike" that the eye is briefly deceived and the spectator must once again readjust his expectations about art and reality.[17]

In fact, much twentieth-century distortion of the body springs from intense and often ambiguous emotion. The *Demoiselles d'Avignon*, despite Salmon's claim about its scientific objectivity, was an angry, almost hysterical assault on the spectator. It is significant that early Cubist nudes—by Picasso or Braque or Duchamp—are almost always female rather than male. The artists thoroughly enjoy shattering what had become *the* symbol of ideal beauty, and often take a cruel misogynist pleasure in fracturing the sensuous curves of the female nude and converting them into geometric shapes.

The new formal freedom has meant that artists are free to explore their subjective response to the nude, the barely conscious fantasies in which desire and disgust constantly re-fashion what we see. The surrealists, trying to tap those fantasies directly and theoretically, often played immensely sophisticated games in which the human body is dissolved into a kaleidoscope of interchangeable parts, or in which bodily parts and other objects are symbolically merged. Dali's *Death of Narcissus* is a brilliant example of this mingling of human anatomy and inanimate objects to recapture an experience at once physical and psychological. Bizarre and disturbing effects can sometimes be achieved by simply putting the conventional nude into a disconcerting setting, or by playing with scale. Paul Delvaux plays weird games with the female nude and clothed men; and Otto Greiner's seated *Prometheus* holding a tiny simulacrum of his own body—cruelly? protectively?—is both baffling and haunting.

A recurring twentieth-century dream has been of a return to the primitive, the barbaric, the naive. Negro and Polynesian fetishes

seemed to have a sexual vigor sadly lacking in the nude of Western tradition. The sculptor Maillol—who in fact produced highly sophisticated nudes very much in the classic style—explained his yearning for something else.

> When nations grow old, their art grows complicated and soft. We should try to return to our youth and to work naively. . . . Our century has tried to return to the primitive. I work as if no art had ever been made before me, as if I had never learned anything. I am the first man to do sculpture.[18]

Artists sometimes try, in an act of aesthetic imperialism, to appropriate some of the religious and cultural power of Negro or Polynesian idols; as if, borrowing alien forms, they might re-capture some of the totemic potency, the barbaric magic once associated with a Hercules or a Christ. The attempt was bound to fail; as Maillol commented sadly, Negro art may contain more ideas than Greek, but "what connection is there between [France] and Negro sculpture? An artist can only create in accordance with the character of his people and his time." But the play with foreign images certainly released powerful creative impulses in some individual artists—Picasso, Braque, Derain—especially in the first decade of this century.

In the attempt to escape a machine age which was increasingly experienced as threat rather than promise, some artists—Lehmbruck, for example—turn back to earlier periods of Western art. Lehmbruck echoes the austere and elongated shapes of Gothic sculpture; his reserved and ghostly nudes are a tragic comment on a dislocating present, and his *Fallen Warrior* remains as the most moving of all First World War memorials to the dead. Other artists—including Germaine Richier, Zadkine, Leonard Baskin—have been attracted by the severe torsos of pre-classical Greece, so simplified that they approach pure abstraction. Baskin's *Great Dead Man*, for example, is moving because the body has been reduced to stark essentials. We are uncertain if the human shape has yet to emerge from stone or wood, or if the body has been worn back, by the passing of time, to mere inert matter.

Germaine Richier often stresses the actual process of bodily decay, sometimes by mixing sticks and branches in with her bronze. In her *Devil with Claws*, or the *Batman* done a couple of years before she died in 1959, the body seems to have been invaded by something alien. The figures are at once primitive, and a science-fiction nightmare; literally monsters, man-insects, destructive and self-destroying. And some of

Baskin's most haunting drawings are half-man, half-bird. They may be wearing masks, or undergoing some inexplicable metamorphosis. They too seem to summon up buried memories—recalling, for example, the sorcerers drawn in neolithic caves—yet they have the immediate reality of something out of an LSD hallucination.

The return to more primitive forms is often associated with an interest in childhood fantasy. Dubuffet, for example, deliberately sets out to mimic the crude sexual energy of child or mad art, or even the forms of scribbled graffiti. His nudes are grotesque, at once comic and terrifying. And it seems to me that Giacometti's later, surreal figures sometimes recall children's stick drawings. Those long brittle bodies, pared down to something even more minimal than bone, are eroded almost to vanishing point. They are like parodies of man consumed away by his anxiety and fear of the void; they are all the more vital and suggestive because they tread the edge of absurdity.

The latest expression of the yearning for the primitive is a paradoxical one; I find it in the pop art of the sixties, obsessed with the artefacts of our mass consumer society. Pinups and publicity borrowed the images of high art; now serious artists take the process a stage further, and choose for themes those slick and second-hand images. A few artists—Warhol, or Richard Hamilton—have commented ironically on mass culture and the way it depersonalizes and exploits the human body. But artists like Wesselmann, with his series of Great American Nudes, Wyn Chamberlain, Mel Ramos, or Allen Jones, all seem to be driven by envy, by a haunting feeling of impotence, of being out of touch with everything except the blinkered and incestuous art world itself. The crude iconography of mass culture appeals to them as the tribal fetish attracted artists at the beginning of the century. It is a primitive power they seek to recapture for art, sexual, magical; the hold that certain faces and bodies exert, simply because they are infinitely reproducible, on all our minds.

SUFFERING

Looking back in 1923, the German artist Kirchner conjured up the idyllic years before the First World War, when he and his young friends were optimistically looking for a new art and a new audience. An essential part of their credo was a return to nature, and "free drawing from the free human body in the freedom of nature." His colleague Pechstein lovingly conjures up those pre-war German

summers when the whole group of artists who called themselves the
Brücke, traipsed off to the lakes at Moritzburg. "We artists set out
early every morning, laden with our equipment, followed by the
models with bags full of good things to eat and drink. We lived in
complete harmony, we worked and we went swimming. If we needed
a male model to set off the girls, one of us would leap into the
breach."[19]

But in retrospect at least, the scores of nudes relaxing, playing and
bathing in the sunshine, seem full of a premonitory anxiety; as if the
artists were aware, on the edges of their consciousness, that time was
running out. Their nudes are angular, the vivid jarring colors and
crowded perspectives suggesting a *will* to freedom rather than genuine
relaxation. Kirchner's *Figures Walking into the Sea* is typical; there is
little hint of the desired harmony between the sexes and with nature.
The two nudes step stiffly, warily, as if the sea were hard and alien;
they are as uncertain of their own bodies as they are of the rest of the
physical world. (There is a comparable tension in bathing scenes done
by contemporaries in other countries as well. When the Norwegian
Munch shows boys swimming, he accentuates their delicate frailty,
and his *Bathing Men*, at first glance confident and healthy, come to
seem at once over-aggressive in their stance, yet tentative and even
spectral.)

In his fascinating book on the great war, Paul Fussell has pointed out
that a memory of seeing soldiers stripped and bathing is almost a set-
piece for poets and diarists, summing up their feelings about the
inhuman brutality of war and the vulnerability of mere flesh and
blood. The writer's feelings are often romantically sexual—a feverish
sexuality intensified by the omnipresence of death. Reginald Farrer,
walking across the burned-out battlefields of the Somme, is typical:

> A little way off a naked Tommy was standing under a spout of
> water. And the beauty of that tiny frail fair thing, vividly white
> in the sunshine upon that enormous background of emptiness
> and dun-coloured monotony of moorland was something so
> enormous in itself that it went straight through me like a violent
> lance of pain. So minute a little naked frog, hairless and helpless,
> to have made the earth such a place of horror. . . . All those
> complicated bedevilments of iron and dynamite, got together at
> so vast an expense of thought and money and labor, to destroy
> just—*that*.[20]

A First World War Memorial at Hyde Park Corner uses the same imagery—the fragile beauty of a naked adolescent commemorates fallen members of the Machine Gun Corps. And some of the romantic youths so popular in 1920s Germany may seem more sympathetic if they are seen as a half-conscious protest against the lingering memory of the slaughter of 1914–18. But on the whole, the sheer physical horror of trench warfare seemed almost impossible to express in direct visual terms.

Kirchner, who was conscripted into the army in 1915 and invalided out in a state of collapse, painted himself as a soldier with his right, painter's hand, amputated. One very powerful painting survives from his period of military service—the 1915 *Artillerymen*. It is a claustrophobic work; soldiers are stripped naked and herded into a shower-room, a uniformed and booted man leans casually against one wall, while a naked man crouches down feeding coal into the big burner in the middle of the room. The men are an anonymous tangle, their arms stiff and angular, as if they were warding off the spouts of water. Stripped of clothes, they are depersonalized; their defenceless-ness only stresses that they are parts of a vast machine, endlessly replaceable. (In an attempt to exorcize his horrors Kirchner retreated to Switzerland and painted landscapes and peasants. But in 1933 his work was proscribed by the National Socialists. He killed himself in 1938.)

Kirchner's war painting may perhaps be compared with Fernand Léger's *Soldiers Playing Cards*, done in 1917 when Léger, after two years in the artillery, was recovering from a gas attack. Léger admitted that he was fascinated and attracted by machines and military equipment; he wrote of being "dazzled by the breech of a 75-millimeter gun which was standing uncovered in the sunlight; the magic of light on white metal."[21] But in this painting he confronts his own ambiguous response. The soldiers themselves—caught, ironi-cally, in a moment of relaxation—have become machines. Their bodies are disintegrated into rounded, robotic shapes that recall the guns they are trained to use—and that can so easily destroy them. According to Robert Rosenblum, the painting achieves a classical lucidity and precision in its "reduction of the visible world to a state of polished regular shapes and well-oiled mechanical functions."[22] This seems to me nonsense. The painting is horrifying because of the contrast between its aesthetic formality and its theme, the contrast

between the easy enjoyment of the card game, and the fact that the soldiers are machines for killing—yet machines of flesh and blood who can be terribly mutilated.

In their attempts to cope with the horrors of war in this century, artists have occasionally turned back to Christian imagery, particularly to the tortured Christ of the late middle ages. Beckmann, who like Kirchner was invalided out of the army, struggled to record and to distance his traumas by painting a powerful *Deposition*, where Christ's angular tortured body serves as an accusation to the present. Picasso has done some terrible variations on Grünewald's already terrible *Crucifixion*; and in at least one work, Zadkine has echoed the contorted shapes of a medieval plague cross. But these contemporary Christs offer no consolation; they pose questions and hold out no answers.

The most famous of all twentieth-century protests against war is Picasso's *Guernica*, his response to the bombing of the Basque town on April 26, 1937. Cubist distortion and disintegration of the body powerfully expresses his anguished identification with the dead and dying. John Berger has given the best account of how the painting works; the protest, he argues, is not in any specific reference to the actual place or event.

> It is in what has happened to the bodies—to the hands, the soles of the feet, the horse's tongue, the mother's breast, the eyes in the head. What has happened to them *in being painted* is the imaginative equivalent of what happened to them in the sensation in the flesh. We are made to feel their pain with our eyes. And pain is the protest of the body.[23]

Zadkine's great monument to the city of Rotterdam, bombed into ruins during the Second World War, achieves a comparable power. The body is inhuman in its mutilated shapes; yet the great arms, raised in supplication and protest, also suggest power, a will to survive and re-build. The figure speaks both death and resurrection—but a resurrection to be accomplished by man alone.

Photography has made the horrors of modern war familiar to us; an intimate knowledge of death and atrocity is embedded in all our imaginations. Yet it is easy to stop *seeing* photographs, to let them distance reality rather than bring it to immediate life. That is why certain drawings—Moore's studies of people using the London underground as bomb shelters, or some drawings by concentration camp inmates—perhaps speak to us as no photograph can. Faviez's

Buchenwald drawing is even more shocking than Goya's *Disasters of War*; because it was drawn as an act of protest, as a way of retaining some hold on life, out of determination to create a record that might survive even if the artist and his people were totally obliterated. The sketch, showing prisoners being inspected for lice, is both pathetic and tragic; even when he is half-starved, even on his way to the gas chamber, man can still feel all the humiliating vulnerability of nakedness.

SEX

In 1916, a bronze by Brancusi, titled *Princess X*, was banned from an exhibition of modern art in Paris, because its highly polished, abstract shapes were unmistakeably phallic. Exactly fifty years later, the London police raided and closed down a show of watercolors by artist Jim Dine. His theme? The penis, in a whole range of shapes and sizes. The paintings are pretty, witty—one is gift-wrapped in flowered Selfridges paper—and all treat the penis purely as an abstract shape, detached from the body.

The penis, however stylized, is apparently more shocking to the guardians of public morality than the vagina, the fully-frontal male nude more offensive than any female. In 1933 New York customs seized and condemned as "shocking pornography" a portfolio of Michelangelo's Sistine nudes. And even in the 1970s, some American artists interested in portraying the male nude minus fig leaf have been refused museum space or their shows threatened with closure.

Modern erotic art has prided itself on breaking down taboos, on giving open and liberating expression to any and every fantasy, however perverse. Yet even avant-garde artists have often had to disguise the extent of their interest in the male body. The Englishman Eric Gill, for example, did scores of sheets of drawings, detailed and vigorous, of the penis; but this was the working out of a private obsession, contrasting sharply with the generalized, bland and sublimated sexuality of his public nudes—the Sebastian now in the Tate or the Ariel carved on Broadcasting House.[24] A modern American painter told Cindy Nemser that he had been drawing fully frontal male nudes for nearly twenty years before he dared to exhibit them; and then, he said, it was men rather than women who disapproved. "They don't like looking at other naked men. 'It's in bad taste,' they say."[25]

For many male artists—because they fear the obscenity laws, because they hesitate to admit their homosexuality in public or are scared of being labeled homosexual, or simply because most men are not in the habit of looking at their own bodies—the penis has remained the hidden, forbidden object.

The Kronhausens' famous erotic exhibition in Sweden in 1968 made it clear that the female body remains—as it was in the nineteenth century—the main subject of erotic art and the vehicle of male sexual fantasy. Many artists were clearly proud of their daring in showing the previously unshowable; female genitals fairly leaped off the wall at the Swedish show. Endless naked girls spread their legs, postured for the spectator, masturbated. Their exposed vaginas were sometimes prettily stylized, sometimes shown in detailed anatomical closeups, and sometimes as nightmare images—as a bleeding wound, a devouring insect, a gaping hole. But where were the male equivalents? In various studies of couples actually making love, the male organ was shown in visible and vigorous action. But except in a small section devoted to primitive art, which included some phallic male totems, there were hardly any straightforward male sex objects. And when the penis was represented alone, it was almost always metaphorically, intellectually: as in Man Ray's witty silver *Paperweight for Priapus*, put together out of highly polished spheres and cylinders.[26]

Modern artists—from pioneers like Brancusi through surrealists like Ray to modern pop artists like Oldenberg—have tended to deal with the penis obliquely, abstracting it away from its vulnerable, flesh-and-blood reality, and giving it the remote dignity of a phallic symbol. Paradoxically, one way of symbolically exploring fears and fantasies about the penis has been by study of the female nude. Many artists who return obsessively to the image of the open vagina seem to be working out an unacknowledged anxiety about castration; they force themselves to confront a body where the worst has already happened. Other artists deliberately turn the female nude into a phallic symbol. Thus some Picasso drawings, harking back to prehistoric fertility figurines, combine in one shape both male and female sex organs. The German erotic artist Hans Bellmer has argued that the female image is determined and wholly defined by male fantasy; in the deepest sense, her breasts and legs and buttocks are masculine.[27] In some of his drawings, the female nude is violently assaulted and re-formed into a phallic shape; her body becomes, in the

269

strict sense, a fetish, a phallic substitute which both evokes the child's original terror of castration, and reassuringly denies it. This is presumably the point as well as Magritte's *The Ocean*, an enormous, recumbent, exhausted-seeming male nude whose only sign of energy is in the small upright female nude who stands in for his penis.

Robert Melville has pointed out that though contemporary artists put the female body and genitals through the most fearful and drastic distortions, they tend to treat their own organs conservatively— gently, protectively. Melville singles out a life-size male nude by the sculptor Ipousteguy, a joke against academic dreams of the strong healthy body, with every part grotesquely distorted—except for the perfect, unblemished genitals. Again, Picasso wrenches the female nude and sex organ into the most startling and disturbing shapes, but tends to treat the male unconventionally. Even some of his Minotaur drawings, mocking man become half-animal in his lust, show the penis, in Melville's words, "as beautifully sedate and serenely limp as the most puritanical aesthete could wish."[28] And artists like Dali or Wunderlich who warp and deform and rearrange the male as well as female, rarely do more than enlarge the penis, or express some wish-fulfilling dream by giving a man more than one set of genitals.

Hans Bellmer, who has done some of the most powerful and disconcerting of all modern erotica, says that he sees the body "like a sentence that invites us to rearrange it, so that its real meaning becomes clear through a series of endless anagrams."[29] But it is the female body that he treats as if it were transparent, that is disintegrated and violated and abused. In drawings showing actual intercourse, the woman is filled and penetrated in every possible and impossible way, while the man is personified by his great plunging penis. Bellmer draws the penis with a stunning, unprecedented realism; concentrating on every detail, every wrinkle and hair. But these naturalistic penises, lovingly observed, are disembodied, multiplied, endowed with an autonomous and magical energy. In one sketch, everything in the room has become a phallus directed threateningly at the woman's body. In another, a penis protrudes from the woman's vagina, so that Bellmer seems to be playing with two contradictory fantasies—the male fear of the phallic woman, and his dream of reentering the woman's body and possessing it completely, from the inside, as he once possessed his mother. In yet another drawing, where a couple are shown making love, the man seems to be

270

everywhere, doing everything. His penis fills the woman's mouth, two more penises penetrate not just her body but her pregnant womb and the still unformed embryo inside. The man simultaneously takes and dominates the woman, nourishes her, impregnates her, and plays a continuing creative role in shaping the embryo into human form.

Only a comparatively few male artists have managed to overcome their deep-rooted alienation from their own flesh, and looked at their own bodies steadily and whole, unmediated through a woman. Egon Schiele's work suggests how difficult and painful that sexual self-scrutiny may prove, how much courage it demands. At first glance his nudes, both male and female, seem highly decorative; their sharp outlines and stylized poses recall the far more superficial work of his teacher Klimt. But in Schiele's case, the stylization permits him to explore yet to contain his fascination and fear about sex. His women fall more easily into the conventional poses of the art school; but his men are truly naked, not nude—uncomfortable and self-conscious. A series of sketches of Schiele's friend Dom Osen show him almost comically tense, his angular but formal gestures making him look like a marionette. But the most interesting of all Schiele's nudes are his many self-portraits. He gazes with horror and pleasure at his exposed body; his bared skin seems over-sensitive, as if even the air were abrasive. In recording his mirror image, Schiele has to overcome his fear of his own narcissism and latent femininity; yet he clearly finds an unexpected masochistic pleasure in exposing himself so intimately and mercilessly. Some studies actually show him masturbating; in one, he clutches at his genitals with both hands as if seeking comfort, in another he depicts masturbation as a lonely, desperate struggle for satisfaction. His masturbating women usually lie back relaxed; Schiele shows himself sitting tense, as if guilt and fear stop him from abandoning his body to the pleasure of his own touch. In one painting only, *The Family*, Schiele seems to be moving beyond his sometimes over-insistent anguish, and beginning to come to terms with his own naked body. He squats, stiff and awkward, his enormous arms and hands ape-like and clumsy; but his pose also suggests protective tenderness toward the naked woman and the tiny child who sit between his legs. The painting was left unfinished when Schiele—and his wife—died in the great influenza epidemic of 1918; he was only twenty-eight years old.[30]

Stanley Spencer's erotic work takes the female body as its central

image, but he too shows unusual frankness in contrasting and comparing his own body with the woman's. In an odd series of drawings, he shows himself and his wife enthroned on his-and-hers lavatory seats, their clothes dropped around their feet; in one sketch, the woman holds her pregnant belly and leans forward to stare down at his erect penis. Both figures are comic, awkward—yet in that most undignified setting manage to attain a kind of grandeur. Spencer's most famous nude painting is the double portrait of himself and his second wife Patricia, done in 1937 and now in the Tate. It is a brilliant study in flesh tones—the man's sallow hairy body set against the rubbery pink flesh of the recumbent woman, and against the deeper pink and red of the leg of mutton that lies so incongruously beside her in the foreground. The bespectacled painter is crouched tensely, gazing down at his relaxed wife with her casually spread legs. The way the face is foreshortened and cropped stresses his ambiguous expression: it includes hostility, hunger (as if he could literally devour her, treat her like a piece of meat) and baffled envy of her superb and oblivious confidence, her air of being at home in her body. The immediate theme of the painting is how Spencer sees his wife's nude body; but by including his own sad, ugly body as well, he enriches and complicates the work, transforms it into a puzzling but haunting image of a real and complicated relationship.

The violence implicit in the relationship between Spencer's two nudes, is spelled out with almost horrifying directness in Francis Bacon's *Two Men on a Bed* (1953). He echoes a traditional image, of two men wrestling, which had often been used to hint at a sexuality that can only be expressed in physical combat. Both figures are blurred, as if on a double-exposed film, to accentuate the violence with which the upper figure moves, and the anguish as well as pleasure of the passive partner. This blurring technique has become a cliché in some of Bacon's later work—a short-cut to *angst*. But this painting remains a powerful statement about a certain kind of sexual relationship between men.

More recently, artists have felt freer to express openly homosexual feelings in their public work. Both David Hockney and Patrick Proctor, for example, have drawn men together on a bed, and several of Hockney's works show a man lying face down on a bed, his buttocks exposed expectantly and provocatively. But I find Hockney's studies of the male nude, however overtly sexual the pose

or expression, curiously thin-blooded and attenuated. His cool, camp Californian style is perhaps a sophisticated disguise for an old-fashioned romanticism. Some recent American artists—Lowell Nesbitt for example—display more sensuous vitality and energy in the treatment of the male nude. But few artists seem to have achieved real originality; partly because they are working in a very familiar convention, and simply substituting a man or boy as sex object, without delineating anything specific about how a man experiences his body, or about how a man sees and responds to another's body.

A couple of drawings illustrated here do achieve something of that erotic particularity. Francisco Lopez concentrates in meticulous, almost obsessive detail, on his model's hands and penis; the rest of his body, including his head, fades into non-existence. The drawing seems to say something about the way sexual attraction distorts the way we see the body, how it makes us split and objectify it, at least temporarily. But Lopez's naturalistic detail also communicates something of the model's sensations, as if, conscious of being looked at and perhaps desired, all the life and energy in his body seems to be in his hands and penis. Barry Flanagan's drawing *David* is interesting for its hints of tension between artist and model. The sharp, aggressive black outline insists on the passive sensuality of the reclining body; yet he lies stiffly and the angry and assertive lift of his head suggests that David feels ambiguously about being used as a model and resents being seen simply as a sex object.

AND OTHER WAYS

Looking at twentieth-century painting, I have found that certain nudes have stayed in my mind. None is particularly startling, most were done in the face of what is considered fashionable or avant-garde; they form no clear pattern or tradition. Very much my own personal preferences, they suggest that artists can still use the male nude to make a direct, moving and dignified statement about contemporary experience.

John Kane paints his self-portrait—he was aged sixty-nine at the time—stripped to the waist, standing proudly upright, directly confronting the spectator. He looks at his own body unsparingly, without self-pity, recording all the marks of hard labor and age on his arms and neck and gaunt torso. His body is almost used up; but his pose suggests his stubborn continuing vigor, and his sense of his own

worth. The tired old body achieves an almost monumental grandeur.

Alice Neel's portrait of a man in Spanish Harlem, desperately ill with T.B., also comments on the way poverty and hard work and illness take their toll on the body. The man is gaunt, fallen back on the pillows; the careful gesture with which he just touches the plaster on his bare chest hints at his extreme frailty. The large eyes are open, but they seem to look inward rather than out at the spectator; he is self-absorbed, even narcissistic, as the very ill must be, preserving and containing all his energy against death. And it is this languid self-containment that is the paradoxical source of his vitality, the impression we get of a deep instinctive will to live, even on the edge of death.

Larry Rivers's gentle portrait of his adolescent son catches a different kind of vulnerability and self-absorption. The naked boy stands awkwardly, off-center in the picture. The big loose socks underline the fact that though he is fully grown, in some ways he is still a child. He has not caught up with himself, not caught up with the adult interests revealed in the untidy clutter of his room—the art books, the desk-lamp, the female pinup whose confident pose contrasts with his tentative stance. The painting catches brilliantly—shrewdly and affectionately—the problems of growing up, the long and difficult transition from boy to man.

The most interesting recent painter of the nude is perhaps Philip Pearlstein. Usually female but often male as well, his nudes are set against minimal backgrounds—a chair, a patterned rug, or as in the one illustrated here, a bed. They are viewed in closeup and from odd angles; they are often apparently casually cropped, so that part of the body or even the head may be missing. They never adopt conventional poses; they are sometimes slumped, not very gracefully, and their bodies are presented in highly individualized detail, with every wrinkle and crease showing. Linda Nochlin has given the most illuminating account of what Pearlstein is doing: "painting models in the studio in the act of posing . . . and he records that act of posing openly, in all its physical discomfort and psychic withdrawal." The models are often bored and tired from sitting or standing or even lying still for hours. As Nochlin says again, his nudes suggest "how it is to be a model and how it is to be a painter really looking at—not knowing about or even thinking about—a model."[31] Pearlstein drains the nude of all its obvious associations, even sexual ones; he does not

sentimentalize the nude, or treat it as a symbol of any kind. He simply presents the body in all its tired, imperfect but irreducible dignity. By paring his art back to basics, he makes us look at the nude freshly, perhaps gives it a new lease of life.

TOP LEFT: Nude athlete, *c.* 1910, August Kattentridt
TOP RIGHT: *The Victor*, early twentieth century, Franz Metzner
BOTTOM LEFT: *Dancer, c.* 1914, Georg Kolbe
BOTTOM RIGHT: *Monument to the Freedom of Danzig*, 1943, Josef
Thorak

COLLECTION, THE MUSEUM OF MODERN ART, NEW YORK, GIFT OF ABBY ALDRICH ROCKEFELLER

PHOTO: RADIO TIMES HULTON PICTURE LIBRARY

LEFT: *Standing Youth*, 1913, Wilhelm Lehmbruck
RIGHT: Memorial to the Ruined City of Rotterdam, 1953–4, Zadkine

TOP: *Artillerymen*, 1915, Ernst Kirchner
BOTTOM: *Revue des Poux, Buchenwald Sketches*, 1944, A. Favier

Self-Portrait, 1929, John Kane

LEFT: *Self Portrait*, 1910, Egon Schiele
RIGHT: Male Nude, 1973, Francisco Lòpez

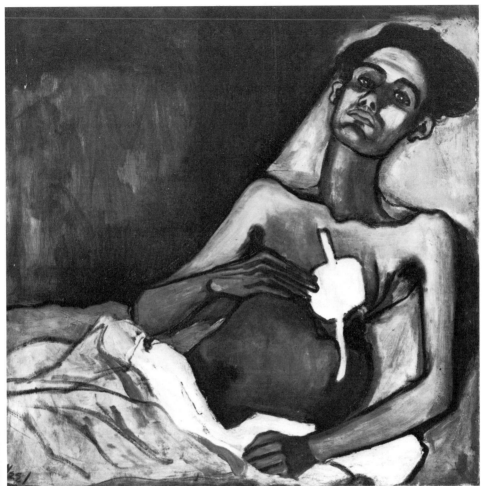

T.B., Harlem, 1940, Alice Neel

282

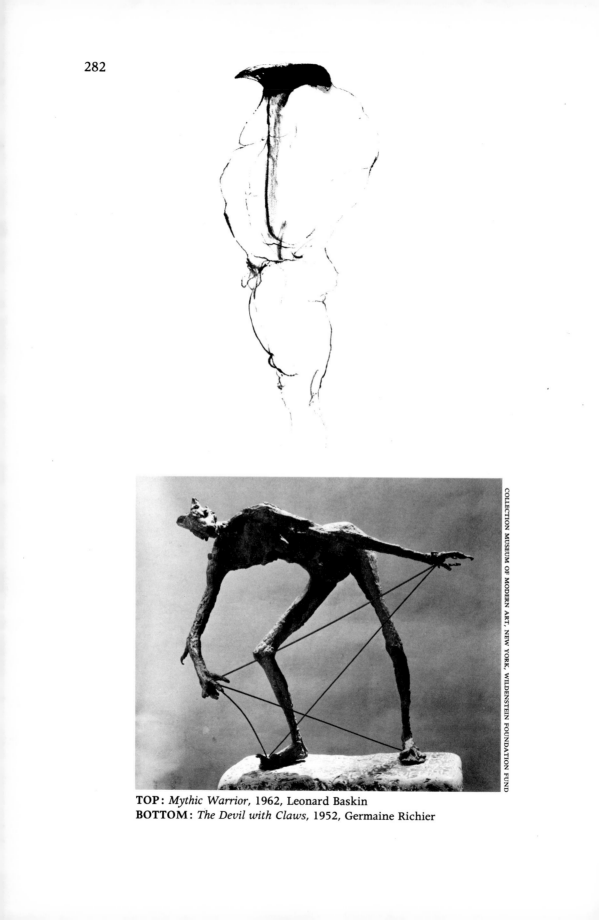

TOP: *Mythic Warrior*, 1962, Leonard Baskin
BOTTOM: *The Devil with Claws*, 1952, Germaine Richier

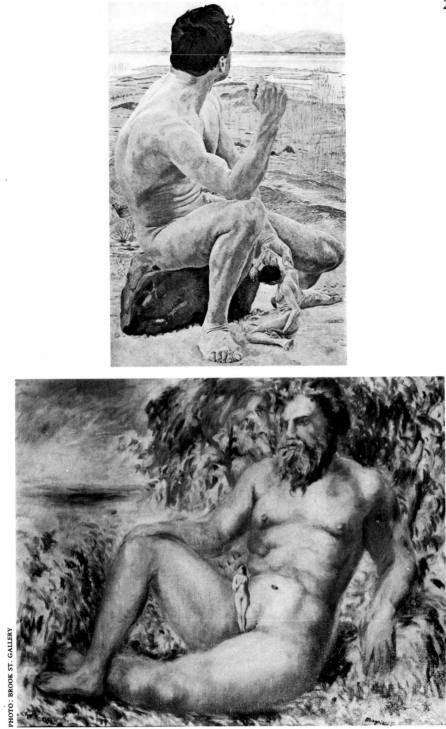

TOP: *Prometheus*, 1909, Otto Greiner
BOTTOM: *The Ocean*, 1943, René Magritte

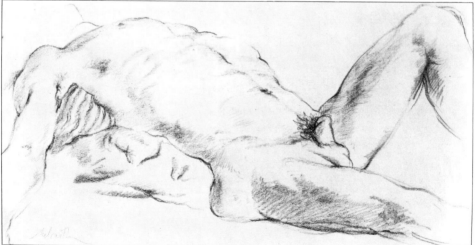

THIS PAGE, TOP: *Study of a nude male,* c. 1910, George Bellows
BOTTOM: *Study of a reclining nude,* Edward Melcarth
OPPOSITE, TOP LEFT: *Laureano,* 1974, Charles Beauchamp
TOP RIGHT: *Gregory Standing Nude,* 1975, David Hockney
BOTTOM: *David,* 1973, Barry Flanagan

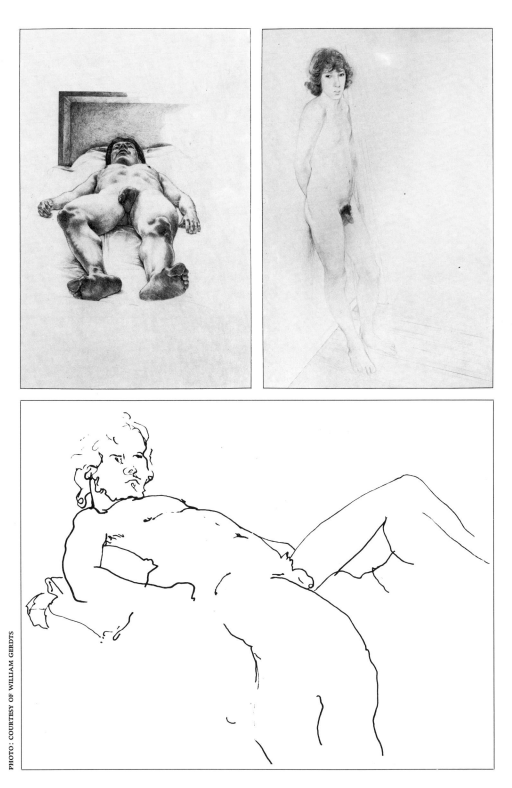

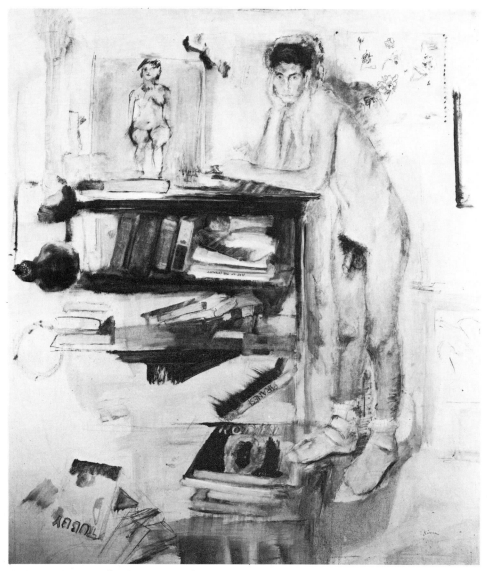

THIS PAGE: *Joseph*, 1954, Larry Rivers

OPPOSITE, TOP: *Prenatal Education*, 1955, Hans Bellmer
BOTTOM: *Drinking Minotaur and Reclining Woman*, 1933, Picasso

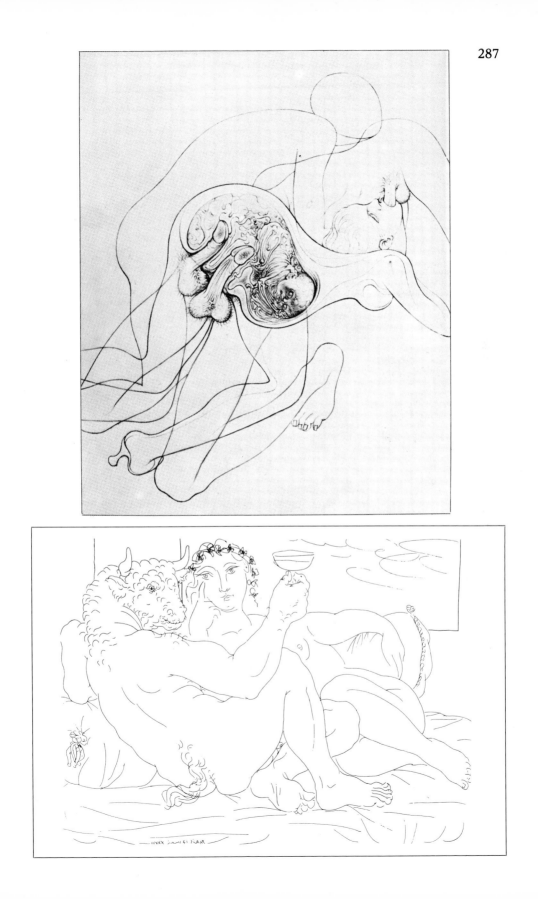

Newsstand Nudes

PINUPS ARE big business. Almost every newsstand has its rack of girlie magazines, ranging from the upmarket glossies *Playboy* and *Penthouse* to more blatant titles like *Knave* or *Cockade* or *Men Only*, to cheaply produced ephemera called things like *Vibration* or *Exposure*. Increasing numbers of shops have begun to stock almost as big a range of homosexual equivalents—*Playguy, Man Date, Zipper* ("every issue it bulges bigger"), and *Man to Man* are all widely available. And alongside *Playboy* and *Playguy*, there is also a *Playgirl*, an attempt to hook women into this hitherto exclusively male market.

The pinup is a modern phenomenon, a product of a mass consumer society. (The phrase "pinup" only dates back to World War II, though the object itself was nearly a hundred years old by then.) Erotic engravings had been published since the sixteenth century, and lithographs since the end of the eighteenth century. But the pinup proper depends on modern technology—photography and high-speed presses. The camera was only invented in the 1830s, but its commercial possibilities were rapidly realized. Paris studios which turned out nude "academies" for artists soon began selling to a far larger and more profitable market. By the 1860s, protests against the sale of "provocative and too real nudes" were in full flood. An English reader complained to one of the new photo magazines that "a man who takes a walk with his wife and daughters dare not venture to look at the windows of many of our photographic institutions".[1] (Presumably walking alone or with his sons, he might respond differently.) In a book on photography published in 1861, the Frenchman Disderi railed against "those sad nudities which display with a desperate truth all

288

the physical and moral ugliness of the models paid by the session".[2] Painting, however titillating and even pornographic, was Art; hallowed by tradition, the classic nude hung in the rarefied atmosphere of a museum. But photos were obviously designed to be pawed and pored over in private. The respectable nineteenth-century gentleman, faced with too direct a reflection of his lusts, reached for the law book. Judges made routine comparisons between the photographer's model—a prostitute selling her body cheap—and the ennobled nude of high art. Photographers were prosecuted, and postal regulations—to this day one of the most effective forms of censorship—were introduced to control the spread of the sexy photo.

It is hard, now, to assess the size of this nineteenth-century market—who bought the photographs and for how much. When a London dealer was raided in 1874, police apparently seized some 5,000 slides, and over 130,000 photos.[3] Specialized markets developed rapidly. Photos of male nudes were circulating among homosexuals by the middle of the nineteenth century. A. J. Symonds—who used to frequent the Serpentine and the Victoria Baths to watch the swimmers—exchanged packets of nude photos with like-minded friends, and it is said that Edmund Gosse passed the time at Browning's funeral in Westminster Abbey by sneaking glances at some of these. Later in the nineteenth century, several photographers—the most famous was Baron de Gloeden, who took photos of Sicilian peasant boys in vaguely classical poses—had an established homosexual clientele all over Europe.[4]

Certainly one thing that has always alarmed moralists is the way the pinup photos, so easily reproduced, could reach such vast audiences. (Today *Playboy* claim a circulation of nearly five million in the United States alone, and *Penthouse* nearly as many.) And if you walk around 42nd Street or Soho or their equivalents in any big city, you can hardly miss the extraordinary number of sex shops supplying not just pinups but the most explicit and specialized pornography. And even this is only the visible tip of the iceberg; probably the biggest business of all is still done via mail order. Wholesale warehouses in, for example, Los Angeles, may cover a couple of acres, with ten-foot piles of magazines, ranging from straightforward nude photos through every conceivable and inconceivable fetish, to hard-core pornography, both hetero- and homosexual.

WOMEN FOR MEN

The archetypal pinup is a nude or semi-nude girl. She may be a calendar girl or a centerfold, a playmate or a pet; she may smile from postcard or poster, or be blown up on a hoarding to help sell anything from cars to cigars. Drawings of sexy girls are sometimes used as pinups as a way of evading legal restrictions; some people prefer drawings because the pencil can achieve an antiseptic pneumatic perfection the camera never quite matches. The popular Varga and Petty girls run by *Esquire* in the forties were aimed at a sophisticated audience that preferred its sex at one remove and spiced with reassuring irony.

But most pinups depend on the illusion that the camera has caught a "real" person. It was this guilty sense of looking through a keyhole that shocked and excited those respectable nineteenth-century gentlemen; the voyeuristic thrill of having see a real woman exposed remains a selling point.

The modern pinup is of course incredibly glamorized. As John Berger argues, she is a nude in the classic sense.[5] She falls into poses sanctified by high art, and her body is perfected and polished with all the resources of twentieth-century technology—lighting, filters and airbrushes smooth out any imperfection.

Playboy was the first and remains the most effective purveyor of this plastic, Disney-world glamor. Its readers are never offended by any suspicion of wrinkle or sag; and though playmates now show their pubic hair—have even moved toward what the trade calls "split beaver" poses—there is never a hair out of place. At the same time, *Playboy* maintains the fiction that this month's Ashley or Sondra or Tracy or Debra is just the girl next door, perhaps tarted up a bit. Readers are always given a few details about her hopes, hobbies and home life; and even, nowadays, about her sexual likes and dislikes. *Penthouse* has always taken this a stage further; it specializes in girls narcissitically absorbed in their own bodies, touching their breasts or their pubic hair. Photos and text suggest that the girls are taking an intense masturbatory pleasure in admiring themselves, in exposing their bodies for the admiration of all those wonderful guys out there. But their fantasies are carefully edited to reassure as well as excite the reader, and endorse what men have always suspected about women. (Gerri: "I've stood around while some skinny bit who thought she was It strutted her stuff in front of the camera. It's nice to find myself the

focus of attention for a change." Josée: "Liberation for women is what I am doing now—posing like this for *Penthouse*.")

All these pinups appeal because they offer a not-too-real reality. The model has just enough individuality and substance to spice the fantasy, never enough to disturb it with any demands of her own. The camera that idealizes her body, also fragments and fetishizes it, turns it into an abstraction. The model may look passive or provocative or passionate, even phallic and threatening; but she is *safe*. Frozen in two dimensions, uncomplaining, uncritical, incapable of jealousy, she is posed and disposed purely for the spectator's pleasure. And the moment he gets bored, he can trade her in for next month's model.

Playmates and Pets are really there for the sake of the ads: to help sell a life style, to assure the reader that the right brand of liquor or car or hi-fi, and the right brand of girl to go with them, will satisfy all his sexual needs and cure all his social ills. Interestingly, the female pinup is also used to persuade women to buy.[6] Some of the barest and most blatantly sexy nudes appear in the glossy women's magazines; they play and prey on women's narcissism, their vague envies, their endless dissatisfaction with their bodies, their Cinderella dreams. The different meanings attached to the male and female bodies in our society emerge very sharply at this point. A nude man is simply a guy who has removed his clothes. A pinup is far more than just a nude female: she incarnates femininity. And femininity, presented as natural, is, in fact, thoroughly artificial, something that has to be worked at, produced, maintained. It is a luxury good that can be bought. The pinup symbolizes women's dreams of a transformed and fulfilled life; she is endlessly fascinating because she is elusive— because no woman can ever achieve that ideal femininity and no man truly possess it.

In the last few years, advertisers have occasionally tried substituting a naked male as a sales gimmick; on the whole it has worked simply because it is a novelty, a good talking point. A famous advertisement on the French *metro* publicized underpants by showing a pretty young man not wearing any. A bath essence firm experimented with a towel-wrapped man waiting for those wonderful things that happen when you take a Badedas bath. And Brut once put out a television commercial showing ex-heavyweight champion Henry Cooper luxuriating in a bubble bath; the camera cut out, teasingly, just as Big 'Enery emerged remarking on "the great smell of Brut—all over." It was

funny and effective. But it depended on Cooper's tough and reassuring masculinity; depended, like all these advertisements, on the spectator's recognition that the joking role reversal is not for real.

Playboy and *Penthouse* have always prided themselves not just on their commercial success, but on their sexually liberated and liberating policies. *Playboy* in particular has tended to bury its naked ladies deep in pages of philosophizing about freedom from ignorance and crippling repression. Its advice columns have certainly helped men to express their doubts and fears about everything from penis size to premature ejaculation and female orgasm. But there remains a gap between this sensible and even sensitive advice, and the visual message of the centerfolds, which is two-fold: women exist only to fulfill male desires; and men who cannot make it with these supergirls are inadequate. Hefner has always insisted that his reader would be inspired by the Playmate—bigger and better every month—and go back with fresh enthusiasm to his wife and/or girlfriend. But the sad and horrified letters in women's magazines from wives who have just discovered their husband's secret stocks of pinups suggest a drastic failure in sexual communication.

For what these "liberated" philosophies never acknowledge is the way the pinup, by definition, plays on and even confirms, the spectator's anxieties. The fantasies associated with photography itself are revealing. "Taking a picture" is seen as a sexual act; the photographer has become a kind of cult figure, a licensed voyeur, a pop sexual hero. (And a hero that more and more people seek to imitate, especially since the invention of self-developing film. Polaroid do not call one of their most popular models "Swinger" for nothing.) The dream of the camera-as-phallus is spelled out in a famous scene from Antonioni's *Blow-up*; the less often acknowledged implications—of sadism arising from impotence—emerge as well. The photographer hero coolly clicks away over the writhing body of the nearly nude Verushka. It is sex—but sex by remote control. The hero is uninvolved, untested, stays dominant as he never could in a real sexual act. Susan Sontag argues that the fantasy goes even further than this: we commonly talk about a camera, not just as a mechanical and therefore infallible phallus, but as a predatory weapon which is loaded, aimed, shot. And she cites the strange but powerful 1950s film *Peeping Tom*, where the photographer, his camera also a weapon, actually records the death throes of his murdered models.[7]

This kind of perversion may seem a world away from the making of your average pinup, even further from the mind of the reader who is casually appreciative of a nice pair of tits or an ass as he flicks through the newest girlie magazine. But the pinup market does depend on some unacknowledged and primitive anger, some inchoate feeling of being cheated and deprived; it perpetuates the appetites it feeds, promising satisfactions that by definition it can never deliver. Gay magazines, and more recently, the new-style women's magazines, have been using the old *Playboy* arguments about sexual freedom in their justified demands for male pinups. But to be a playguy or a playgirl, to achieve equality with the playboy, may only trap us all in new frustrations.

MEN FOR MEN

Even when the subject is another man, pinups have always been aimed at a mainly male audience. And not necessarily a homosexual one.

Body-building pinups have always been popular; the sport—or should it be art?—has had its superstars from way back. Circus strongmen had always enjoyed a certain popularity, but in the 1890s Ziegfeld promoted an English muscleman, Eugene Sandow, into a major celebrity. Sandow performed all over provincial America, starting with simple acts like poker-bending and weight-lifting, and moving up to more spectacular stunts—wrestling with a lion, lying down while three horses trampled on him. His sex appeal was played up; wearing no more than a garland, a fig leaf and some bronze body paint, he would do a series of classical poses to music. Publicity releases encouraged audience identification, claiming that he had been a weakling until a classical statue of Hercules inspired him to self-improvement.[8]

Sandow made a fortune. (He died in retirement, aged 56, trying to lift an automobile out of a ditch.) But it was left to others to capitalize on his fame by selling Mr. Average the means of turning himself into Hercules. Bernarr McFadden—"Weakness is a crime. Don't be a criminal"—staged the first physique contests as publicity for his successful string of keep-fit magazines. To advertise his own patented regime, he bared his own well-developed body; and so of course did his successor Charles Atlas, "the most perfectly developed man in the world," whose advertisements in comics and magazines appealed to generations of small and not-so-small boys. Glowingly healthy in

leopard skin briefs, he testifies that "I myself was once a puny 97 pound runt" ashamed of being seen in a swimsuit. And he assures the reader that only fifteen minutes a day of his Dynamic Tension will produce the "Greek-god type of physique that women rave about at the beach—the kind that makes other fellows green with envy." Women's magazines make exactly the same appeal to the adolescent girl's insecurities about her body; they too prescribe diet and exercise to build up or slim down, and run advertisements for devices guaranteed to produce a better bust line.

Part of the fascination of professional body-building is that it is a world apart, with its own heroes, its own rites and rituals, and its own highly technical jargon for assessing the body beautiful.[9] "Note the striation in Lou's thigh," enthuses *Muscle* magazine, "and the clarity of his intercostal definition." Growing numbers of readers obviously appreciate these highly technical analyses of the form and training regime of the champions; and write in for advice about their personal programs. And depending on whether they want to develop their lats or their pecs, their deltoids or their triceps, they can send away for the most varied equipment. You don't work out with a plain old bench and weights any more, but with any one of a dozen mysterious machines—a King Kong Krusher, for example, a Bull Worker, a Kambered Kurling Bar, a Triangle Bomber, a Calf Burner or an Arm Blaster.

Particularly over the last few years, body-building has broken through into the really big time, and big money. Muscle magazines are booming, weight-lifting has become show biz, and since the success of the book and movie *Pumping Iron*, the· "one and only" Arnold Schwarzenegger has become a household name—and body—even to people who have never seen the inside of a gym.

It is possible that this sudden leap in popularity has something to do with the decline in the sheer number of manual workers in America, and the tendency to devalue manual work and traditional definitions of masculinity. It may mark a reaction against what is felt to be a feminizing of men betrayed in fashions for long hair, male jewelry, deodorants, even makeup for men. But paradoxically, body-building is the most purely narcissistic and, in that sense, most feminine, of pastimes. The body-builder's goal is appearance not action. He is less like the sportsman trying to improve on his time or performance, than he is like the woman, who sees her body as raw material to be

pummeled, pounded, starved and even cut into better shape. The muscle magazines themselves insist that what they do is art as much as sport, and vaguely invoke Michelangelo and classical male nudes. (But could anyone seriously want to look like one of Michelangelo's expressively distorted nudes? Or like the Farnese Hercules, if it comes to that?) Schwarzenegger sees himself, he says, as a living sculpture. But where the artist slaps on paint or clay to improve the proportions of his work, the body-builder does it the hard way, working from the inside out. Most of the champs take pleasure in the sheer pain of training, the gut-wrenching discipline and almost religious dedication needed to add a fraction of an inch to deltoid or calf.

At a London press conference, Schwarzenegger suggested that the new interest in body-building is partly a response to women's lib. He claims that at least half of his audiences, in the United States at least, are women. "For years men looked at women. Now women are looking back at men." But the body-builder is less concerned with women than with his mirror—his main tool and his greatest reward. And for most body-builders, the greatest thrill of all is the "pump"—the rush of oxygenated blood to the stretched muscle. "You feel like you're flying," they insist, as if you are about to explode; it is as satisfying as coming.

The whole thing is an engaging series of paradoxes. A big contest like Mr. Olympia or Mr. Universe is great fun to watch; but it is a beauty pageant no less, with the strongman, just like the beauty queen, offering up his body as an object to be admired. He deforms his body even more than she does; the irony is that those grotesquely developed muscles are for display, not use. All the body-builder's athletic training is directed to aesthetic ends. Weight-lifting as such is no longer even part of the contest ritual, which centers on a series of pseudo-classical poses in which one set of muscles after another is— literally—erected. For all his super-masculinity the body-builder's exaggerated breast development, as well as his dedicated self-absorption, can make him look unexpectedly, surreally feminine. And many men seem to view body-builders with exactly that mix of mockery and unwilling admiration with which women eye beauty queens.

At times, there has been an overlap between body-building and overtly homosexual pinups. For years, physique magazines were almost the only readily available source for men who wanted to look at

other men naked. In the early part of this century, publications like *Health and Efficiency* and *Vim* appealed skillfully to a varied audience. They include a wide range of types, from athletes who clearly benefited from the articles praising healthy exercise, to pretty pubescent boys who look as if they would faint at the thought of lifting a barbell. In the 1950s, homosexual pinup magazines were still called things like *Body Beautiful, Physique Pictorial* or *Young Physique*, though the top dressing—the comparisons with classical gods and the hymns to health—was spread much thinner. But to this day, after half a century of having to disguise their real interests, many homosexual magazines retain an in-group tone, with their own codes, jokes and verbal and visual allusions not immediately accessible to outsiders. Over the last twenty years, they have become far more explicit and freely available; but like their audience, the magazines remain in a legal twilight area. Partly because of this, they are far more expensive than their straight counterparts.

On the whole, the assumptions behind homosexual pinups are not so different from heterosexual ones. One favorite type is the slim and delicate adolescent, sometimes hardly into puberty, who is posed in different ways, like any playmate, to emphasize his buttocks or his legs or his provocative face. But there is always that reassuring bonus, the large and prominently displayed penis. (Mark Gabor claims in his *History of the Pinup* that male models sometimes masturbate just before photo sessions, then hold the penis down with invisible string so that it appears enviably large in a relaxed state.)[10] There is a long tradition, sanctified by art, of passive but provocative poses for the female nude. The boys, on the other hand, inevitably appear rather self-conscious; they often hover between an easy nonchalance, a determined seductiveness, and an aggressive look-what-I've-got stance. Models occasionally seem to be overtly parodying feminine poses and come-hither expressions. Thus a young boy is posed reclining, with his penis bulging through a girl's lace panties; at the same time his tough expression indicates that he is no sissy, is in fact very rough trade indeed. Because photographers are not always confident enough to allow the sensuous beauty of the relaxed male body to speak for itself, they sometimes seem to be working overtime looking for kinky new thrills. *Mister International*, for example, features a very young bottle blond, wearing a plastic windbreaker and sneakers and socks (which seem to have the same fetishistic charge as high heels and stockings for

straights). His expression ranging from cherubic to cheeky, he coyly conceals his penis behind a paperback titled *How to Improve your Man In Bed*; and when we finally get to see his (large) penis, it is actually pierced by a cock ring. The fantasies behind that one leave me baffled.

The other favorite type is, of course, the superstud, and whole magazines are straightforward celebrations of virility. (*Him*, "because a hard man is good to find"; *Sam*, "the mag for the macho male"; *Big and Butch*, available only by post, which promises black men built like nothing you have ever seen.) The he-man is shown bursting out of his jeans, or stomping round in nothing but boots and leather jacket. So Judd—described as "hunky . . . hirsute . . . hung"—glowers from under a black Stetson as he pulls down his jeans, or—clad only in socks and boots—sits clutching his penis like a gun. Al, also featured in *Q International*, is "a boy with a lot going for him. Incredibly long . . . uh . . . eyelashes. An almost hairless body and biceps, and thick thighs just made by Father Nature for wrapping around flesh." But the butch poses pose problems. By law, the penis must never be shown erect. And after all, even the erect penis is not all that phallic, taking the word to mean the whole mystique of masculine dominance. So the photos depend heavily on fetishes, all the different kinds of gear—leather, denim, tattoos, uniforms, motorbikes—which proclaim tough masculinity.

These magazines often resort to drawings rather than photography, partly because of legal problems, but also because no photograph can ever be quite tough enough. Certain kinds of manual laborers are favored types; "Ohh" coos *Sam*, about Mark, who is a garage mechanic, "just think of those lovely greasy overalls cladding his great body." But in his photograph, Mark looks rather sweet and very well washed; it is mainly in drawings that the dirt can be enjoyed. Plumbers, cowboys, telephone linesmen, construction workers (men with tools?) all turn up regularly, but their hairy bodies, half dressed in scruffy overalls, are at least as idealized as any Varga girl. They are romantic figures, incarnating an impossible virility. The most famous of all these artists is the widely imitated Tom of Finland, who specializes in hulking brutes in and out of leather suits, with military caps and leather boots as accessories to their muscles and their enormous penises. The fascist associations are quite explicit; the model—the ideal man—lurking behind all these leather boys is a Nazi storm trooper.

297

In her book *The Undergrowth of Literature*, Gillian Freeman labeled the chapter of homosexual pornography "Mein Camp."[11] Homosexual fetishism can obviously be paralleled in the heterosexual pinups catering to people with a taste for bondage or flagellation. But I get the impression that a preoccupation with dominance and submission is more widespread—or perhaps just closer to the surface—in homosexual pinups. Perhaps this is because the male spectator has an ambivalent response when he looks at another man in a passive role. He is likely to respond with contradictory fantasies—his fear of his own masochistic longings and his identification with the passive victim, may issue in more extreme and overt hostility and even brutality. Thus one of the models in *Q*—Jean-Paul, described as "sentimental, nut-brown eyes, auburn hair . . . likes fast cars, leather and soul music"—is shown naked except for a red biker's helmet, enormous black gauntlets and boots, and a chain stretched tightly from his neck to his penis. If it is a joke, it is a rather sick one.

Some magazines express open envy of women who can enjoy submitting, stripping, being admired as a sex object. Thus a writer quoted in *Sam* claims that plenty of men are anxious to be exploited and manipulated in their turn: "the naked male is ready and waiting to hop into the Bunny void." But another magazine juggles uneasily with the idea of the passive male pinup. *Playboy* readers, it insists, "are looking at objects which they view always in a passive light and that attitude will not, of course, do when we are dealing with men. . . . Stevie gives us more. . . . We can imagine him as a lover or as a friend. We can even imagine him as both. Now that is something your *Playboy* reader can't do." The layout on Stevie is attractive and imaginative; but it is, as the text also admits, beefcake, and certainly no different in kind from the run-of-the-mill *Playboy* centerspread. In both cases, the personal note is just strong enough to assuage the spectator's guilt at his own inevitably predatory fantasies.

It has been possible, more recently, to find some nude picture books that do treat the male body gently, affectionately and imaginatively. Certain photographers and agencies—most notably, Jim French—have developed a market for genuinely evocative and stunningly photographed male nudes, that perhaps escape the limits of the mere pinup. They are a protest, and an important and valid one, against the unthinking assumption that beauty belongs only to women; against the kind of old-fashioned bias that allowed, for example, a London

Sunday supplement to have a whole series on Beauty hardly mentioning men except as observers and judges. We need to be reminded, for all our sakes, that men are beautiful too.

MEN FOR WOMEN

There are plenty of pinups for women—movie stars, pop singer— but they are rarely nude. "You made me love you," Judy Garland sang to "dear Mr Gable," and summed up the romantic dreams of generations of movie-goers. But those dreams have centered on a face, a style, a personality—and maybe an occasional glimpse of manly chest.

In 1926, a fan magazine ran a photograph of the nude Ramon Novarro as a galley slave in *Ben Hur*; discreetly cropped and romantically shadowed, it caused a stir, but hardly started a fashion. Douglas Fairbanks's appeal was certainly based on his superbly athletic body as much as his rakishly handsome face. But he usually wore, not just clothes but costume; and it was the way he moved that was important, the nonchalant grace with which he performed those breathtaking stunts. In the thirties, Tarzan movies' Olympic swimmer Johnny Weismuller bared most of his body, and very nice too. But it was the fantasy of the gentle and domesticated apeman that was so appealing, and I doubt if he lost many female fans when he put on weight and had to hold in his stomach as he swung through the jungle.

Nor have things changed much today, despite Hollywood's claims to greater permissiveness. Even the most serious of our current screen actresses—Jane Fonda, Glenda Jackson, Vanessa Redgrave—have probably enhanced their star images by stripping in front of the cameras; we have yet to see Robert Redford or Jack Nicholson follow suit. As many people pointed out at the time, the movie *Last Tango in Paris* stripped everything from Maria Schneider, but not from Marlon Brando, perhaps because the director felt a protective identification with his male star. Most recent movies where men have appeared naked have been making a fairly overt appeal to homosexuals. *A Bigger Splash*, which was casual about full frontal nudity and even showed two men making love, explored the openly homosexual milieu and life style of David Hockney and friends. *Sebastiane*—where male nudes in various stages of ecstacy positively littered the screen—was again successfully aimed at a very specialized homosexual audience. And even the famous nude wrestling scene in *Women in Love* was about the

problems men experience in expressing physical affection for one another; its stills were endlessly reproduced, but in men's rather than women's magazines.

The rock idols of the late fifties and sixties provided a new kind of pinup, based on different fantasies; fans were both male and female. The whole phenomenon goes far beyond the theme of this book. But clearly one element in the appeal, particularly of the rougher, tougher bands, is the way they arouse, then deny, fantasies about the naked male body. When Presley first appeared on American television, the famous pelvis was censored out and audiences were allowed to see nothing below the waist. Many rock stars flaunt their bisexuality; but their clothes, their movements on stage, and publicity photographs (for example, the Rolling Stones' cover with its closeup of a zipper), all concentrate our attention almost obsessively on the crotch. Singers like Mick Jagger move in a way that resembles nothing so much as the stripper's bump and grind; and he plays the old stripper routine of hinting that extraordinary things *might* be revealed. P. J. Proby's following was vastly increased when he split his skin-tight trousers on stage, and Jim Morrison was arrested when he got carried away and actually exposed his penis. In fact, he was simply taking his act to its logical conclusion. Both women and men are invited to identify with the aggressive, contemptuous masculinity. But hard rock—hard core rock, if you like—is also cock rock. And in that androgynous, but at the same time compulsively macho, world, the girl—lacking the essential qualification—rarely dreams of being more than a groupie.

But in other ways as well, times are changing. Since 1972 the newsstands have been displaying magazines dedicated to evening things out between the sexes. If men have their pets and playmates, magazines like *Viva* and *Playgirl* were designed to provide women with full frontal sex objects, playmales of their very own.[12]

The whole thing started as a joke. Way back in 1970, the feminist paper *Off Our Backs* ran an April fool parody, with a bearded naked man dreaming over a flower, brooding over his typewriter and stirring up a quick soufflé in the kitchen. A couple of years later, still half in jest, *Cosmopolitan* picked up the idea, and ran a centerfold of tough-guy movie star Burt Reynolds, baring his hairy chest but coyly concealing his "private" parts. I rather liked that one. It was so cheerfully conscious of its own absurdity—would you like to sin, on a tiger skin, with Burt?—that it ended up making a witty comment on

all pinups. The English edition posed a different man (chosen partly because he was Germaine Greer's ex-husband) in a similar semi-recumbent sprawl. But trying too hard to improve on nature, to give the model the plastic sheen patented by *Playboy*, they managed to airbrush out, not just his sagging belly but his navel as well. Since then, *Cosmopolitan* has retired the gimmick and gone back to its tried-and-true formula for rather cosy glamor.

Playgirl and *Viva*, launched after careful market research, are altogether different, much cooler and harder, and much more sexually explicit. You would hardly guess the contents from the covers, which tend to be tasteful and discreet, presumably so that women will not be embarrassed buying them in public. Inside, they exploit the format perfected by the expensive men's magazines; they are all glossy paper, fancy camera angles, hazy color and classy writing. The trendy context softens the impact of nakedness; sex is part of a whole life style, a world of easy living and easy loving. It is slick, hip—and expensive. *Playgirl*, in particular, rapidly developed a formula which has hardly varied in six years. A typical early issue has Burt Reynolds flashing a close-up grin on the cover; inside there is a lot of print—short stories, interviews, articles of general and cultural interest and fashion spreads, as well as readers' letters and sex advice columns. But the nudes are what it is all about. There is a four-page pull-out of "Woody, our Man of the Month," his suntan glowing as he stands naked in an expensively arty pad. Phone in hand, tough but tender, he gazes directly, manfully, out at us. If you don't fancy the well-built Woody, *Playgirl*'s Discovery for the Month is the more languid Terry, reclining gracefully on a bed. If you have a taste for outdoor types, there are some naked skiers; and as a bonus, a *Playgirl* fantasy where a couple roll gracefully in their pretty pink sheets, flirting with the camera rather than with each other.

The pinup sections are carefully designed so as not to affront our expectations and prejudices. We nearly always see the man dressed, as well as undressed, going about his daily routine; we are led by gentle stages to that full frontal. And the models are far more personalized than their female equivalents; we are given many details about the pinup's ideas and ambitions—and about what he is looking for in a woman.

Both text and camera try to reassure us that—even if they are posing nude—these are no sissies. The more delicate indoor types, men who

are "into" art or meditation or self-discovery, are always in very good shape. They take care of their smoothly bronzed bodies, and there is usually at least one outdoors shot to establish just how healthy and natural, how basic and male, they really are. Some spreads even include a shot or two of the man wrapped round a girl—which may be a way of allaying any lurking female suspicions that male models are probably homosexual. (In fact, more than one *Playgirl* "discovery" would be hailed as an old friend by readers of homosexual papers like the *L.A. Advocate*.)

Playgirl's favorite type is strongly built, sporty, a little wild. Sea and sun make his nakedness seem natural; and the photographers are nothing if not ingenious at thinking up new thrills. We not only get naked surfers, swimmers and canoers, but bare-bottomed riders and, of all the uncomfortable things, sky-divers. The men are supported by all the predictable phallic props—guns, motorbikes, cars, skis, horses, dogs, even billiard cues. And just in case we still miss the point, the text keeps underlining the message. The mild-looking Greg hates being cooped up, and loves "working out and keeping fit— backpacking and practicing my karate." Stroud, a would-be film actor who goes in for body-building, "has dark hair curling out of his unbuttoned shirt, an instinctive animal wariness in his deep-set eyes. He is completely male." Stuntman Nick "takes to chicks and violence the way a duck takes to water." Shep, a soccer goalkeeper, finds sexual pleasure in sport—a "climax and a feeling of conquest," and vice versa.

Yet, we are assured, even the toughest man is also sensitive, creative, *deep*. So the naked Nick buries his face in a bunch of red roses; Shep sits in a wicker chair gazing thoughtfully, moodily, into the shadows. And the chunky and hairy Tom reports that his mother is thrilled that he is in *Playgirl*: "two years ago, one of your centerfolds decorated her bedroom wall."

Women are being asked to adopt the traditional male role, to look at these men with a coolly appraising and judging eye. They are skillfully seduced into accepting a dominant role. Thus *Viva* often featured photo stories where a girl, with whom women presumably identify, is the active partner, while the man simply offers himself to be admired, photographed or seduced. One series—which came close to homo- sexual fantasy—showed a girl picking up a super-stud biker, then stripping and making love to him in a sleazy motel room. In another

picture story, a girl photographed her lover, and particularly his penis, from every possible angle. And yet another—which rather negated its ostensible message—showed a girl admiring and caressing her lover's penis. But his utter self-absorption made it only too clear that even if she were the only girl in the world, he'd never get it up for her.

The pinup sections are a brilliantly calculated mixture which manages to gloss over any and every contradiction. On the one hand, the models are presented as thoroughly manly, independent and tough. On the other hand, they are being photographed and packaged, put on display as passive pegs for other people's fantasies. But the men never go in for those come-hither looks and openly seductive poses so familiar in both homo- and heterosexual pinups for men. If they look at the spectator, it is thoughtfully, or with a friendly grin. More often the man is shown absorbed in his own activities, pleasures and thoughts. The message is always, don't call us, we'll call you. Even in the nude, the male model remains his own man.

This is still true when he is obviously there not just to be judged, but to be bought. Occasionally, we are given a pinup who is a straight and solid citizen: there was a doctor, once, a few school teachers, and the unforgettable Andrew Cooper III, who was a millionaire. But far more of the models are fringe types—gamblers, surf bums, part-time students, would-be actors, drop-outs. They are hanging loose and hanging free, waiting for the breaks. And there is sometimes a hint that the big break just could be a wealthy woman. Woody frankly admits that he used to be a gigolo, though he reassures us, and perhaps himself, that he was, in fact, friend, lover, traveling companion. The woman reader is reminded, subliminally, that her new independence means that she can go out and buy what she wants—and maybe that includes sex. *Viva* once ran a piece on brothels for women, and another on kept men. But the "kept" men gave the game away, for they expressed consistent and open contempt for the women and saw themselves as the exploiters. A whore is a whore is a whore, but a stud is something else again. Even when he sells himself, the man retains his masculine integrity.

At times, the nude spreads play subtly on the old maternal fantasy of the tough guy who is a small boy at heart. (Greg, as wild as James Dean, is also a "vulnerable boychild.") Sometimes they evoke romantic fantasies about a lover who will share and understand—and perhaps, having been a pinup himself, will understand things most

303

men miss. But the most persistent fantasy is the wild and woodsy unattainable man—who just might be tamed, who might settle down if he only found the right girl. ("My personality is changing," confides Randy, "I used to go with a lot of different girls, but in the last couple of years one at a time is all I can manage.") So traditional romantic fantasies are skillfully dovetailed into the new insistence that a woman knows what she likes and is free to get out there and get it.

But the challenge is thrown back on to the woman—*is* she, could she ever be, the one he has been waiting for? Is she woman enough to hook and hold on to a man like Woody or Greg or Randy or Rock? I suspect this may be one central difference between pinups for men and for women. For the man, looking is an activity in its own right: a way of taking possession and control, a symbolic equivalent to the sex act. And the myth goes that the female pinup, by the very fact of her nudity, is available; that she is turned on just because she's being photographed and admired. But the woman must imagine attracting and arousing that self-contained man, giving him an erection. I suspect that one of the most common fantasy responses is not simply of touching the man, but of going down on him. The ambiguities of oral sex exactly correspond to the ambiguities built into the male pinup. Oral sex is an expression of power over the man; the woman is taking control and doing something to him. But it also sets off fantasies of being used and humiliated. (And more deeply, the fantasy of at once taking nourishment and being choked and polluted.)

Male pinups certainly appeal to a straightforward female curiosity about how various men look without their clothes—a curiosity almost as intense in the teenage girl as in the boy, and one that, given less chance to satisfy it, often survives into adult life. And it is funny to see the tables turned. Women often laugh when they first see the new pinups, half pleased, half embarrassed. A lot of women I talked to were as curious about the reactions of husband or lover as about their own; and were secretly pleased if he seemed—as men often do— unsettled or irritated. Many girls stick the pictures on the walls of dorms or offices, as a joke, as an act of bravado, as a challenge to boyfriends or co-workers who drool over girlie magazines; and in some cases because they genuinely enjoy and are turned on by pictures of the naked male body.

But it is interesting to find that *Viva* decided that the male nude was not a continuing commercial proposition. At first they insisted that

304

women are "frankly, boldly and actively fascinated with sex in all its aspects. Women *enjoy* looking at the male body" and simply have not had the chance to look at pinups. But less than two years later, they admitted that advertisers "didn't want their products near the photos," that women were embarrassed to be seen in public with *Viva*, and that new surveys showed that only a small minority of women were turned on by the male nudes. And more recently, *Playgirl* has tried to bring a touch of humor to at least a few of their nude spreads.

I suspect that many women who are intensely appreciative of male beauty in life, would still not be bothered to go out and buy male pinups. *Playgirl's* continuing success may derive in part from the fact that it has always managed to sell to male homosexuals as well as women. I suspect, too, that a lot of couples buy it, and the appeal there may be as much to the man as the woman, as a safe outlet for unacknowledged attraction to other men. And *Playgirl's* basic message is simple—a woman should be more like a man. Today's liberated woman should be frank and feminine, independent but happy to serve a man. She hangs on to her charm, her romantic, affectionate nature—and she hangs her pinups on the wall. She knows what she wants, coolly assesses what is available, and goes out and gets it. Liberation is unisex; it is easy, and fun—especially if you can afford it.

The message is that any and every sexual problem can easily be resolved—with a little help from experts, with better technique, with pinups that help you discover what really turns you on. Sex is presented both as a luxury good—a good meal or a nice trip—and as a quasi-mystical experience that will free you from all your everyday frustrations and hangups. The naked Ross explains that "making love is the greatest adventure there is. I feel like a pioneer on the sexual frontier." And another pretty boy pitches it still higher. "When we find our true nature we discover it is nothing other than the beautiful and awesome revelation of divine love itself. Fucking is just a way of saying *Amen.*" There is never a hint that everyday boredom might carry over into your sex life, that self-discovery might be a "trip" but that can mean a painful journey into obscenity and extremity, that this sexual dream world is close to a nightmare. Nightmares do not make good selling points.

It is interesting to notice where the line is drawn. The (male) psychologist who used to provide instant interpretations of sexual fantasies for *Viva* readers, struck an encouraging, let-it-all-hang-out

note to anything and everything. He only balked once—when a woman admitted to violent fantasies in which she humiliated men. "I have heard and read a good many women's fantasies," he assured us, "but I have read few that reveal such hatred of men. . . . I hope I never meet Sarah in real life, in a situation in which she might get her talons into me." This obviously tells us more about the psychologist's hangups than about Sarah's. Both sadistic and masochistic fantasies are so commonplace in pinups for men as to be almost invisible; and the psychologist seems to be scared out of his job, which is to discuss fantasy, something rather different from action. But more importantly, he forgets that if you encourage women to adopt male roles, to look and buy like men, they will inevitably begin to react with as much aggression and even sadism as men show toward women. For the pinup magazines, feminism is becoming more like a man—then they hastily put the lid on the disturbing tendencies they may have inadvertently let loose. For all their cries of liberation, the hidden message is clear enough. You've come a long way, baby. Just don't try pushing your luck.

LEFT: *Sicilian Youths*, 1880s, Baron von Gloeden
BOTTOM LEFT: *Nude study for Arcadia*, 1883, Eakins
BOTTOM RIGHT: Body-builder Bernarr McFadden in classical pose, early twentieth century, Nickolas Muray

PHOTO: CINEGATE LTD

PHOTO: CINEGATE LTD

THIS PAGE: Arnold Schwarzenegger posing as Mr. Olympia

OPPOSITE, TOP: Pinups from *Viva*, 1974
BOTTOM: Nude boxers in the London *Evening Standard*, 1975

THIS PAGE: *Nude Study*, 1970s, Jim French

OPPOSITE: *Nude Studies*, 1970s, Jim French

Nude Study, 1970s, Jim French

The Men, 1960s, Tom of Finland

Through the Looking Glass

SYLVIA SLEIGH'S *Philip Golub Reclining* (1971) is a painting of herself painting the male nude. His graceful, sensuously relaxed back fills the foreground of the picture; he gazes at his own face in the large mirror running behind the couch, and reflected in the mirror we see the artist as well, alert and attentive, concerned not with her image but her canvas. The painting is not simply a matter of role reversal; it is a conscious and witty challenge to our expectations about artists and models, about men and women.

For a woman to paint the male nude, as against being painted nude by a man, is a break with our whole art tradition. The ban on women studying the live model—historically an insurmountable barrier to anyone with serious professional ambitions—survived almost until the end of the last century. Occasional women seem to have found ways of getting around the taboo; in the seventeenth century, for example, Artemisia Gentileschi did vigorous and overtly sensual paintings of the female nude, and the early eighteenth-century Venetian artist Giulia Lama somehow even managed to do sustained and detailed drawings of the male nude. "The poor woman was persecuted by [other] painters," remarked a contemporary, "but her virtue triumphs over all."[1] It is not clear whether she was persecuted because she had risked her moral reputation, or because, aspiring to do large-scale altar paintings, she was regarded as professional competition by men.

But—and increasingly—any woman who tried to work professionally as an artist was exposed to ridicule, jealous denigration, and scurrilous rumors of all kinds. (Angelica Kauffman is the clearest

example; as her fame grew, so did the prurient slurs on her morals.) The American sculptor Harriet Hosmer, working in Rome in the middle of the nineteenth century, advised a girl art student: "Learn to be laughed at, and learn it as quickly as you can." The determinedly independent Hosmer actually risked doing a large-scale marble nude, a close and skillful version of the Barberini sleeping faun. The rather dull neoclassicizing manner fashionable at the time does not disguise her attempt to convey sensual abandon and pleasure. "This is going it rather strong," protested one male contemporary, while others dismissed her as a mere second-rate imitator, or criticized her for her strained attempt at a "manly energy," her mere travesty of real creativity.[2]

On the other hand, Mary Cassat—an American working in Paris, who took care never to overstep the bounds of propriety—was labeled as *merely* feminine: that is, charming, superficial and slight. Cassat certainly preferred to paint women and children; in fact there is more sense of actual flesh in some of her studies of mothers and children than in many contemporary scenes showing bedrooms or brothels. Thus her *Mother and Boy* (1901) catches the intense physical relationship between mother and her small son: suggests her pride in his naked body, her loving attempt to keep him close in her feminine world, and—even as he leans lovingly against her—hints at his inevitable movement away.

Ironically, as women artists slowly won access to life classes on equal terms with men, the male nude was losing much of its traditional importance. At the end of the nineteenth century when, at last, a woman was free to study the male model without irretrievably labeling herself fallen, she came up against a brand new version of an old myth—the equation of creativity with masculinity, with male virility. Renoir's famous remark, "I paint with my prick," was a retort to an intrusive journalist who asked how he managed to paint with his crippled hands.[3] But the metaphor was increasingly common. Van Gogh praised the "male potency" of Cezanne's work, and later Vlaminck spoke of painting "with my heart and my loins." Renoir's comment could have served as a battle cry for a whole generation of younger artists in France and Germany, eager to live up to the public suspicion that artists were immoral and subversive. The Expressionists often saw themselves as free spirits, getting back to nature, back to more instinctive levels of the personality. They would, by main force if

315

necessary, break down bourgeois hypocrisy and sexual repression. And the image which proved their freedom from convention, their artistic and sexual virility, was the female nude.[4]

No woman artist can ever "penetrate" below the surface of things, argued George Moore. And Renoir insisted that a woman's function was to charm and please a man; she might be a dancer or a singer, but as an artist, she is merely ridiculous. Once, coming across some drawings by his model and—temporarily—his mistress, Suzanne Valadon, Renoir remarked, "Ah, you too, and you hide this talent!"— and never again referred to the matter.[5] According to Valadon, his indifference spurred her to step out of her role merely mirroring male talent and develop her own. She used her own naked body as a basis for a number of powerful and moving paintings; and she was one of the first women to paint a frankly sensual, undisguisedly personal, male nude. *The Nets* celebrates her pleasure in the body of André Utter, twenty-one years younger than herself, who became her lover and then husband. The painting is perhaps too self-conscious to be fully successful; though Valadon delights in the three different views of his body, she carefully shields his genitals. And she is inevitably over-conscious of the way she—former model and mistress—is turning the tables on men. But her painting throws down a challenge to her contemporaries, to a centuries-old tradition—and looks forward to attempts to create new ways of seeing, nearly fifty years later.

Since the early 1960s, a number of women artists, particularly in the United States, have turned back to the traditional nude, both male and female. Starting from a premise that women have a distinctive, and hitherto largely unexpressed, sexual experience, they have begun questioning the invisible but powerful bias of most art up until now. Out of a new self-confidence, some women have turned to look freshly at their own bodies, and at men's.[6] Some of the new nudes may prove no more than a flash in the pan, a way of shaking people out of comfortable preconceptions, but not necessarily of more than ephemeral interest. But what is exciting is the richness, the variety and the fantasy of the new women's art—its willingness to take risks, to open doors, slowly perhaps to develop new ways of seeing and feeling.

Some artists present the male nude provocatively and programmatically. In 1973, Anita Steckel formed a *Fight Censorship* group protesting the double standard of museum authorities, only allowing the male nude if decently fig-leafed, while the most blatantly sexual

female nude is considered permissible Art. Connie Greene asked professors at Rhode Island art college, who had taught and drawn from the female nude for years, if they would be willing to pose themselves; and based a very beautiful and sympathetic series of paintings on this role reversal. Marion Pinto actually called one of her exhibitions "Man as Sex Object"; while Sylvia Sleigh, painting her favorite young models Philip Golub and Paul Rosano over and over again is obviously turned on by their grace and almost feminine narcissism. And by their body hair; in striking contrast to the depilitated classic nude, her paintings of Paul Rosano, reclining or gazing at his reflected image, delight in the heavy patterning of dark hair on his body. Works by Pinto or Sleigh or Jillian Denby often have a dislocating effect, because we are not used to seeing the male body so relaxed, passive and sensuous. The artists ask pointed questions about the power relationships underlying traditional sexual attitudes. If there is occasionally a note of hostility toward the male, a surprising number of these nudes are gentle and genial in tone. (Tomar Levine's domestically naked man, grinning back as he lies with knees cramped up in his old-fashioned bathtub, is a good example.) The artists often express a kind of fellow feeling for their subjects, as they honestly expose their own fantasies.

Other artists play jokes with the sexual metaphors we take for granted. Anita Steckel, for example, has done a number of phallic city skylines, sometimes funny and sometimes surreally menacing. Her *Feminist Peepshow* consisted of forty photographs of dignified Victorian gentlemen, bearded and heavily clothed; below the waist, Steckel drew in bare legs and weird and comic penises. (One penis turns in a groping hand, another twines like a vine, yet another is so long and thin that it turns into a rope with a tiny naked man hanging at the end.) Marjorie Strider, who used to do rather conventional pop female nudes, has recently done some weird blowups of nudes off Greek vases—one shows a woman about to be penetrated by two men with big erections, another shows nude warriors—that are being broken and forced apart by brightly colored plastic goo. Its formless, messy, subhuman energy, something out of science fiction, oozes all over the sacrosanct forms of high art.

The penis, often erect, is the central image in much of Eunice Golden's work. From one point of view, she is simply offering a visual answer to the endlessly emphasized and blown-up vaginas so run-of-

the-mill in modern erotic art. (Golden has even done a parody of Magritte's famous *Le Viol*, where the man's genitals are superimposed on his face.) But her more abstract phallic fantasies are imaginative and often very beautiful—as are the various "landscapes" she discovers in the male body. Some of her work is sharply satirical, but there is little of that open or suppressed disgust that male artists often betray when they paint the female genitals. In her *Purple Sky*, the disconcerting colors and almost abstract shapes resolve themselves into a closeup of a man lying on his back playing with his erect penis. The painting is coolly impersonal, but it is also a genuine attempt to identify with the way a man experiences his body, his erection.

Nancy Grossman's art also uses the male body as the focus of fantasy, this time somber and rather frightening. Much of her work is preoccupied with violence. But the *Portrait of A.E.*, a nude man with a meticulously detailed gun strapped to his head, is not making any obvious equation between phallus and weapon. It implies, rather, that violence is in the head, that this man cannot speak except murderously, cannot see except through the sights of his gun. His shoulders are heavy, and his arms stiff, as if he were being constrained and invisibly fettered. The bonds are made visible in some of Grossman's disturbing figure sculptures, where a leather man struggles desperately with the buckles and zips and belts that confine him. Grossman uses the gear and imagery of sadomasochism, but there is all the difference in the world between her work, and that of someone like Allen Jones, who simply exploits pop images of punished and punishing women. Grossman's art is an attempt to understand the tragic roots of cruelty, the way it traps us. The bonds her men fight are the only thing that holds them together, the leather that encases and stifles them is their own skin.

In her painting *Michelangelo's David*, Audrey Flack turns back to the past, playing with the fact that this is the most famous of all male nudes, a stereotype of masculine beauty; and she sets out to re-investigate its basic meanings and plastic virtue. As it turns out, the life in the painting emerges most strongly in the rough-textured brick background, Flack's sensual rendering of the pattern of rectangles and shadows and chipped corners. The effect is as if the nude, however stunning, is not quite in focus, as if it does not—and never can—quite serve as a symbol for a woman's sexual fantasy. In some ways more interesting, certainly more deeply moving, is Flack's

318

Davey Moore, based on a photograph of the black boxer who "was sitting in the back of Madison Square Garden after a match, talking to *Life* reporters when he dropped dead."[7] Flack's cool super-realism plays up Moore's masculinity, celebrates it and sees it as the instrument of his being exploited and destroyed. Moore, caught gesturing in a moment of animated conversation, looks sad and beautiful, almost as if he were appealing or protesting his fate.

Like *Davey Moore*, many nudes done recently by women have been portraits. As Linda Nochlin argues, this is itself a contradiction in terms. Western art has always distinguished sharply between the severed portrait head and the ideal, generalized body. The nude, Nochlin points out, "is somehow supposed to be timeless, ageless and above all anonymous, not someone you might meet on the street, shake hands with or bump into at a cocktail party."[8] Artists like Sylvia Sleigh, Connie Greene or Jillian Denby all paint actual, recognizable people. Their skin tone, their body hair or their genitals are as distinctive as their faces, and so are their poses and gestures. Sylvia Sleigh's *Turkish Bath* deliberately harks back to Ingres's famous painting of the same name; but where Ingres's women are sweetly anonymous dream figures made to the same identi-kit, Sleigh has tried hard to differentiate precisely between each of her men. Though she does include Paul Rosano twice, once playing the guitar, and again standing listening to himself on the other side of the painting—as if the painter has given in momentarily to a romantic tendency to transform all men into her personal image of ideal beauty.

But there are some superb "naked portraits." One of my favorites is Connie Greene's *George K*, who emerges vividly, immediately, as a defined and living personality. He is cheerful, plump, bespectacled, and as he sits grinning in the corner of his sofa, is somehow very dignified. Martha Edelheit has been experimenting with a great variety of male nudes since the early 1960s, ranging from straightforward "academic" studies to imaginative meditations on the male body. The man in *Dx2* looks at first glance like a mere sex object. He is painted like a still life, his body treated with the same sharp definition as the brilliant blue-and-yellow drapery behind him. But this unsentimental and even dehumanizing clarity is counteracted by the fact that we are offered two views of the same man—once sitting defensive, alert, a little sullen, then falling back into idle and mindless relaxation. His personality exists in at least two dimensions. Perhaps

319

my favourite Edelheit painting is her *View of the Empire State Building from Sheep Meadow*, one of a series of cityscapes, with four nudes, two men and two women, sitting in the vividly green grass of Central Park. It is disconcerting in its immediacy, in its unromantic and only too clear-sighted view of the naked body, and in the mordant comedy of the urban setting. None of the nudes is conventionally attractive, and if this is supposed to be paradisial picnic, traditional image of man's yearning to get back to nature, it is very much an idyll for our times. Empty Coke cans are scattered around, and none of the participants looks particularly satisfied or abandoned or even comfortable. But the painting combines dignity and laughter in a particularly attractive way.

Probably the finest of all contemporary painters of the nude is Alice Neel, a remarkable and, until recently, neglected painter. Most of her work—whether she was painting her neighbors in Spanish Harlem in the late 1930s, her own children, or fashionable personalities in the New York art world—is remarkable for its social and psychological insight. Much of her art consists of portraits, and she uses the nude only occasionally—but then with extraordinarily telling effect. Her nudes range from the somber and tragic Puerto Rican dying of T.B. in Spanish Harlem, to the equally terrifying Andy Warhol, stripped to the waist and seen against a blank background, holding himself upright on the edge of collapse. His breasts look almost female above the belly, terribly scarred and strapped together. His eyes are closed, his whole body turned in on itself; yet there is a disturbing hint in pose and expression, that he takes a masochistic pleasure in displaying his very real suffering.

One of the qualities that makes Neel's work so powerful and difficult is the combination of a deep physical empathy with her sitters, an almost animal awareness of their tensions; and a vision so unsentimental and unsparing that it verges on brutality. The *Joe Gould*, painted back in 1933 though not exhibited till 1971, shows him skinny, devilishly grinning, delighted to display himself without clothes. But Neel gets a surreal effect by loading his body with genitals; he has not just one, but three sets, their formalized shape mirrored again in the cut of his beard. Moreover, his sitting figure is flanked by two standing images of his belly and genitals, this time described in disconcerting detail—the foreskin is pushed back on the right but not on the left. The painting—its dazzling wit hovering on

320

the edge of cruelty—is a biting comment on exhibitionism, arrogance and impotence.

More recently Neel painted art critic John Perreault, with a gentler and more affectionate irony. Stripped of his clothes, he remains a sophisticated urbanite. Neel is interested in the confidence and the self-possessions that allow him to pose nude, fully aware that he and the artist are doing something experimental and rather "liberated." Yet somehow, for all the intelligent awareness expressed in his steady outward gaze, he is not quite able to relax. His pose is a little too casually unconcerned, and his self-consciousness emerges, for example, in the awkwardness of that propped-up leg.

There is nothing timeless or classless about any of Neel's nudes, male or female. Social differences and sexual tensions are not discarded with our clothes, they go skin-deep and deeper, are expressed in the tiniest physical details. The way we live in society is also expressed in the way we inhabit our naked bodies.

Mother and Boy, 1901, Mary Cassatt

TOP: *The Nets*, 1914, Suzanne Valadon
BOTTOM RIGHT: *Sleeping Faun*, mid-nineteenth century, Harriet Hosmer
BOTTOM LEFT: *Love Locked Out*, 1884, Anna Lea Merritt

324

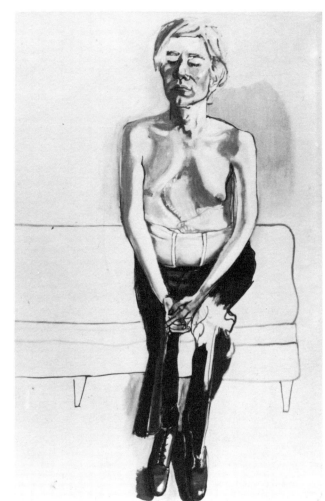

RIGHT: *Andy Warhol*, 1970,
Alice Neel
BOTTOM: *John Perreault*, 1972,
Alice Neel

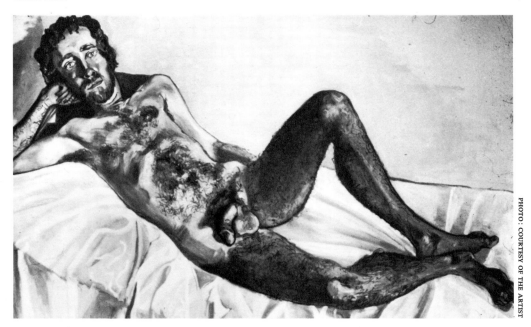

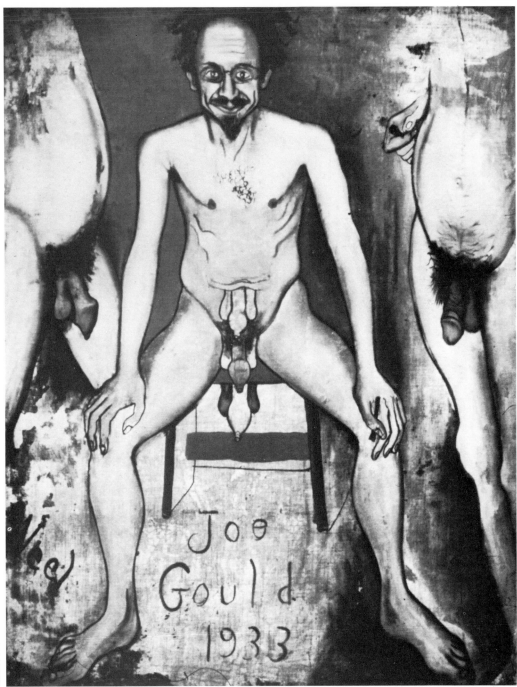

Joe Gould, 1933, Alice Neel

THIS PAGE, TOP: *The Turkish Bath*, 1973, Sylvia Sleigh
BOTTOM: *View of the Empire State Building from Sheep Meadow*, 1970–2, Martha Edelheit

OPPOSITE, TOP: *George K*, 1974, Connie Greene
BOTTOM: *John J*, 1974, Connie Greene

326

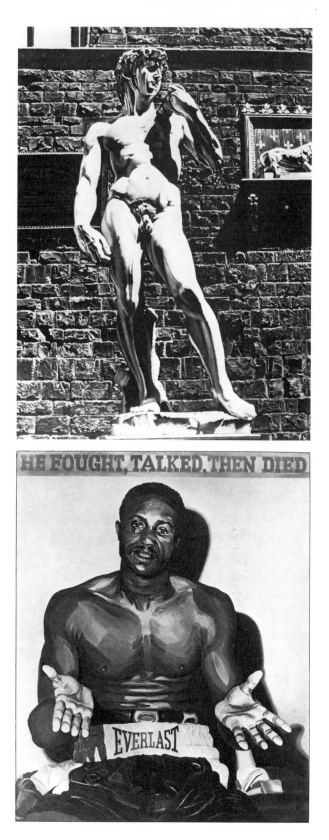

Michelangelo's David, 1971, Audrey Flack

Davey Moore, 1960s, Audrey Flack

Untitled, 1975, Jillian Denby

TOP RIGHT: *Portrait of A.E.*, 1973, Nancy Grossman
TOP LEFT: *Purple Sky*, 1969–70, Eunice Golden
BOTTOM: *Dx2*, 1969–71, Martha Edelheit

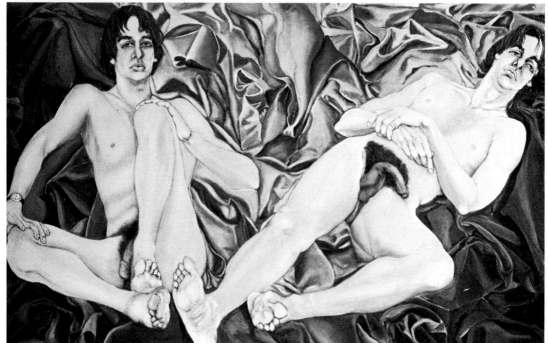

PHOTO: COURTESY OF THE ARTIST

PHOTO: COURTESY OF CORDIER AND EKSTROM INC

PHOTO: COURTESY OF THE ARTIST

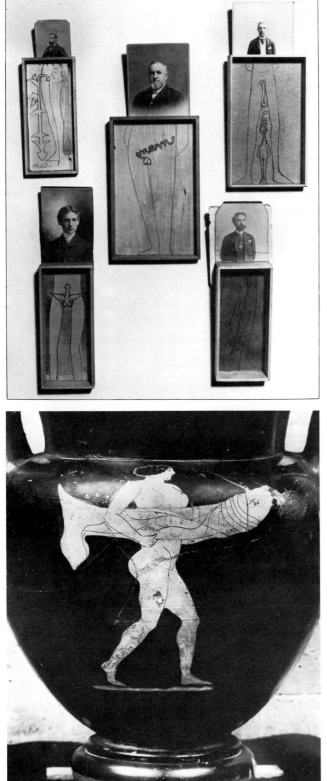

TOP: *Feminist Peepshow*, 1970s, Anita Steckel

BOTTOM: Naked woman carrying off a giant phallus, Greek vase, fifth century B.C.

NOTES

Introduction

1. For two very different accounts of phallic imagery, see Thorkil Vanggaard, *Phallos: A Symbol and its History in the Male World* (London, 1972); and Bruno Bettelheim, *Symbolic Wounds: Puberty Rites and the Envious Male* (London, 1955).
2. S. Giedion, *The Beginnings of Art* (London, 1962), esp. pp. 173ff. and 193ff. See also Bettelheim, esp. pp. 156ff., and Jacquetta Hawkes, *Dawn of the Gods* (London, 1968), p. 131.
3. Kenneth Clark, *The Nude: A Study in Ideal Form* (London, 1960), p. 25.
4. Robert J. Stoller, *Perversion* (London, 1976), pp. 97–8.
5. Sigmund Freud, *Civilization and its Discontents* (London, 1963), esp. p. 43.
6. Clark, *op. cit.*, p. 3.
7. *Ibid.*, p. 1.
8. John Berger, *Ways of Seeing* (London, 1972), p. 54.
9. Clark, *op. cit.*, p. 11.
10. John Berger, *Selected Essays and Articles* (London, 1972), p. 215.
11. See Marie Delcourt, *Hermaphrodite* (London, 1961), on ancient images of bisexuality; and Bettelheim, *op. cit.*, esp. p. 63.
12. P. Hamerton, *Man in Art* (London, 1892), p. 39. For accounts of women artists and the male model see Linda Nochlin, "Why Are There No Great Women Artists?" in Vivian Gornick and Barbara K. Moran, eds., *Woman in Sexist Society* (New York, 1971), pp. 493–7; and Ann Sutherland Harris and Linda Nochlin, *Women Artists 1500–1950* (New York, 1977), pp. 21–3 and 51–3.
13. D. H. Lawrence, *The White Peacock* (London, 1950), pp. 200–1.
14. Quentin Bell, *The Schools of Design* (London, 1967), p. 126; and G. Hendrix, *The Life and Works of Thomas Eakins* (New York, 1974), pp. 137–45.
15. Thomas B. Hess and Linda Nochlin, eds., *Woman as Sex Object* (London, 1973), pp. 9–15.

The Classic Nude

1. Clark, *op. cit.*, p. 11.
2. The line runs from Winckelmann's *Thoughts on the Imitation of Greek Works of Art in Painting and Sculpture*, first published in 1755, to the end of the 19th century and beyond; see Walter Pater's "Winckelmann," written in 1867 and published in *The Renaissance*.
3. Clark, *op. cit.*, p. 20.
4. See, for example, Adrian Stokes, *Greek Culture and the Ego* (London, 1958), and his *Reflections on the Nude* (London, 1967).
5. Hanns Sachs, "The Delay of the Machine Age," *Psychoanalytical Quarterly*, XI, 1933, p. 422.
6. Gisela Richter, *Kouroi* (London and New York, 1970), p. 4.
7. Clark, *op. cit.*, p. 69.
8. J. J. Pollitt, *Art and Experience in Classical Greece* (Cambridge, 1972), pp. 7–9.
9. Richter, *Kouroi*, p. 2.
10. Sarah B. Pomeroy, *Goddesses, Whores, Wives and Slaves: Women in Classical Antiquity* (New York, 1975), p. 9.
11. Clark, *op. cit.*, p. 70.
12. Pomeroy, *op. cit.*, p. 145.
13. J. J. Pollitt, *The Art of Greece 1400–31 B.C.: Sources and Documents* (New Jersey, 1965), pp. 128, 131.
14. Aeschylus, *The Oresteian Trilogy*, translated by Philip Vellacott (London, 1956), pp. 169–70.
15. D. von Bothmer, *Amazons in Greek Art* (Oxford, 1957).
16. Hans Licht, *Sexual Life in Ancient Greece* (London, 1932), p. 39, and see Pomeroy, *op. cit.*, pp. 93ff.
17. Philip Slater, *The Glory of Hera* (Boston, 1971), pp. 33–4.
18. Peter Brown, "Violence in Olympia," *New York Review of Books*, Nov. 25, 1976, p. 23.
19. Pomeroy, *op. cit.*, p. 142. See also John Boardman, *Pre-Classical* (London, 1967), pp. 106ff.
20. Sachs, *op. cit.*, p. 420 note.
21. Quoted in A. De Ridder and W. Deonna, *Art in Greece* (London, 1968), pp. 100–1.
22. Quoted *ibid.*, pp. 90–1.
23. Vanggaard, *op. cit.*, p. 62.
24. See Peter Brown, and Alvin W. Gouldner, *Enter Plato* (London, 1967), esp. pp. 41ff.
25. Clark, *op. cit.*, p. 21.
26. *Iliad*, Book XXII.
27. Plato, *Symposium*, translated by Walter Hamilton (London, 1951), esp. pp. 42–50.
28. *Symposium*, p. 62. See the discussions in Hans Licht, pp. 411ff; and in Robert Flacelière, *Love in Ancient Greece* (London, 1962), pp. 49ff.
29. Slater, *op. cit.*, p. 34.
30. Quoted Flacelière, *op. cit.*, p. 69.
31. Quoted E. W. Gardiner, *Greek Athletic Sports and Festivals* (London, 1910), p. 132.
32. Antisthenes, quoted Jack Lindsay, *The Ancient World: Manners and Morals* (London, 1968), p. 98.
33. See E. R. Dodds, *The Greeks and the Irrational* (Berkeley and Los Angeles, 1951).

34. Quoted Margarete Bieber, *The Sculpture of the Hellenistic Age*, (New York, 1955), p. 48.

35. Quoted J. Charbonneaux, R. Martin and F. Villard, *Classical Greek Art* (London, 1972), p. 111. See also the discussion of changing style in Rhys Carpenter, *Greek Art* (Philadelphia, 1962).

36. Quoted Pollit, *Art and Experience*, p. 175.

37. E. W. Gardiner, *op. cit.*, has a valuable discussion of changing ideals in art and athletics.

38. Pollitt, *Sources and Documents*, p. 148.

39. Pollitt, *Art and Experience*, pp. 189–94.

40. Pollitt, *Sources and Documents*, p. 129.

41. Pomeroy, *op. cit.*, p. 146.

42. *Ibid.*, pp. 142–8.

43. Bieber, *op. cit.*, gives a detailed survey. See Pollitt, *Art and Experience*, for an interpretation of early Hellenistic art.

44. See George Ryle Scott, *Phallic Worship* (London, 1970), esp. pp. 137ff.; Peter Webb, *The Erotic Arts* (London, 1975), pp. 52ff.; Jean Marcadé, *Eros Kalos: Essay on Erotic Elements in Greek Art* (Geneva, 1962); and Otto J. Brendel, "The Scope and Temperament of Erotic Art in the Graeco-Roman World," in T. Bowie and C. V. Christenson, eds., *Studies in Erotic Art* (New York, 1970), pp. 3ff.

45. Michael Grant, *Eros in Pompeii: The Secret Rooms of the National Museum of Naples* (London, 1975).

The Naked Christian

1. See Peter Brown, *The World of Late Antiquity* (London, 1971), and E. R. Dodds, *Pagan and Christian in an Age of Anxiety* (Cambridge, 1965).

2. Dodds, *op. cit.*, p. 30.

3. *Ibid.*, esp. pp. 32–3, and see Marina Warner, *Alone of All Her Sex* (London, 1976), pp. 54–7, 92–9.

4. Quoted Herbert A. Musurillo, S. J., *Symbolism and the Christian Imagination* (Dublin, 1962), p. 65.

5. André Malraux, *The Metamorphosis of the Gods* (London, 1960), p. 244; Edwyn Bevan, *Holy Images* (London, 1940), p. 87.

6. Emile Mâle, *Religious Art from the Twelfth to the Eighteenth Century* (London, 1949), p. 141; Erwin Panofsky, *Tomb Sculpture* (London, 1964), esp. pp. 63–6.

7. *Ibid.*, pp. 142–50; J. Huizinga, *The Waning of the Middle Ages* (London, 1955), esp. pp. 140–52; and James M. Clark, *The Dance of Death* (Glasgow, 1950).

8. Philip Ziegler, *The Black Death* (London, 1970).

9. Francis Douce, *Holbein's Dance of Death* (London, 1858), and James M. Clark, *op. cit.*

10. Huizinga, *op. cit.*, p. 147.

11. Frank Kendon, *Mural Painting in English Churches During the Middle Ages* (London, 1923), pp. 120ff.

12. See Gertrud Schiller, *Iconography of Christian Art* (London, 1968), II, pp. 88ff; and Paul Thoby, *Le Crucifix* (Nantes, 1959).

13. Quoted Schiller, *op. cit.*, p. 98.

14. Mâle, *op. cit.*, p. 115.

15. Georg Scheja, *The Isenheim Altarpiece* (New York, 1971), pp. 8–11.

16. Quoted Norman Cohn, *The Pursuit of the Millennium* (London, 1962), p. 124.

17. Quoted David Knowles, *The English Mystical Tradition* (London, 1964), p. 126; see also George Henderson, *Gothic* (London, 1967), pp. 160–74.

18. *Revelations of Divine Love*, translated by Clifton Wolters (London, 1966), pp. 72, 89.

19. Millard Meiss, *Painting in Florence and Siena after the Black Death* (Princeton, 1951), p. 106.

20. Schiller, *op. cit.*, II, p. 147; and Scheja, *op. cit.*, p. 60.

21. *Revelations of Divine Love*, p. 169.

22. *The Book of Margery Kempe, 1436: A Modern Version*, ed. W. Butler Bowdon (London, 1936), p. 276.

23. *Ibid.*, p. 109.

24. Schiller, *op. cit.*, p. 179.

25. Musurillo, *op. cit.*, p. 108.

26. Elizabeth G. Holt, *A Documentary History of Art* (New York, 1957), I, p. 315 note.

27. Giorgio Vasari, *The Lives of the Artists*, selected and translated by George Bull (London, 1971), p. 175.

28. Quoted in Raymond Crawford, *Plague and Pestilence in Literature and Art* (London, 1914), p. 99; see also Louis Réau, *Iconographie de L'Art Chrétien* (Paris, 1955), III, 3, pp. 1190–1199; and Victor Kraehling, *Saint Sebastien dans L'Art* (Paris, 1938).

29. R. and M. Wittkower, *Born Under Saturn* (London, 1963), p. 179.

30. Thoby, *op. cit.*, p. 24.

31. Holt, *op. cit.*, pp. 165–6; Peter Burke, *Tradition and Innovation in Renaissance Italy* (London, 1974), p. 173. On the Counter Reformation, see Anthony Blunt, *Artistic Theory in Italy 1450–1600* (Oxford, 1962), pp. 103ff; and Jean Seznec, *The Survival of the Pagan Gods* (Princeton, 1972), p. 263ff.

32. Burke, *op. cit.*, pp. 172–3.

33. Robert Goldwater and Marco Treves, *Artists on Art* (London, 1976), pp. 100–1.

34. Blunt, *op. cit.*, p. 124.

35. *Ibid.*, pp. 125–6.

36. Warner, *op. cit.*, p. 203.

37. Blunt, *op. cit.*, p. 118.
38. *Ibid.*, p. 118.

Naked into Nude
1. Geoffrey Squire, *Dress, Art and Society 1560–1970* (London, 1974), esp. pp. 23ff. and 38–9.
2. Erwin Panofsky, *The Life and Art of Albrecht Dürer* (London, 1945), I, p. 33.
3. Dürer in Holt, *op. cit.*, I, p. 317; K. R. Eissler, *Leonardo da Vinci* (London, 1962), pp. 237–8.
4. Vasari, *op. cit.*, p. 251.
5. Holt, *op. cit.*, p. 164. See also Richard Krautheimer, *Lorenzo Ghiberti* (Princeton, 1956), esp. pp. 294ff.; Roberto Weiss, *The Renaissance Discovery of Classical Antiquity* (London, 1969); and Michael Levey, *Early Renaissance* (London, 1967), esp. pp. 149–75.
6. Holt, *op. cit.*, pp. 210–11.
7. Vasari, *op. cit.*, p. 241. See also P. Kristeller, *Andrea Mantegna* (London, 1901).
8. Erwin Panofsky, *Meaning in the Visual Arts* (New York, 1957), esp. pp. 50–4, also his *Renaissance and Renascences in Western Art* (Stockholm, 1965).
9. Charles Seymour Jr., *Sculpture in Italy 1400–1500* (London, 1966), pp. 4–6.
10. Goldwater and Treves, *op. cit.*, p. 35.
11. Quoted in Cornelius Vermeule, *European Art and the Classical Past* (Cambridge, Mass., 1964), p. 95.
12. See Rudolf Wittkower, *Architectural Principles in the Age of Humanism* (London, 1967), esp. pp. 14–16, 27–30.
13. Pacioli quoted Wittkower, p. 15. Cennini in Goldwater and Treves, pp. 23–4; see also Joan Gadol, *Leon Battista Alberti* (Chicago, 1969), esp. p. 81.
14. Holt, *op. cit.*, p. 309.
15. See the accounts in Charles Singer, *The Evolution of Anatomy* (London, 1925); and C. D. O'Malley, *Andreas Vesalius of Brussels* (Berkeley, Cal., 1964).
16. Eissler, *op. cit.*, p. 201.
17. R. and M. Wittkower, *op. cit.*, pp. 55–6.
18. Eissler, *op. cit.*, esp. pp. 196–7.
19. Goldwater and Treves, *op. cit.*, p. 37. See the discussion in Erwin Panofsky, *Idea: A Concept in Art Theory* (New York, 1968), pp. 47ff.
20. Holt, *op. cit.*, pp. 316, 322, 324.
21. Quoted in John Addington Symonds, *The Renaissance in Italy* (London, 1877), III, pp. 280–1.
22. See Georgina Masson, *Courtesans of the Italian Renaissance* (London, 1975), p. 5.
23. Quoted in Geoffrey Coulton, *Life in the Middle Ages* (Cambridge, 1928–30), I, p. 221.
24. Ruth Kelso, *Doctrine for the Lady of the Renaissance* (Urbana, Ill., 1956).
25. Clark, *op. cit.*, p. 314.
26. *Ibid.*, p. 113.
27. See Oliver Logan, *Culture and Society in Venice 1470–1790* (London, 1972); and A. R. Turner, *The Vision of Landscape in Renaissance Italy* (Princeton, 1966).
28. Edgar Wind, *Pagan Mysteries in the Renaissance* (London, 1967), p. 143.
29. Gene Brucker, *Renaissance Florence* (London, 1969), pp. 109–13.
30. A. Chastel, *Art et Humanisme à Florence au Temps de Laurent le Magnifique* (Paris, 1959), esp. p. 289; see also R. and M. Wittkower, *op. cit.*, pp. 169–75.
31. Wittkowers, *op. cit.*, p. 169.
32. Chastel, *op. cit.*, p. 293; and Kelso, *op. cit.*, p. 205.
33. See Adrian Stokes, *The Quattro Cento* (London, 1932), pp. 130–5; and Josef Kunstmann, *The Transformations of Eros* (Edinburgh, 1964).
34. Levey, *op. cit.*, p. 164.
35. Sigmund Freud, *Leonardo da Vinci* (London, 1963), pp. 162–3.
36. J. P. Richter, *The Literary Works of Leonardo da Vinci* (London, 1939), I, p. 59.
37. Frederick Hartt, *A History of Italian Renaissance Art* (London, 1970), pp. 271–2.
38. Clark, *op. cit.*, p. 191.
39. Shakespeare, *Antony and Cleopatra*, V, ii, 93–4.

Michelangelo
1. See the life by Michelangelo's pupil, Ascanio Condivi (I have used the translation by S. Elizabeth Hall (London, 1905); Vasari, *op. cit.*, pp. 325–442. See also E. H. Ramsden, ed., *The Letters of Michelangelo*, 2 vols (Stanford, 1963). Robert J. Celements, *Michelangelo: A Self Portrait* (New Jersey, 1963) is useful; and I found Adrian Stokes, *Michelangelo* (London, 1955) the most thought-provoking account. See also *The Complete Poems of Michelangelo*, translated by Joseph Tusiani (London, 1961); though no single translation of the poems seems completely satisfactory.
2. Condivi, *op. cit.*, par. XII, Hall, p. 13.
3. Ramsden, *op. cit.*, II, p. 192.
4. *Ibid.*, I, p. 5.
5. *Ibid.*, I, p. 75; Stokes, *op. cit.*, p. 37, and see his illuminating discussion of Michelangelo's relationships with his family, pp. 32ff.
6. Clements, *op. cit.*, pp. 24–5, 106–7. (Tusiani, no. 58.)
7. Quoted Herbert von Einem, *Michelangelo* (London, 1959), pp. 35–6.
8. Leo Steinberg, "Michelangelo's Florentine

Pieta: The Missing Leg," *Art Bulletin*, L, 1968, pp. 343ff; and "The Metaphors of Love and Birth in Michelangelo's Pietas," in Bowie and Christenson, *op. cit.*, pp. 231ff.; also Robert S. Liebert, "Michelangelo's Mutilation of the Florentine Pieta: a Psychoanalytical Inquiry," *Art Bulletin*, LIX, 1977, pp. 47ff.

9. Ramsden, II, p. xxxv. Burgess, "The Artist as Miracle Worker," *Sunday Times Magazine*, 2 Feb. 1975, p. 34.

10. Ramsden, in the introductions to the two volumes of letters; he also includes a useful survey of past and present attitudes to Michelangelo's sexuality. See also Pierre Langeard, *L'Intersexualité dans L'Art* (Montpellier, 1936).

11. Ramsden, *op. cit.*, II, p. 137.

12. Vasari, *op. cit.*, p. 420.

13. Clements, *op. cit.*, p. 114.

14. *Ibid.*, p. 92.

15. Charles de Tolnay, *Michelangelo* (Princeton, 1943–60), III, pp. 111–12. See also the comparison of Michelangelo and Leonardo in Eissler, *op. cit.*, pp. 129–31.

16. Condivi, *op. cit.*, par. LXV, Hall, p. 76.

17. Vasari, *op. cit.*, p. 335.

18. See Charles Seymour Jr., *Michelangelo: The Sistine Chapel Ceiling* (New York, 1972), for a collection of different views; esp. S. J. Freedberg, pp. 192ff. See also Tolnay, *op. cit.*, II, pp. 63ff. and 161ff.

19. Clements, *op. cit.*, p. 174 (Tusiani, no. 87, p. 78).

20. Vasari, *op. cit.*, pp. 253–4.

21. Clements, *op. cit.*, pp. 51–2, 139–41.

22. See Robert J. Clements, *Michelangelo's Theory of Art* (New York, 1961), p. 59; Vasari, *op. cit.*, pp. 404–5 also describes his method of work as an old man.

23. Charles Seymour Jr., *Michelangelo's David* (Pittsburgh, 1967), esp. pp. 7–8.

24. Vasari, *op. cit.*, p. 338.

25. Tusiani, *op. cit.*, no. 69, pp. 55–7.

26. See de Tolnay, *op. cit.*, II, p. 59 (Tusiani, *op. cit.*, no. 76).

27. See Clements, *Theory*, pp. 23–7. Frederick Hartt, *Michelangelo: The Complete Sculpture* (London, 1969) and Martin Weinberger, *Michelangelo the Sculptor* (London, 1967), are both interesting on Michelangelo's relationship with stone.

28. Quoted Clements, *Theory*, p. 27. (Tusiani, *op. cit.*, no. 125.)

29. Clements, *Theory*, pp. 21–2.

The Well-mannered Nude

1. E. H. Gombrich, *The Story of Art* (London, 1950), p. 265.

2. J. Shearman, *Mannerism* (London, 1967), p. 48.

3. Anthony Blunt, *op. cit.*, p. 92.

4. Shearman, *op. cit.*, p. 162.

5. Quoted Julius S. Held and Donald Posner, *17th and 18th Century Art* (New York, 1973), p. 70.

6. Shearman, *op. cit.*, p. 81. See the account of mannerism in Walter Friedlander, *Mannerism and Anti-mannerism in Italian Painting* (New York, 1965); and Erwin Panofsky, *Idea*, pp. 71ff.

7. Shearman, *op. cit.*, p. 86.

8. Blunt, *op. cit.*, pp. 95–7.

9. Franzepp Würtenberger, *Mannerism: The European Style of the 16th Century* (London, 1963), p. 44.

10. Vasari, *op. cit.*, pp. 382–3.

11. Giuliano Briganti, *Italian Mannerism* (London, 1962), pp. 12–13. See also F. Antal, "The Social Background of Italian Mannerism," *Art Bulletin*, XXX, 1948, pp. 102ff., and Lauro Martines, "The Gentleman in Renaissance Italy," in Robert S. Kinsman, ed., *The Darker Vision of the Renaissance* (Los Angeles, 1974), pp. 77ff.

12. Vasari, *Life of Rosso*, translated by Gaston DuC. De Vere (London, 1912–15), V, p. 191.

13. *Ibid.*, and see Kenneth Clark, *A Failure of Nerve: Italian Painting 1520–33* (Oxford, 1967), pp. 17–19.

14. *Ibid.*; Vasari, *op. cit.*; see also S. J. Freedberg, *Painting in Italy 1500–1600* (Harmondsworth, 1970), pp. 126–32; and F. M. Clapp, *Jacopo da Pontormo* (New Haven, 1916).

15. Freedberg, *op. cit.*, p. 131; Shearman, *op. cit.*, p. 195.

16. Vasari, *op. cit.*, VIII, pp. 145ff. See also Freedberg, *op. cit.*, pp. 118–126.

17. Janet Cox Rearick, *The Drawings of Pontormo* (Cambridge, Mass., 1964), I, p. 247. See also Wurtenberger, *op. cit.*, p. 174.

18. Rearick, *op. cit.*, p. 291.

19. Vasari, *op. cit.*, esp. pp. 168–9, 179ff.; Freedberg, *op. cit.*, 316–18.

20. Clark, *op. cit.*, p. 16; Vasari, *op. cit.*, p. 180.

21. Baldassare Castiglione, *The Book of the Courtier*, translated by Thomas Hoby (London, 1928), pp. 40, 43.

22. See Shearman, *op. cit.*, generally but especially pp. 17, 21–2.

23. Squire, *op. cit.*, pp. 45–69.

24. Robert Melville, *Erotic Art of the West* (New York, 1973), pp. 202–3.

25. Vanggaard, *op. cit.*, p. 165.

26. Vasari, *Life of Bronzino*, trans. De Vere, X, p. 9.

Nude Directions

1. Robert Engass and Jonathon Brown, *Italy and Spain 1600–1750: Sources and Documents* (New

Jersey, 1970), p. 118.

2. Elizabeth Du Gué Trapier, *Ribera* (New York, 1952), pp. 83–4.

3. Goldwater and Treves, *op. cit.*, pp. 150–7.

4. Nickolaus Pevsner, *Academies of Art Past and Present* (Cambridge, 1940), pp. 69–139.

5. Quoted Michael Kitson, *The Age of the Baroque* (London, 1966), p. 16.

6. Rudolf Wittkower, *Gian Lorenzo Bernini: The Sculptor of the Roman Baroque* (London, 1955), pp. 209–10.

7. Quoted John Rupert Martin, *Baroque* (London, 1977), p. 45.

8. Goldwater and Treves, p. 148.

9. Quoted Edward Lucie-Smith, *Eroticism in Western Art* (London, 1972), pp. 79–80.

10. Clark, *The Nude*, p. 139.

11. *Ibid.*, pp. 131–2.

12. Quoted Anthony Bertram, *The Life of Sir Peter-Paul Rubens* (London, 1928), pp. 197–8.

13. Blunt, *op. cit.*, pp. 127, 136.

14. Mâle, *op. cit.*, p. 176.

15. *Don Juan*, Canto XIII, lxxi.

16. Charles de Brosses quoted R. and M. Wittkower, *op. cit.*, p. 180. St. Teresa quoted and discussed by Peter Murray, Introduction to Heinrich Wolfflin, *Renaissance and Baroque* (London, 1964), p. 8.

17. John Rupert Martin, *Rubens: The Antwerp Altarpieces* (London, 1969), p. 62.

18. John B. Knipping, *The Iconography of the Counter Reformation in the Netherlands* (Nieuwkoop, 1974), I, p. 2.

19. See Howard Hibbard, *Bernini* (London, 1965), pp. 192–3.

20. Mâle, *op. cit.*, p. 178.

21. Engass and Brown, *op. cit.*, p. 78.

22. Scanelli, quoted in Stefano Bottari, *Caravaggio* (London, 1971), p. 21.

23. For discussions of Caravaggio and his context, see Donald Posner, "Caravaggio's Homoerotic Early Works," *Art Quarterly*, XXXIV, 1971, pp. 301ff.; Roger Hinks, *Michelangelo Merisi da Caravaggio* (London, 1953); Francis Haskell, *Patrons and Painters: A Study in the Relations Between Italian Art and Society in the Age of the Baroque* (London, 1963), esp. pp. 28–9.

24. Clark, *op. cit.*, p. 252.

25. Rudolf Wittkower, *Art and Architecture in Italy 1600–1750* (Harmondsworth, 1973), p. 29.

26. Hinks, *op. cit.*, p. 89.

27. Martin, *Baroque*, p. 284.

28. Carducho in Engass and Brown, pp. 173–4; on the academies, Pevsner, esp. fig. 9 (facing p. 92). See also the discussion in Rensselaer W. Lee, *Ut Pictura Poesis: The Humanistic Theory of Painting* (New York, 1967).

29. Martin, *op. cit.*, pp. 272–3. For Bellori on art, see Enggass and Brown, *op. cit.*, esp. p. 11.

30. Reynolds, *Discourses* (London, 1905), no. 5, p. 128.

31. Anthony Blunt, *Art and Architecture in France 1500–1700* (Harmondsworth, 1953), pp. 182–95.

Revolutionary Eros

1. J. C. Flugel, *The Psychology of Clothes* (London, 1930), esp. pp. 138ff.

2. Quoted David Irwin, *English Neoclassical Art* (London, 1966), p. 49; and Irwin, ed., *Winckelmann: Writings on Art* (London, 1972), p. 52.

3. For Canova's arguments, Goldwater and Treves, *op. cit.*, p. 196. Margaret Whinney, *Sculpture in Britain 1530–1830* (London, 1964), p. 215.

4. Hugh Honour, *Neoclassicism* (London, 1968), p. 118. See also Mario Praz, *On Neoclassicism* (London, 1969), pp. 130ff.

5. Quoted in Eleanor Tufts, *Our Hidden Heritage* (London, 1974), p. 129.

6. Quoted in Michael Levey, *Rococo to Revolution* (London, 1966), p. 121. For a discussion of the new importance of the female nude see Donald Posner, *Watteau: A Lady at her Toilet* (London, 1973).

7. Diderot, *Salons*, Jean Adhemar and Jean Seznec, eds. (Oxford, 1957–67), III, p. 250. Quoted Ann Sutherland Harris and Linda Nochlin, *op. cit.*, p. 169.

8. *Ibid.*, p. 30.

9. Victoria Manners and G. C. Williamson, *Angelica Kauffman, R.A.* (London, 1924), pp. 37, 46; Adeline Hartcup, *Angelica: Portrait of an 18th Century Artist* (London, 1954), p. 133. J. T. Smith, *Nollekens and his Times*, Walter Sichel, ed. (London, 1929), pp. 46 and 93 suggests the kind of gossip pursuing Kauffman.

10. Diderot, *Salons*, III, p. 252.

11. Michael Levey and Wend Graf Kalnein, *Art and Architecture of the 18th Century in France* (London, 1972), p. 113. Nancy Mitford, *Madame de Pompadour* (London, 1968) is useful on her life and tastes.

12. Levey, *op. cit.*, p. 86.

13. *Ibid.*, p. 43.

14. Quoted Honour, *op. cit.*, p. 118. For discussions of Diderot's criticism see Anita Brookner, *The Genius of the Future* (London, 1971), and J. A. Leith, *The Idea of Art as Propaganda in France 1750–1799* (Toronto, 1965), esp. pp. 27ff.

15. F. Antal, *Classicism and Romanticism* (London, 1966), pp. 1–45. See also H. T. Parker, *The Cult of Antiquity and the French*

Revolutionaries (Chicago, 1937).

16. Robert Rosenblum, *Transformations in Late Eighteenth Century Art* (Princeton, 1967) especially pp. 68–74. See also Honour, *op. cit.*, pp. 194–5; Levey, *Art and Architecture*, pp. 190–6; and L. Hautecoeur, *Louis David* (Paris, 1954).

17. André Maurois, *J.-L. David* (Paris, 1948), Introduction.

18. *Ibid.*, notes to Plate 12.

19. David Lloyd Dowd, *Pageant-Master of the Republic: Jacques-Louis David and the French Revolution* (Lincoln, Nebraska, 1948), pp. 105, 107.

20. Elizabeth G. Holt, *From the Classicists to the Impressionists* (New York, 1966), pp. 4ff., and 11–12.

21. Quoted Honour, *op. cit.*, p. 198.

22. Denys Sutton, "Frivolity and Reason," in *France and the 18th Century* (Royal Academy, London, 1968), p. 37; Honour, *op. cit.*, p. 171.

23. Quoted Vasile Florea, *Goya* (London, 1975), p. 13. For a discussion of Goya see also Levey, *Rococo to Revolution*, pp. 201ff.

The Disappearing Male

1. Quoted in Werner Hofmann, *Art in the 19th Century* (London, 1961), pp. 69–71.

2. Holt, *op. cit.*, p. 40, and see Anita Brookner, *op. cit.*, esp. pp. 44–6.

3. John Rewald, *The Ordeal of Paul Cézanne* (London, 1950), p. 139.

4. *The Marble Faun* (1859), Ch. XIV. George P. Landon, *The Aesthetic and Critical Theories of John Ruskin* (London, 1971), pp. 167–9, 253.

5. Quoted Linda Nochlin, *Realism* (London, 1971), p. 60, and see her whole discussion of death, pp. 57ff.

6. Steven Marcus, *The Other Victorians* (London, 1969), p. 22.

7. Marcus, *op. cit.*, esp. pp. 18–22. See also Alex Comfort, *The Anxiety Makers* (London, 1968), pp. 77ff. For prudery in general in England, see Peter Fryer, *Mrs Grundy* (London, 1963); and Eric Trudgill, *Madonnas and Magdalens* (London, 1977). For America see Milton Rugoff, *Passion and Prudery* (London, 1972).

8. Betty Miller, *Robert Browning* (London, 1952). pp. 104–8. Jean Renoir, *Renoir, My Father* (London, 1967), pp. 315–16.

9. For reactions of American travelers to Europe, see Neil Harris, *The Artist in American Society: The Formative Years 1790–1860* (New York, 1966), esp. pp. 124ff. For a young English girl's reactions, see the letter by Drusilla Way in A. M. W. Stirling, *The Ways of Yesterday* (London, 1930), I, pp. 238–9. For Queen Victoria, Frank Davis, *Victorian Patrons of the Arts* (London, 1963), pp. 18–19.

10. Reproduced in Peter Webb, *op. cit.*, p. 157. See also *Fuseli* (Tate Gallery, London, 1975), and the essays by Gert Schiff and Werner Hofmann.

11. See Maurice Z. Shroder, *Icarus: The Image of the Artist in French Romanticism* (Cambridge, Mass., 1961).

12. See Lorenz Eitner, *Géricault's Raft of the Medusa* (London, 1972), which not only gives a full account of the incident, but reproduces Géricault's superb studies for painting. For Géricault, see also D. Aimé-Azam, *Géricault et son Temps* (Paris, 1956), and *Géricault* (Los Angeles County Museum, 1971), catalogue and introduction by Lorenz Eitner.

13. Quoted Eitner, *Medusa*, p. 42.

14. *Ibid.*, p. 55.

15. James Barry, quoted by Anna Jameson, *A Handbook to the Public Galleries in and near London* (London, 1845), p. 50. See the discussion on the nude in Hofmann, *op. cit.*, pp. 69–71.

16. Quoted Hofmann, *op. cit.*, p. 33.

17. Quoted Ann Coffin Hanson, *Manet and the Modern Tradition* (New Haven, 1971), p. 19.

18. See discussions in Aaron Scharf, *Art and Photography* (London, 1968), esp. pp. 89ff.; Susan Sontag, *On Photography* (New York, 1977); and Nochlin, *Realism*, esp. pp. 150, 164–7.

19. Hanson, *op. cit.*, p. 91.

20. *Ibid.*, pp. 105–6. See also George Heard Hamilton, *Manet and his Critics* (New York, 1960), pp. 51–65.

21. Quoted George Heard Hamilton, *Painting and Sculpture in Europe 1880–1940* (Harmondsworth, 1967), pp. 23–4.

22. Jack Lindsay, *Courbet* (London, 1973), pp. 102–3.

23. See the discussion of "The Earthly Paradise" in Hofmann, *op. cit.*, pp. 363–402. Also Robert J. Goldwater, *Primitivism in Modern Painting* (London, 1938).

24. Quoted Paul Fussell, *The Great War and Modern Memory* (Oxford, 1975), p. 303, and see his whole chapter "Soldier Boys." See also Brian Reade, *Sexual Heretics* (London, 1970).

25. Quoted Bernard Dorival, *Cézanne* (London, 1949), p. 63.

26. Theodore Reff, "Cézanne's Bather with Outstretched Arms," *Gazette des Beaux-Arts*, LIX, 1962, pp. 173ff.

27. Quoted Vern Bullough, *Sexual Variance in Society and History* (New York, 1976), p. 535.

28. See A. J. Busst, "The Image of the Androgyne in the 19th Century," in *Romantic Mythologies*, Ian Fletcher, ed. (London, 1967), pp. 1ff.

29. Quoted Giuseppe Marchiori, *Gauguin* (London, 1968), pp. 22–3; see also Robert J.

Goldwater, *Paul Gauguin* (London, 1957).
30. See Rupert Croft-Cooke, *Feasting With Panthers* (London, 1967), esp. pp. 38–47, and 55–62.
31. See the general discussion of the period in Timothy d'Arch Smith, *Love in Earnest* (London, 1970), esp. pp. 60ff.
32. Martin Harrison and Bill Waters, *Burne-Jones* (London, 1973), p. 100.
33. Quoted Philippe Julian, *Dreamers of Decadence* (London, 1974), p. 46. See the discussion in Mario Praz, *The Romantic Agony* (London, 1960), esp. pp. 232, 352–60.
34. Pierre-Louis Mathieu, *Gustave Moreau* (Oxford, 1977), p. 164.

The Disembodied Nude
1. Arp quoted in George Heard Hamilton, *Painting and Sculpture*, p. 462. Boccioni in Herbert Read, *A Concise History of Modern Sculpture* (London, 1964), pp. 122–3.
2. Goldwater and Treves, *op. cit.*, p. 380.
3. Léger, *Fonctions de la Peinture* (Paris, 1965), p. 76.
4. Berger, *op. cit.*, p. 139.
5. Hans Peter Bleuel, *Strength Through Joy: Sex and Society in Nazi Germany* (London, 1973), p. 242.
6. Herbert Read, *The Art of Sculpture* (London, 1956), pp. 56, 67–8, and Fritz Novotny, *Painting and Sculpture in Europe 1780–1880* (Harmondsworth, 1970), pp. 235–6.
7. Hellmut Lehmann-Haupt, *Art Under a Dictatorship* (New York, 1954), pp. 101ff. See also Franz Roh, *German Art in the 20th Century* (London, 1968), pp. 151ff.
8. Susan Sontag, "Fascinating Fascism," *New York Review of Books*, Feb. 6, 1975, p. 26.
9. Quoted *ibid.*, p. 25.
10. Lehmann-Haupt, *op. cit.*, p. 96. On the *Napolas*, see Bleuel, *op. cit.*, pp. 147–53.
11. Bleuel, *op. cit.*, p. 250.
12. Quoted Sontag, *op. cit.*, p. 27.
13. *Ibid.*, pp. 26–7. And see the catalogue *Kunst im 3. Reich*, Frankfurter Kunstverein, 1974.
14. Bleuel, *op. cit.*, p. 244.
15. Metzinger in Edward F. Fry, *Cubism* (London, 1966), p. 59.
16. *Ibid.*, p. 82.
17. See discussions in Werner Hofmann, *Turning Points in 20th Century Art 1890–1917* (London, 1969); Carola Giedion-Welcker, *Contemporary Sculpture* (London, 1961); Peter Selz, *New Images of Man* (Museum of Modern Art, New York, 1960); Joseph Masheck, "Verist Sculpture: Hanson and De Andrea," in *Super Realism*, Gregory Battock, ed. (New York, 1975), pp. 187ff.

18. Maillol in Goldwater and Treves, *op. cit.*, p. 407.
19. Wolf-Dieter Dube, *The Expressionists* (London, 1972), pp. 28 and 30. See also Bernard S. Myers, *Expressionism* (London, 1963), and Charles Kessler "Sunworship and Anxiety: Nature, Nakedness and Nihilism in German Expressionist Painting," *Magazine of Art*, 1952, p. 305ff.
20. Fussell, *op. cit.*, p. 301.
21. Robert Rosenblum, *Cubism and 20th Century Art* (London, 1960), p. 130.
22. *Ibid.*, p. 130.
23. John Berger, *The Success and Failure of Picasso* (London, 1965), p. 169.
24. See Webb, *op. cit.*, pp. 228–9.
25. Quoted Cindy Nemser, "The Male Nude at Last," *Changes*, July, 1972.
26. See *Erotic Art*, compiled by Drs. Phyllis and Eberhard Kronhausen (New York, 1968).
27. Quoted Volker Kahmen, *Eroticism in Contemporary Art* (London, 1972), pp. 62–4.
28. Melville, *op. cit.*, pp. 271–2.
29. Quoted Webb, *op. cit.*, p. 370.
30. See Allessandra Comini, *Egon Schiele* (London, 1976).
31. Linda Nochlin, "The Art of Philip Pearstein," Introduction to catalogue, Georgia Museum of Art, 1970–1.

Newsstand Nudes
1. Aaron Scharf, *Art and Photography*, (London, 1968), p. 270 and see discussion pp. 98–101. See also Peter Webb, *op. cit.*, pp. 186–9.
2. Quoted Scharf, *op. cit.*, p. 98.
3. *Ibid.*, p. 270.
4. Timothy d'Arch Smith, *op. cit.*, esp. pp. 62–8. "The Nude in Photography," *Studio*, I, 1893, pp. 104ff.
5. Berger, *Ways of Seeing*, esp. pp. 134–40.
6. See the whole discussion of publicity images in Berger, pp. 129–154; and Edward Lucie-Smith, *Eroticism*, pp. 268–9.
7. Susan Sontag, *On Photography* (New York, 1977), p. 13.
8. See Robert C. Toll, *On with the Show: The First Century of Show Business in America* (New York, 1976), pp. 297–9.
9. See Charles Gaines and George Butler, *Pumping Iron: The Art and Sport of Body Building* (New York, 1974), for a fascinating and well-illustrated account.
10. Mark Gabor: *The Pin-up: A Modest History* (London, 1972), p. 205. See also Richard Wortley, *Pin-up's Progress* (London, 1971), pp. 130–48; and Peter Webb, *op. cit.*, pp. 409–11.
11. Gillian Freeman, *The Undergrowth of Literature* (London, 1967), pp. 63–78.

12. See Angela Carter, "A Well-hung Hang-up," in *Arts in Society*, ed. Paul Barker (London, 1977), pp. 73–8; and Germaine Greer, "What turns women on?" *Esquire*, July, 1973, pp. 88ff.

Through the Looking Glass
1. See R. Ward Bissell, "Artemisia Gentileschi—A New Documented Chronology," *Art Bulletin*, L, 1968, pp. 153–68. Comment on Giulia Lama quoted Harris and Nochlin, *op. cit.*, pp. 165–6; her drawings are reproduced in U. Ruggeri, *Dipinti e Disegni di Giulia Lama* (Bergamo, 1973).
2. Hosmer, quoted in Josephine Withers, "Artistic Women and Women Artists," *Art Journal*, XXXV, 1976, p. 334. See also Karen Petersen and J. J. Wilson, *Women Artists* (New York, 1976), pp. 79–81. Comment on Faun quoted William Gerdts, *The Great American Nude* (New York, 1976), p. 86. For Cassatt, see Frederick A. Sweet, *Miss Mary Cassatt, Impressionist from Pennsylvania* (Oklahoma, 1966).
3. Jean Renoir, *Renoir, My Father* (London, 1962), p. 185.
4. See Carol Duncan, "Virility and Domination in Early 20th Century Painting," *Artforum*, 1973, pp. 30ff. See also Bernard Myers, *Expressionism* (London, 1963).
5. George Moore, *Modern Painting* (London, 1893), pp. 220ff. Barbara Ehrlich White, "Renoir's Sensuous Women," in Hess and Nochlin, *op. cit.*, pp. 169–70. John Storm, *The Valadon Story* (London, 1959), p. 72; see also Harris and Nochlin, *op. cit.*, pp. 259ff.
6. Articles on the new art include Cindy Nemser, "The Male Nude Arrives at Last," *Changes*, July, 1972; Jamaica Kincaid, "Erotica!", *Ms*, Jan, 1975; Dorothy Seiberling, "The Female View of Erotica," *New York*, Feb, 1974; and Lynda Crawford, "Women in the Erotic Arts," *Viva*, Jan, 1974.
7. Cindy Nemser, *Art Talk: Conversations with 12 Women Artists* (New York, 1975) p. 309. See also her fascinating discussions with Nancy Grossman, pp. 327–46 and Alice Neel, pp. 113–38.
8. Linda Nochlin, "Some Women Realists: Painters of the Figure," *Arts Magazine*, May, 1974, p. 30, and see her whole discussion. See also Cindy Nemser, "Alice Neel: Portraits of Four Decades," *Ms*, 1973, no. 4, pp. 48ff.

SELECTED READING

There are very few books on the male nude; many writers on the nude concentrate exclusively on women. The following books touch on aspects of my theme—including several which may appear to be on unrelated subjects, but which I found very useful:

Brandt Aymar, *The Young Male Figure* (New York, 1972).
John Berger, *Ways of Seeing* (London, 1972).
Kenneth Clark, *The Nude: A Study in Ideal Form* (London, 1960).
Malcolm Cormack, *The Nude in Western Art*, (London, 1976).
Georg Eisler, *From Naked to Nude: Life Drawing in the 20th Century* (London, 1977).
J. C. Flugel, *The Psychology of Clothes* (London, 1930).
William Gerdts, *The Great American Nude* (New York, 1974).
Michael Levey, *The Nude* (National Gallery, London, 1972).
Mervyn Levy, *The Artist and the Nude* (London, 1965).
Edward Lucie-Smith, *Eroticism in Western Art* (London, 1972).
Steven Marcus, *The Other Victorians* (London, 1969).
Robert Melville, *Erotic Art of the West* (New York, 1973).
Cindy Nemser, *Art Talk: Conversations with 12 Women Artists* (New York, 1976).
Geoffrey Squire, *Dress, Art and Society* (London, 1974).
Adrian Stokes, *Reflections on the Nude* (London, 1967).
 Michelangelo (London 1955).
Peter Webb, *The Erotic Arts* (London, 1975).

LIST OF ILLUSTRATIONS

Page

19. ALBRECHT DÜRER, *Naked Self-Portrait*, c. 1503. Schlossmuseum, Weimar.

20. GREEK, *Aphrodite*, third century B.C. British Museum, London.

20. GREEK, Athlete, copy after Polykleitos, c. 430 B.C. National Museum, Athens.

21. MICHELANGELO BUONARROTI, *David*, 1501–4. Accademia, Florence.

21. GIORGIONE, *Venus, c.* 1510. Staatliche Gemaldegalerie, Dresden.

22. FRANCESCO DA SANT'AGATO, *Hercules*, 1520. Wallace Collection, London.

22. EMILE BOURDELLE, *Hercules, c.* 1910. David Daniels Collection, New York.

23. FLORENTINE, *Christ Crucified*, fifteenth century, Victoria and Albert Museum, London.

23. ANDREA MANTEGNA, *Dead Christ, c.* 1500. Brera, Milan.

24. GREEK, Satyr, 575–50 B.C. National Museum, Athens (Karapanos Collection).

24. GERMAN, *Death*, sixteenth century. Victoria and Albert Museum, London.

25. MICHELANGELO MERISI CARAVAGGIO, *St. John the Baptist, c.* 1595.

26. Copy after Michelangelo, *The Rape of Ganymede*, sixteenth century. Royal Library, Windsor.

26. DAMIANO MAZZA, *The Rape of Ganymede*, mid-sixteenth century. National Gallery, London.

27. REMBRANDT VAN RIJN, *The Rape of Ganymede*, 1635. Staatliche Kunstsammlungen, Dresden.

27. BERTEL THORWALDSEN, *Ganymede with Jupiter as the Eagle*, 1817. Thorwaldsen Museum, Copenhagen.

28. HUGO VAN DER GOES, *Adam and Eve, c.* 1470. Kunsthistorische Museen, Vienna.

29. PHILIP PEARLSTEIN, *Male and Female Models on a Cast Iron Bed*, 1974. Private Collection, USA.

30. LEONARDO DA VINCI, *Anatomical Study of a Man*, showing the blood vessels, c. 1500. Royal Library, Windsor.

30. GEORGE STUBBS, *Anatomical Study*, for *A Comparative Anatomical Exposition of the Human Body with that of a Tiger and a Common Fowl*, 1804–6.

31. THÉODORE GÉRICAULT, *Study of a Male Nude*, 1810–12. Musée des Beaux-Arts, Rouen.

31. EDGAR DEGAS, *Study of a Male Nude*, 1857. David Daniels Collection, New York.

32. Photograph of Thomas Eakins in the nude, 1884–9. Hirshorn Museum and Sculpture Garden, Smithsonian Institute, Washington, D.C.

Page

32. EDWEARD MUYBRIDGE, *Man Batting Baseball*, from *Animal Locomotion*, 1887. Museum of Modern Art, New York, gift of Philadelphia Commercial Museum.

33. JOHANN ZOFFANY, *Royal Academicians in the Life School at Somerset House*, 1772. The Queen's Collection.

33. SYLVIA SLEIGH, *Philip Golub Reclining*, 1971. Private Collection, New York.

57. *Kouros, c.* 560 B.C. British Museum, London.

57. *Kouros, c.* 520 B.C. British Museum, London.

58. *The Strangford Apollo, c.* 490 B.C. British Museum, London.

58. Roman copy after Praxiteles, *Apollo with a Lizard, c.* 350 B.C. Vatican Museum, Rome.

59. PRAXITELES, *Hermes with the Baby Dionysus, c.* 350 B.C. Olympia Museum, Greece.

59. *Silenus with the baby Dionysus*, fourth century B.C. Vatican Museum, Rome.

60. Black-figure vase showing running man, c. 550 B.C. British Museum, London.

60. Red-figure cup with running boy, 525–500 B.C. Ashmolean Museum, Oxford.

60. Cup with athletes, 525–15 B.C. British Museum, London.

61. Cup with man courting a boy, 500–475 B.C. Ashmolean Museum, Oxford.

61. Cup showing orgy, early fifth eentury B.C. Louvre, Paris.

62. *Bearded God* (Zeus or Poseidon), c. 470 B.C. National Museum, Athens.

62. *Reclining God* from the Parthenon (Dionysus or Herakles), c. 440 B.C. British Museum, London.

63. Herm, c. 500–475. Norbert Schimmel Collection, New York.

63. ROMAN. Phallic lamp. Wellcome Library, London.

63. HELLENISTIC. Phallic altar of Dionysus at Delos.

86. MASACCIO, *The Expulsion of Adam and Eve*, 1427–8. Santa Maria del Carmine, Florence.

86. JAN VAN EYCK, *Adam and Eve, c.* 1432. Ghent altarpiece.

87. ITALIAN. *Christ Crucified and The Death of Judas, c.* 420–300. Ivory casket, British Museum, London.

87. MATHIS GRÜNEWALD, *Crucifixion*, 1513–15. Isenheim altarpiece, Colmar.

88. GERMAN. *Death*, sixteenth century. Victoria and Albert Museum, London.

88. LORENZO MAITANI AND WORKSHOP. *Hell, c.* 1310–30. Orvieto Cathedral, Italy.

89. GERMAN. *Plague Christ, c.* 1304. St. Maria in Kapitol, Cologne.

Page

89. ITALIAN. *Christ Showing his Wounds*, fifteenth century. Victoria and Albert Museum, London.

90. GERMAN. *Pietà, c.* 1300. Rheinisches Landesmuseum, Bonn.

90. ITALIAN. *Pietà*, late fifteenth century. Victoria and Albert Museum, London.

91. JACQUES DUBROEUCQ, *Dead Christ*, 1535. Victoria and Albert Museum, London.

91. GIOVANNI BELLINI, *Dead Christ Mourned by the Virgin and St. John, c.* 1465. Brera, Milan.

92. ALBRECHT DÜRER, *Self Portrait as the Man of Sorrows*, 1522. Formerly at Bremen, now lost.

93. MICHELANGELO BUONARROTI, *Risen Christ, c.* 1532–3. Royal Library, Windsor.

120. ALBRECHT DÜRER, *Apollo and Diana, c.* 1501–3. British Museum, London.

121. BIANCHI DEI FERRARI, *Daphnis and Chloe*, late fifteenth century. Wallace Collection, London.

121. ALBRECHT DÜRER, *Apollo and Diana, c.* 1505. British Museum, London.

122. DONATELLO *"Attis-Amor," c.* 1440. Bargello, Florence.

122. ANDREA DELLA ROBBIA, *Child with Bagpipes*, late fifteenth century. Victoria and Albert Museum, London.

123. DONATELLO, *David, c.* 1440. Bargello, Florence.

124. PADUAN. *Drawing of Two Nudes Fighting*, late fifteenth century. British Museum, London.

124. ANTONIO POLLAIUOLO, *Hercules and the Hydra, c.* 1460. Uffizi, Florence.

125. FLORENTINE. *Hercules and Antaeus*, late fifteenth century. Victoria and Albert Museum, London.

125. ANTONIO POLLAIUOLO, *Ten Fighting Nudes*, 1460–80. Victoria and Albert Museum, London.

126. LEONARDO DA VINCI, *Anatomical Study, c.* 1492–4. Royal Library, Windsor.

127. PERUGINO, *Apollo and Marsyas, c.* 1495. Louvre, Paris.

127. TITIAN, *Three Ages of Man, c.* 1515. Duke of Sutherland Collection, on loan to the National Gallery of Scotland, Edinburgh.

MICHELANGELO

144. *Dying Captive, c.* 1514. Louvre, Paris.

144. *Struggling Captive, c.* 1514. Louvre, Paris.

145. *Bacchus, c.* 1496–8. Bargello, Florence.

145. *Victory*, 1527–30(?). Palazzo Vecchio, Florence.

146. *Day*, 1521–34. Medici Chapel, San Lorenzo, Florence.

146. *Evening*, 1521–34. Medici Chapel, San Lorenzo, Florence.

147. *Dawn*, 1521–34. Medici Chapel, San Lorenzo, Florence.

147. *Night*, 1521–34, Medici Chapel, San Lorenzo, Florence.

148. Nude Youth from the Sistine Chapel Ceiling, 1508–12. Sistine Chapel, Vatican, Rome.

148. Nude youth from the Sistine Chapel Ceiling, 1508–12. Sistine Chapel, Vatican, Rome.

149. *Awakening Slave*, 1520–23. Accademia, Florence.

150. *Madonna of the Stairs, c.* 1491. Casa Buonarroti, Florence.

150. *Madonna and Child* (detail), 1521–34. Medici Chapel, San Lorenzo, Florence.

151. *Rondanini Pietà*, 1555–64. Castello Sforzesco, Milan.

168. GIOVANNI BOLOGNA, *Mercury, c.* 1576. Bargello, Florence.

168. GIOVANNI BOLOGNA, *Apollo, c.* 1573–5. Palazzo Vecchio, Florence.

169. ROSSO FIORENTINO, *Moses Defending the Daughters of Jethro, c.* 1523. Uffizi, Florence.

169. CARAGLIO, after Rosso Fiorentino, *Pluto*, 1526. British Museum, London.

170. JACOPO PONTORMO, *Nude Self-Portrait, c.* 1525. British Museum, London.

171. JACOPO PONTORMO, *Nude Boy, c.* 1520. Uffizi, Florence.

171. JACOPO TINTORETTO, *Seated Nude*, 1575–81. Victoria and Albert Museum, London.

172. ROSSO FIORENTINO, *Dead Christ*, 1530–40. Louvre, Paris.

172. EL GRECO, *Laocoön, c.* 1610. National Gallery of Art, Washington, D.C., Samuel H. Kress Collection.

173. AGNOLO BRONZINO, *Andrea Doria as Neptune, c.* 1550–55. Brera, Milan.

173. AGNOLO BRONZINO, *Grand Duke Francesco I dei Medici as Orpheus*. Philadelphia Museum of Art, gift of Mrs. John Winterstein.

174. Engraving after Primaticcio, *Nymph Mutilating a Satyr, c.* 1543–4. Bibliothèque de L'Ecole des Beaux-Arts, Paris.

174. AGNOLO BRONZINO, *Venus, Cupid, Folly and Time*, 1545. National Gallery, London.

175. GIOVANNI BOLOGNA, *The Dwarf Morgante*, late sixteenth century. Victoria and Albert Museum, London.

175. Attributed to Juste de Juste, *Acrobat*, late sixteenth century.

195. PETER PAUL RUBENS, *St. Sebastian, c.* 1615. Staatliche Museum, Berlin.

195. PETER PAUL RUBENS, *Andromeda*, 1638. Staatliche Museum, Berlin.

196. PETER PAUL RUBENS, *Venus and Adonis, c.* 1615. Hermitage, Leningrad.

196. PETER PAUL RUBENS, *Venus Lamenting the Dead Adonis, c.* 1612. British Museum, London.

197. PETER PAUL RUBENS, *Study of Two Male*

Page

Nudes, David Daniels Collection, New York.

197. GERRIT VAN HONTHORST, *St. Sebastian*, c. 1623. National Gallery, London.

198. GIAN LORENZO BERNINI, *David*, 1623–4. Galleria Borghese, Rome.

198. GIAN LORENZO BERNINI, *Daniel*, 1655–61. S. Maria del Popolo, Rome.

199. JUSEPE DE RIBERA, *St. Bartholomew*, c. 1638. The Prado, Madrid.

200. MICHELANGELO MERISI CARAVAGGIO, *Amore Vincitore*, 1598–9. Staatliche Museum, Berlin.

201. PETER PAUL RUBENS, *Silenus*, c. 1600–08. British Museum, London.

201. LUDOVICO CARRACCI, *Study of a Sleeping Nude Boy*, c. 1585. Ashmolean Museum, Oxford.

202. Studio of Rembrandt, *Male Nude*, c. 1646. British Museum, London.

202. DIEGO VELASQUEZ, *Vulcan's Forge*, 1630. The Prado, Madrid.

203. DIEGO VELASQUEZ, *Mars*, 1639–42. The Prado, Madrid.

220. ANTOINE WATTEAU, Sketch of a Nude Man, c. 1705–9. David Daniels Collection, New York.

220. ANTONIO CANOVA, *Theseus and The Dead Minotaur*, 1781–2. Victoria and Albert Museum, London.

220. MATHIEU COCHEREAU, *Studio of David*, 1814. Louvre, Paris.

221. FRANCOIS BOUCHER, *Study for Apollo*, c. 1753. David Daniels Collection, New York.

221. FRANCOIS BOUCHER, *Venus and Cupid with Doves*, 1754. Wallace Collection, London.

222. Edmé Bouchardon, *Cupid Making His Bow From The Club of Hercules*, c. 1750. Louvre, Paris.

222. ETIENNE-MAURICE FALCONET, *Amour Menaçant*, 1757. Louvre, Paris.

222. CLAUDE-AUGUSTIN CAYOT, *Cupid and Psyche*, 1706. Wallace Collection, London.

22. SIR RICHARD WESTMACOTT, *Achilles*, monument to the Duke of Wellington from the ladies of England, 1822. Hyde Park, London.

223. HORATIO GREENOUGH, *George Washington*, 1840. Smithsonian Institute, Washington D.C.

224. JACQUES-LOUIS DAVID, *Paris and Helen*, 1788. Louvre, Paris.

224. JACQUES-LOUIS DAVID, *The Death of Barra*, 1793. Musée Calvet, Avignon.

225. JACQUES-LOUIS DAVID, *Intervention of the Sabine Women*, 1799. Louvre, Paris.

225. JACQUES-LOUIS DAVID, *Leonidas at Thermopylae*, 1799–1814. Louvre, Paris.

226. JACQUES-LOUIS DAVID, *Marat Assassinated*, 1793. Musée Royaux des Beaux-Arts, Brussels.

227. FRANCOIS GOYA, *Saturn*, c. 1820. The Prado, Madrid.

227. WILLIAM BLAKE, *Nebuchadnezzar*, 1795. Tate

Page

Gallery, London.

246. JEAN-AUGUSTE-DOMINIQUE INGRES, *Oedipus and The Sphinx*, 1808. Louvre, Paris.

247. GUSTAVE MOREAU, *Oedipus and the Sphinx*, 1864. Metropolitan Museum of Art, New York Bequest of William H. Hariman.

247. FRANZ VON STÜCK, *The Kiss of the Sphinx*, c. 1895. Museum of Fine Arts, Budapest.

248. HONORÉ DAUMIER, *The Wrestlers*, c. 1867–8. Ordrupgaard Collection, Copenhagen.

248. GUSTAVE COURBET, *The Wrestlers*, 1853. Museum of Fine Arts, Budapest.

248. THOMAS LAWRENCE, *Satan Calling his Legions*, late eighteenth century. Royal Academy, London.

249. THÉODORE GÉRICAULT, *Study of Two Severed Legs and an Arm*, c. 1819, Musée Fabre, Montpellier.

249. THÉODORE GÉRICAULT, *The Raft of the Medusa*, 1819. Louvre, Paris.

250. EDUOARD MANET, *Dead Christ with Angels*, 1864. Metropolitan Museum of Art, New York, H. O. Havemeyer Collection.

251. EDGAR DEGAS, *Young Spartan Girls Provoking the Boys*, 1860. National Gallery, London.

251. THOMAS EAKINS, *The Swimming Hole*, 1883. Fort Worth Art Museum, Texas.

252. HONORÉ DAUMIER, *The Bathers*, C. 1852. Glasgow Art Gallery, Burrell Collection.

252. GEORGES SEURAT, *Bathers, Asnières*, 1884. National Gallery, London.

253. PAUL CÉZANNE, *The Bather*, 1885–7. Museum of Modern Art, New York, Lillie P. Bliss Collection.

253. PAUL CÉZANNE, *Male Bathers*, c. 1875–80. Whereabouts unknown.

254. THOMAS EAKINS, *Salutat*, 1898. Addison Gallery of American Art, Phillips Academy, Andover, Massachussetts.

255. AUBREY BEARDSLEY, *The Lacedaemonian Ambassadors* from *Lysistrata*, 1896.

255. ERIC ROBERTSON, *The Artist and his model*, 1911. David Daniels Collection, New York.

276. AUGUST KATTENTRIDT, *Nude Athlete*, c. 1910. Shepherd Gallery, New York.

276. FRANZ METZNER, *The Victor*, early twentieth century, Shepherd Gallery, New York.

276. GEORG KOLBE, *The Dancer*, c. 1914. David Daniels Collection, New York.

276. JOSEF THORAK, *Monument to the Freedom of Danzig*, 1943. From *Grosse Deutsche Kunstansstellung*, 1943.

277. WILHELM LEHMBRUCK, *Standing Nude*, 1913. Museum of Modern Art, New York, gift of Abby Aldrich Rockefeller.

342

Page
277. OSSIP ZADKINE, *Memorial to The Ruined City of Rotterdam*, 1953–4.
278. ERNST KIRCHNER, *Artillerymen*, 1915. Museum of Modern Art, New York, gift of Mr. and Mrs. Morton, D. May.
278. "REVUE DES POUX" from A. Favier, *Buchenwald Sketches*, 1944. Wiener Library, London.
279. JOHN KANE, *Self-Portrait*, 1929. Museum of Modern Art, New York, Abby Aldrich Rockefeller Fund.
280. EGON SCHIELE, *Self-Portrait*, 1910. Albertina, Vienna.
280. FRANCISCO LÓPEZ, *Male Nude*, 1973. Galerie Herbert-Meyer-Ellinger, Frankfurt.
281. ALICE NEEL, *T.B., Harlem*, 1940. Collection of the artist.
282. LEONARD BASKIN, *Mythic Warrior*, 1962. Collection of H. Shickman, Delphic Arts.
282. GERMAINE RICHIER, *The Devil With Claws*, 1952. Museum of Modern Art, New York, Wildenstein Foundation Fund.
283. OTTO GREINER, *Prometheus*, 1909. Shepherd Gallery, New York.
283. RENÉ MAGRITTE, *The Ocean*, 1943. Brook St. Gallery, London.
284. GEORGE BELLOWS, *Study of a Nude Male Model*, c. 1910. Private collection, New York.
284. EDWARD MELCARTH, *Study of a Male Nude*. David Daniels Collection, New York.
285. CHARLES BEAUCHAMP, *Laureano*, 1974. Gimpel fils, London.
285. DAVID HOCKNEY, *Gregory Standing Nude*, 1975. Kasmin Limited, London.
285. BARRY FLANAGAN, *David*, 1973. Private collection, New York.
286. LARRY RIVERS, *Joseph*, 1954. David Daniels Collection, New York.
287. HANS BELLMER, *Prenatal Education*, 1955.
287. PABLO PICASSO, Drinking Minotaur and Reclining Woman, 1933.
307. BARON VON GLOEDEN, Sicilian Youths, 1880s.
307. THOMAS EAKINS, Nude Study for Arcadia, 1883. Metropolitan Museum of Art, New York. David H. McAlpin Fund.
307. NICKOLAS MURAY, Bernarr McFadden in classical pose, early twentieth century.
308. Arnold Schwarzenegger posing as Mr. Olympia.
308. Arnold Schwarzenegger as Mr. Olympia.
309. *Viva*, male pinup, 1974.
309. *Viva*, male pinup, 1974.
309. Photograph in London *Evening Standard* of boxers John Conteh, Bunny Johnson and George Francis, 1975.
310. JIM FRENCH, nude study, 1970s.
311. JIM FRENCH, nude study, 1970s.
311. JIM FRENCH, nude study, 1970s.
312. JIM FRENCH, nude study, 1970s.
313. TOM OF FINLAND, *The Men*, 1960s.
322. MARY CASSATT, *Mother and Boy*, 1901, Metropolitan Museum of Art, New York, bequest of Mrs. H. O. Havemeyer.
323. SUZANNE VALADON, *The Nets*, 1914. National Museum of Modern Art, Paris.
323. ANNA LEA MERRITT, *Love Locked Out*, 1884. Tate Gallery, London.
323. HARRIET HOSMER, *Sleeping Faun*, mid-nineteenth century, Iveagh House, Dublin.
324. ALICE NEEL, *Andy Warhol*, 1970. Collection of the artist.
324. ALICE NEEL, *John Perreault*, 1972. Collection of the artist.
325. ALICE NEEL, *Joe Gould*, 1933. Private collection, New York.
326. SYLVIA SLEIGH, *The Turkish Bath*, 1973.
326. MARTHA EDELHEIT, *View of the Empire State Building from Sheep Meadow*, 1970–2.
327. CONNIE GREENE, *George K*, 1974.
327. CONNIE GREENE, *John J*, 1974.
328. AUDREY FLACK, *Michelangelo's David*, 1971. Private Collection, New York.
328. AUDREY FLACK, *Davey Moore*, 1960s, Collection of the artist.
329. Gillian Denby, Untitled, 1975.
330. NANCY GROSSMAN, *Portrait of A.E.*, 1973.
330. EUNICE GOLDEN, *Purple Sky*, 1969–70.
330. MARTHA EDELHEIT, *DX2*, 1969–71.
331. ANITA STECKEL, *Feminist Peep Show*, 1970s.
331. GREEK. Vase showing naked woman carrying a giant phallus, fifth century B.C. Staatliche Museum, Berlin.

343

INDEX

Page numbers given in *italic* type indicate illustrations.

Achilles, 41, 44, 232, 236
Achilles (Wellington monument), 205, *223*
Acrobat (Juste de Juste), *175*
Actaeon, 40
Adam, 66, 79, 94, 108
Adam (Michelangelo), 128, 131, 135
Adam and Eve (Cranach), 108
Adam and Eve (Della Quercia), 108
Adam and Eve (Dürer), 108
Adam and Eve (Raphael), 108
Adam and Eve (Tintoretto), 108
Adam and Eve (van der Goes), *28*, 108
Adam and Eve (van Eyck), *86*, 109
Adonis (Rubens), 15
Adrian VI, Pope, 83
advertising, nudity in, 11, 257, 291–2
Aegina, temple at, 38
Aeneas fleeing from Troy (Bernini), 179
Aeschylus, 50
aging body: attitudes to, 10–11, 105–6; Greek, 39, 45–6, 55; Michelangelo and, 131, 140–1; mannerists and, 153
Alberti, Leon Battista, 96, 99, 101–2, 107
Alcibiades, 57
Alexander the Great, 50–1, 52
Amazons, 15, 41–2, 55–6
Ammanati, Bartolommeo, 83
Amore Vincitore (Caravaggio), 187, *200*
Amour Menaçant (Falconet), 210, 222
Anatomical Study (Leonardo), *126*
Anatomical Study of a Man (Leonardo), *30*
Anatomical Study of a flayed man (Stubbs), *30*
Anchises, 176
Andrea del Sarto, 158
Andrea Doria as Neptune (Brozino), 163, *173*
Andreas, John de, 262
androgyny, 15, 54, 114, 117–18, 166, 191, 241–2, 244

Andromeda (Rubens), 180, 182, *195*
Anguissola, Sofonisba, 134
Antaeus, Hercules and, 114, *125*
Antinous, 50
Antonioni, Michelangelo, 292
Aphrodite, *20*, 34, 39, 40, 52–3; birth of, 41
Aphrodite of Knidos (Praxiteles), 39, 40
Apollo, 14, 50; symbolism of, 34, 37, 39–40, 50; on temple of Zeus, 38; phallus, 44; homosexuality of, 47; Christ and, 78–82
Apollo (Belvedere), 12–13, 51, 96, 106, 143, 179, 194, 205, 212
Apollo (Bologna), *168*
Apollo (Strangford), 37, *60*
Apollo and Daphne (Bernini), 178–9
Apollo and Diana (Dürer), 12, 105–6, *120, 121*
Apollo and Marsyas (Perugino), 100, 127
Apollo visiting the forge of Vulcan (Velasquez), 191, *202*
Apollo with Lizard (Praxiteles), 53, *60*
archaeological discoveries, 96–7
Aretino, Pietro, 84, 135, 153, 160, 165
Aristophanes, 47
Arp, Jean, 256
art, Western: formative periods, 7–8; classic nude in, 12, 35–49 *passim*; late Greek, 49–58 *passim*; Christian, 69–85 *passim*; Renaissance, 95–119 *passim*; Mannerist, 152–67 *passim*; Baroque, 176–94 *passim*; rococo, 204–19 *passim*; nineteenth century, 228–45 *passim*; modern, 256–75 *passim*; women in, 314–21 *passim*
art training, 7, 16, 153–4, 166, 178, 193, 315
Artemis, 39
Artillerymen (Kirchner), 266, *278*
Artist and his Model (Robertson), *255*
asceticism, 68–9, 107; *see also* martyrs
Atalanta, 41

Athene, 40, 41
Athens, civilization in, 35, 43, 49
athletics: Greek, 42–3, 44, 54; language of, 68; in Nazi Germany, 259–60
Atlas, Charles, 293
Attis-Amor (Donatello), 115, 122
August Blue (Tuke), 240
Awakening Slave (Michelangelo), *149*

Bacchus (Michelangelo), 136, *145*
Bacchus (Velazquez), 191
Bacon, Francis, 272–3
"Ballade des Pendus" (Villon), 70
Balzac (Rodin), 245
Bandinelli, Baccio, 155
Banquet (Xenophon), 44
Barberini, Cardinal, 177, 315
Barlach, Ernst, 259
Baroque art, 176–94 *passim*; illustrations, 195–203
Barra, Joseph, 214, *224*
Barrocci, 156
Bartolommeo, Fra, 82–3
Baskin, Leonard, 263–4, *282*
Bather (Cézanne), 241, *253*
Bathers, Asnières (Seurat), 239, *252*
Bathers (Daumier), 239, *252*
Bathing Men (Munch), 265
Batman (Richier), 264
Battle of Cascina (Michelangelo), 102, 139
Baudelaire, Charles, 235, 236, 257
Bazille, Frédéric, 239
Bazzi, Giovanni Antonio, 112
Bearded God (bronze), *64*
Beardsley, Aubrey, 245, *255*
beauty: mathematical expression of, 38, 101–2, 104, 109; nature of, 113, 177–8, 236, 258, 299
Beckmann, Max, 267
Bellini, Jacopo, 80, *91*
Bellmer, Hans, 270–1, *286*
Bellori, 180, 187, 192–3
Belvedere Apollo, *see* Apollo Belvedere
Ben Hur, 299
Berger, John, 12, 257, 267; definition of nudity, 12; on

female nudity, 14; on pinups, 290
Bernini, Gianlorenzo, 177–9; 184–5, 186, *198*
Bianchi dei Ferrari, *121*
Big and Butch, 297
Bigger Splash, A, 299
bisexuality, 15, 113, 133, 245
Biton, Kleobis and, 37, 45–6
Black Death, 71
Blake, William, *277*, 230, 241
Blow-up (Antonioni), 292
Blumenthal (fascist), 258
Boccioni, Umberto, 256
bodybuilding, 293–5
Bologna, Giovanni, 152, 153, 164, 166, *168*
Bosch, Heironymous, 72
Botticelli, Sandro, 82, 109–10, 113
Bouchardon, Edme, 209–10, *222*
Boucher, François, 206, 208–9, 216, *221*
Boulanger, 233
Bourdelle, Emile, *22*
Bourges cathedral, 71
Brancusi, Constantin, 261, 262, 268–9
Brando, Marlon, 299
Braque, Georges, 262, 263
Breker, Arno, 260
Bridget of Sweden, 76
Briganti, Giulio, 157
Bronzino, 154, 160, 163, 165, 166, *173*, *174*, 187
Brown, Peter, 43
Browning, Robert, 231, 289
Brücke group, 265
Brucker, Gene, 111
Brunelleschi, 81, 113
Brutus (David), 213, 215
Buchenwald drawings, 268, 278
Burgess, Anthony, 133
Burne-Jones, Edward, 243
Byzantine art, 73, 79, 156

camp, 189, 243, 298
Canova, Antonio, 205, 232
Caraglio, 164, 169
Caravaggio, *25*, 177, 187–92, *200*, 237
Carducho, 192–3
Carpaccio, Vitorre, 95
Carracci, Annibale, 176
Carracci, Ludovico, 176, *201*
Carriera, Rosalba, 206
Cascina, battle of, 102, 139
Cassat, Mary, 315, *322*

Castiglione, Baldasare, 113, 163–4
castration: fears of, 14, 104, 141, 190, 270; symbolic, 40, 84–5; ascetics and, 69; of a satyr, 166, *174*
Catherine of Siena, 76
catholicism, *see* Roman Catholicism
Cavalcanti, Giovanni, 112
Cavalieri, Tommaso, 134, 140
cave art, 9, 264
Cellini, Benvenuto, 84, 111, 155, 164
Cennini, Cennino, 101
Cézanne, Paul, 228, 240–1, *253*, 315
Chamberlain, Wyn, 264
Charles V (Leoni), 163
Charles V (Titian), 165
Christ, 263, 267; crucified, 7, *23*, 69, 72–8, 143; nakedness of, 13, 66, 73, 82, 131, 140, 159; as a child, 115, 132, 141–2; in Baroque art, 177, 190
Christ Crucified, 23
Christ in Limbo (Bronzino), 154
Christ Mocked (Manet), 229, 237
Christ Showing his Wounds, 89
Christian art, 69–85 *passim*
Christianity, 66–85 *passim*; attitude to sex, 9–10, 11; attitude to nudity, 34, 67, 82–3; dualism of, 50, 67; and homosexuality, 111–12; Michelangelo and, 129; *see also* martyrs, Roman Catholicism
Cima da Conegliano, 82
Cimabue, 73
Clark, Kenneth, 10, 11, 34, 108, 110, 119; definitions of nudity, 12–13; on Greek nudes, 36; on Rubens, 180–1; on Caravaggio, 189
Cleopatra, 96
Clodion (Claude Michel), 209
Clytemnestra, 41
Cochereau, 220
Cockade, 288
codpieces, 165
Cohn, Norman, 75
Colonna, Vittoria, 80, 133–4
Colossus, The (Goya), 219
Concert Champêtre, 110
Condivi, 135
Conversion of St. Paul, The

(Michelangelo), 131
Cooper, Andrew (III), 303
Cooper, Henry, 291
Corday, Charlotte, 214, 215
Correggio, Antonio, 181
Cosmopolitan, 300–1
Courbet, Gustave, 237, 238, *248*
Cranach, Lucas, 108, 181
crucifixion, 67, 71, 72–8
Crucifixion (Grünewald), 74, 82, 87
Crucifixion (Michelangelo), 10
Crucifixion (Picasso), 267
Crucifixion (Rubens), 185
Crucifixion and the Death of Judas, The, 73, 87
cubism, 256–7, 261–2
Cupid, 82, 114–16, 138, 187; in rococo, 209–11
Cupid and Psyche (Cayot), 210, *222*
Cupid and Psyche (Gérard), 217
Cupid making his bow . . . (Bouchardon), 209, *222*

Dx2 (Edelheit), 319, *330*
Dali, Salvador, 262, 270
Dancer (Kolbe), *276*
Dances of Death (Holbein), 71
Daniel, 68; by Bernini, 186, *198*
Dante Aligheri, 72
Danti, Vicenzo, 164
Daphnis and Chloë (Bianchi dei Ferrari), *121*
Daumier, Honoré, 236, 238, 239, *248*, 252
Davey Moore (Flack), 319, *328*
David, 14, 95, 114, 117
David (Bernini), 177, 179, 186, *198*
David (Donatello), 95, 106, 116–17, *123*
David (Flanagan), 273, *284*
David (Michelangelo), 8, *21*, 99, 133, 138–9, 155
David (Verrochio), 116
David and Goliath (Caravaggio), 191
David, Jacques Louis, 212–19, *220*, 228
David's Studio (Cochereau), *220*
da Vinci, Leonardo, *see* Leonardo
Dawn (Michelangelo), 14, *147*
Day (Michelangelo), 141, *146*
Dead Christ (Dubroeucq), *91*
Dead Christ (Mantegna), *23*, 97
Dead Christ mourned by the

Virgin and St. John (Bellini), 80, *91*
Dead Christ with Angels (Manet), 228, 237, *250*
Dead Christ With Angels (Rosso), 81, 159, 160, *172*
death: Greek attitude to, 38–9, 44–5; Christian attitudes to, 68–71; Renaissance attitudes to, 103; war and, 265; illness and, 274
Death, 24, 88
Death of Adam (della Piero Francesca), 95
Death of Narcissus (Dali), 262
Degas, Edgar, *21*, 237, *251*
Déjuner sur l'herbe (Manet), 229, 237
Delacroix, Eugène, 233
Delphi, 37, 43
Delvaux, Paul, 263
de Medici, *see* Medici
Demoiselles d'Avignon (Picasso), 261–2
Denby, Jillian, 317, 319, *329*
Denis, Mauric, 256
Deposition (Beckmann), 267
Depths of the Sea, The (Burne-Jones), 244
Derain, André, 263
Descent from the Cross (Rubens), 185
D'Este, Duke Alfonso, 135
D'Este, Isabella, 16, 97, 100
Devil with Claws (Richier), 264, *282*
Diane de Poitiers, 16, 163
Diderot, Denis, 205, 207, 211
Dine, Jim, 268
Diocletian, Emperor, 81
Dionysus, 41–2, 53, 55, 57, *61, 64, 65*
Diotima, 49
Disasters of War (Goya), 268
discus thrower (Myron), 38
dissection, 103–4
Dodds, E. R., 68
Donatello, 106, 108, 115–18, *122*
Doria, Andrea, 163, *173*
Doryphoros, 37–8
Drinking Minotaur and Reclining Woman (Picasso), 286
Dubroeucq, Jacques, *91*
Dubuffet, Jean, 264
Duchamp, 262
Dürer, Albrecht, 12, *19*, 79, *120, 121*, 162; drawings of Christ, 75; self-portraits, 19, 92, 96,

104–5, 161; anatomical studies, 101, 102–6
Dying Captive (Slave) (Michelangelo), 136, 138, *144*

Eakins, Thomas, 17, *32*, 238–40, *251, 254, 307*
Edelheit, Martha, 319–20, *326, 330*
Eissler, R. H., 104
Elevation of the Cross (Rubens), 183
Endymion (Girodet), 217
Entombment (Caravaggio), 189
epicurean cult, 52
Erasmus, 183
Eros, 46, 53, 115
Eros (Praxiteles), 53
eroticism in art, 11, 14, 54, 57; Christian, 81, 84–5; Renaissance, 95ff, 108, 113, 134; mannerist, 157–8, 165; Baroque, 177–8; rococo, 206–7, 214; nineteenth century, 232, 234; modern, 268–71; magazines, 288–306
Euripides, 49
Eve, 66, 79, 94, 108; *see also* Adam
Evening (Michelangelo), 141, *146*
exhibitionism, 164, 321
Exposure, 288
Expressionist artists, 315, 316
Expulsion from Paradise (Masaccio), 66, 86

Fabriano, Gilio da, 154
Fairbanks, Douglas, 299
Falconet, Etienne-Maurice, 209–10
Fallen Warrior (Lehmburck), 263
Family, The (Schiele), 272
fantasies, sexual, 11, 16, 116–17, 167, 219, 228, 268, 297, 305–6, 318
Farnese Gallery, 176
Farnese Harakles, 52
Farrer, Reginald, 265–6
Fascinus, 9, 58
fashion, 13, 95, 164–5, 204–5, 206–7
Faviev, A., 268, 278
feminism, 18, 291, 300–1, 306
Feminist Peepshow (Steckel), 317, *331*
Ficino, 112
Fight Censorship group, 316–17

Figures Walking into the Sea (Kirchner), 265
Flack, Audrey, 318–19, *328*
flagellation, 73, 75, 80, 183, 218, 298
Flanagan, Barry, 273, *284*
Flaxman, John, 217
Floris, 155
Flugel, J. C., 204
Fonda, Jane, 299
Fontainebleau, decoration of, 160, 166–7
Fourment, Hélène, 181–2
Fréminet, 155
French, Jim, 298, *310, 311, 312*
French Revolution, 215–16, 233
Freud, Sigmund, 11, 116
Fuseli, Henry, 232–3
Fussell, Paul, 265

Gabor, Mark, 296
Galen, 104
Ganymede, 14, *27*, 46–7, 134, 192
Ganymede with Jupiter as the Eagle (Thorwaldsen), *27*
Gauguin, Paul, 242
genitals, fear of, 84–5, 104, 162; female, 269–70; *see also* penis
Gentileschi, Artemisia, 314
George K (Greene), 319, 327
George Washington (Greenough), *223*
Gérard, Baron François, 217
Géricault, Theodore, *31*, 233–4, *249*
Ghiberti, Lorenzo, 83, 96, 98, 113
Ghirlandaio, Domenico, 129
Giacometti, Alberto, 264
Gilio da Fabriano, 183
Giorgione, 8, *21*, 110
Gill, Eric, 269
Giotto, 72
Girardon, François, 194
Girodet de Roucy-Troson, Anne Louis, 217
Gloeden, Baron de, 289, *307*
gnosticism, 68
gods and goddesses, 35–42, 56, 178, 206; *see also* Olympus
Goebbels, Joseph, 260
Golden, Eunice, 317–18, *330*
Goliath, 117, 177, 190
Goltzius, Hendrik, 155
Gombrich, E. M., 152
Gosse, Edmund, 289
Gothic art, 13, 263

Goya, Francisco, 218–19, *227*, 268
Graf, Urs, 165
graffiti, 264
Great American Nudes (Wesselman), 264
Great Dead Man (Baskin), 263
Greco, El, 156, 162, *172*
Greek art, 7–9, 11, 16, *19*, 24, 35; nudity in, 34–58 *passim*, 205, 256, 261; illustrations, 59–65; vase painting, 35–6, 317, *331*
Greene, Connie, 317, 319, *327*
Greenough, 223
Greer, Germaine, 301
Gregory of Tours, 82
Gregory Standing Nude (Hockney), *284*
Greiner, Otto, 263
Grossman, Nancy, 318, *330*
Grosz, Georg, 259
Grünewald, 74, 80, 87, 267
Guernica (Picasso), 267

Hadrian, 50
Hair, 11
Hamilton, Richard, 264
Hartt, Frederick, 118
Hawthorne, Nathaniel, 229
Hell (Orvieto cathedral, Maitani), 88
Hefner, Hugh, 292
Hera, 37, 39, 40
Herakles, 39, 41, 47–8, 52, *64*, 79; *see also* Hercules
Hercules (Herakles), 9, 13, 96, 98, 113, 114, 118–19, 194, 263
Hercules (Bandinelli), 155
Hercules (Bourdelle), *22*
Hercules (Canova), 232
Hercules (Pollaiuolo), 95
Hercules (Sant'Agato), *22*
Hercules and Antaeus (Pollaiuolo), 114
Hercules and Antaeus (Mantegna), 114, 125
Hercules and Omphale (Spranger), 167
Hercules and the Hydra (Pollaiuolo), *124*
Hermaphrodites, 15, 53–4, 56, 96, 98, 113, 242, 245
Hermes, 38, 236
Hermes holding Dionysus (Praxiteles), 53, 55, *61*
herms, 9, 57, *65*, 262
Herodotus, 37

Hildebrand, Adolf, 258
Him, 297
"Histoire Ancienne" (Daumier), 236
History of the Pinup (Gabor), 296
Hitler, Adolf, 259–60
Hockney, David, 273, *284*, 299
Holbein, Hans, 71
Holy Family (Michelangelo), 132
Homeric legends, 39, 43–4, 45; Flaxman's illustrations to, 217
homosexuality, 10, 14, 82; in classical Greece, 14, 34, 36, 40, 46–8, 49, 53, *63*; Renaissance, 111–14; of Michelangelo, 133–5; Baroque, 188–9; rococo, 217–18; in nineteenth century, 14–15, 240–3; in twentieth century, 269, 273; pinups and, 288, 296–8, 302
Honor triumphing over Falsehood (Danti), 164
Honthorst, Gerrit van, *197*
Hosmer, Harriet, 315, 323
Houbraken, Arnold, 192
How to Improve Your Man in Bed (Barber), 297
Huizinga, J., 71
humanists, 79, 98–9, 100

ignudi, 136–7, 143, 176, 192
incest, 78, 133, 166, 245
Ingres, Jean August, 239, 244, *246*, 319
Intervention of the Sabine Women (David), 216, *225*, 228
Ipousteguy, 270
Isaac (Ghiberti), 113–14
Isenheim altarpiece, 74, 82
Ixion (Ribera), 177

Jackson, Glenda, 299
Jagger, Mick, 300
Jeremiah (Donatello), 106, 117
Jerome (Leonardo), 106, 154
Joe Gould (Neel), 320, *325*
John J (Greene), *327*
John the Baptist (Rodin), 245 (see also St. John)
Jones, Allen, 264, 318
Joseph (Rivers), *286*
Joseph in Egypt (Pontormo), 160
Judgment of Paris: by Rubens, 181; Nazi theme, 260
Julian of Norwich, 76–7
Julius II, Pope, 131, 136, 138
Jupiter's seduction of Callisto (Boucher), 209

Juste de Juste, 167, 175

Kameraden (Breker), 260
Kandinsky, Wassily, 259
Kane, John, 274, *279*
Kattentridt, August, 258, 276
Kauffman, Angelica, 16, 207, 314–15
Kelso, Ruth, 107
King of Kings (Brancusi), 262
Kirchner, Ernst, 265–6, *278*
Kiss, The (Brancusi), 262
Kiss of the Sphinx, The (von Stücke), *247*
Kleobis and Biton, 37, 45–6
Knave, 288
Kneeling Boy (Minne), 245
Knipping, John, 186
Kolbe, Georg, 258, *276*
Kollwitz, Käthe, 259
kouroi, 37, 59, 262
Kouros in Nine Parts (Noguchi), 262
Kronhausen exhibition, 269

L.A. Advocatel, Giulia, 314
landscapes, 100, 110
Lane, John, 245
Lanfranco, Giovanni, 189
Laocoön, 56, 96, 140, 186, 212
Laocoön (El Greco), 156, *172*
Lapiths, 38, 41
Last Judgment, 71–2
Last Judgment (Michelangelo), 84, 131, 140, 155–6
Last Tango in Paris, 299
Lawrence, D. H., 17
Lawrence (artist), *248*
Leburn, Charles, 194
Leda and the Swan (Leonardo), 110
Leda and the Swan (Michelangelo), 135–6
Léger, Fernand, 257, 266
Lehmann (fascist), 258
Lehmbruck, Wilhelm, 263, *277*
Leighton, Lord, 242
Leonardo da Vinci, 30, 95, 117–18, 138, 155; self-portraits, 96; athlete in squared circle, 101; anatomical studies, 102–4; attitude to nudity, 106; attitude to women, 110, 112
Leoni, Leone, 163
Leonidas at Thermopylae (David), 216, *225*
Lepeletier (David), 212, 215
Levey, Michael, 208, 210

Levine, Tomar, 317
Lisiewska-Therbusch, 207
Lives of the Artists (Vasari), 84
Lomazzo, Giovanni, 154
Lopez, Francisco, 273, 280
Lorenzo di Credi, 83
Love Locked out (Merritt), 323
Loyola, Ignatius, 185, 186
Lucian, 40
Lysippos, 50–2, 53
Lysistrata, 245, *255*

McFadden, Bernarr, 293, *307*
Madonna and Child
 (Michelangelo), 142, *150*
Madonna dei Palafrenieri
 (Caravaggio), 190
Madonna of the Stairs
 (Michelangelo), 141–2, *150*
Madonna with Saints John and
 Jerome (Parmigianino), 154
Maenad (Skopas), 55
Magritte, René, 270, 283, 318
Maitani, Lorenzo, 71, *88*
*Male and Female Models on a
 Cast Iron Bed* (Pearlstein), *29*
Male Bathers (Cézanne), *253*
Male Nude (Degas), *31*
Male Nude (Géricault), *31*
Male Nude (Lopez), *280*
Male Nude (studio of
 Rembrandt), *202*
Male Nude (Watteau), *220*
Male Nudes (Rubens), *197*
male strippers, 17
Mâle, Emile, 74, 186
Maillol, Aristide, 263
Man Batting Baseball
 (Muybridge), *32*
Man Date, 288
Manet, Edouard, 229, 236–7,
 250
Mannerist art, 152–67 *passim*,
 illustrations, *168–75*
Man Ray, 269
Mantegna, Andrea, *23*, 82, 95,
 97–8, 100, 115
Marat, Jean Paul, 212, 214–15,
 217
Marat Assassinated (David),
 214–15, 218, *226*
Marble Faun (Hawthorne), 229
Marcks, Gerhard, 258
Marcus, Steven, 230
Margery of Kempe, 77–8
Marisol, 262
Mars (Botticelli), 113
Mars (Velasquez), 192, *203*

Mars and Venus (Botticelli), 110
Marsyas, 56, 100, *127*, 184
Martial, 50
martyrs, 14, 56, 68–70, 97, 179,
 183–7
Martyrdom of St Sebastian
 (Pollaiuolo), 113–14
Mary (mother of Christ), 79, 80,
 132–3; *see also* Madonna
Mary Magdalen, 77; by
 Donatello, 117
Masaccio, 66, *86*, 95
masochism, 10, 75, 179, 244,
 271, 298, 306
masturbation, 56, 230, 241, 269,
 271, 290, 296
Mazeppa (Byron), 233
Mazza, Damiano, *26*
Medici, 157, 160–2; Francisco
 de, 166, *173*; Lorenzo de, 129,
 139; Marie de, 16
Medici Chapel, 141, 142, *146*,
 147, *150*
Melcarth, Edward, *284*
Melville, Robert, 270
Memorial to the Ruined City of
 Rotterdam (Zadkine), *277*
Men Only, 288
Mercury (Bologna), 152, 168
Merritt, Anna Lea, 323
Messina, Antonio da, 82
Metzinger, Jean, 261
Metzner, Franz, 258, *276*
Michelangelo, 79, 99, 102–3,
 155, 162, 181; nudes of, 7–8,
 16, 83, 95, 109, 268; Cruci-
 fixion, 10, 80; pietà, 78, 140–2;
 Risen Christ, 81, 84, *93*; attitude
 to his work, 111, 137–8; and
 homosexuality, 112, 133–5;
 themes of work, 128–9; brief
 biography, 129–31; family
 feeling, 130–3; female nudes
 of, 135–6; Rudkin on, 231;
 illustrations, *93*, 144–51
 passim
Michelangelo's David (Flack),
 318–19, *328*
Milo of Croton (Puget), 177
Mirandola, Pico della, 112
Mister International, 297
modern art, 256–75 *passim*
Monument to the Freedom of
 Danzig (Thorak), 260, *276*
Moore, George, 316
Moore, Henry, 268
Moreau, Gustave, 244, *247*
Morgante (by Bologna), 166, *175*

Morrison, Jim, 300
Moser, Mary, 16
*Moses Defending the Daughters
 of Jethro* (Rosso), 159, *169*
mother: as woman, 14, 41, 271;
 symbolism of, 15, 141, 190,
 231; influence on sons, 42,
 129
Mother and Boy (Cassat), 315,
 322
Mulready, William, 231
Munch, Edvard, 265
Murillo, Bartolomé Estebán, 183
Muybridge, Edweard, *32*
Myron, 38
Mystery cults, 42, 50, 52, 67
mysticism, 101, 185, 241, 243
Mythic Warrior (Baskin), *282*

nakedness, defined, 10–12; *see
 also* nudity
Naked Self-portrait (Dürer), 12,
 19, 105, 161
Nano di Banco, 98
Napolas, 259
Napoleon (Canova), 205
Napoleon, Emperor, 216–17, 218
Narcissus, 13, 113, 114, 116–18,
 194, 236
Narcissus (Poussin), 194
narcissism, 42, 45, 135, 245,
 271; bodybuilding and,
 274–5
Nazi movement, art and,
 258–60, 297
Nebuchadnezzar (Blake), 227,
 230
necrophiles, 70
Neel, Alice, 274, 281, 320–1, *324*
Negro sculpture, 261, 263
Nemser, Cindy, 269
neoclassicism, 217–19, 232, 315
neo-platonism, 79, 109, 112, 116
Nesbitt, Lowell, 273
Nets, The (Valadon), 316, *323*
Nicholson, Jack, 299
Night (Michelangelo), 136, 141,
 147
nineteenth-century art, 228–45;
 illustrations, 246–55
Niobe, 38
Noah, 131
Noble Savage, 205, 218, 242,
 261, 263
Nochlin, Linda, 18, 275, 319
Noguchi, 262
Novarro, Ramon, 299
Nude, The (Clark), 10

Nude Athlete (Kattendrit), *276*
nude battles, 119
Nude Boy (Pontormo), 171
Nude Boxers, *309*
Nude Male (Bellows), *284*; *see also* Male Nudes
Nude pinups, *307–13*
Nude Study for Arcadia (Eakins), 307
Nudes Fighting, 119, *124*
nudity: general, attitudes to, 10–12, 257; in Greek art, 35–56 *passim*; in Christianity, 66–85 *passim*; in Renaissance art, 94–119 *passim*; in Mannerist art, 152–67 *passim*; in Baroque art, 176–94 *passim*; in rococo, 204–19 *passim*; in nineteenth century, 228–45 *passim*; in modern art, 256–75 *passim*
nudity, female, 7–8, 12–13, 17; in Greek art, 11, 57; in Renaissance art, 94, 128; in Baroque art, 178, 180–1; in rococo, 204, 206, 208; in nineteenth century, 228; in modern art, 262, 269, 316; *see also* women
nudity, male, 7–8, 12–13; symbolism of, 8; Greek, 44–5, 48–50, 55–8; Michelangelo and, 128–43 *passim*; in nineteenth century, 228; *see also* male nudes
Nurmi, Paavo, 259
Nymph Mutilating a Satyr (after Primaticcio), 166, *174*

Oath of the Horatii (David), 212, 215
obscenity laws, 268–9, 297
Ocean, The (Magritte), 270, 283
Oedipus and the Sphinx (Ingres), 244, *246*
Oedipus and the Sphinx (Moreau), *247*
old age, *see* aging body
Oldenberg, Lkaus, 269
Olympia, 38–9, 43
Olympia (Manet), 229, 237
Olympic games, 43, 259
Olympus, 50, 160, 165, 176; *see also* Gods and Goddesses
Omphale, 167
Oresteia, 41
orgasm, 68, 136, 185, 230, 292
Orphic cults, 50

Osen, Dom (Schiele), 271

Pacioli, Luca, 100
paleolithic figurines, 8–9
Pan and Syrinx (Boucher), 209
Panofsky, Erwin, 95, 98, 100–1, 110
Paperweight for Priapus (Man Ray), 269
Paris and Helen (David), 214, *224*
Parmigianino, Francesco, 153–4, 161, 165, 187, 190
Parthenon, 38
pastoral art, 100, 239; *see also* landscapes
Pater, Walter, 243
Pearlstein, Philip, *29*, 274, 275
Pechstein, Max, 265
Peeping Tom, 292
penis, 8, 14, 57, 104, 165, 166, 211, 244–5, 268–71, 296; fears of, 269, 270; *see also* phallus genitals
Penthouse, 288–9, 292
Pergamon, 55–6
Perreault, John, 321, *324*
Persephone, 129
Perseus and Andromeda (Burne-Jones), 243
Perseus and Andromeda (Rubens), 180, 182
Perseus with the Head of Medusa (Cellini), 164
Perugino, 82, 100, *127*
Petty girls, 290
phallic woman, 41–2, 116, 232; *see also* Amazons
phallus: symbolism of, 10, 14, 44–5, 55–8, *65*, 268, 317
Phidias, 38, 53, 187, 205
Philip Golub Reclining (Sleigh), *33*, 314, 317
photography, 236; for homosexuals, 243, 288, 297; effect on art, 261; of war; in erotic magazines, 288–9, 292
Phryne (courtesan), 40
Phyllis and Demophoön (Burne-Jones), 243–4
Picasso, Pablo, 182, 257, 261, 263, 267, 270, *286*
Piero della Francesca, 95
pietà, 78, *90*, 132, 142–3
Pietà (Michelangelo), 78, 159
Pinto, Marion, 317
Pinups, 7, 10, 17, 260, 264, 288–306 *passim*

Pisano, Niccolo, 79
plague, 70–2, 74–5
plague crosses, 74–5, 76, *89*, 267
Playboy, 288–90, 292, 298
Playgirl, 17, 288, 300–1, 305
Playguy, 288
Plato, 44, 47, 49, 67, 112
Pliny, 40, 53, 96, 142
Pluto (Caraglio, after Rosso), 164, *169*, 179
politics: art and, 16, 211, 214–15, 234; athletics and, 43, 259–60; homosexuality and, 47; death and, 71–2
Pollaiuolo, Antonio, 95, 98, 102, 118–19; brothers, 113–14, *124*
Pollitt, J. J., 52
Polykleitos, *20*, 37–8, 51
Polynesian sculpture, 261, 263
Polyphemus, 176, 232
Pomarancia, 183
Pomeroy, Sarah, 40, 53
Pompadour, Madame de, 16, 208, 209–10
Pompeii, 58
Pontormo, 155, 157, 158, 160–2, *170*, *171*
pop art, 264, 269
pornography, 11, 210, 260, 268, 289
Portrait of A.E. (Grossman), 318, *330*
Poseidon, 38, 64
Possevino (Jesuit), 83, 85, 183
Poussin, Nicolas, 177, 193–4
Praxiteles, 39, 50, 53, 205
Prenatal Education (Bellmer), 270
Presley, Elvis, 300
Priam, 45
Priapus, 57, 269
Primaticcio, Francesco, *174*
Princess X (Brancusi), 268
Proby, P. J., 300
Proctor, Patrick, 273
Prometheus, 233
Prometheus (Greiner), 263, *283*
Prometheus (Rubens), 183
propaganda art, 257–60
prostitution, 14, 46
psychoanalysis and psychiatry, 11, 34, 42
Publicity, nudity in, 257, 264
Puget, Pierre, 177
Pumping Iron, 294
Purple Sky (Golend), 318, *330*
putti, 115–16, 161, 210

Pygmalion, 13, 135, 243

Q *International*, 297–8
Quercia, Jacopo della, 79, 84, 94, 108, 112

Raft of the Medusa, The (Géricault), 234, *249*
Ramos, Mel, 264
Ramsden, H. E., 133
rape, 166, 179, 181, 183
Rape of Ganymede, The (after Michelangelo), *26*, 134
Rape of Ganymede, The (Damiano Mazza), *26*
Rape of Ganymede, The (Rembrandt), *27*, 192
Rape of the Daughters of Leucippus (Rubens), 182
Rape of the Sabine, The (Bologna), 153
Raphael, 106, 108, 138, 153, 155
Read, Herbert, 258
Redford, Robert, 299
Redgrave, Vanessa, 299
Reff, Theodore, 241
religion, 156, 162; Greek, 40, 43, 50; eroticism and, 136; mysticism and, 185; *see also* Christianity, Roman Catholicism
Rembrandt van Ryn, *27*, 177, 192, *202*
Renoir, Jean, 231, 315
Republic (Plato), 49
Renaissance art, 7, 9, 13, 14, 94–119 *passim*, 153; influence on mannerists, 155; Christian art during, 69–85 *passim*; view of nature, 109
Reynolds, Burt, 300–1
Reynolds, Sir Joshua, 180, 193
Ribera, José, 177, 184, *199*
Richier, Germaine, 263–4, 282
Richter, Gisela, 35
Riefenstahl, Leni, 259
Risen Christ (Michelangelo), 81, 84, *93*
Rising of the Sun, The (Boucher), 208, *221*
Rivers, Larry, 274, *286*
Rizzo, Antonio, 108
Robertson, Eric, *255*
rock idols, 300–1
Rococo art, 13, 204–19 *passim*; illustrations, 220–7
Rodin, Auguste, 236, 245
Roger de Piles, 185

Rolling Stones, 300
Roman Catholicism, 69, 115, 154, 157, 183, 185
Romano, Giulio, 155, 165
romantic artists, 232–5
Romans, 67, 98, 212; phallic symbols of, 9, 58; attitude to nudity, 49; art of, 51; religion, 73
Rondanini Pietà (Michelangelo), 143, *151*
Rosano, Paul, 317, 319
Rosenblum, Robert, 267
Rossi, Pedro Maria, 165
Rosso, Fiorentino, 81, 156–7, 158–60, 164, *169*
Rousseau, Jean Jacques, 211
Royal Academicans in the Life School . . . (Zoffany), 16, *23*
Rubens, Peter Paul, 13, 15, 16, 67, 177, 179–82, 183, 185–6, 193, *195*, *196*, *197*, *201*, 206
Ruskin, John, 229, 231

Sach, Hanns, 35, 44
sadism, 10, 16, 77–8, 82, 103, 137, 164, 184, 219, 232–3, 292, 306
sadomasochism, 78, 85, 134, 182, 318
St. Agatha, 183
St. Andrew, 183
St. Anne, 190
St. Anthony, 69
St. Bartholomew, 183–4, *199*
St. Basil, 69
St. Bernardino, 107
St. Catherine, 183
St. Clement, 69
St. Francis, 74
St. Jerome, 69, 189
St. John (the Baptist), 14, 80, 113–14, 132, 142, 154
St. John (Leonardo), 106, 117–18
St. John (Veneziano), 113
St. John the Baptist (Caravaggio), *25*, 188, 190–1
St. John Chrysostom, 69, 183
St. Lawrence (Bernini), 179, 183
St. Matthew (Caravaggio), 189, 191
St. Mechtilde, 78
St. Peter, 183
St. Peter baptizing Converts (Masaccio), 95
St. Sebastian, 14, 81–2, 99, 114, 184

St. Sebastian (Mantegna), 95, 97–8
St. Sebastian (Rubens), 183, *195*
St. Sebastian (van Honthorst), *197*
St. Theresa in Ecstasy (Bernini), 184–5
Salmon, André, 261
Salome, 190–1, 244
Salviati, Francesco, 156
Salutat (Eakins), 238, *254*
Salutati (chancellor), 118
Sam, 297–8
Samson, 79, 118
Samson (Bologna), 164
Sandow, Eugene, 293
San Stefano Rotondo, Church of, 183–4
Sant'Agato, Francesco, *22*
Sant'Andrea of Quirinale, 184
Satan Calling His Legions (Lawrence), *248*
Saturn (Goya), 218, *227*
satyrs, *24*, 54, 56, 113, 136, 165–6, 182
Savonarola, 83, 99, 112
Scene d'Eté (Bazille), 239
Schiele, Egon, 271, 280
Schlemmer, Oskar, 258
Schneider, Maria, 299
School of Pan (Signorelli), 100
Schwarzenegger, Arnold, 294, *308*
science, 101–5
Seated Man (Tintoretto), *171*
Sebastiane, 299
Sebastiano del Piombo, 80
Self-portrait (Kane), 274, *279*
Self-portrait (Pontormo), 161, *170*
Self-portrait (Schiele), 271, *280*
Self-portrait as the Man of Sorrows (Dürer), *92*; *see also* Naked Self-portrait
Semele, 41
Setting of the Sun, The (Boucher), 209
Seurat, Georges, 239, *252*
sex: political significance of, 8; Christianity and, 9, 68–9, 153; stereotypes, 15; symbolism of, 39–40, 194, 211; fear of, 229–30; in modern art, 268–73; pinups and, 303–5; *see also* fantasies
Sexuality: female nudity and, 13–14; suppressed, 17–18, 107–14; of women toward

Christ, 76–7; in Mannerist art, 157–8, 159; in modern art, 257, 265; *see also* eroticism
Shearman, John, 153
Sicilian boys, 243, 289, *307*
Signorelli, Luca, 72, 95, 98–9, 100–1, 106
Silenus, 55, 57, *61*, 182, *201*
Sintenis, Renée, 258–9
Sistine Chapel, 16, 84, 128, 130–1, 135–8, *148*, 159, 176, 268
Skopas, 53, 55
Slater, Philip, 42, 47
Sleeping Boy (Carracci), *201*
Sleeping Faun (Hosmer), 323
Sleigh, Sylvia, *33*, 314, 317, 319, *326*
Sluggard, The (Leighton), 242
Socrates, 44, 49
sodomy, 46–7, 112
Sodoma, Il (Giovanni Antonio Bazzi), 82, 112
Soldiers Playing Cards (Léger), 266
Solomon, Simeon, 243
Sontag, Susan, 259–60, 292
Spaceman (Marisol), 262
Sparta, 40, 46, 212, 216
Spencer, Stanley, 272
Sphinx, 244, *246*, *247*
Spiritual Exercises (Loyola), 185
Spranger, Bartholomew, 166–7
Squire, Geoffrey, 95, 164–5
Standing Youth (Lehmbruck), 277
Stanley, Alan, 240
Steckel, Anita, 316–17, *331*
Steinberg, Leo, 133
Stendhal, 228–9
Stoller, Robert, 11
Strangford Apollo, 37, *60*
Strider, Marjorie, 317
strongmen, 9, 49, 51, 232, 238, 293–5
Struggling Captive (Michelangelo), *144*
Stubbs, George, *30*, 230
Stück, Franz von, 244, *247*
Studio (Courbet), 237
surrealism, 257
Sutton, Denys, 217
Swimming Hole (Eakins), 239–40, *251*
Swinburne, Algernon, 243
Symonds, A. J., 289
Symposium (Plato), 47, 49, 112

taboos: on nudity, 11, 40, 106, 166; on women painting nudes, 16, 207, 314
T. B. Harlem (Neel), 274, *281*
Tempest (Giorgione), 110
Ten Fighting Nudes (Polliauolo), 119, *124*
Theocritus, 48
theology, 13, 38, 95
Theseus, 41
Theseus and the Dead Minotaur (Canova), 205, *220*
Thorak, Josef, 260, *276*
Thorwaldsen, Bertel, *27*
Three Ages of Man (Titian), 110, *127*
Three Crosses (Rubens), 67
Three Shades (Rodin), 245
Thucydides, 43
Tintoretto, Jacopo, 108, 157, *171*
Tiresias, 40
Titian, 109–10, *127*, 165, 181
Tityus overwhelmed . . . (Michelangelo), 134
Tom of Finland, 297, *313*
Torso of a Young Man (Brancusi), 262
Transfiguration of Christ (Raphael), 153
Trent, Council of, 84
Truth Unveiled (Bernini), 179
Troy, fall of, 45
Tuke, Henry, 240
Turkish Bath (Sleigh), 319, *326*
Two Men on a Bed (Bacon), 272–3
Two Severed Legs and an Arm (Géricault), 249

Undergrowth of Literature, The (Freeman), 298
Uranus, 41
Urbino, Duke of (Bronzino), 165
Utter, André, 316

vagina, 268–9, 318
Valadon, Suzanne, 316, *323*
Valla, Lorenzo, 113
Van der Goes, Hugo, 108
Van der Weyden, Roger, 72
Van Eyck, Jan, *86*, 109
Vanguaard, Thorkil, 44, 165
Van Gogh, Vincent, 315
Varga girls, 290, 297
Vasari, Giorgio, 82, 84, 106; on antiquities, 96–7, on

Michelangelo, 133–4, 136–7; on mannerists, 153–5, 158–9, 160
vase painting, Greek, 35–6, 41, 43, 46, *62*, 317, *331*; changing styles of, 51–2, 54
Velasquez, Diego Rodriguez, 191, 192
Venus figures, 8–9, 13, 79, 96, 109, 176, 194, 209
Venus (Botticelli), 109
Venus (Giorgione), 8
Venus and Adonis (Rubens), 15, 182, *196*
Venus and Cupid with Doves (Boucher), *221*
Venus lamenting the Dead Adonis (Rubens), *196*
Venus, Cupid, Folly and Time (Bronzino), 166, *174*
Venus de Milo, 7
"Venus" of Willendorf, 9
Verrochio, Andrea del, 116
Vibration, 288
Victor (Metzner), 258, *276*
Victoria, Queen, 231
Victory (Michelangelo), 140, *145*, 154, 164
View of the Empire State Building . . . (Edelheit), 320, *326*
Vigée-Lebrun, Elizabeth, 206–7
Villon, François, 70
Viol, Le (Magritte), 318
virago, 111, 113
virginity, 68–9
Virgin with St. Anne (Leonardo), 190
virtu, 111, 118, 153
Vitruvius, 101
Viva, 300–1, 303–5, *308*
Vivarini, Alvise, 80
Vlaminck, Maurice, 315
Volterra, Daniel da, 84
voyeurism, 40, 56, 161, 176, 229
Vulcan, 209
Vulcan's Forge (Velasquez), 191, *202*
vulval triangles, 9, 57

Warhol, Andy, 264, 320, *324*
Watteau, Antoine, 204, *220*
Ways of Seeing (Berger), 257
Weismuller, Johnny, 299
Wellington, Duke of, 205, *223*
Wesselmann, 264
West, Benjamin, 205

Wheel of Fortune, The (Burne-Jones), 244

Where Do We Come From? (Gauguin), 242

Wilde, Oscar, 243

Winckelmann (scholar), 211, 216

Wind, Edgar, 110

Wittkower, Rudolf, 103, 190

women: nudity and, 14; view of male nudes, 15–16, 17–18, 42, 76–8; as artists, 16, 244, 314–21; Greek, 36, 39, 52; powers associated with, 39, 41, 190; Christianity and, 69; in Renaissance, 94, 101–2; 107–14; and rococo, 206–10; nineteenth-century, 231, 237–8; pinups of, 290–4, 299–306

Women in Love, 299

World War I Memorial, 266

Wrestlers (Courbet), 238, *248*

Wrestlers (Daumier), 238, *248*

Wunderlich, 270

Xenophon, 44, 47, 107

Young Spartan Girls Provoking the Boys (Degas), 237, *251*

Zadkine, Ossip, 263, 267–8

Zeus, 39, 40, 50, *64*; temple of, 38–9; and Dionysus, 41; and Ganymede, 46–7

Zeuxis, 105

Zipper, 288

Zoffany, Johann, 16, *33*